The Technique of Bird Photography

John Warham
PhD, FRPS

Focal Press
London & Boston

Focal Press

is an imprint of the Butterworth Group

which has principal offices in

London, Boston, Durban, Singapore, Sydney, Toronto and Wellington

First published 1956
Second edition 1966
Third edition 1973
Fourth edition 1983

British Library Cataloguing in Publication Data

Warham, John
 The technique of bird photography.—4th ed.
 1. Photography of birds
 I. Title
 778.9'32 TR729.B5

 ISBN 0-240-51084-4

Jacket photography by Mike Wilkes

Originated by Adroit Photolitho Ltd. Birmingham

Phototypeset by Tradespools Limited, Frome, Somerset
Printed in Great Britain by Robert Stace Ltd, Tunbridge Wells, Kent
and bound by Mansell Bookbinders Ltd, Witham, Essex

Contents

problems with 35mm SLRs; Using cameras with blade-type or sectional shutters; Working singlehanded; On taking a chance; Special problems with cine; Drill for setting up (TTL) cine camera in hide; Stills and cine together; Bird series; Automated nest photography.

sheet; Collecting ancillary shots; Checking the exposure; Subject behaviour; Human interest; Editing and presentation; Common defects; Suitable soundtrack; Stills and black-and-white shots; Commentary and continuity.

Preface to the fourth edition

Continuing improvements in camera design, techniques and accessory equipment have required that this book, first published in 1956 and twice revised, be completely rewritten and reillustrated. The opportunity has been taken to include discussion of methods for both still and movie photography, with the emphasis on the use of 35mm SLR stills cameras and on substandard (8 and 16mm) cine ones. A short history of bird photography has been added, the parts dealing with bird photography for zoologists much expanded and a detailed bibliography appended.

John Warham
Christchurch,
New Zealand.

Introduction

Outdoor pursuits have never been more popular. Increasing leisure has enhanced the wider interest in natural history that has developed in recent years and this has inevitably been reflected in photography. More and more people are using their cameras to portray plants, insects and other animals. Few living things have been studied more than birds, and bird photographs tend to dominate the nature sections of photographic exhibitions, just as bird books outnumber those devoted to other aspects of wildlife. This is understandable as birds are abroad by day, occur in all countries and climates, and positively command attention by their activities, by their songs and by their varied colours.

This book has been written for the guidance of photographers wishing to portray wild birds in their natural surroundings. The approach throughout is a practical one; the work is intended to act as both a training manual and a reference book, and it is hoped that it may help the reader past some of the more common problems which face all beginners in this field.

The approach is not a parochial one, for there is much interest in bird photography outside Europe and North America, while many photographers from those areas travel far in search of subjects. Field conditions in Africa or South America may be vastly different from those in the northern hemisphere (and I have dealt with some of the problems likely to be encountered) but even so the basic techniques for success still apply.

A knowledge of elementary darkroom procedure and basic movie methods has been presumed and the illustrations have been carefully chosen to demonstrate certain aspects of technique or to illustrate particular problems. Most of the pictures included carry some practical message.

People photograph birds for various reasons. Some, primarily photographers, see birds as attractive camera subjects. Others are part ornithologist, part photographer. At the other extreme are zoologists whose main field of research is among birds but who find the camera a useful tool for recording data. Many people work alone or with a friend, and solo workers have often been very successful bird photographers, although major nature films tend to be the result of team work in the field, studio and cutting room. This book aims to help all these differing categories of people wishing to develop skills in bird photography.

Good bird stills and films are not made by good cameras but by good cameramen or directors. The photographer's skill, ability to

anticipate and to improvise, flair for composition and understanding of the subject's habits, are some of the basic essentials on which he or she relies, knowingly or otherwise. Beginners lack these skills and having the very latest camera does not mean that you can start turning out masterpieces forthwith. Skill is only acquired with practice, but some of the basic rules, at least, can be taught.

The techniques described represent the combined wisdom and experience of several generations of bird photographers, and we all learn from fellow practitioners. If there is a nature photographer's club in your region it may well be worthwhile joining, for fellow enthusiasts are generous with help and advice. In Britain there are groups that circulate nature photographs and the Royal Photographic Society has an active Nature Group. This organizes meetings and field excursions in various parts of the country and includes many bird photographers among its members but, of course, you have to be a member of the RPS to participate.

The standard at which the reader is invited to aim is a high one. Too often birds are regarded as extremely difficult subjects and people tend to consider any picture of a bird, however crude, as praiseworthy. But the truth is that many species may be easily photographed provided that correct methods are used. Out of focus pictures or those with detail blurred by camera shake, subject movement or by jerky panning are quite unacceptable nowadays, given the ease of operation of modern cameras.

Throughout this book there is an insistence on putting the bird's interests before the needs of photography. This is particularly important when working at a nest site, for here the photographer is taking advantage of the bird's breeding drive, and carelessness or lack of consideration can be disastrous. Only by an honest regard for the subject's welfare can the photographer make sure that his activities do not hinder successful breeding.

It is partly because the bird must have first consideration that so much preliminary work is often necessary before the camera can be brought into use. Experience of countless generations has influenced most birds to avoid man and the very survival of many species depends on this innate wariness. Sometimes much hard work may be needed to overcome this timidity and it is a capacity for hard work rather than an abundance of patience that is the essential need for a good bird photographer. Birds living where man is seldom seen, as in the polar regions, show little fear, for man has not formed part of their evolutionary environment, and it is possible to walk cautiously into a penguin colony, for example, without causing a mass exodus. Such tameness may be more apparent than real. It has been found that while penguins may show no overt reaction to a passer-by, their heartbeats accelerate considerably when someone approaches; the birds are responding without showing it! Thus even with apparently tame species, photography is often best done from concealment.

Photography can be an expensive activity and, with erratic targets like birds, wastage tends to be higher than if you are working with static subjects like landscapes or even with people, for the former do not move unpredictably out of range while people can often be asked to cooperate. Nonetheless, 35mm cameras are so well designed that wastage is reduced; and the film itself is a much cheaper medium than the larger format material once favoured by bird photographers.

Hunting birds with a camera is fun, your pictures trophies of the chase. Modern equipment has made possible a wide range of photographic opportunities formerly impossible outside the laboratory. Even in crowded Europe there are still many opportunities for original work, the complete behavioural repertoire of many common birds having yet to be satisfactorily captured on film. The ubiquitous house sparrow is definitely not the world's best-photographed bird; and overseas many common species offer even more scope for the enterprising photographer.

Early days

We shall probably never know when the first successful photograph of a wild bird was taken, but this was certainly well before half-tone reproduction was possible, so that the earliest photographs had to be copied as line drawings or a kind of half-way process such as 'simili-gravure'.

Still photography

According to Guggisberg[1], one of the earliest bird photographs dates from May 1870. It shows a white stork at its nest and was taken by an American, C. A. Hewins. Like most of the bird subjects of the early photographers this was a large, leisurely-moving species—an essential requirement for the long exposures needed with the slow plates then available. The same is true of the subjects captured by the photographers of the *Challenger Expedition* (1872–76), whose portraits included those of crested penguins and wandering albatrosses; the negatives are still held at the British Museum of Natural History. These early photographs were, of course, all stills; cinematography was not to be practicable until some thirty-five years later. They were also taken on wet plates; not until about 1877 were the more convenient dry plates commercially available.

Meanwhile in France the scientific study of natural flight was being actively pursued and E. J. Marey developed the 'photographic gun' for taking free-flying birds. This device seems to have originated as an 'astronomical revolver' invented by J. Janssen for recording photographically the transit of the path of

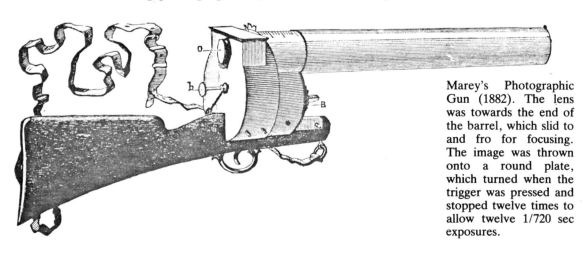

Marey's Photographic Gun (1882). The lens was towards the end of the barrel, which slid to and fro for focusing. The image was thrown onto a round plate, which turned when the trigger was pressed and stopped twelve times to allow twelve 1/720 sec exposures.

Venus across the sun on 8 December 1874. Marey was stimulated to develop his gun as he wanted to improve on results shown to him in 1881 by Eadweard Muybridge of captive pigeons and eagles in flight taken in 1878 at 1/500 sec but which were not sharp enough for Marey's purposes. His new 'gun' made faster exposures possible—1/720 sec or even 1/1500 sec in strong light. He used a long-focus lens at the end of the barrel to throw the image onto a sensitized plate. When the trigger was pressed the plate was advanced 12 times per sec, stopping long enough for each frame to be exposed by a rotating shutter. The images were tiny but revealed some significant features such as the twisting of the feathers due to wind pressure[2].

Quite independently, B. Wyles of Stockport took photographs of gulls on the wing in 1888. This was the same year that William Dougall of Invercargill, New Zealand, was on the sub-Antarctic islands to the south, photographing the animals and scenery. Among other things he took pictures of the albatrosses—large, phlegmatic birds ideally suited to exposures several seconds long. About the same time A.J. Campbell, in Western Australia, photographed three kinds of terns. This was in 1889 and some were reproduced in his book printed in Sheffield in 1900[3]. In 1890 Campbell photographed the nest of a white ibis for the first time in an Australian swamp and in 1893 took the first known photographs of a famous southern hemisphere gannetry at Cat Island, Bass Strait. A year later A. Hamilton, Professor at the University of Otago, went to Macquarie Island and brought back a number of bird photographs, mostly of penguins, which are now in the National Museum, Wellington. In the same year D. le Souef took photographs of the white-capped albatross and of a flock of silver gulls in flight at Albatross Island in Bass Strait.

In France, Marey's shots with the camera gun were replaced by better photographs recording a series of images on a single plate—'chronophotography'. Marey's new equipment enabled him to capture the flight of birds in instantaneous photographs at rates of up to 60 per second. He used sensitized film running between bobbins and allowing daylight loading. The picture size was 9 × 9cm and exposure times 1/900 sec. His birds were mostly captive ones—large, white species like egrets, duck and pigeons, that were released to fly across a black background. However, the results were sharp, showing the wings in successive positions and, by using three cameras, he made a series of the bird from three points of view simultaneously. His work was published in numerous papers culminating in *Le Vol des Oiseaux*[4].

Bird photography in Britain at this time lacked any real scientific direction; it was primarily a hobby pursuit. R.B. Lodge was a prominent exponent, active as early as 1890. In 1895 he succeeded in using a trip wire by which a lapwing fired the camera shutter as it came onto its eggs. However, the best known of bird photographers at the end of the century were the Kearton brothers—Richard and Cherry—and their work over the next 30

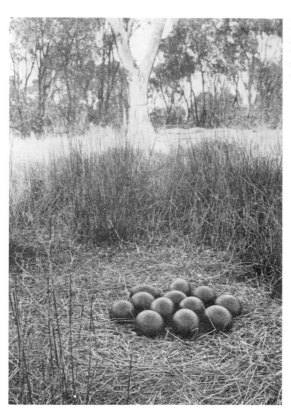

Emu's nest photographed in 1895 by A. J. Campbell. Time exposures gave good results with such static subjects.

The Cat Island gannetry, Bass Strait, on 21 November 1893 taken by A. J. Campbell. Large seabirds were often the subjects of the early bird photographers, being usually in well-lit situations and slow moving, so that instantaneous exposures were possible.

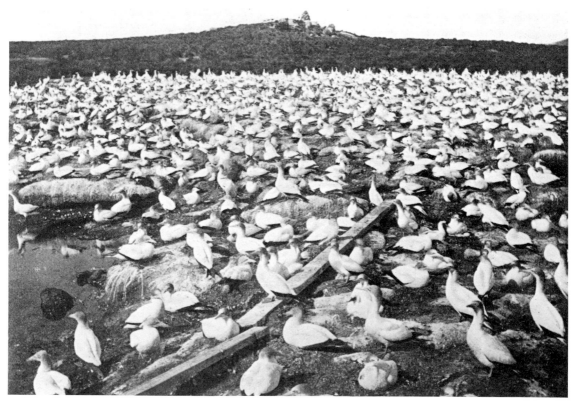

years was to prove the main stimulus behind the increasing popularity of bird photography as a sport and hobby in Europe. Their first book, *British Birds Nests* (1895) was illustrated with photographs throughout and in 1898, in *Wild Life at Home*, they set out to provide a manual for nature photographers. The Keartons developed and probably invented the use of a hiding device from which to take their photographs. They used a dummy tree trunk, a stuffed ox skin, an imitation rock and even an artificial rubbish heap in which to hide themselves and their cameras. Their numerous books to 1931 provoked lots of interest, were often reprinted, and many of their methods are still used today, e.g. the display of a white handkerchief to signal to your assistant at the end of a session. Richard also had much advice to offer, such as on how to get on with landowners and gamekeepers, on the use of landmarks to help find a nest where the bird has

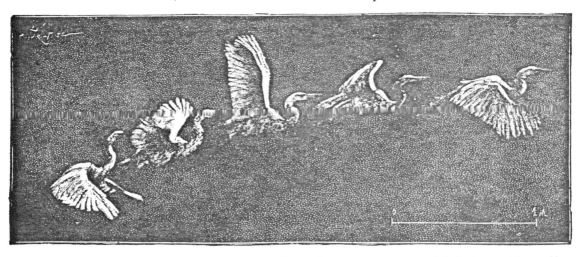

One of Marey's 'chrono-photographs', with five exposures of a white heron flying against a black background. Each exposure lasted 1/900 sec. Date about 1885. For a modern chrono-photograph see page 230.

been watched onto it, on how to encourage birds to nest in coffee pots and biscuit boxes around stack yards and gardens and even how to use strong ammonia in a bottle buried near bushes in which birds were nesting—to repel cats! By 1898 Richard Kearton had taken many sea birds in flight including terns and a great skua attacking an intruder—exposure 1/600 sec. Most of his bird-at-the-nest pictures included plenty of surroundings which give a good impression of both the bird and its habitat.

The Keartons used a tripod-mounted camera, typically a half-plate square bellows outfit made by Dallmeyer and Co. For flying birds they attached a smaller square-bellows 'miniature camera' on top, which was used as a viewfinder, the camera being hand held and the bird 'snapped' when it appeared to be in focus.

R. B. Lodge took his large camera to Europe and the Balkans. His pictures of nesting herons and bitterns were frequently reproduced as late as World War II. His younger friend, Oliver G. Pike, became even better known. Pike moved from a square-bellows field camera to a single-lens reflex built to his own design, which he marketed as 'The Bird-Land Camera'.

The Keartons' artificial tree trunk (photo courtesy Cherry Kearton).

In America, Eadweard Muybridge's work was not overlooked and in 1881 Professor A. Hyatt took some of the first satisfactory bird photographs on islets off the Atlantic coast. One, of a gannet colony, required an exposure of 20 sec! Then in 1885, M. S. Northrop successfully photographed an American woodcock on its nest near New York, while in 1887 Professor L. A. Lee took pictures of pelicans, cormorants and other sea birds during a cruise through the Straits of Magellan and up the Pacific coast to Alaska.

Bird photography advanced notably between 1890 and 1900 as dry plates improved allowing shorter exposure times, and at the American Ornithologists' Union meeting of 1891, a series of 80 photographs of live birds and nests was shown. One of the best examples from this period was R. W. Shufeldt's cedar waxwing study, reproduced as the frontispiece for the January 1897 issue of *The Osprey*.

Frank M. Chapman, of the American Museum of Natural History, took his first photograph (of a buzzard at bait) in 1888 and his *Bird Studies With A Camera* appeared in 1900. His were the best bird photographs from the New World to date and they were taken with a single-lens reflex built to his own design. He also invented the 'umbrella blind'. This was a hiding tent made from an umbrella which opened within a canvas bag large enough to reach to the ground. The umbrella stick was driven into the soil and the whole contraption was easily portable.

About the same time another professor, Francis H. Herrick, published his *Home Life of Wild Birds*. It was devoted to a new method of the study and photography of birds and, according to Guggisberg[1], Herrick's use of a tent to take red-winged blackbirds in 1899 was the first time an uncamouflaged blind was used. However, Herrick's technique for using the blind was unusual, to say the least, and would be quite unacceptable today. He

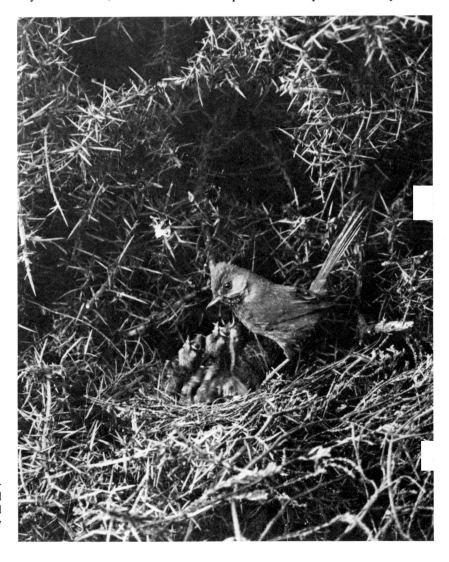

Dartford warbler photographed by Richard Kearton and published in 1910 (photo courtesy Cherry Kearton).

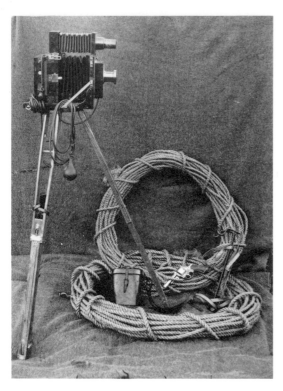

The Keartons' square bellows camera with the 'miniature' used as a viewfinder for flying birds (photo courtesy Cherry Kearton).

removed the nest and its immediate surroundings—branch, bush or tussock—and set it up in front of the hide in a well-lit position! Later, however, Herrick moved to less extreme methods. Perhaps his best-known effort was the series of bald eagle pictures which he took from an 80ft steel pylon hide, surmounted by a nine-foot-square platform, carrying a blind big enough to house two people.

It is interesting that these early American workers tended to be professional zoologists; their British counterparts mostly amateurs. An exception was A. Radcliffe Dugmore, an American army man who, rather appropriately, stalked his birds with a Graflex and a long focus lens. Some of his results were published in 1901[5] and his instructional book the next year[6]. Some of Dugmore's methods are questionable by modern standards, for he often resorted to putting nestlings onto perches to lure the parents into range, interference fraught with danger to the chicks. Some of his early studies, however, like that of the American woodcock, are as good as today's equivalents.

Another early American in the field was William L. Finley who started to photograph birds as a youth in 1897. In 1904 Finley and H. T. Bohlman took a series of the golden eagle nesting in the Californian mountains with a 12in lens on a specially built reflex camera. In the course of their career as nature photographers, Finley and his wife Irene collected together some 50,000 negatives and 200,000ft of motion picture film.

Soon many Americans were photographing from hides but

Chapman, Herrick and A.O. Gross were outstanding in using photography to further their understanding of birds and their behaviour. In 1915, A.A. Allen was appointed Professor of Ornithology at Cornell University. He had taken his first bird photograph in 1902 and was the first teacher to include a course on bird photography in the academic curriculum.

Other photographers were active in foreign parts. The first bird work from Africa illustrated with photographs, seems to have been Henry Harris' *Essays and Photographs: some birds of the Canary Islands and South Africa*[7]. Published in 1901 it included studies of kingfishers, jackass penguins and cape gannets. Later the van Somerens (R.A.L. and V.G.L.) worked in East Africa and published their first bird book in 1911[8]. India too had its bird photographers, notably E.H.N. Lowther, and it was on this continent that perhaps the oddest hide of all time was used—Mrs Illum Berg's balloon basket which she had hung over a Himalayan precipice. Hidden within the basket, she took the first photographs of a lammergeier at its eyrie.

The appearance of the Keartons' books and the half-tones of birds that began to appear in illustrated periodicals like *Country Life* and *Illustrated London News* and *National Geographic Magazine* stimulated worldwide interest, and as the quality and speed of sensitive materials and lenses improved, so did the quality and range of the photographs taken. By about 1912 photographs were commonly used to illustrate ornithological articles.

Famous bird series from before the first World War include Chapman's roseate flamingos in the Bahamas and Howard Cleaves's studies of ospreys at Gardiner's Island, New York. Another pioneer worker was Maud D. Haviland who returned to England from a visit to Siberia in the summer of 1914 with many photographs of nesting phalaropes, plover, Lapland bunting, Temminck's stint and the like, which she had studied along the Yenesei River[9].

In Britain, an important stimulus to stills bird photography has been the Zoological Photographic Club. This was founded in 1899 and works through the circulation of postal portfolios. Most of the best British nature photographers became members in due course, while a few distinguished overseas workers contributed as corresponding members. This club has been a potent force in raising the standards of bird photography and in discouraging dubious practices.

Until the advent of the 35mm single-lens reflex, most bird photographs were taken at or near to nests or baits. Hides and tripod-mounted cameras were used. The most popular instrument was a square-bellows field camera fitted with a silent 'Luc' or similar behind-lens shutter, a lens of about 200mm focal length and quarter-plate or 5 × 4in plates or cut film. The swing and tilt back of the field camera and its rear focusing directly onto the ground glass screen were ideal for photography under the rather

controlled conditions and some very fine pictures resulted. Others used 3½ × 2½in or quarter-plate single-lens reflexes, such as Thornton-Pickard, Graflex and so on, but generally speaking their noisy focal plane shutters were useless with timid birds at close quarters. However, these cameras were more practicable at greater distances and one pioneer of wait-and-see photography, Miss E.L. Turner, obtained a wide range of pictures of birds (including some quite timid kinds like hooded crows and shelduck) from lake- and mereside hides from 1914 onwards. She wrote perhaps the first article on this topic in 1915[10]. Miss Turner also made many excellent at-the-nest studies, of which her long-eared owls were among her best.

When the first 35mm cameras appeared with coupled range-finders, some were soon in use for flight studies. However, high-speed flight photography was not exactly new: J.A. Speed had made some remarkable studies, using magnesium powder flash, of swallows and kingfishers around 1928–30, and Arthur Brook, a watchmaker from Wales, later built his own truly high-speed shutter and made some outstanding photographs of peregrines and swifts in action.

Magnesium powder flash had been in use since about 1889 and the first flash photo of a bird is said to have been George Shiras' study of a sleeping great blue heron taken on White Fish Lake, Michigan in 1893. His first of many articles illustrated with flashlight photographs was published in 1906[11]. Another flash photographer was W. Nesbit who, like Speed, managed to get quite high-speed results from flash powder. He explained his methods in a book published in 1926[12].

The appearance of flashbulbs in 1929 was a big advance and bulbs were used in the late 1930s and 1940s to make excellent studies of nocturnal birds, like nightjars and owls, mostly with field cameras and using the 'open-flash' technique. Presently, internal flash synchronization of shutters became possible and in 1945 the first of the high-speed flash circuits, based on Harold Edgerton's designs, became commercially available. Owl photography again flourished and the startling action shots of Eric Hosking, Ronald Thompson and others were widely published. Many of these have not been bettered in later years except that they are now shot in colour, a mode not really practicable with the slow stock available in the 1940s. Edgerton himself produced pin-sharp shots of humming birds in flight[13] but Arthur A. Allen was soon the most prominent American exponent of the new technique, and one of the first to combine high-speed flash with colour[14]. His more sensational results often enlivened the pages of *National Geographic Magazine*.

Colour photographs of birds were taken as early as 1911 by the autochrome process, but not until the appearance of reversal material like Agfacolor and Kodachrome did colour photography attract the attentions of any but the most experimentally inclined exponents.

During the 1950s more people started looking to 35mm for their equipment and this trend accelerated with the appearance of the first 35mm SLRs in the late 1950s. They came from Kodak, Zeiss and Voigtlander. All had sectional shutters synchronized for electronic and bulb flash at all speeds. The fastest shutter speed was 1/500 sec. They were fairly quiet and extremely easy to operate, having built-in exposure meters and fast wind-on, but could not accept lenses of focal lengths greater than about 200–250mm and these lenses did not focus very closely, which imposed some limitations. Nevertheless many fine shots were obtained and some of these cameras are performing well to the present day.

Cinematography
Bird photography was well established before cinematography was invented but Marey's 'chronophotography' of birds and insects and his other experiments of the 1890s were important steps in the evolution of the movie camera. Just who made the first film of a wild bird is obscure, but in Britain Oliver Pike was certainly a pioneer, his earliest film being shown in 1907 at the Palace Theatre, London. In the USA Frank M. Chapman's first film on Pelican Island was shot and screened in 1908, and shortly after this date Ad David of Basle filmed kites and vultures at bait in Africa, to be followed in 1910 by Cherry Kearton whose early African wildlife films included many shots of birds. His Indian and Borneo films were also very popular and were widely screened up to World War II. Another famous member of this coterie of early wildlife film-makers was Herbert Ponting. His stills and movies of the Antarctic while photographer with Scott's second expedition were outstanding. His original film *With Captain Scott in the Antarctic* was screened throughout the world. It was reissued in 1933 as *Ninety Degrees South* and includes some excellent shots of Adelie penguins and Antarctic skuas.

In those days all cine cameras had to be hand cranked. Just think how limiting that must have been for the early wildlife photographers. Ponting recounts the difficulty he had when he tried to film Antarctic skuas regurgitating food for their chicks. The adults were not particularly frightened of him, but as soon as they started to disgorge and he commenced to crank away at the massive camera he then used, the skuas became alarmed by the clatter and movement and persistently reswallowed the food. For some reason Ponting did not use a hide, but sat for hours in the open. The shot would have presented no difficulty had he been concealed, for the birds would not have then been distracted by his flailing arm and would soon have accepted the noise of the mechanism. Antarctic skuas are, in fact, among the easiest of birds to film while nesting.

However, all these early films were of wildlife generally. The first film to be devoted solely to birds may have been those of Bengt Berg, a Swede who filmed cranes, storks and vultures in

their African winter quarters and breeding grounds in 1924[15]. Cherry Kearton's film of jackass penguins at Dassen Island, South Africa was also a pioneer study.

Oliver Pike will probably be best remembered for his classic film on the cuckoo made in 1922. The making of this film is a good example of the value of knowing your subject, for it could hardly have been shot without the expertise of a man who had studied cuckoos all his life—Edgar G. Chance. Pike described how the operation was carried out in his (the first) book on nature cinematography[16].

The site of the action was a Worcestershire common where the cuckoo's victims were meadow pipits. Chance prepared a map of their nests, 13 in all, and he knew from long study that the female cuckoo would lay on alternate days when the first two eggs of the pipit's clutch had appeared. If she did not find a nest until the complete clutch had been laid, the cuckoo would pull the pipit's nest to pieces so that they would make another, re-lay, and so give her a second chance of parasitizing them. Now, for filming the cuckoo actually laying and the method by which she did this, it was essential to know just when the bird would be most likely to visit each nest, so that the cameraman could be there ready to record the event. Accordingly, Chance emulated the cuckoo and destroyed the meadow pipits' nests one by one at two-day intervals before the eggs had been laid. The birds started rebuilding within a few hours, so that Chance had a series of pipits' nests coming into laying readiness about two days apart. He could thus predict with reasonable accuracy the laying dates of each pipit and the day on which the cuckoo would visit each in order to lay her single egg. By then, hides were already in position at the first of the nests and a team of a dozen assistants had been organized to keep the cuckoo under constant surveillance.

This particular bird seems to have been very tame, and the watchers were able to signal to Pike, ensconced in his hide, when she started to fly towards him. He then started up his Newman Sinclair 35mm camera and was able to get the whole sequence— the cuckoo arriving, picking out one of the pipit's eggs, moving on to the nest to lay her own and then flying off with the egg of the foster-parent-to-be still in her bill. The whole operation lasted only eight to 10 seconds on each occasion. It will be obvious that without Chance's expert knowledge the possibility of being at the right time and place to catch the cuckoo in action would have been nil; but Chance could predict when and where the cuckoo would come, giving the cameraman the opportunity to intercept the bird and record her behaviour.

Such successes led in turn to more intensive studies of particular species, such as the films shot under Julian Huxley's direction of great crested grebes and gannets in the 1930s. These films, probably for the first time, attempted a photographic inventory of a single bird's displays. Alfred Brandt and A. A.

Allen were probably the first to put together a sound-movie of birds. This was in 1931 and their techniques for synchronization were perfected over the next few years. Later Konrad Lorenz's more detailed studies, as recorded in A Seitz's film *Ethology of the Grey Goose*[17], showed the way to the films of modern behaviourists.

Slow-motion bird photography probably began in 1930 with R Demoll's study of flight movements in small and large birds[18]. He shot at 150 frames per sec and his work triggered off further research. Presently more advanced high-speed cameras allowed M. Stolpe and K. Zimmer[19,20] to film and analyse the complex whirring flight of hovering hummingbirds and sunbirds.

Cameras and lenses

The nature photographer's main problem when dealing with wild birds in their natural environment is how to counter their innate shyness. This often makes it impossible to get the camera close enough, without concealment, in a place to which birds regularly resort. Even then the camera can only be brought to within a limited distance from the bird. There is inevitably some noise associated with camera operation and most birds are easily frightened by strange sounds. This means that with such small subjects, the permissible working distances only enable correspondingly small images to be produced when lenses of medium focal length are used. To show the birds large enough on the film to reveal adequate detail in printing or projection usually necessitates lenses of longer focal length than are employed for general photography.

As birds are such independent animals, many photographs show them at their nests. When nesting, birds are more approachable, more tolerant of casual noises, and the photographer has a good idea of where to train his camera so that, all in all, his chances of taking successful pictures are greatly increased. But the very fact that he takes advantage of his subject's parental instincts imposes another problem—he must operate without prejudicing successful nesting. Thus cameras which are noisy in operation, whether due to the shutter (the commonest source of trouble), the mirror return, the film winding mechanism, or any other cause, are unsuitable for this kind of close-up work unless these disadvantages can somehow be overcome.

Although the camera may be trained on a nest, or some other point to which the bird is expected to return, it is frequently impossible to be sure just where the bird will be when the opportunity for making an exposure occurs. It may stand slightly to one side of the field covered by the lens, and while it is there it may be impossible to move the camera lest the bird detects the movement and departs in panic. Thus, not only is a fairly large image desirable but the negative should also include a good deal of the surroundings. The greater the area included, the greater the chances of securing a picture. Many prints of birds are the result of enlarging only part of the negative or transparency.

Cameras have to be considered in the light of these special problems as regards their suitability for bird work. Here, as in other fields of photography, it is not merely the camera used but the skill and imagination of the person handling it that determines

the quality of the final result. There is no one camera which is ideal in every respect. Certain types excel for certain aspects of bird photography and several kinds are capable of yielding first-class results, yet some are quite unsuitable.

A specification for an 'ideal' camera for birds, given in an earlier edition of this book some 16 years ago, is still valid. It calls for:

1 A smooth, quietly working shutter and film transport mechanism so that the camera can be used at close quarters without alarming shy subjects.

2 An eye-level, through-the-lens viewing and focusing system. Such reflex systems are extremely convenient for hide and blind photography. They solve parallax problems and enable moving subjects to be followed relatively easily.

3 A shutter speeded to 1/1000 sec, or shorter, allowing flight shots using natural lighting.

4 A shutter with X-synchronisation, allowing electronic flash to be used at all speeds. By this means close-up flight studies can be made despite high ambient light conditions.

5 Detachable backs enabling the photographer to change quickly from monochrome to colour etc, without having to invest in and carry around two separate cameras.

6 A full range of telephoto and mirror lenses up to about 1000mm focal length.

7 Automatic diaphragms, at least with the short-range tele-lenses, i.e. 135 and 250mm, and close focusing to two to three metres without supplementary lenses or extension tubes.

8 Through-the-lens metering of the light received at the camera enabling a continuous check on fluctuations to be made and corrected for, either manually or automatically. This is of special value to those who take birds from hides and blinds.

Additionally, the mechanism must be known and proved by use to be reliable. It is too complicated to be put right when you are in the field, perhaps on an island hundreds or thousands of miles from the nearest mechanic.

The nearest approach to meeting all these requirements seems to have been the very advanced but unfortunately discontinued 'Contarex' system which had many refinements including true interchangeable backs. Many major makers supply special backs to take 250-exposure rolls. These are expensive and may have some relevance for certain kinds of bird work in the scientific field, but are not the sort of detachable backs referred to above, which allow you to change from one type of film to another in the middle of a roll. Such a facility seems to be unavailable among 35mm cameras at the present time. The type of camera that most nearly matches the ideal is the 35mm eye-level viewing single-lens reflex (SLR) with through-the-lens (TTL) metering of the light. Much of this book is about photography using this kind of camera. It is the mainstay of the

bird photographer's equipment for still photography. Bear in mind, however, that there is no camera of *any* kind or size that is completely ideal for all aspects of this specialised field of photography. Money cannot buy the perfect camera and the assertions of different manufacturers that theirs is a perfect system for everything is just plain nonsense. In practice a compromise has to be drawn between the limitations and advantages of the different types and makes. This being so, you have only yourself to blame if you allow some glib-tongued salesman, who probably cannot tell a rook from a jackdaw (and has never tried to photograph either), to talk you into buying a camera offering few of the above requirements.

An important limitation with modern SLRs is that electronic flash can generally not be used at shutter settings of more than about 1/60–1/125 sec. This imposes a severe limitation with fast-moving birds when the flash is used for supplementary illumination. At these speeds, and at the stop needed for a medium-powered flash at around 2m, daylight may register and things like swaying heads of nestlings may still appear blurred. In other words you cannot take full advantage of one of the big assets of electronic flash—its ability to overcome subject movement.

35mm SLR cameras

These cameras depend on using the taking lens as the viewing lens up to the time of the exposure. By means of an ingenious arrangement of mirror, focusing screen and reversing prism (pentaprism) the user gets an upright view, right way round, of the scene covered by the lens. The camera is held at eye level and the system greatly facilitates the following and focusing of a moving target like a bird. Furthermore, at all distances, the viewfinder shows exactly what the lens sees—there is no problem of parallax as there is with many other types of camera, no matter how close the range. Also, in many models the lens apertures, shutter settings and meter readings are visible to one side of the viewing screen. Focusing through the viewfinder is done either directly on the ground glass screen or using a split-image system of some kind, again incorporated in the screen. The lens is fully open,

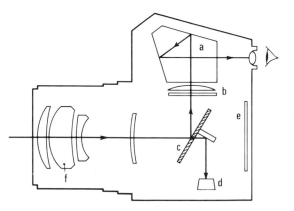

Construction of a 35mm SLR camera: (a) pentaprism, (b) focusing screen, (c) mirror, (d) photocell, (e) film plane, (f) lens.

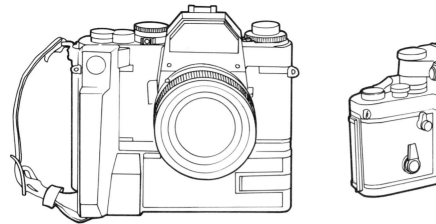

Two examples of the many 35mm SLRs with TTL metering. Eye-level viewing is normal and compact motor drive units can be attached (above left). A vast range of coupled lenses may be fitted, while automatic exposure control by aperture and/or shutter is possible with some models.

giving a bright clear image. The linking of these various controls means that the time needed to select the correct settings, to focus and to compose the picture can be very short. Hence this type of camera comes into its own particularly for taking birds which briefly present themselves as targets and then are gone.

The bright screen image in an SLR results from the fully automatic diaphragm (FAD), an arrangement whereby the iris is fully opened until the shutter release is pressed when the iris automatically closes to the selected aperture, the mirror springs up out of the way and the shutter then moves to expose the film to the uninterrupted beam. Winding on in readiness for the next exposure involves a simple stroke of a geared lever, which also resets the shutter. As this can be done with a flick of the thumb, a series of shots can be taken in rapid succession. For faster shooting most models can be fitted with auto-winders and/or motor drives. These automatically wind on and set the shutter at rates of up to about five frames per second. Most SLRs also have a button which when pressed gives a preview of the picture at the taking aperture, showing the depth of field.

SLRs usually have focal plane shutters of metal or fabric that run just in front of the film. Exposure is varied by changing the width of the slit passing in front of the film rather than by changing the speed of the shutter blind as a whole. This arrangement facilitates the design of interchangeable lenses and most makers supply a wide range from fisheyes to zooms and long telephotos of up to 1000 or 2000mm focal length.

There is a bewildering array of cameras of this type available and improvements and refinements are continually being incorporated in new designs. These are often in the direction of automation of the taking process. Most models are expensive and it pays to shop around, to handle the various makes, and weigh up the advantages and disadvantages of each for the purpose you have in mind. As it is 'trendy' in some quarters to be able to display the very latest models, earlier ones can be readily purchased secondhand, in guaranteed condition.

Formerly, many SLRs had quiet, blade-type shutters set just behind the lens and these enabled electronic flash to be used at any shutter speed. Cameras of this type are no longer made but can occasionally be purchased in good order secondhand and are worth acquiring as a second string for their particular advantages. For our purposes they need to have at least an 135mm telephoto lens.

35mm SLRs are becoming increasingly automatic in operation and this trend is bound to continue with automation extending to lower-priced models. There are two main types of automatic exposure control. With one the user sets the shutter speed and the circuitry monitors the light and sets the lens aperture (shutter priority); with the other, the user sets the aperture and the circuitry monitors the light and selects the correct shutter speed (aperture priority). The majority of such cameras have stepless electronic shutters, so that precise exposures are possible. Automatics generally couple to computer-type electronic flash units (page 163) but often only to units specifically designed for the camera in question. Some models permit manual control and auto-exposure with aperture priority *or* shutter priority. All this is regulated by a tiny electronic unit and a TTL meter which can monitor the light within the 1/30 sec between pressing the release button and the actual exposure.

These automated features may be worth paying for since any system reducing the delay between identifying a target and preparing the camera to photograph it are obviously of great value with highly mobile subjects like birds. Automatic iris control can also help when working from blinds or hides. Absolute reliance should not be placed on these automatic controls, for there will be times when you wish to cut them out and most manufacturers provide a system of 'manual override' in which the camera can be turned back to non-automatic operation. Automation is being extended to focusing. In one method, the camera generates a sound signal, which is received back at the camera as an echo whose return time is measured to give the range and to drive the lens to the critical focus position. How useful such refinements will be for bird photographers time alone will tell.

The through-the-lens metering system has many advantages in bird photography. There are several different designs for metering the light coming through the lens and diverting part of it inside the camera onto a photo-sensor, and the pros and cons of the various systems are much discussed in some photographic circles; but basically most of the systems work quite well if used intelligently. It is necessary to know your particular camera and by experimentation to establish the circumstances in which the light-metering is precise and in which a manual adjustment of perhaps half a stop more or less is needed. It is doubtful whether any present system of TTL completely disposes of the need to have a good hand-held and conventional meter if you intend to do

a wide variety of work, including close-ups of eggs and nests and the like.

The 35mm camera appeals particularly to those who want to produce transparencies for projection. Even without electronic flash, modern colour film allows quite brief shutter speeds to be used and this both widens the field of potential subjects and helps to cut down wastage through subject movement. The results are considerably cheaper, of course, per exposure than when the larger formats are used. Furthermore, the reflex viewing system means that focusing can be done quickly allowing advantage to be taken of sudden opportunities.

The 35mm camera can be used very effectively with flash, synchronisation is simple and flight studies in colour are fairly easily produced using high-speed flash and high-speed film. Likewise, without flash, the through-the-lens rangefinder system simplifies the photography of flying birds. The camera is set to the anticipated taking distance and the bird's image kept on the split-image system until the two have almost met, when the release button is pressed.

Despite the 35mm camera's versatility it has certain practical disadvantages. First, the bird photographer who wishes to produce negatives good enough to make exhibition prints of the usual 50 × 40cm size will be hard-pressed to succeed using such small negatives or transparencies. The reason is that while a 35mm negative can certainly produce a 50 × 40cm print showing adequate detail, this is usually only possible by a combination of careful technique and enlargement of the whole of the negative area. Unfortunately, with such wayward creatures as birds, the subject is often not in the correct position on the negative to make a satisfactory enlargement from the whole of it.

On the other hand not everyone wishes to produce such large prints, and those who are satisfied with a 25 × 20cm picture should be able to produce many satisfactory photographs with a suitable 35mm SLR. If you are mainly interested in birds rather than photography—that is, if you are a photographically-inclined ornithologist rather than an ornithologically-inclined photographer—then the 35mm reflex may be ideal for making the record shots you need and for taking series depicting different facets of behaviour, where exhibition quality prints are neither called for nor expected.

Larger format SLRs
Single-lens reflex cameras taking 120 size or 70mm rollfilm from various makers incorporate advanced techniques to differing degrees. Basically, these are SLRs producing medium-sized negatives or transparencies. They are mostly intended for use at waist level as the viewing screen is at right angles to the axis of the lens but they can be converted into eye-level reflexes by fitting appropriate reversing prisms. The scene is then viewed right way round and right way up, as in a 35mm SLR.

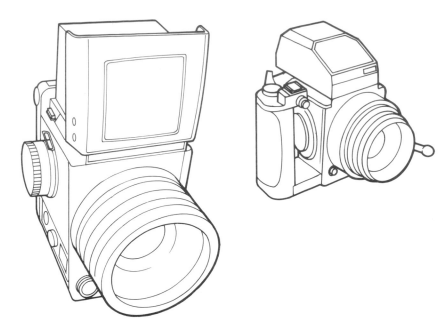

Two examples of SLR cameras for 6×6 or 6×4.5cm pictures. They have TTL metering, and automatic and non-automatic models are often available. Motor drives may be built in (1) or attachable (2). Very long (400mm plus) and mirror lenses may not be available. Eye-level finders can be fitted, and rapid film change is possible by means of detachable backs or cartridges.

Most makers of these larger format SLRs offer a range of accessories—interchangeable lenses, motor drives (sometimes incorporated as integral features of the camera body itself), TTL metering and many have electronic shutters with either shutter or aperture priority exposure control.

The virtue of such cameras is their ability to produce a larger size negative or transparency than 35mm and hence the possibility of better quality and resolution in big prints, whether in colour or monochrome. However, they are expensive to buy, to maintain and to run.

Many have true interchangeable backs so that switching half way through a roll from black and white to colour is simple. Some have leaf-type shutters in their lenses, and hence can be used with electronic flash at any speed (maximum 1/500 sec) and are thus excellent for true high-speed photography of small birds in flight.

The format is quite important. A square picture is not ideal for birds since they are longer than they are broad, so that a square format is wasteful if you want to compose the picture at the time of taking and to fill the whole frame. How often do you see a square picture of a bird in an exhibition or on the printed page? To some extent the format restriction can be countered by using magazines giving smaller pictures, e.g. 15 or 16 on 120 film.

Non-square SLRs producing 'ideal format' pictures, usually 6×7 or 6×4.5cm, cannot be faulted for format and they are worth investigating if funds allow. Check that the model you are looking at is quiet enough in operation (including the noise made during winding on and the return of the mirror).

Automation has been introduced to these larger format cameras, which now tend to have electronically controlled shutters, motor drives and power batteries—a valuable combina-

tion for remote control work (page 50) and capable of being fired via cable, interval timer or radio signal. No manual wind-on is needed with these and film changes can be made very quickly. But check the noise level before buying or hiring these expensive outfits.

Monorail or view cameras

These represent today's equivalent of the teak, brass-bound quarter- or half-plate 'field' cameras with which so many classic bird photographs were made, and which are nowadays mostly collector's pieces. Like the modern monorails they were not intended to be used in the hand but firmly supported by a tripod and in this mode the monorail still has advantages when used from hides.

Monorail cameras consist of a sort of optical bench carrying a lens panel joined by a pleated, folding and extensible bellows to a back. This carries a ground glass focusing screen which can be turned to one side to admit holders for the films or other sensitive materials. The whole is supported by, and slides along, a single base or monorail. Both lens panel at the front and the back are capable of independent to and fro movement, can be swivelled, raised and lowered, and the rail itself couples to a tripod via a standard screw or tilting top.

Most monorails are designed for studio and laboratory use and are large format cameras, but several makers market models to take 120 size film in rollholders. These give 6×7 or 6×9cm pictures and this is large enough for most kinds of bird photography using today's high-resolution film stock.

Advantages of the monorail include the wide range of movements that can be used, especially the swing back, so useful for photographing birds at the nest and the side swing, which is equally valuable in difficult situations such as when working close to cliff faces (page 139). Also the arrangement of the lens panel allows for a wide range of lenses to be fitted in blade-type shutters making an excellent outfit for high-speed flash applications. The film holders can be switched at the flick of a finger so that you can change from colour negative to colour reversal to black and white in a trice, as long as you have the necessary filmholders on hand.

The rotating back means that you can change from horizontal to vertical format readily without needing to shift the camera—impossible with 35mm SLRs, as these are designed for horizontals and have to be turned on their side for verticals. Perhaps the chief advantage of the monorail system, however, is that both lens panel and back can be shifted to and fro and focusing done either by moving the front or the back. The rear focusing facility is particularly good when in a hide, for once the camera is correctly placed alteration of focus—for example, from the front to the rear of a nest—can be done without the lens being shifted and without any danger of such a shift being detected by the bird and alarming it.

Monorail cameras are robust and their focusing ratchets firm and positive. If bought secondhand, check for the absence of play and noise in the focusing mechanism, that the lens panel is really firm when in place and absolutely parallel to the focal plane of the back. If you plan to use the camera from a hide it is important to see that no part of the monorail support protrudes beyond the lens panel. If this happens, it is tricky trying to position the lens and its hood so as to protrude through the hide fabric without some other part of the camera front pushing hard against the fabric. If this occurs it is likely to result in camera shake and other problems. A number of current makes are unsuitable for our purposes on this score.

Focusing with a monorail is done directly on the ground glass screen, using a focusing magnifier if possible. This is a very positive method and, despite the inverted image, is excellent for picture composition.

Press and similar cameras
These are basically very similar to monorails but the lens panel is mounted on twin rails screwed to a bed that folds up when the camera is not in use. When focusing, the lens and its panel are shifted to and fro and the lenses used are set in their own blade-type shutters. The camera back accepts rollholders and there is a rangefinder coupled to the rack and pinion focusing mechanism. Like the monorail this kind of camera is effective on a tripod but is also fitted with a viewfinder for hand use and a 'sports finder' which can be quite effective when taking large to medium-sized birds in flight.

Although these are quite versatile cameras for those wishing to work in the larger format, they have certain disadvantages. Adjustment of stops and shutter speeds is difficult in hides, as you cannot see front of the lens panel (a disadvantage shared by most monorail cameras), while focusing involves shifting the panel with the danger of frightening the bird. It is very common to find that a change of focus is needed during the course of a session. Such cameras are also not intended for use with ultra-long, telephoto or mirror lenses. The panels will simply not carry these without special supports.

A few manufacturers produce a sort of hybrid between monorail and single-lens reflex—a sort of reflex view camera. The front and body of the camera slide on a rail but the body has a reflex housing for viewing and can be fitted with an eye-level prism. These cameras are made in 6 × 6cm size and would seem to offer some advantages for bird photography, although they are quite expensive.

Still camera lenses
35mm. The standard 45-55mm lenses fitted to 35mm SLRs are not suitable for photographing birds, although good for close-ups of nests and for habitat shots. Telephotos are needed to show the

A monorail camera (top) showing various movements possible. Such cameras have to be supported on a tripod, and focusing is done on the rear ground-glass screen. They are useful for scientific work where large negatives or transparencies are required and for close-up high-speed flight studies. The press-type camera (below) is good for large-format hand-held work with flying birds by day or night (like the shearwater study on page 178) using the sports-type frame finder illustrated. They can be fitted with rangefinders coupled to the lens and accept a wide range of roll holders, Polaroid backs etc., but are inconvenient for photography from hides.

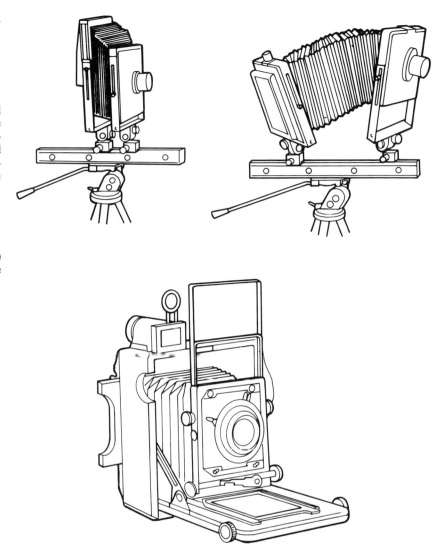

subject large enough at practical working distances. As a general principle the shortest focal length lens that will do the job should be used and an enthusiast will gradually acquire a set of lenses, each of which is best fitted for a particular purpose.

In the 35mm field the range of lenses available is vast but, as usual, you get what you pay for. The cheaper lenses in any focal length range rarely have the resolving power and edge-to-edge sharpness of the more expensive ones. The cheaper lenses may be good enough if you are taking transparencies for projection and are not aiming at producing large high-quality prints for exhibition. They may also be a good buy if you are a beginner at bird photography and want to learn the ropes before graduating to better lenses. On the other hand there is much to be said for buying the best you can afford. Avoid very expensive lenses of wide aperture. These are usually more by way of status symbols

than practical aids to good nature photography. They are heavy, their conspicuous eye-like appearance often upsets a sensitive bird and such lenses are very seldom used at full aperture anyway. Many makers now sell two ranges of lenses; one series of large aperture is heavy and expensive, the other of smaller aperture is lighter and cheaper and usually adequate for birds. Choose lenses with automatic diaphragms so that you can focus at full aperture, stopping down being automatic when the shutter release is pressed. Some medium- to long-focus telephoto lenses lack this facility but have pre-set diaphragms. These are not so convenient. The stop needed can be preset but the iris has to be opened for focusing, then immediately flicked round manually just before releasing the shutter. Lenses for the old-style SLRs with blade shutters are difficult to find and the maximum focal length is usually about 250mm. They are of special design for interchangeability with the standard lenses and for engaging into the shutter mounts. They cannot usually focus closer than about 2m and need special extension tubes or supplementary lenses for shorter distances. The following discussion refers therefore to lenses for use with modern SLRs having focal plane shutters.

Many telephoto lenses can be bought secondhand but do not finalise the purchase until you have checked the definition, using some sort of test chart, and see that the lens is compatible with the focusing screen you use. Most advanced 35mm cameras have interchangeable screens, allowing the choice of the one that best serves the particular type of lens in use. For instance, with some screen and lens combinations, the rangefinder or split system will not function correctly so a change of screen is needed. Note too that the modern tendency to have a built-in sliding lens hood is a good arrangement as lens hoods are one of the most frequent items to be lost when you are working in the field.

A basic set of lenses could consist of the following in addition to the standard lens:

1 A telephoto, focal length 135–150mm, for general work, for bird-nesting studies from blinds and free-flying birds.
2 A telephoto, focal length 300–400mm, for more distant subjects in the open, for stalking and, with follow-focus devices, for birds on the wing.
3 A mirror lens, or 500–1000mm focal length, for stalking at long range, waders, birds in tree tops and the like.

Each of these is discussed below:

Medium range telephotos, 135–150mm. Important here is the point of nearest focus. Many older-style lenses do not focus closer than about 2m. You need such a lens to focus down to 1 or 1½m—a bird as small as a tit, chickadee or silvereye only fills ⅓ of the picture area at 1.6m with a 135mm lens. Some lenses (usually called 'macro' or 'micro') are designed to focus very close; most fixed-mount versions go from infinity to half lifesize.

An alternative solution, usually with reduced automation, is to mount a 'lens head' on a close-up bellows mount.

Long range telephotos, 250–400mm. These are fairly cumbersome and for hand use some sort of camera support is desirable. Again the closer the possible focus the better. With a 300mm lens, a tit, chickadee or silvereye 10cm long, fills ⅓ of the width of the 35mm field at about 4m. Lenses of this power are useful when it is impossible to approach the bird very closely, such as for taking buzzards and ravens across gullies, crows and eagles in tree tops from neighbouring trees etc. As with other long-focus lenses, definition is reduced drastically if there are convection currents between the camera and subject. If this is the normal condition where you are working, then distant shooting must be done early or late in the day when the shimmer is absent. However, even when shimmer is not obvious there may be some loss of contrast due to atmospherics. For fast-moving subjects, follow-focus lenses favoured by sports photographers, such as the Novoflex range, can be a boon.

Mirror lenses. Also known as reflex and catadioptric lenses, these are perhaps the best of the truly long-focus lenses for bird photography. At focal lengths of above 350mm the conventional lens becomes very cumbersome, heavy and difficult to balance and hand hold. A 500mm lens of standard construction measures 500mm from the front element to the film. Telephoto construction reduces this, and modern designs with aspheric surfaces and artificial fluorite-type elements can be quite small and light. Mirror lenses are still more portable, however; the light rays are reflected twice by internal mirrors, so that the path is in effect folded upon itself and the length and weight of the whole reduced accordingly. In fact an *f*8 500mm mirror lens is quite compact and easy to use, and even 1000mm models can be hand held if necessary, although it is better to use some sort of shoulder pod if possible.

Lenses of this range really bring distant birds close and are much favoured for stalking waders and other wild birds. Mirror lenses can often be focused down to quite short distances, much closer than most all-glass lenses. A popular 500mm *f*8 mirror

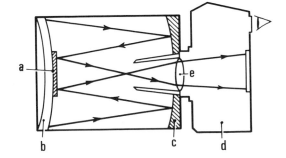

Mirror lens: (a) secondary mirror, (b) corrector plate, (c) primary mirror, (d) camera, (e) correcting lens.

lens, for example, goes down to about 3.8m, at which distance a 10cm long chickadee fills about half the picture frame.

There are several designs of these lenses but all are modifications of the Newtonian reflecting telescope. While being extremely light and manageable, despite their power, mirror lenses do have some disadvantages. A good, properly adjusted example gives quite good resolution of detail, but not as good as that of a good all-glass lens of the same focal length, and the resolution declines a little at close range, being at its best at about 100 times the focal length. Also the lenses are normally of fixed aperture—there is no iris diaphragm. Apertures range typically from *f*8 to *f*16 and the depths of field are therefore also fixed and very shallow. Hence out-of-focus foregrounds can be a problem, whereas focusing itself is very positive because of the shallow depth: when trained on a wader like an oystercatcher the bird almost clicks in and out of focus. Another characteristic of mirror lenses is that the light distribution tends to be a little uneven which may result in a darkening in the corners of a picture with a uniform background, such as the sky. This fault is also encountered in many conventional telephotos and is not usually obtrusive. Mirrors in the lenses have to be very critically aligned and need protecting against shocks, something that is not always possible under field conditions.

Improvements in lens design continue and one company, Meta-Geraetechnik, has produced a 500mm *f*8 lens made from mirrors only but which has an iris diaphragm for stopping down to *f*32. This lens is claimed to have overcome all the problems normally associated with images formed by mirror lenses.

It is not advisable to purchase mirror lenses secondhand unless they can be thoroughly tested. In addition, the mirrors may tarnish after a while and even brand new examples need carefully checking to ensure that the mirrors are absolutely in alignment and produce sharp pictures. Cheaper versions probably will not do so.

The TTL meters in most cameras can operate in the stop-down mode, either when mounted with a non-coupled lens or at the press of a button. As mirror lenses are of fixed aperture, exposure is controlled by altering the shutter speed to satisfy the meter readout. In practice one has merely to decide whether this shall be 1/250, 1/500 or 1/1000 sec. High-speed film is normally used and only a little experience is needed to decide which of the three is appropriate, even without a meter. It is often quicker to shoot a bracket of all three exposures than to check with a hand-held meter; the subject may have left by then.

A further disadvantage of mirror lenses is that out-of-focus spots, such as highlights on leaves, form ring-shaped images which at times are quite distracting. Similarly out-of-focus lines, such as ripples, tend to produce a corrugated effect due to the doubling of each single line. Hence the best results are achieved when taking birds against clear skies, flat water or distant

landscapes with nothing to produce unsightly highspots.

Despite their tremendous ability to bring up distant birds, the more powerful of these lenses are pretty cumbersome to operate except with large and rather inactive subjects. A good tripod is essential and on windy, hazy days or those with any heat shimmer they are virtually useless.

Zoom lenses. A zoom lens has adjustable focal length. Its advantage is that it allows you to vary the size of the bird's image without having to change lenses. This can be particularly helpful when working concealed and the lens front is in full view of the target. The range of focal lengths available in one lens is restricted but quite adequate for many purposes. Zoom lenses for still cameras usually have a comparatively modest zoom ratio, about 2× in most cases. They can cover wide-angle, normal and long focal-length ranges. The last is most appropriate for bird photography; the most widely available zoom lenses in this range are 75–150 mm and 80–200mm. These can be quite light and practicable and recent models are more compact and portable than earlier ones. If a really wide range is sought the price in cash and weight must be paid. The 50–300mm *f*4.5 Zoom Nikkor, for instance, weighs 2270g, whereas the 300mm *f*4.5 Nikkor weighs only about 1100g. Furthermore, the definition of even a good zoom lens is not quite as fine as that of individual lenses each computed specifically for their particular focal lengths, though the quality of some zoom types is nevertheless high and certainly acceptable for projection-slide production. Most couple with the automatic diaphragm and TTL metering systems. Not all zoom lenses focus close enough for small bird work, but many have a close-up 'macro' mode.

Other lenses for 35mm. Wide-angle lenses are not of much use in field work with birds; they may occasionally be helpful when having to work in restricted space and trying for high-speed flight close-ups. Likewise there is perhaps a place for a shorter length telephoto in the 80–85mm range, but there is also little use for this if you have a 135mm lens already.

Lenses for larger format SLRs. As many of these cameras lack extensible bellows, long focus lenses for use with rollfilm SLRs have to be designed, like those for 35mm SLRs, to incorporate their own focusing mounts. With some larger format SLRs, notably certain Hasselblad models, each lens has its own blade-type shutter. Cameras relying on focal-plane shutters can be equipped at less cost. Some focal-plane shutter models can be used also with diaphragm-shutter lenses for flash and hide work, with the shorter focal-plane shutter speeds available for stalking and general open-air studies, with the blade shutter fully open. In this way you have the best of both methods—a quiet shutter for close-ups and high-speed electronic flash, and a faster shutter for open air activities where shutter noise is less important.

For rollfilm reflex cameras a telephoto of about 200mm focal length may prove to be a basic requirement if you wish to work from blinds, and most models allow conventional telephotos of up to 350 and 500mm focal length to be used. Mirror lenses may be more difficult to fit to some models and it may be necessary to have an adaptor made to effect a satisfactory match. Extension bellows may be needed when adapting long 'straight-through' telephotos for 6 × 6cm cameras.

Lenses for monorails. The maximum extension possible with the camera bellows determines the maximum focal lengths of the lens that can be used. For the 6 × 9cm format, a 200–250mm lens is adequate for much close-up work from hides. The lens is a simple non-telephoto type and is set in a blade-type shutter. With many models the maximum focal length lens that can be used conveniently is about 350mm. For close-up photography of small flying birds where a rather wide field is needed a shorter lens is useful, say around 150mm focal length. For much longer focal lengths telephoto lenses have to be used and probably some additional support will be required, but monorails are not really designed for this mode of operation. New developments are increasing the flexibility of monorail/view cameras. For example, Prontor Autolux shutters can meter either ambient light or flash or both, and provide a fully-automated exposure control for a monorail camera!

Teleconverters and other supplementary lenses. Teleconverters (or extenders) are supplementary lenses that fit between the camera and the ordinary lens. Such a combination gives increased focal length and hence greater magnifying power than the prime lens alone, multiplying the focal length usually by 1.4, 2 or 3. Naturally, altering the focal length without moving the lens diaphragm changes the effective *f*-number of the combination. In fact the *f*-number setting is multiplied by the magnification ratio of the converter (e.g. *f*4 becomes *f*8 with a 2× converter). One advantage of the combination is that it still focuses as close as the prime lens, but otherwise behaves just like a telephoto of the same focal length.

Apart from the focusing advantage, the main attraction of a teleconverter is that it can extend the focal lengths of each of a series of lenses (including zooms). For example, a 2× teleconverter with 50mm, 85mm and 250mm lenses gives a range of 50, 85, 100, 170, 250 and 500mm focal length. Top-quality converters from major manufacturers may cost as much as a good 100mm lens, and offer excellent results. Lower-priced converters, especially the four-element versions, often give rather poorer performance, especially at the edges of the image area.

Simple supplementary lenses fit in front of the existing lenses and are useful for approaching the subject very closely, where a bellows is not convenient. They are seldom needed with birds, as most standard lenses focus close enough for showing nests, eggs

and small chicks. These supplementary lenses also tend to take the fine edge off the definition although the effect is usually small.

The SLR 35mm system readily adapts to a wide variety of lens types, providing that these have the necessary focusing capacity, hence the feasibility of designs like teleconverters. A few firms also market a prism monocular that couples, via a collar, to a 35mm camera. The effect is of a powerful, short-bodied telephoto of medium resolution and small aperture. The device has some points in its favour—small size and its duplicate role as viewing device and camera lens—but few serious bird photographers seem to use it. Blaker[21] gives more data on monoculars and telescopes as camera lenses, how to calculate exposures, and a brief bibliography.

Eyepiece correction lenses. Spectacle wearers, and those whose eyesight is deteriorating with age, often have difficulty in focusing through SLR viewfinders. Many manufacturers supply correction lenses to meet this problem; the lenses screw into the eyepiece of the finder. You have to push your spectacles onto your forehead out of the way (a safety chain is advisable in the field) when sighting through the camera. The lenses are simple + or − ones, but it is important that you get one of the right strength. Some Japanese makers mark their correction lenses + 1 dioptre less than they really are; if you need a + 1.0 lens, you ask for a Nikon 0, for instance. The scheme is not universal even among Japanese manufacturers, so a practical check is essential. Cine users are less troubled as reflex viewfinders have built-in adjustments.

Movie cameras and lenses
Good bird films can be shot without expensive equipment, for film-making involves much more than setting in train a piece of machinery at the right time and place. Excellent nature films have been made on minuscule budgets and with equipment that many photographers would consider quite inadequate. Conversely, rubbish is frequently churned out by people with fine equipment who seem incapable of using it intelligently. Clearly, there is no sense in using limited facility or poor quality equipment if you can afford the best, but most of us do have to compromise. Bear in mind the fine work done by people like Ponting and Kearton using hand-cranked cameras under the most adverse conditions, and realise that far better cameras than were available to them may be purchased nowadays secondhand, at very reasonable prices.

Basic equipment
Fundamentally, what you need for filming birds is a reliable camera equipped with at least one standard and one telephoto lens, or a good zoom, a strong tripod and some inexpensive accessories. Most modern makes of camera are fairly reliable and secondhand ones can be bought from firms who will guarantee

their reliability. Thus, it is not normally necessary to insure against mechanical breakdown by having a second camera in reserve, but if you are working in remoter areas it is most desirable to have a second camera as an insurance, not only against mechanical failure but also against accidents. This becomes essential if a team is tied up with the making of the film. Also it should not be forgotten that you are dealing with animals. If, through the failure of some piece of equipment, a key shot is missed a retake may be impossible for another year—as the event in the bird's life cycle may have been completed.

Another factor to bear in mind when choosing a camera is the range and availability of accessories and of servicing facilities. It is not much good having the most advanced of cameras if it has to be sent half-way round the world every time it needs servicing. Many of the best makes offer a wide range of ancillary equipment and have servicing agencies manned by trained staff in every continent. If you plan to operate around the world yourself, then clearly these services may be invaluable.

Understandably enough, no commercially available camera has been designed with nature photographers in mind. Every make, therefore, proves to have some disadvantages, however satisfactory it may be for filming generally.

Just as the SLR with TTL metering has revolutionised still photography of birds, so the development of reflex cine cameras—in which the viewfinder shows the scene through the taking lens—has revolutionised the filming of birds. The ability to see just what is going onto the film throughout a shot, with no worry about parallax compensation in close-ups, is a real boon with these and other mobile animals. It makes for more effective shooting and less film wastage. In choosing a cine camera for bird photography, reflex viewing is essential.

The ideal camera

All modern movie cameras in the Super 8 or 16mm gauges have some sort of reflex viewing. This is not so in standard 35mm cameras but very few bird films are shot on this size film today, so the present discussion is limited to Super 8 and 16mm. Some of the desirable features in a camera for the bird worker, starting with the most important, are as follows:

1 Quietness in operation.
2 Portability—lightness and compactness.
3 An automatic through-the-lens exposure control, so that changes in lighting occurring after a shot has been started are automatically compensated for.
4 A robust construction that can stand the rough-and-tumble of use in the field under conditions when even valuable cameras often cannot be accorded the care they deserve.
5 Spring drive capable of allowing at least 50ft of film to be shot at 24 fps from a single winding (16mm).

6 A good range of film speeds, particularly above 24 fps.

7 Conventional lenses of up to 310mm focal length (for 16mm) as well as variable-focus zooms.

8 Cable release or electric remote control.

9 Simple loading and unloading (16mm).

10 Facilities for easy fitting of colour correction and other filters.

11 An indicator to show how much film has been used up.

12 The possibility of operation by electric motor drive (16mm).

13 In 16mm the ability to accept 200 and 400ft magazines in addition to 100ft ones. (Super 8, 200ft instead of 50ft cartridges.)

14 A variable shutter.

15 Facilities for single-shot and time-lapse operation.

16 Facility for fades.

17 A self-timing control.

Most of these requirements are self-evident and most are attainable in the better makes and models. Quietness in operation is very important, as with stills, when working at nests or at feeding places at close quarters, but the movie maker tends to work further back than the still photographer and by and large the continuous purr of the cine camera seems less disturbing to many birds than the sharper, intermittent sounds of the still camera. Some birds are too timid even to be filmed without a blimped camera unless the taking distance is excessively great.

Super 8 cameras

The Super 8 film size dominates the amateur cine scene. A vast range of makes and models is available, virtually all with TTL metering linked to an automatic iris in which the diaphragm opens and closes according to the amount of light 'collected' by the lens. Most of these cameras are fairly quiet in operation, easily loaded with cartridges of film, and have fail-safe features that help to avoid wasteful shooting when the light is insufficient, and so forth. Most rely on battery-powered motors to drive the film transport, shutter, light metering and lens zooming. The majority are built round a single zoom lens that has to cover the whole gamut from near wide angle to medium or long telephoto, i.e. typically from about 8mm to 60mm—a 1:8 range. Some of the more expensive models can accept interchangeable lenses so that zooms and standard telephotos can be used according to need. With the cheapest models it may not be possible to control filming via a cable or remote release. This is particularly irksome when working from hides as you do not want to have to hold your hand on the button until the opportunity for a shot occurs. Many advanced models have provision for single shot operation and some can be programmed to take single shots at predetermined intervals, i.e. they have a time-lapse facility. Such cameras also allow film to be shot at a range of speeds, particularly at higher speeds, so that good slow-motion work can be done. But this may

Modern Super 8 cameras offer a range of sophisticated features, including sound-on-film models, 8:1 or greater power zoom lenses, and fade and dissolve controls. Some can take a 200-foot film cartridge.

require a supplementary battery pack as high framing rates involve a heavy battery drain.

A good Super 8 camera is a beautiful piece of engineering. It is light and very portable, typically with the shutter release built into a pistol grip. With a good zoom lens such a camera is particularly effective for off-the-cuff shooting of birds in the open. Having an automatic iris means that if an opportunity for a picture presents itself, the cameraman need only adjust the focus and zoom in on the bird and filming can begin. Portability apart, the Super 8 format scores heavily over 16mm on cost, since it is much cheaper to shoot in Super 8 than in 16mm. However, even with the improved quality and speed of 8mm film, the quality

available in the smaller format is inevitably considerably lower than that of the larger size. This means that it appeals mainly to the amateur who does not wish to market his work, or to the zoologist who wishes to use the camera as a notebook and is therefore not aiming for perfection. 16mm seems likely to hold its commanding position as the medium for high-quality work for many years to come.

A reason why the low cost of 8mm compared with 16mm is important, is that when working with animals there is always an extra wastage beyond the control of the camera operator. This wastage is the same whatever the film size used, but at least with 8mm the cost of the film that has to be cut out is minimised. Automatic exposure control, as pointed out, is a big help but with older cameras may introduce another source of uncontrolled loss. The response of some earlier iris circuits was not always as fast as required so that over- and underexposure during takes was quite common when the light changed rapidly during a shot. For static situations also a manual override facility to cut out the automatic iris is useful and allows control over the picture density. Such an override is not provided on some of the cheaper models; reliance on automation may mean the loss of the picture with some cameras if the circuitry fails. A manual control ensures that filming can continue.

16mm cine cameras

16mm tends to be used only by semi- or fully professional wildlife photographers. 16mm cameras are inevitably heavier, larger, and more expensive to buy, to run and to maintain than Super 8 cameras and to some extent are less advanced in their design. Few depend on a single zoom lens, but have a range of lenses carried in a turret so that each can be flicked into taking position as needed. Such cameras accept 100ft of film at a loading and most makers also supply 400ft magazines. The larger magazine is a more practical arrangement for field work, where reloading may pose difficulties and mean loss of pictures.

There are still a few clockwork-driven models that can be coupled to a motor drive powered by a separate battery. Most 16mm cameras rely entirely on a battery-powered drive usually carried separately rather than built into the body as with Super 8 cameras. Others have the battery pack built in, e.g. the Bolex 16 EBM. Some 16 mm cameras have an automated iris or use a TTL system giving meter readings in the viewfinder, e.g. Arriflex 16S (B). All take a cable release.

Reflex viewing helps also with 16mm in avoiding problems due to parallax error, and composition in close-ups is much easier. You can zoom in to fill the screen with a bird's eye knowing that the eye will be properly centred when screened. With some systems, however, the stopped-down picture seen during filming (as opposed to framing up beforehand which is done at full aperture) is pretty dim at $f16$ or less.

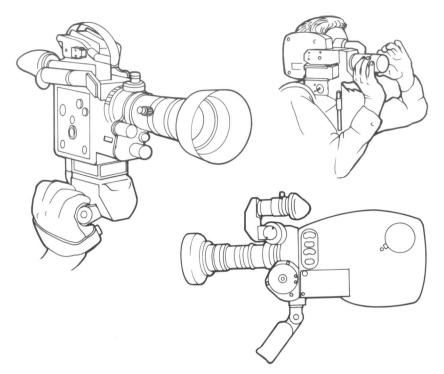

16mm movie cameras vary from comparatively simple models derived from amateur-type cameras of 30 years ago to scaled-down equivalents of the film industry's 35mm models. They all provide impressive image quality, and the user's choice depends on the features required.

16mm cameras tend to be noisy both when running and, in the case of spring-driven models, when being wound. Many are self-blimped and have sound facilities built-in. Otherwise you may have to buy a blimp or make one for your particular model. Professional cameras, like the various models of Arriflex, Eclair and others with their great range of lenses and refinements, high picture steadiness and so forth, are the best currently available for wildlife work. The self-blimping, of course, means that they are virtually noiseless. Naturally they are in quite a different price category to the amateur reflexes. Some use compact coaxial cassette magazines which allow rapid loading without handling the film itself. Their chief disadvantage, to my mind, is the lack of any spring-motor drive: this means that any fault in the motor side of the mechanism and the camera is useless. Having both spring and motor drives gives a built-in margin of safety. The cameras are, of course, inevitably rather heavier, but at the same time they are also quite robust. This is important in wildlife cine work, where you are sometimes too concerned about your own safety to trouble too much about how the equipment is faring.

These professional cameras are the natural choice of film units, where portability is not so important but where the very best quality is needed, e.g. if 35mm prints are to be made from the 16mm original. If you have a team of workers, then clearly weight becomes less of a problem. Nevertheless, while relying on an Arriflex or similar camera for the main filming, it is quite normal to carry a spring-driven camera as a second string for use in

emergencies or in difficult country where portability is a paramount consideration.

When shooting in a studio, of course, automatic exposure control is less vital. In wildlife work, however, through-the-lens metering systems are invaluable. This is because so many outdoor shots are ruined when the light changes before a take is complete. Without automatic exposure control there is often nothing you can do about this but to try to retake. Thus automatic iris control means less wasted film, better tempers and fewer lost opportunities, though like other devices it has to be used intelligently and is not foolproof.

Professional 16mm outfits nowadays usually have provision for adapting to videotape—an example is the Arriflex 16SR—hence this is a dual-purpose machine.

Lenses for cine

As already stated, zoom lenses are the norm with Super 8. As the results are seen projected, however, any loss of definition is much less apparent in movies than it is in stills. Zooms have another advantage—if you are working from a hide, only the one lens protrudes and you can adjust the image size at will with little fear of scaring the birds. Although each lens in a turret may give a sharper picture than a zoom, to change from one focal length lens to another means rotating the turret and this is difficult or impossible at close quarters if the birds have their eyes on the hide.

The normal range of zooms used with Super 8 cameras is adequate for most birds. Many focus down to about 1.2m or less, at which distance a 10cm silvereye or chickadee just about fills the frame when the lens is fully extended to the 50–60mm position. It is more practicable to work further back and, using the same lens, a 10cm bird sideways on fills about ⅓ of the frame at around 10m. Some Super 8 cameras also have a macro setting allowing big close-ups of eggs or chicks to be taken, without changing lenses or using a supplementary one. A few, like the Canon Scoopic (16mm) can also be fitted with teleconverters (page 36). The Angenieux 2.8 × 16B (16–44mm) zoom has attachments to convert it to 12–34mm wide angle and 52–74mm telephoto. 16mm zooms usually operate between 20 and 100mm focal length but some have a much greater range. Angenieux has one working from 10 to 150mm (1:15 ratio) which can focus down to 2m without an accessory lens. A good battery of telephoto lenses for 16mm would include a standard 25mm and telephotos of 50, 75 and 150mm focal lengths. The 75mm is perhaps the most used of these but even with this you have to be within 2m of a small 10cm bird like a silvereye, tit or chickadee to fill half the 16mm frame. My biggest lens is a 300mm but this has to be supported by a special bracket screwed to the tripod—the lens being too heavy to be held merely by its thread on the camera turret. A lens of this power is occasionally useful for really distant shots but it can be

quite tricky to frame and to focus accurately before the bird has left the scene. A really heavy tripod is essential and so is a cable release, for despite a stout cradle, hand pressure on the camera while shooting causes vibration which may be undetectable at the time but which definitely takes the edge off the resolution. So do atmospherics, of course.

Accessories

Since the bird photographer has to use lenses of long focal lengths to obtain reasonably sized images, the risk of camera shake is increased and the need for some kind of camera support to reduce that risk is accordingly high. To get the best from a lens the camera *must* be rock steady when used at anything but the highest shutter speeds. On no account should rigidity be sacrificed for lightness: an unstable tripod is worse than useless—it is better to risk hand-held shots.

Tripods and other camera supports
If funds allow, it is convenient to have two tripods, one of them raising the camera to about 1½m, for situations where the lens must be placed low down, such as when working with ground nesting birds or filming their chicks. A number of sturdy but lightweight makes are available. A model popular among British nature photographers is the Kennett Benbo[22] which has ingenious, independently adjustable legs capable of coping with almost any terrain and a centre pillar that can be separately adjusted to bring the camera below ground level.

The larger tripod should extend to bring the camera slightly above eye level. You can then tilt it upwards without having to stoop or crouch. Modern types with centre pillars are more convenient than those where the tripod head is connected directly to the legs, but do not forget that stability is a function of the spread to the legs. Furthermore, with many centre pillar designs the spread is the same for each leg which is inconvenient for use in hides. It is often better to have the front leg shorter than the others to bring the camera forward, so that the lens can protrude through the front. Hence the ability to extend the legs to different lengths is also important.

Tripods for small still and Super 8 cameras can generally be rather lighter than those for 16mm cine. For these you should reckon to have to carry 7–10kg of tripod around. Nearly all movie shots are made with the camera on a tripod so it is worthwhile taking a lot of care in the selection of this essential item. Old-fashioned wooden models with folding and sliding legs can be quite satisfactory, although there may be a tendency for the wood to swell when wet. The extending sections then lock up until they have been dried out. All sliding parts of metal tripods need to be kept free of dirt or mud or they become clogged and useless.

(1) A useful camera stand for shooting from inside a vehicle. Suction pads hold the camera platform against the windscreen. An extending leg with swivel foot supports the other end of the platform and is braced by elastic retainers which clip under the dashboard. (2) More than one camera can be mounted on the same tripod if a suitably drilled board (3) is fitted with a tripod screw. Each camera should have its own pan-tilt head. (4) A car window mount that clamps easily on the window, and has a pan-tilt head. (5) The Manfrotto 3D tilt head. Very versatile tripods (6) can be easily adjusted to hold the camera in any position.

Similarly, aluminium stored in damp conditions corrodes and the sliding parts seize up. For bird photography, the feet are going to have to be thrust into soil and jammed into rocks, so sharp spiky feet are often the best for this.

For movies the tripod should have a pan-and-tilt head with a long pan handle (some are telescopic) and the movements must be smooth-acting in all directions. The locking device should be firm and positive.

Damped panning movements like those given by a fluid-filled head such as the Miller head are excellent for general photography, as they enable really smooth professional pans to be made. However, when you are working with animals such a damped system may be inconvenient if you wish to follow rapid move-

ment. I once filmed the display of a bower-bird and in one phase of the male's performance he chased the female round and round the bower. With only one camera available I had simply to follow the two birds, the male as he danced around pirouetting and posturing and occasionally darting at the female, who just succeeded in keeping out of his way. The result comes very close to 'hose-piping', the sort of thing that should be avoided if possible, since such rapid movements of the camera can be very unpleasant to the viewer. Here, however, the result is quite satisfactory, as the birds are held in the picture all the time. The shot, in fact, makes quite a 'show-stopper'.

Another thing to look for in a tripod is whether the camera can be levelled without having to shift the tripod legs. Many tripods have a floating hemispherical bowl arrangement, by means of which the top can be levelled independently of the legs. This is useful, because it is surprising how often situations arise where you cannot spread the legs out as freely as you would like, if there is a cliff, rock or something to one side. To get the camera level in this kind of situation is difficult without such a device. A level on the tilt-top is also useful, particularly when you have to make long pans of landscape scenes.

Many pan-and-tilt heads also have a cable release or other shutter-control device built into the pan handle. This allows one hand to control the camera angle and film transport, leaving the other to operate the zoom lens and so on. This arrangement is obviously very convenient and is well worth the extra cost.

A tilting top of some sort is also needed for stills. The size of this depends less on the size of the camera than on the kinds of lenses used. The bigger the lens/camera combination, the heavier the tripod and its tilting top need to be. When using big lenses on 35mm cameras, the whole is mounted via a bush on the telephoto, as this lies closer to the centre of gravity of the combination and so reduces any strain. If in doubt err on the side of the heavier-duty tripod and tilt top rather than on the side of lightness. A popular model for use with medium-range telephoto lenses is the Italian Manfrotto 3D[22] which has tilting movements in three dimensions, independently locked but with no long panning handle. This type of tilt head is very convenient for work in hides with 35mm cameras.

The best tripods are rather cumbersome things to carry around and there are times when you just cannot do this. It is often quite practicable to carry a monopod, however. The first one that I had was just a 1.5m aluminium tube which doubled as a walking-stick when I had to clamber over steep hillsides and dangerous screes. Into the top of this a Whitworth screw was recessed so that the stick could be screwed easily onto the camera bush. More advanced (and more expensive) types are adjustable for height. Apart from being adjustable, these are no better than the more primitive design and, generally speaking, you use a monopod at eye-level. Several makes are available.

I find a monopod a most useful accessory. It takes the weight of the camera off the shoulders and enables you to concentrate on holding the camera steady. Furthermore, if it suddenly becomes necessary to shoot into the sky you can pick up camera and monopod bodily and carry on filming as though the latter was just a pistol grip. This is not possible if you are shooting from a tripod.

On the other hand, the monopod has obvious restrictions. It is a good deal less stable than a tripod and is really pretty useless if there is a strong wind blowing. You simply cannot hold a camera still under such conditions unless you can contrive to brace it against something solid like a wall or tree trunk. A monopod is perhaps more useful with stills than with cine because the extra support may allow you to take single shots between wind gusts where filming would be quite out of the question.

Even lighter than a monopod are the various types of chestpod. These consist of a sling which passes round your neck while a short support rests in a pocket on your chest. These devices are very light and may certainly be advantageous on some occasions. Better, at least, than relying purely on hand support.

Much the same can be said of pistol grips. There are various types and all have a shutter-release control built in. A pistol grip or a side grip, depending on your preference and the camera's shape, is very useful, and if the camera has to be hand-held, better results are usually obtained using a grip than without one.

Some of these holding devices are elaborated into a rifle grip with a shoulder strap by which the butt is strapped to the shoulder. One hand grasps the grip and the trigger (connected to the shutter release by cable) and braces the attached camera towards the body. This leaves the other hand free to control the focus, stop and zoom. A variety of models is available, the more elaborate being adjustable to fit the user's body.

The rifle grip idea has been elaborated further in various 'follow-focus' systems such as the Novoflex. There are various models that fit any 35mm SLR. The basic idea is that the camera is mounted on a shoulder support behind a spring-loaded pistol grip which, when squeezed, shifts the focus of the lens attached to the front of the focusing device. Such gadgets permit you to follow a moving bird and continually adjust the focus right up to the moment of exposure. Novoflex systems are used with 'straight-through' telephotos and are so well balanced that some people can use 600mm lenses in the hand, providing that a reasonably fast shutter speed is used—typically 1/250 sec or more. Other rapid-focus systems are available from different 35mm camera makers, not all being spring-loaded like the Novoflex.

When hand-holding 16mm cameras, some kind of support is almost essential. Professional makes like Arri and Eclair have body supports where most of the weight is carried on the shoulders. With the Bolex 'static handle' the weight is taken on the wrists and the camera steadied against the cheek. If you do

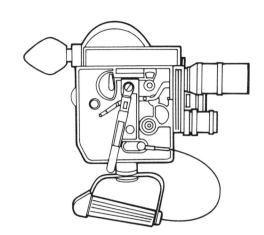

Handles such as the Bolex 'static' can provide extra grip when shooting with a 16mm camera.

have to film while moving yourself it *is* possible to do this where the ground is unobstructed without excessive camera wobble at each step, but practice is needed to develop the proper gait.

Other small holding devices like simple, lightweight ball-and-socket heads are very convenient, e.g. for attaching flash heads or photocells to stands, and at least one firm makes a useful clamp with rubber-lined jaws which fastens over the rim of an opened window of a car. The camera then can be mounted directly on a side window. Other devices are designed to carry a camera at the front of the car to facilitate shooting through the windscreen.

It is sometimes necessary to use two cameras on one tripod—typically this arises in hide work. A suitably drilled board will suffice. It has a tripod bush screwed firmly to the centre by means of which the board is attached to the tripod top. Holes drilled at each end admit conventional screws with wing nuts to allow separate cameras to be fixed independently, each with its own tilting top. In this way two cameras can be mounted side by side.

With any camera that is not hand held, it is advisable that exposures are made with the help of a cable release. This lessens the risk of operator-induced camera shake. Long releases are often good when you are sitting in a hide with your head well below the camera level, but the shorter the release the less the time lag between your brain ordering 'press' and the shutter's opening. Cable releases with kinks, or in which the plunger movement is not really smooth, are useless. Apart from taking normal care to coil them up when not in use, I have found that it helps occasionally to lubricate the action by fastening the release to a line, threaded end up, and allowing a little thin oil to run down the inside of the casing.

Motor drives
Most makers of 35mm SLRs have designed motor drive units that clip onto the camera and enable film to be rapidly exposed at

rates as fast as five frames per second. These drives are battery-powered and wind on the film and reset the shutter after each exposure. Linked to an automatic photo-trip (page 178) or to other automatic triggering systems—time-lapse, radio control and so on—a motor drive permits photographs to be taken in the photographer's absence. However, as well as being expensive, many of the earlier and still widely used drive units are noisy and of limited value when working with timid birds. Perhaps their most effective role is for taking birds in flight using focal plane shutters (page 76), for taking birds from long distances where camera noise is less important, and for certain types of scientific work (page 235). Manufacturers are responding to criticisms about motor drive noise and some units are now quiet enough in operation for bird work at close quarters.

Super 8 cameras have electric drives which are integral parts of the camera and permit a whole roll of film to be shot at one time. 16mm cameras without built-in drives can be fitted with attachments for continuous filming using power from an external battery pack. However, while people will stand and watch a sequence of events that lasts for say ten minutes, they will not sit and watch the same thing on the cine screen in its entirety without getting bored. Thus it is unusual to take shots lasting for longer than about 25 sec, because of the danger of tedium and of slowing down the whole pace of the film. When a long operation has to be filmed this is done by linking up a series of comparatively short shots with interspersed cut-aways or other devices which enable the time scale to be compressed.

When filming wild animals, however, especially if the work is of a scientific nature, you may want to show the complete sequence of a particular pattern of behaviour, uninterrupted by artificial breaks. In such cases clearly a clockwork-driven camera, which gives you at most about 25ft of film per winding, is quite inadequate. An electric motor drive has to be used and, if really long takes are called for, 200ft, or larger, magazines. A motor drive is also desirable if it is necessary to do much slow-motion work, since here the rate at which the footage is consumed is high.

Electric drive also ensures that the rate of film transport is constant throughout the shot. This may be essential in scientific applications where the film transport speed or frames-per-second rate are used as the time base. With a spring drive, no matter how carefully designed, there is inevitably some difference between the rate of movement at the start of the shot when the spring is fully wound up and that at the end when it is partly unwound.

An electric drive, with its necessary batteries, adds to the weight to be carried, for batteries are not light. Another snag with separate motor drive units is that the various wires and flexible couplings tend to get in the way when you are working out of doors. Fortunately, modern designs often incorporate battery and motor in the camera, so that there are no trailing

leads. In remote areas it may be difficult to get batteries recharged. The answer here is to use dry packs of disposable batteries or to carry a small electric charging plant.

Despite these snags, an electric drive is a good investment. It enables you to shoot reasonably long sequences and, perhaps more importantly, ensures that the camera does not come to a halt just before the action, for which you may have waited hours or days, is completed. Such events are a great source of irritation and a waste of film; you cannot insure against them without the continuous drive facility.

No doubt it would be possible for manufacturers to produce a spring-driven mechanism capable of shooting 100ft at a single winding. In fact, Newman-Sinclair did this with their 35mm NS cameras, in which 180ft could be shot at a single winding. This facility would be very convenient for the field cinematographer, for it is far more economical to put the necessary energy for film transport into the mechanism via the human muscles, than to have to carry around the energy in the inefficient form of a heavy battery and an electric motor.

Exposure meters

Despite the convenience of having built-in meters in SLR and Super 8 cameras, both still and cine users also need a separate exposure meter, for there are times when camera meters are not satisfactory and a closer check with an independent instrument is necessary. A separate meter also acts as an insurance against failure of the camera meter—commonly a consequence of having inadvertently left the battery switched on—though failures through other causes also occur.

Some very elaborate exposure meters are available. Many can be operated with one hand and give very clear readings using light emitting diodes (LEDs). Single-hand operation is clearly a valuable consideration for a natural history photographer, who has at times to work in awkward situations. Many instruments are made with 'solid state' components, having no moving parts, and give direct readings of the stops required. Some types have wide acceptance angles and allow a reading to be taken of the whole scene covered by a standard or wide-angle lens; others, called 'spot meters', have only a very narrow angle of acceptance and are designed to give light values for specific parts of the scene. They are excellent for use through the observation ports of a hide. A few models have a zoom system allowing the angle of acceptance to be adjusted to match that of the particular lens in use. Finally, there are various kinds of flash meters which measure the light falling on them when a flash or flashes are fired. They can be held at the point where it is hoped the bird will be when the flash is fired and give direct reading of the stop needed for correct exposure according to the speed of the film being used. Such meters give more precise information about exposures than guide numbers alone and are particularly effective where

two or more flash heads are in use. Some models give both continuous light and flash readings without the use of special attachments. It is best to carry the meter by a neck cord, or, as I have found from bitter experience, the tendency is to put the meter down when you are working and in the heat of the moment forget all about it. Quite apart from the time and trouble involved in finding the thing, it is even more annoying to realize that you left it on the rocks below high water and that as the tide is right in, you have to write off the instrument as lost.

Filmholders

With larger format still cameras, film is normally loaded into rollholders. Most of these are well designed, easy to load with film and can be attached and detached quickly from the camera. Some couple to motor drives for semi-automatic operation. The rapid wind-on enables a series of shots to be made in a short space of time and this is a valuable facility when you are taking birds like eagles, pigeons or petrels which return to their nests only briefly, with long intervals elapsing between visits.

Rollholders also provide a convenient means of switching from one film to another without change of camera. In practice I have three holders fitting the one camera; one is loaded with black-and-white, one reversal colour and the third colour negative film.

When you look for a rollholder be careful not to buy one with a noisy ratchet action. It is obviously pointless going to the trouble of finding an outfit with a quiet shutter if the film wind-on is accompanied by a machine-gun rattle: some well-known roll-holders do just that. Rollholders are best bought new. Second-hand ones tend to have faults of which the most likely is a tendency to create parallel scratches—'tramlines'—on the emulsion surface of the film. Such defects are virtually uncorrectable.

Filters and lens hoods

Most bird photographers protect the exposed outer elements of their expensive lenses against sand abrasion, dust and salt spray by fitting each with a screw-in haze or UV filter and leaving this in place permanently. The still photographer usually needs a few other filters, but these can also be in screw-in mounts. The cine photographer may well require a battery of filters for use with different film stocks. Gelatin filters, as used in many Bolex models, are simple, lead to no loss of definition, but have to be handled carefully and replaced as soon as they are even slightly soiled. Glass mounted ones can, of course, be cleaned. You may also need filters to correct colour casts in the ambient lighting, e.g. if you have to shoot early or late in the day, filters to lessen the yellow cast prevailing at those times can be helpful. The Wratten 82 series are pale blue filters which are useful here. Likewise when filming under overcast skies the rather cold and blue results often obtained can be warmed up a little by pale blue absorbing filters in the Wratten 81 range. You may also require

daylight-to-tungsten and tungsten-to-daylight conversion filters (not necessary with Super 8) for the stock that you are using and perhaps neutral-density filters.

On many cameras there is only one way to fix filters into the system and that is on the lens. You then need individual filters for each type of lens. On professional cameras, filters are dropped into holders in the matte box, and this has the advantage that several filters can be used together and also that they can be rotated. The increasingly popular 'system' filters slot into a matte-box-like holder, which attaches to any normal front-lens filter thread.

Every lens needs its own hood to lessen the chance of oblique light causing flare, especially when it is fitted with a filter, which is a prime source of stray reflected light. For both cine and stills, screw-in hoods are the best. Clip-ons tend to fall off at critical moments and go tumbling down the cliff face or drop down the front of the blind when the bird has just returned after a two hour wait. The type that is built into the mount and slides forward in use is eminently suitable for bird photography.

Miscellaneous accessories for cine photography

A number of smaller items are needed: brush for cleaning the camera gate, spare loading spools (16mm), lens-cleaning tissues and so forth. These should normally be carried with the camera. Do not forget that if you have to shoot on some special stock for a particular take—on high-speed film perhaps where normally you can use a slower one—and use a 50ft roll of 16mm film, you need to carry an empty 50ft spool as well as the larger ones which you customarily use.

For close-ups, extension tubes may be needed. Remember that it is generally necessary to increase exposure significantly when working close-up. Short tubes are useful, too, when using a telephoto lens at a taking distance shorter than that provided by the focusing mount. For instance, the 75mm Yvar focuses down to about 1.8m but, by adding a tube only 10mm deep, you can get down to a taking distance of 0.6m with the same lens. This is better than using a close-up attachment, but naturally, the lens can no longer be focused at infinity and middle distances while the extension tube is in position.

I find an auto-timing device a rather handy gadget, because it allows the cameraman to get into the shot himself. Quite often you need human interest in a shot, and if you are working single-handed you may be the only human being around. Several designs are available; they screw into the cable-release socket. I was once filming some sleeping elephant seals on 16mm. In the viewfinder they looked just like a mob of bloated slugs and there was really nothing to indicate their size at all. So, with the nearest other human at least five miles away, I drove my monopod into a convenient patch of sand, lined up the lens and started the film running by locking the button into place. Then I walked into the

picture and stirred the sleeping monsters into life. The shot has proved very successful. The seals' switch from somnolence to wrath, and the revelation of their size in contrast to mine, almost always brings down the house.

Many people think that these days a changing bag is a relic from a former era of large plate cameras. On the contrary, when reloading with medium-speed or high-speed stock in strong sunshine, some sort of changing bag is needed unless your camera is of the magazine-loading type. Otherwise fogging is likely to occur along the edges of the film, especially if the spool is at all distorted. This fogging may not be limited just to the start and end of a roll. In the colour positive it shows as an orange flare along the affected edges and it usually ruins all the shots on which it occurs.

The answer is to load and unload in really subdued light and for this a changing bag is still the most convenient method when you are outdoors. The bag need not be completely sealed. It is enough to get a piece of light-proof black cloth, fold it once and have the two sides sewn up so that you have an open bag into which the camera can be placed and into which just enough reflected light penetrates for you to see what you are doing. If there is no changing bag available, you have to improvise and use a coat or a shirt and, of course, bedding can be used for this purpose. Do not let fluff from blankets into the camera or you may get a fungoid effect around the gate! The changing bag need take up very little space and it comes in quite useful for packing round the accessories in the camera case.

Talking of cases, have you noticed how elaborate some of these are? They are really quite unsuitable for carrying a camera about that is intended to withstand the rough-and-tumble of field conditions. You would do better to make your own.

The camera case needs to be light but tough, so that you can drag it through thorn bushes or on ropes up ships' sides and rock faces without caring whether it gets scratched. It should be sectioned to carry most of the small accessories, should be capable of being waterproofed and strong enough to sit on. A suitable material is fibre-board. The result does not look particularly handsome, but fibre-board has the advantage of being both light and strong. Aluminium cases are also good. They can be bought with lock and key, shoulder strap, with foam interiors that can be cut out to fit camera and accessories, and some have movable partitions.

Looking over these various items, it will be clear that quite a lot of things need to be carried on a wildlife filming assignment. And there are others, too, if you are intending to use hides. So it is well worthwhile listing all the various things that may be needed on a card kept in the camera case. You can then check off everything against this list before setting out on a trip and so ensure that nothing essential is overlooked.

Sensitive materials

For most bird work only two, or at most three, types of film are needed when using either colour or monochrome. Use the slowest film that will give adequately short exposure times with sufficient depth of field. Mostly you need a slow or medium-slow film and a high-speed one. Having mastered the use and got the measure of a particular maker's product, and its processing, keep to the same material until some real improvement occurs.

An ideal arrangement if you use rollholders is to find monochrome and colour films of the same speed. This means that a switch from monochrome to colour, and vice versa, can be made quickly and without any alteration to the iris setting.

Processing is important, for a colour film is only as good as the processing available, so that the correct choice of a processing house, particularly with cine film, is vital. You may prefer to process stills yourself, processing becoming easier as methods are refined and the steps simplified. But it seems doubtful if the home processor can produce the consistently high standards achieved by the best professional laboratories which have the latest equipment for standardising solutions, times, temperatures and all the other variables.

No two makes of colour film give identical results when correctly exposed on the same subject: each type has its own characteristics. Within limits this does not matter a great deal. After all, contrary to what is often said when slides are being screened, there is no such thing as the 'correct' colour of an object. This depends on the quality of the light by which it is seen. What is the correct colour of those hills in Africa and Australia which appear grey in the early morning, terra cotta at midday and purple towards evening? What is the 'correct' colour of the mantle of a kingfisher or roller which appears blue from one angle and green from another (a type of colouring incidentally of which no colour film can portray more than one facet at a time)? Furthermore the impressions sorted out by the retinal cells and passed to the brain are never the same in two different people. A transparency that appears just right to one person may seem slightly off to another.

Colour reversal films have only a slight latitude and exposure must be just right if the best results are to be obtained. Nor are the films capable of handling high contrasts; the highlights should not reflect more than four times the light reflected by the shadows. Otherwise one end of the tone scale will not be accurately rendered. To check on this, several light readings on different parts of the subject area should be made where possible.

With birds whose plumage is not neutral in tone—a gull or a crow for instance—a matt card can be used to represent the bird. For the crow a black card, for the gull a cream or white one might be used to take a reading from. If in doubt, or if the contrast range is too great, it is best to expose for the bird and to let the surroundings take care of themselves. If the bird as the main

subject is accurately portrayed, some inaccuracy in the surroundings may be acceptable.

As the light is liable to fluctuate, at least in temperate climates, during the course of a session in a hide, readings at the nest should be checked against the reflection from the ground at the rear of the hide. With a manual 35mm TTL SLR camera, the meter needle should be checked frequently and the exposure adjusted accordingly before each exposure. These methods ensure that the alterations in the light can be allowed for. With automatics, the electronic circuitry should correct automatically for the light variations.

So far, in this section, only reversal colour film has been discussed. Colour negative material like Vericolor, Kodacolor, Agfacolor CNS etc., is mainly used by those who wish to make colour prints. But the negatives can, of course, be used to produce excellent transparencies suitable for projection and block-making, or for the production of black-and-white prints, on special panchromatic papers like Panalure, by direct projection. You can get as many transparencies and prints of the same quality as you wish in this way.

Negative colour films have a greater latitude in exposure than reversal materials and a good deal of correction to slight faults in colour balance can be made in printing or in the making of transparencies. So, if there is a need for both colour and monochrome results from one film, colour negative may be the answer. But it should be realised that the black-and-white prints seldom have the sparkle and quality attainable from a well exposed black-and-white negative.

Another way in which the same material can be used for producing both colour transparencies and monochrome prints is to shoot on a fine-grain reversal film like Kodachrome and prepare black-and-whites from an intermediate monochrome negative. If the internegative is prepared by projection on to a large panchromatic film, no grain should be evident even in large blow-ups. Again, however, some loss of print quality will be inevitable in comparison with that possible from an original black-and-white negative, if only because the intermediate processes and double projection must mean some loss of resolution. One method is to use Kodachrome as the original stock and project the transparencies, by means of a carefully blacked-out enlarger, onto 8×10in sheets of slow pan film, from which prints can be made by contact, or enlargements by projection. This method is recommended for those special 35mm transparencies that you wish you had managed to duplicate in black-and-white. Of course, you can get black-and-white negatives made commercially from 35mm transparencies, but I should think that many readers with properly equipped darkrooms could produce better prints via the large internegative by the above system than from commercially prepared 35mm ones.

To have positive transparencies made from colour negatives is

probably just as costly as to use reversal films in the first place. If you are tackling a difficult subject, however, where many shots are inevitably spoilt, the lower initial cost of the negative film and of development may make this a better proposition. This is because the failures can be thrown away and only the really successful shots printed or made into transparencies.

The need for using colour negative film as the starting point for the production of high quality colour prints has declined since the appearance of print processes allowing the direct production of positive colour prints from positive colour transparencies. Ilford's Cibachrome process is probably the best known. These papers produce sparkling prints with good resolution, colour saturation and fidelity. Because of the lower brightness range of paper, however, high-contrast transparencies can produce disappointing prints, even on the latest broader-range reversal materials. Cibachrome prints are fade-resistant and can be processed in the home darkroom. Commercial systems using laser scanning, digital recording and video processing techniques allow optimum-contrast prints with both shadow and highlight detail to be made from good transparencies.

When making a start in the colour photography of birds it is an excellent plan to keep a careful record of the first season's exposures. Such notes should include the meter readings of highlights and shadows, the flash gear used and the distance from the subject of the flash heads, together with the shutter speed and stops used and the filters if any. By checking the results against these data you should be able to ensure the success of subsequent work.

Seabirds are very suitable subjects for the colour camera as the light by the sea is generally good and short exposures are possible. Here you will generally need a haze filter to cut down excessive blues, due to the effects of ultraviolet radiation. A similar filter is also necessary when working near expanses of water inland, particularly when there are blue skies overhead. To cut out glare from water, a polarising filter is useful.

Choice of film stock
Kodak's Ektachrome film is widely used for shooting in 16mm. This reversal material has a good exposure latitude and produces a soft-contrast original, from which prints of very high quality can be made on suitable 'dupe' material. Ektachrome is unsuitable for projection, for the emulsion is easily scratched, but because of its soft gradation it produces excellent copies. It is designed for this purpose. If you have no need for copies, however, then Kodachrome and similar films which are tough, capable of great resolution and cheaper, are better. Few 16mm users will, however, project original film, so Ektachrome or its successors may be the most suitable material.

Where the light is poor and cannot be boosted in any way, a faster colour film is needed. Various types are available with

daylight speeds of ISO/ASA160–200. Like other high-speed films, these are not to be used for general purposes since they tend to be grainy, but they do help out in difficult lighting conditions. They are also rather expensive. Ektachrome ER, for example, costs about 25% more than Ektachrome Commercial or 60% more than Kodachrome 25.

Alternatively, instead of shooting on a reversal colour film you can use a negative colour stock like 16mm Eastmancolor. This film is widely used professionally and is perhaps the best stock to shoot with if many release prints will be needed, as copies cost substantially less than those made from either Kodachrome or Ektachrome. Negative materials have excellent exposure latitude and colour corrections can be made in printing more easily than when copying from reversal originals.

Professional film stock is edge-numbered at every foot. This makes the job of editing a good deal easier, for these numbers are printed through onto the work prints. Once the latter have been cut up and assembled for the final colour master, it is then relatively easy to locate the appropriate shots on the original reels and to cut at the precise frame required. The ease of finding a particular shot by matching up edge numbers also means that you have to handle the delicate colour original appreciably less.

Professional movie film is not usually processed by the makers but by commercial laboratories, and the cost of processing is not included in the purchase price as with many amateur stocks.

If it is necessary to shoot in black-and-white, then there is a range of film available both of the reversal and negative type. Each of these has certain advantages and disadvantages: negative film has greater latitude and tends to be faster, for example. If you shoot on reversal film, joins and dust particles are less obvious on the prints. If a lot of copies are needed, it is often better to shoot on reversal and make internegatives from which release prints are taken, without the original film being further handled. If, on the other hand, you use negative stock in the camera and make release prints directly from this material, it will not be long before scratches and other blemishes start to appear on the master. You can avoid this, of course, by getting a dupe negative made from your original, but this may involve an appreciable loss of quality because two copying stages are involved. Rather similar considerations apply *vis-à-vis* negative versus reversal when shooting in colour.

Most black-and-white 16mm cine films are edge numbered to facilitate editing. Slow-, medium- and high-speed films are available, but the choice is becoming restricted.

Choice of film stock depends largely on the job, on the number of copies likely to be needed and so forth. It is obviously important when shooting in colour to use the same stock (and if possible the same batch number) throughout the film. If different types are used in one film, it may be difficult to edit the film owing to variations in colour balance between the materials. Such

differences will probably be accentuated in printing unless special precautions are taken.

All photographic materials deteriorate with time, and colour film is particularly vulnerable to fading. Tony Bond[24] has drawn attention to the fact that slow reversal film keeps better than high-speed reversal and colour negative film. His list of the keeping life of Kodak films shows that while Kodachrome of various types may retain its colour for up to 50 years when stored in the dark at normal temperatures, some of the high-speed and negative films may change within six years, even without being projected. All keep much better if stored under cool or refrigerated conditions. These lasting qualities may well be improved with further research but the lesson seems to be the old one—use the slowest film that will do the job—and for permanence use reversal film. Copy shots on negative or high-speed film onto slow reversal stock if long-term storage is needed.

Hides and blinds

For very good reasons most wild birds avoid people and, while it is possible to film them at long range with the help of telephoto lenses, for really intimate photography a closer approach is often essential. This calls for some sort of concealment. Hides and blinds are devices, usually portable, to provide this.

Fabric hides

Hides can be constructed from stones, turfs, reeds and so forth, but the most often used and the simplest forms are made from dyed fabric. A typical and inexpensive hide for use at ground-level is shown on page 60. It consists of a canvas cover 1m square and about 1.5–1.7m high, supported on a metal frame.

The box-shaped cover is made from thick cotton sheeting, dyed or sprayed with paint in greenish or brownish shades. The top, 1m square, is sewn onto the sides which are also sewn to each other, except along one edge. This unsewn side allows access to the hide when it is erected.

A simple and durable frame can be made from four lengths of 16mm steel tubing, round or square, each about 1.5 1.7m long. One end of each piece is flattened with a hammer and shaped to a point so that it may be more easily forced into the ground. Alternatively, solid conical points can be fashioned and welded in by a blacksmith. Four pieces of stout galvanized wire (8–10mm gauge) about 1.15m long are needed. The last 7cm of each piece are bent down at right-angles so that each forms a shallow U. These pieces are then inserted into the open tops of the uprights when the latter are driven into the ground, about 1m apart. Another wire can be placed across the centre of the roof and looped over two supporting wires to keep the roof from drooping on to the cameraman's head.

The covering is made to fit this framework and, after draping over, can be drawn tight from within and pinned into place with

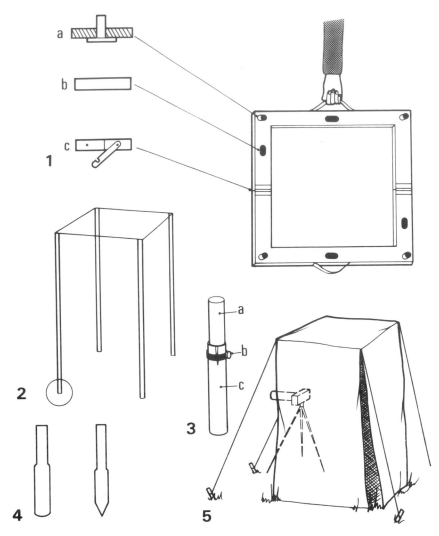

A portable hide is a necessary part of the bird photographer's equipment. The frame may consist of four uprights of aluminium tubing with galvanised wire connecting pieces at the top (2). The ends of the uprights are flattened and pointed (4) so they can be pushed into the ground. It is a useful refinement if the uprights are adjustable for height (3); the top section (a) slides into a bottom section of larger diameter (c) and is secured by a hose clip (b). A hessian or canvas cover is slipped over the frame, and the completed side secured by guy lines (5). A. W. P. Robertson's 'mobile' hide (see page 146) has a wooden base frame (1); the tubular uprights push on to pegs at the corners, and the frame folds for carrying and is provided with holes for staking down.

safety pins. Guy ropes tied inside around the ends of the cross wires pass out through small holes in the canvas and down to pegs driven into the ground. These guys are then drawn tight and contribute greatly to the stability of the structure. Use nylon to avoid shrinkage when wet.

The right choice of fabric is important. Its colour is less important than its opacity. A common fault is to use material that is not thick enough. Animals mostly have very good eyesight and when the sun shines on a hide made from thin fabric, they can easily detect the silhouette of anyone within and at the slightest movement they are off. Industrial sheeting dyed with fast vat colours is perhaps the best and the more patchy the dyeing the better. A refinement is to make the cover from two layers of thinnish material. One layer is dyed brown and the other green, so that by turning the cover inside out the shade which best fits the habitat can be used. Hessian can be used for hide covers, but

it tends to be rather heavy and yet not very opaque and may have to be used in double thickness. This material shrinks a lot when it is wet, so should be made to fit the frame loosely to allow for this. For waterproofing the roof, a simple and effective system is to slide plastic sheeting under the canvas and over the supporting wires.

A simple hide of this type has many uses and it can often be fixed on sloping ground by driving some uprights farther in than the others. Aluminium tubes will suffice instead of the heavier conduit, but the uprights have to be strong, as they will often need to be driven into the ground with the help of a hammer or mallet. Telescopic uprights are an improvement if well made. They can be fashioned from two pieces of aluminium tubing each about 1m long, one of 15mm external diameter and the other 19mm external diameter, so that the narrower tube slides inside the wider one. At one end of the wide tube a short downward cut is made with a hacksaw so that this end can be tightened against the inner tube by means of a collar of thin metal turned up at both ends which are drilled to admit a nut and screw for tightening. The collar is shaped to fit snugly round the top of the wider of the tubes. Except at the ends, the collar is firmly attached to the tube. The easiest way with aluminium is to use a glue suitable for metal. The nut of the tightening screw can also be permanently glued to the band by one of these adhesives. A small coin or screwdriver suffices for slackening or tightening the band.

Hides made from tubing in this manner have the advantage of packing into quite a small space. The metal itself is not very heavy. A disadvantage of using metal poles is that it is not easy to fix anything to them. When wooden uprights are used it is easy and convenient to have one or two nails or hooks on the inside of the hide on which to hang a jacket or camera cases; equipment such as flash reflectors and lights are more easily fastened to wood than to iron. Despite this, tubing is probably the best and simplest material to employ.

The hole for the lens is normally in the centre of the front panel. To fill the gap around the edges of this hole a 'nurse's sleeve' is often used. This is a piece of fabric shaped like a truncated cone, open at both ends. The narrow end has elastic inserted and fits snugly and well back down the barrel of the lens hood. The broad end is safety-pinned to the hole. This arrangement helps ensure that movement of the front of the hide is not transmitted to the camera and allows stops etc. to be altered on the lens barrel, without movements being seen by the birds.

Ground hides can be purchased ready-made[25], but I have seen none that are more practicable than the type described above. I do not favour elaborate affairs with zip fasteners and other such frills. A hide is simply a piece of field equipment and you should not be averse to cutting holes in it whenever and wherever these may be needed. Zip-fastened openings are usually in the wrong place and are quite unnecessary.

The canvas ground hide is most useful in forest or scrub country and for photography at or near ground-level. It can be readily camouflaged in such environments to avoid the unwanted attentions of other people. But in deserts and on moorland or tundra hides tend to be extremely conspicuous. Birds do not mind this if the blind has been properly introduced to them, but if you wish to avoid attracting human attention it is often advisable to keep the structure low.

When a hide is used at ground level a folding seat is needed. This should be strong, for it will often have to be used on irregular surfaces where there will be a fair amount of strain on the framework. It should have cross-struts on the legs which are set high enough up for the ends of the legs to sink slightly into the ground if need be. This gives a firmer seat when working on moist, peaty and soft ground generally.

Equipment hire

With cameras and accessories becoming increasingly specialised and increasingly expensive, it is often financially unwise to invest in advanced equipment which, while being essential for particular kinds of work, is needed only intermittently. Rather than tie up capital by direct purchase, it often makes sense to hire instead. If you live near a large city this is often a perfectly feasible proposition, for today you can hire a wide range of photographic gear—35mm and larger cameras, lenses, motor drives, 'sun guns', tripods and so on.

Clearly, to keep costs down, the use of such facilities calls for planning, both to make sure that the apparatus you need is available and that as soon as hiring charges start accruing you can get into action. This means working out in advance just when you can take the shots for which the gear is needed and this in turn implies that you know the habits of your subject—that you've picked the right tide, the correct hatching date etc.

Once there was a time when no professional and certainly no amateur photographer would have dreamed of using someone else's equipment. Times change, however, and the trend towards hiring specialised equipment may well become recognised practice, particularly among professional wildlife workers who have to cover a wide range of subjects, scenarios and locations.

Birds wild and free

This chapter covers techniques for taking stills and cine shots of wild birds without resort to concealment. This style of bird photography was once the province of very specialised workers but has become increasingly popular with the perfection of the 35mm SLR and of the Super 8 TTL cameras, light in weight and hence capable of being hand held even when powerful optics are used.

Stalking

Birds' senses are so acute and their distrust of man so great that even with powerful telephotos some species are impossible to approach sufficiently close for successful photography. Many others can be stalked into camera range. For such situations the most powerful lens available, consistent with the needs of mobility and avoidance of camera shake, should be used. Local knowledge of the terrain and of the bird's use of it help a lot and your own style of approach is important too. Do not look directly at the subject you are stalking. Use any cover that is available, even if this only hides your feet. All your movements must be cautious and smooth and your approach direct, so that the bird can less easily judge your distance. Watch for signs of unease in your quarry or in its companions, slow down accordingly and be ready to start shooting before it takes off. If you can move when the bird is involved in some activity—chasing off a neighbour, dissecting a polychaete, preening or whatever, so much the better. Wear dull clothing with nothing that can flap in a breeze and if the sun is on your back, do not forget the effect on your silhouette.

Stalking for stills

Stalking can sometimes succeed even when extra-long focus lenses are not available. Incubating woodcock and duck often sit so tightly that photographs can be taken at 3–4m without a hide. Owls roosting in trees also allow you to get quite close if approached circumspectly. They generally hide up in deep shade so that a short tele-flash (page 170) may help. Rain forest birds can also be very tame and even wild passerines may be naturally indifferent to man. A student of mine working on the New Zealand robin (a highly territorial flycatcher) had only to walk into the territory and whistle or bang on a tree trunk for the

Scarlet robin asleep. Roosting birds are easily awakened, and generally you get the chance for just one shot before they shift to deeper cover. This one was successful because I could focus with the help of a hand torch before firing shutter and flash (photo John Warham).

resident male to appear within a few feet to investigate. The student had then to give the bird time to relax and to revert to its normal behaviour before he could begin his observations. These necessitated his following the bird and timing its daily activities— a task that was quite feasible without altering the behaviour patterns in any detectable way. Photography of such birds is accordingly simplified, perhaps the chief problem being the need for continual shifts of focus with the continually moving bird and of dodging trees and bushes and monitoring changes in light, or in stops needed, if working with flash. Here automated flash is often useless as the bird is generally too small in the picture area to reflect the light to the sensor. Instead, it is generally the reflection from the foreground or background vegetation that is monitored. Under- or overexposure of the bird often occurs if the manual override is not used and reliance placed on simple calculations of distance and hence stops needed.

Stalking may also be rather easy with colonial birds. Often their colonies are sited relatively safe from interference and they are accordingly tame. This is not true of all colonial species—pelicans, ibis, herons and egrets, for instance, often become deeply alarmed when their sanctuaries are penetrated and wholesale desertions of nests may occur. With sea birds like auks, kittiwakes, boobies, noddy terns and penguins, however, a cautious approach occasions little obvious alarm. Then the camera may even be carried with a tripod attached and ready for action. When close enough the tripod is set down, levelled and photographs taken without haste. One advantage of using the tripod is that it allows you to use a fairly slow exposure, small stop and so get a good depth of field. This helps to avoid photographs of the whole colony being spoiled by the heads of out-of-focus birds too close to the camera—a common fault. Also, if you can use a tripod then really big telephoto or catadioptric lenses of up to about 1250mm focal length become practicable in calm weather, free from heat haze.

More often greater mobility is needed and the camera has to be hand held, but success is unlikely with straight-through tele-photos of more than 400mm focal length or mirror lenses of more than 500mm focal length, as camera shake takes the edge off the definition. A rule-of-thumb guide is that the slowest exposure practicable for hand-held stills is the reciprocal of the focal length of the lens, e.g. with a 1000mm, nothing longer than 1/1000 sec is likely to succeed. Exposures slower than 1/250 sec are seldom feasible.

With such heavier optics some additional support is essential—a monopod, chest- or shoulder-pod or a follow-focus rig of some sort. For a given magnification the conventional telephotos are heavier than mirror lenses, of course, but many have automatic diaphragms and hence, with the TTL metering, precise exposure is more easily obtained and some control of depth of field may be possible. With mirror lenses this cannot be done and exposure control involves changing shutter speeds as the aperture is fixed. It can happen with mirror lenses that the film is too fast so that, even at 1/1000 sec, overexposure is possible in the rather open situations where such lenses are often used. The only answer is to fix on a neutral density filter and continue. With a conventional lens you merely have to close down another stop, which is far more convenient and also means better depth of field and definition. This can be quite important if you are lined up on a sanderling tripping along the surf or a mallard leading her brood to the water.

Whenever you work with a hand-held camera, any firm support that becomes available should be used—a car bonnet, a fence rail, a sea wall, a tree trunk—all can give that little extra stability and allow the smaller aperture that may make all the difference between a hit and a near miss. Even so, many shots fail due to inaccurate focusing, subject and camera movement and exposure

Antipodes Island parakeet—a rare but rather confiding species shown here feeding among *Anisotome* plants on Antipodes Island, New Zealand. A 135mm tele lens was used for this SLR shot (photo John Warham).

An American wood duck stalked at a Canadian coastal reserve. Monopod, 35mm SLR and 300mm tele-lens (photo John Warham).

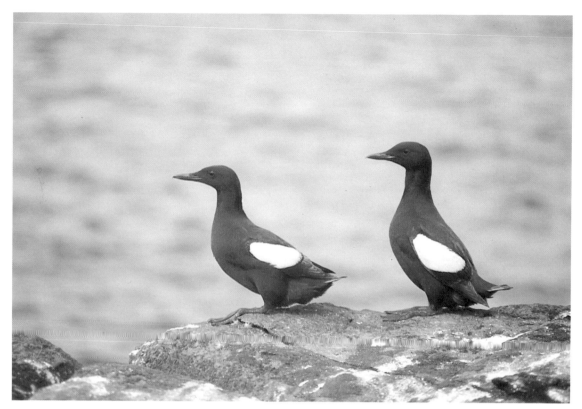

Two black guillemots—
stalked with a 35mm
SLR and 300mm lens.
Seabirds are often
rather tame but a quiet,
cautious approach is es-
sential. Note the help
given here by the out-
of-focus background
(photo John Warham).

European shags in the
Orkney Islands—a typi-
cal study of a nesting
seabird obtained with-
out concealment (photo
John Warham).

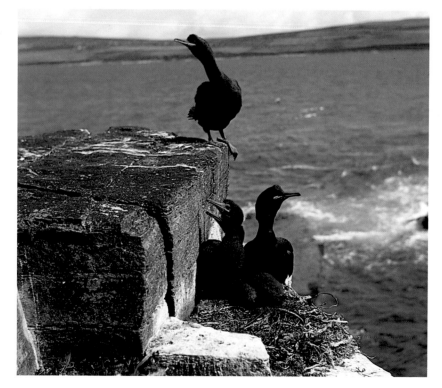

Stalking with SLR, mirror lens and monopod. The camera is pulled firmly against the face, the left hand adjusts the focusing ring and the right the shutter release (photo T. R. Williams).

An upland sandpiper taken with a mirror lens (photo J. B. & S. Bottomley).

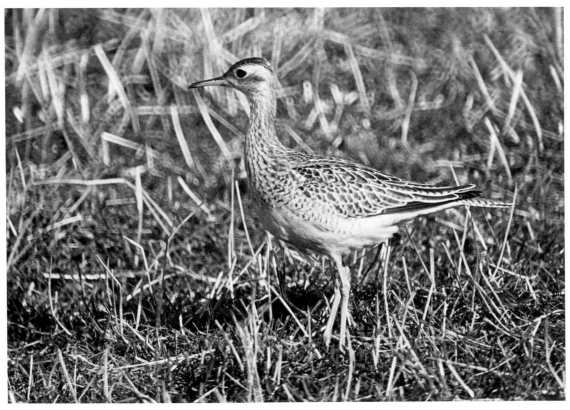

inaccuracies. Moving birds give you little time to make fine adjustments and it pays to duplicate or triplicate your shots. A motor drive makes this simpler and increases the chances of success, nor do you have to move your hand so often between shots and so risk alerting the bird.

Stalking has become a popular activity, particularly for wader enthusiasts who usually work with mirror lenses and chest pods. Their targets are often fairly tame, occur in open, well-lit situations and offer lots of variety, some 32 kinds being common visitors to British coasts, sewage farms and estuaries. A similar range of species can be found along the winter shorelines of temperate northern hemisphere countries and in the southern summer of the southern hemisphere when Arctic breeders 'winter' south of the equator.

Stalking for movies

Stalking with a cine camera is usually easier than stalking for stills, particularly when you use a lightweight Super 8 with a good 8:1 or 10:1 zoom. The procedure is much the same as for stills, and tripod, chest- or monopods should be used whenever possible, for shots are easily spoiled by camera shake when the zoom is fully extended. So use any support that becomes available and do not waste film by shooting while you are still out of breath after some hurried flanking movement to get within range.

When it is necessary to go into action at the drop of a hat the monopod's lightness comes into its own, but this tool must be used intelligently. The camera needs to be braced tightly against the body and the foot of the monopod firmly placed in the ground. If a tree or sapling is handy, it may be possible to lean your body against it or to rest the camera against the trunk and so get extra rigidity. This is most desirable if there is a wind blowing. In sandy country, muddy swamps or other places where the ground is soft the monopod can be driven well in, and the resulting pictures are correspondingly stable.

A good deal of wildlife filming is of an opportunistic nature and the small Super 8 with an automatic iris and rapid cartridge loading has a great advantage in terms of time needed between seeing a chance and shooting. With 16mm, weight becomes important because stalking birds is a one-man operation. Hence, unless the battery is built into the camera you have to rely on the spring-motor drive. If there is no TTL meter then regular checks with a hand-held meter are needed to maintain correct stops during takes. When you are travelling light and relying on the spring drive, do not forget that if you re-tension the spring in view of your quarry, you must move very carefully or it may fly for its life. But it *is* important to wind up after every shot (behind a bush or some other temporary cover if possible), so that you are always ready for action.

When using conventional lenses you will generally have a fairly

shrewd idea of what you are hoping to achieve. The focusing scales of all the lenses in the turret can be preset, according to the light and anticipated maximum shooting distance, to give a worthwhile image size. If an interception is made it may be imperative to get the film moving without delay and it is often best to take a shot without bothering to check stops and distances. Then, if the bird seems likely to remain within range, you can make a quick check of settings and a meter reading and, if needed, effect a retake at once. When stalking, however, it makes sense to use a zoom because it is lighter to carry and the focal length can be changed at the flick of a switch without taking your eye off the subject. This is more convenient and faster than having to swing a lens turret around.

Cattle egret taken with a 500mm mirror lens, 1/500 sec at f8. Shallow depth of field helps in separating the bird's head from the background. Note the doubling of out-of-focus highlights and darkening of the picture edges characteristic of mirror-lens shots (photo John Warham).

Stalking from cars, boats and planes
The bird stalker cannot always work on foot. Cars are often used to drive within camera range, the engine switched off and the lens rested on the open door window for shooting. Eric Hosking has pointed out the value of a 'bean bag' for steadying a long lens on a door lintel. The bag is a sausage of fabric filled with dried beans, sand, even polystyrene chips, and can be moulded to the shape of the door edge and to the lens barrel. A second sand bag can be laid on top of the lens to keep it in place. Other camera stands for use in cars have been described (page 46).

Bean bags can also be used when shooting stills or cine from

70

small boats, lying the bag over the gunwale just as with a car door, but with rubber dinghies the camera can be rested directly on the inflated rim of the boat. Bean bags etc. are useless except in calm seas or on quiet lakes, otherwise it is necessary to counter the pitching, yawing and rolling with appropriate body movements and leg flexions. It is rather surprising how, with practice, all these can be countered while keeping the subject more or less centred in the frame and the horizon reasonably level. The camera is hand held and the body in effect used as a shock absorber. Not only does this take care of wave-induced movement but also vibration caused by an inboard engine or outboard motor. Such vibrations make it quite out of the question to rest the camera on the gunwale even in calm seas, for if the engine is running the shots will be ruined. When stalking from boats you will probably be trying to get shots of auks, terns or petrels feeding offshore, pictures of heronries, pelicanries and cormorant

Stalking birds from the air: these Rüppell's vultures were followed from a powered glider during research on flight mechanics. A good example of the flexibility of the SLR camera. (photo C. J. Pennycuick).

colonies from lakes and such like. One of the keys to success is to keep the horizon horizontal!

Much the same applies when shooting from light airplanes. Here again the 35mm SLR for stills, and the zoom lens on the cine are generally the best for most circumstances. Focusing may be difficult as both birds and plane will be pitching. Engine vibration, if nothing else, may prohibit the use of the sill of a door. Special anti-vibration mountings are available for planes as for motor vehicles. Worst of all are helicopters, where juddering becomes very pronounced under turbulent conditions. The camera must be hand held at fast shutter speeds and the body used to damp vibration.

Few people have photographed birds from the air, although a census of Antarctic and sub-Antarctic penguins is being made primarily from aerials. Dr Colin Pennycuick, during aerodynamics research, followed African gliding birds in his own glider. The picture of Rüppel's Vultures (page 71) is an example of one of his photographs.

Wildfowl and other flocks of medium- to large-sized birds can be taken with 35mm, 6 × 6cm and press-type cameras. This shot with a Speed Graphic at 1/500 sec was fast enough to arrest wing movements adequately (photo John Warham).

Birds on the wing

Taking birds in flight by natural light is fun. You need many of the skills of the hunter for success. This is an activity that can be pursued at any time of the year but which tends to be more of a winter pursuit. In this season, many birds that are dispersed

during breeding, flock together and establish regular flight patterns and movements to and from feeding grounds and roosts. There are also fewer alternative attractions for the bird photographer in wintertime. The kinds of birds photographed tend to be geese and other wildfowl, waders flighting over estuaries, gulls, starlings, crows and kites commuting between rubbish tips and roosting places and so on. Other possibilities may also be seasonal, like the migrations of birds of prey and storks across the Bosphorus, or be available at any time, as with the everyday actvities of birds that use thermals to spiral into the sky. There are also many opportunities for flight studies in the vicinity of seabird colonies and from the tops of cliffs.

In flight a bird offers a larger target than when settled. Even a starling 15cm long has a wingspan of about 35cm. Thus although a long focus lens, usually a telephoto is needed, it does not always need to be a very powerful one. Just what is required depends on the size of the bird and how closely you can approach it. For a massive bird, like a swan, a medium length telephoto would often suffice if you had a good shooting position. Similarly for a rook-sized bird, like the Cape petrel, which tends to come within about 7m of the stern of a boat and often sweeps in at deck level, a 135mm lens is quite adequate for 35mm camera shots. For smaller birds at greater ranges, more powerful lenses are needed but in general really long lenses are not satisfactory in the hand-held situations essential for flying birds. All the same, most people find that they get less camera shake when swinging a long lens with a flying bird than they do when holding the same lens on a perched one.

A number of compromises between conflicting requirements are involved. There is the need to focus accurately and hence the

Southern skua attacking: it is hard to catch the right moment of exposure when faced with such high-speed action. This SLR shot at 1/500 sec was made with a 135mm lens and wings are still blurred. A slow-speed electronic flash has lit up the head and mouth (photo John Warham).

value of small stops to give good depth of field. But it may be impossible to use small stops because high shutter speeds are necessary to counter bird and camera movement. The result is that you generally have to load with fast film. Also, since some of the best opportunities for flight shots arise around dawn or towards dusk, the use of a Wratten 82B filter to counter yellow casts may be needed and it may also be necessary to 'cook' the film in processing to uprate the film speed.

Correct exposures are sometimes difficult to determine because direct readings tend to give readings for the sky, whereas the bird will need an extra one or two stops. In cine it is usually best to operate via the manual override and open up one or two stops. Exposure also varies a lot, according to the angle between the bird and the light.

Successful flight photographers depend greatly on their knowledge of the habits of their subjects. They know when a bird or birds shift from A to B and the routes they take; they know when the hawks migrate over the passes and the effects of winds and weather on these movements. The flight photographer in fact needs many of the skills of the hunter—an intimate knowledge of his quarry until the birds are within range. Perhaps a companion can drive them forward. It should be remembered that birds always rise into the wind, though they will often turn as soon as they are airborne. So by taking up a stand upwind of the birds the

Northern fulmars: the birds are gliding slowly in the face of a strong updraught from the cliff edge, offering plenty of opportunity for flight shots. The birds were probably two males courting a lone female. 35mm SLR, 135mm lens and 1/500 sec (photo John Warham).

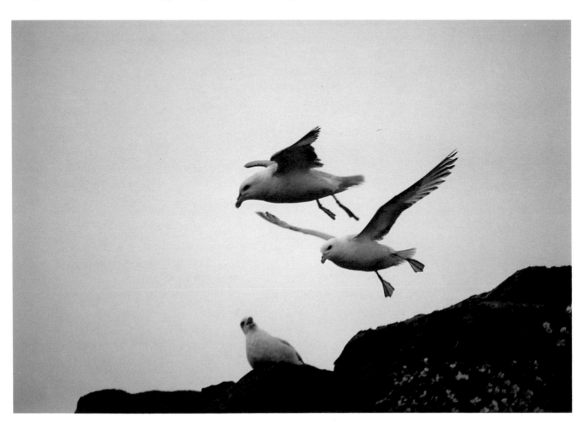

Kestrel hovering. A fine result of quick action and focusing with a hand-held camera. European kestrels are often seen hovering beside motorways, but these are *not* the places for attempting photography (photo J. B. & S. Bottomley).

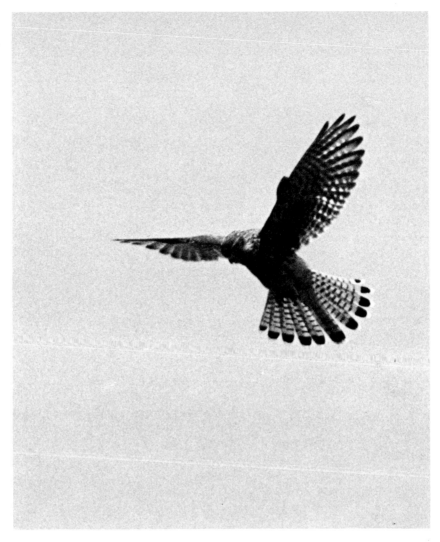

photographer may experience the pleasure of having his quarry fly overhead.

When after birds on the wing, choose a bright day and go out in the morning or afternoon when the sun is fairly low so that your quarry's flanks and underparts are illuminated as they fly past. On such days a position in the shadow of a bush, or in a dip or ditch where you are not silhouetted, is desirable. It is remarkable how little concealment is needed providing you are seated and motionless, apart from the movement of the camera. Many birds may pass right overhead and will either not see you at all or will be unable to swerve in time. Others may bank away at the last moment, offering a fine opportunity for a shot as they expose their bellies to the sun. Naturally, quite a number of the pictures will be useless because of wing movement or faulty judgement, and the more you take the greater the likelihood of first-rate results.

Your position in relation to wind and sun is important. As the birds fly up into the wind they have slower ground speeds and they then make easier targets. Ideally the light should be behind or to one side of the camera. But if you are seeking pictures of birds immediately after take-off and the wind is blowing away from the sun, you may find yourself shooting straight into it.

Taking stills
For most flying birds the 35mm SLR is the best camera to use allowing short exposures of up to 1/1000 sec (even 1/2000 sec in some makes) in conjunction with powerful telephotos. Both can be combined without loss of the hand-held facility.

Focusing is a major problem. For medium to distant shots the bird or birds can usually be followed directly in the viewfinder and the focus continually adjusted up to the moment of exposure. A follow-focus system like the Novoflex (page 48) may be used. For close- to medium-distance shots, follow focusing is usually out of the question and the viewfinder is essentially used to centre the subject. The lens must be set for a predetermined distance based on past experience, the size of the bird and other factors. The moment when the bird has reached that distance is then gauged by means of the split-image rangefinder or by seeing that the image is almost sharp on the viewfinder screen. In practice the maximum size telephoto feasible with this method is about 300mm. A well-designed shoulder pod is recommended to increase camera steadiness. A follow-focusing system may be used but, except for slowish-moving targets like swans, eagles and pelicans, you will probably find it better to set the focus to a predetermined figure and shoot when the birds pass through the field covered. Continual panning before, during and after exposure is essential and if you use a motorised camera you may be able to get a series of shots before the bird flies out of range and thereby increase your chances of taking a really successful picture.

Many camera makers are experimenting with automatic focusing systems for SLR cameras. Automatic focusing will be a boon for the flight photographer when lightweight systems allow telephoto lenses to be focused automatically.

A good motor drive is a useful accessory. With some models you can take up to five frames per second which means that what would otherwise be a chance for just one flight picture may be extended to four or five chances. With a motor drive you can start shooting before the image is sharp and continue until it is again out of focus: the middle shots ought then to be sharp.

Good flight studies are often taken on larger-format cameras, particularly where the birds can be closely approached, as at seabird colonies like gannetries and fulmar cliffs. A wire frame-finder is a useful aid and is often used with a press camera as shown on page 31. A telephoto or long lens is needed and this has to be prefocused as before.

Spine-tailed swift. This speed specialist was shot at 1/500 sec at a range of about 3m using a 6 × 6cm Super Ikonta. It was the best of 16 attempts (photo John Warham).

Sometimes no viewing device is of any help. The spine-tailed swift shown here is perhaps the world's fastest bird. A mob of them was feeding over a field and quite ignoring me. I had a 6 × 6 Super Ikonta to hand, set the focus at about 3m and then just snapped the birds as they tore past. There was no time to look through any viewfinder, let alone try to use the rangefinder and the result was just two sharp pictures from about 16 attempts.

Filming birds in flight

Even if your film is not primarily concerned with flight, a few flying studies are often needed to increase the visual variety, and they are often not too difficult to take. If well executed they can be quite compelling.

A reflex finder makes following the birds during the shots fairly easy but, as with stills, it is often better to prefocus rather than attempt to adjust focus while shooting. Also select the shortest position of the zoom or the least powerful telephoto that will give a large enough image, for the greater the magnification the more difficult it is to keep the bird well framed. Sometimes even the standard lens may be enough, for instance if you are taking large flocks of birds, when the whole frame is filled with targets.

Flying birds are generally medium or long shots rather than close-ups. R.T. Peterson has a very good shot of a dunlin hovering above its display ground in his *Birds of the Bering Sea*[26], and he manages to hold the bird as it sweeps down to the ground and alights, a most difficult shot to bring off smoothly and successfully like this. For success it is essential that when the bird is last seen on the ground it is quite sharp, and I should imagine that this one was only achieved after many failures.

For the reasons discussed above, well-centred shots are most likely to be achieved using telephotos of medium focal length. If more powerful lenses are needed it may be better to rely on slow motion. If you can then keep the bird centred for only a few seconds you may have enough footage for a usable shot, while not enough for one at normal speed. There is something to be said for using the bigger magnification lenses because of the enhanced separation of the planes. One of the most attractive shots of a flying bird that I can recall was of a jabiru taken by H.J. Pollock in the Australian bush[27], and evidently he used a long telephoto and slow motion. It is seen flying against a backcloth of thick rainforest and stands out beautifully; but this is a large stork, not very fast flying, and therefore easy to frame up accurately and keep in the centre of the field, even of a powerful lens.

When shooting birds with a camera there is no need to aim off to make a hit as you must when shooting with a gun. If you are filming a single bird, however, or even a skein of geese and these are not travelling too fast, it is worth making a conscious effort to try to place the birds slightly to the rear of the centre of the frame, rather than smack in the middle of it. What is bad, and very irritating, is the flight shot in which the camera persistently lags behind the subject and at intervals moves jerkily forward as the operator tries to rectify his error. Shooting should begin well before the bird is really big enough in the picture and should continue as it approaches and flies past, the camera being swung smoothly and steadily meanwhile. If the bird passes overhead, the shots are often not too good, as there is only a restricted arc through which you can swing: beyond that the camera simply cannot be held steady enough and if you try too hard you may end up on your back! With birds that pass to one side, however, it is not too difficult to cover their flight by swinging through an arc of about 120°. After this your body gets so contorted that picture steadiness rapidly deteriorates.

The slower a bird moves, the easier it is to keep it accurately centred. And here we are concerned with the animal's speed relative to the ground. In a headwind of 20 mph, a bird travels that much slower to the ground observer than it does on a windless day. So it is usually better to choose windy days for flight work, to stand with your back to the breeze and shoot the birds as they fly into the teeth of the wind.

When filming at roosts or nesting colonies, where there are perhaps thousands of birds aloft at once and travelling in every direction, it is better to take only those coming from a certain angle or arc and to ignore the rest. Otherwise you will be constantly changing your stance, resetting stops and so on. It is far more productive to settle for one direction, preferably that where the birds are facing the wind or perhaps streaming down to alighting points.

Cameras with variable-speed shutters can be used to good effect in flight photography. By speeding up the shutter, wing

blurring is lessened. So, if there is light enough, faster shutter speeds should certainly be used where the reduced depth of field permits. As the number of frames per second remains unaltered, no impression of slow motion is created and the shots therefore show the action as this appears to the human eye. Faster shutter speeds are almost obligatory with smaller birds like terns, auks, waders, swallows and so forth, whose wing-stroke frequencies are high. Slow wing-beaters like pelicans and eagles do not really call for any increase on normal speeds. At higher speeds, of course, the lens aperture must be increased to allow for the reduced light reaching the film.

Using slow motion

In addition to the normal sound speed of 24 fps, most 16mm cameras allow shooting at higher frame rates such as 32 and 64 fps and perhaps 48 or 50 fps as well. At 32 fps, a slight effect of slow motion is achieved, but at 64 fps this effect is considerable as the action is slowed down considerably when the film is projected at normal speed. Use of high filming speeds not only slows down the action but also smooths out camera instability and at 64 fps camera shake has usually disappeared. Thus high filming speeds are doubly suitable for shooting birds in flight and such shots can be very effective, revealing a grace and synchrony of motion not apparent at normal speeds. Everyone has seen this technique applied to birds like egrets and flamingoes on the wing: the result is often quite dramatic.

As with other special techniques, slow motion is a device that can be overworked and then, like wipes and zooms, degenerates to a gimmick. Personally, I dislike slow-motion shots injected into the action in such a way that the viewer is not at first aware that what he sees is in slow motion. After all, this is a form of distortion. It seems to me much better first to show the animal moving at its natural pace and only then to cut to the slow-motion sequences. This gives the onlooker a chance to adjust. Some of the best shots of seabirds in slow motion I have ever seen were of greater shearwaters taken off the coast of Maine by C.E. Huntington. The sequences were superb, showing these fast-flying birds diving, fishing and swimming underwater with great clarity of detail. Unfortunately, there was not a single shot showing the birds at their normal flight speed for comparison, an oversight which I know Professor Huntington regretted and which he has probably rectified by now.

Increased filming speeds require bigger lens openings: at 64 fps you have to open up by 1½ to 2 stops. The variable-speed shutter can also be used in conjunction with increased rates of film transport; with the Bolex this enables exposure times as short as 1/640 sec to be given. Obviously the light would need to be very good for fully exposed results at such speeds.

As takes at high filming speeds last so much longer on the screen, it is often only necessary to shoot for two to three

seconds, i.e. in quite short bursts. In any event, if you are not relying on an electric drive, the camera spring will quickly run down. If you are using electric drive, the batteries must be fully charged.

Baits and lures

This chapter is concerned with some of the methods for photographing birds away from their nests and in which, unlike stalking, concealment is essential. There are three basic approaches:

1 The wait-and-see technique in which the cameraman is concealed overlooking some place that past experience has shown to be attractive to birds, and then waits to see what will turn up.

2 Concealment near food and water baits to attract birds to within camera range.

3 Concealment near devices of some kind that will lure birds within range.

None of these methods, sensibly used, involves significant interference with the birds themselves and while bird at-the-nest photography requires permits in countries like Britain, these are not needed for photography away from the nest.

As usual in wildlife work, success depends partly on luck,

A wait-and-see shot of a white-faced heron stalking for food in the shallows. Slow-moving birds like this allow slow exposures and small stops and hence enhance focusing through permitting greater depth of field, but the birds tend to be very wary and camera panning is unlikely to succeed (photo John Warham).

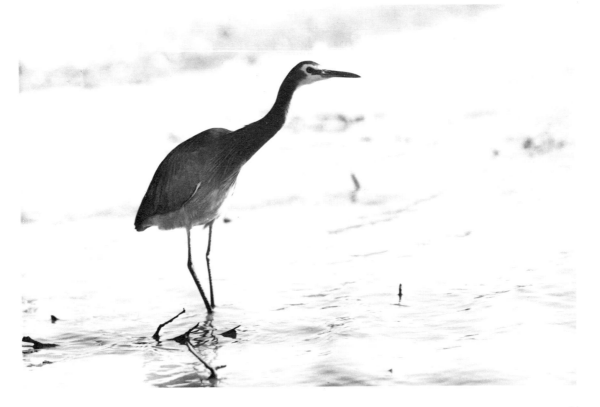

partly on the photographer's knowledge of the habits of the birds, and on his or her skill in using the camera.

'Wait and see'

Any naturalist with local experience knows something of the preferences of certain birds for certain places; that you repeatedly see an egret at this particular corner of the lake, waders thickest around one end of a sewage farm, a bird-of-paradise that customarily appears at dawn on his special display perch, blackcocks at their 'leks', located in the same spot on the moor year after year, and so on. The photographer also knows that these places tend to be attractive only at certain seasons. For example, in northern Europe and America the best time to photograph water birds away from their nests is in the winter when estuaries and shallow lakes become iced over and the hungry birds congregate near open water. Similar work is often feasible on the seashore, where migrant wading birds rummage about along the tide-line, at water-holes, or at temporary flushes of food, such as a farmyard after threshing or a strip of sunburnt country after a cyclonic rain has swept through. Their predators may be attracted to such places too. The point about taking advantage of such opportunities is that you never know what precisely may come into range. You may miss the bird you hoped to get, but find something much better and less expected. This

Australian pelicans taken from a wait-and-see hide. Follow-focus systems are highly advantageous in such situations, where long tele-lenses are needed and the subjects' distance to the camera is continually changing (photo John Warham).

An example of the sort of study possible in a suburban garden by providing suitable food in a particular place. Although starlings have adapted to life cheek-by-jowl with man, they are always alert and proper concealment (or remote control) is essential (photo Mike Wilkes).

method can also produce much disappointment and cold feet and is not recommended for those impatient for results.

The placing of the hide is important. It should enable full advantage to be taken of the sun and be fairly well concealed against a background of bushes or reeds. Obviously this must be put up several weeks before it is likely to be used and so constructed that gusty winds will not lift the material with which it is covered (see page 146). It is usually advisable to camouflage the hide well, so that from the bird's-eye view it blends with the landscape. It may then also escape the notice of passers-by, and the possibility of human interference. If you can work on private land within view of house or ranger's cottage, so much the better.

Under wait-and-see conditions you have to be prepared to take whatever comes within range. It is not practicable to focus on any particular point, so that a reflex is necessary to enable the birds to be followed as they come into view and to be kept in focus up to the time of exposure. As the camera will have to be swung from side to side, the slit in the front panel of the blind through which the lens protrudes must be horizontal, so that the necessary traversing movements can be made. To guard against anything showing through this slit you can use a large cardboard lens shield as described on page 118. A horizontal, zip-fastened slit is useful here, particularly the sort with two zips so that an opening can be arranged at any point and the rest closed.

Even when the birds have been long accustomed to the hide,

they will seldom come close enough when it is occupied for a lens of medium focal length to be of much use. On 35mm you need a 400–600mm lens and, since this work is done with the help of a firm tripod, straight-through telephotos are better than mirror-lenses. The former give better definition and greater control over depth of field and out-of-focus foregrounds.

If shooting in cine the same is true—on Super 8 the longest setting of the zoom will probably be needed; on 16mm, a 300mm or even a 600mm lens. The tripod needs to be very firm and heavy and it is important to ensure that the lenses have adequate clearance through the front of the hide for the whole of the lateral traverse. This may not be easy to arrange with some lenses, bearing in mind that you have also to reach the stop and focusing rings without sticking your hand out. You may have to shift the tripod during a session to bring the lens to bear at an oblique angle to the front of the hide. This is not too difficult if done slowly and the birds are not too close. High-speed film may be needed in winter at high latitudes. The dull grey days of the northern winter should be avoided, for a touch of sunlight, however watery, makes a big improvement, while long shadows cast across snow or ice may help in picture-making with birds as with other subjects.

Some bird photographers have produced fine pictures of waders by working in coastal estuaries where there are isolated banks of sand or rock to which the birds retire at high tide. Here they rest to await the ebb and the uncovering of their feeding grounds. As the sea moves in the birds are forced higher and higher until favoured banks above water are covered with waders and gulls of various species. A hide properly placed is usually ignored and many opportunities are given the fortunate occupant.

A good deal of 'wait and see' work is done in very open places to which there is no concealed means of access. Then it may be necessary to get inside the hide before daybreak, and this can often be done without disturbing the quarry. Indeed it is not unknown for a 'wait and see' photographer to enter his hide before daylight and to leave it after dark. For such long sessions of course you have to take the day's food and drink, be properly clad and ensure from the start that you are really comfortable. Needless to say, premature emergence from a blind to which the birds have become accustomed will put paid to its usefulness on subsequent occasions.

While 'wait and see' tends to be an uncomfortable pastime, particularly in cold or hot weather, there are now many reserves equipped with permanent viewing hides from which photography can be done in comfort. The advantage of these is that the hides are part of the landscape, have been accepted by the resident birds, and these in turn tend to draw in visitors and migrants that might otherwise seldom be seen within camera range.

Using baits

In the very broadest sense, even a bird's nest can be looked upon as a bait by the photographer who uses the attractions of such temporary or permanent shelters to get pictures. However, the following discussion is restricted to the use of food and other lures introduced by the naturalist to entice his prospective subjects within shooting range.

First some general principles. Food baiting as a means of luring animals is clearly most likely to succeed at times of food scarcity. When the countryside is teeming with natural foods, baiting is usually just a waste of time—you do not find tits much interested in peanuts in May and June in an English garden. There is far better food in the trees and hedgerows. Even under the right conditions it is, in my experience, pretty hopeless putting out baits and expecting these to be taken that same day or night. More likely, food will have to be provided for days or perhaps weeks before the animals you are after catch on to the idea that they can get a meal at that particular spot. The spot needs choosing carefully. You need to consider points like whether a blind can be built conveniently, whether light, wind direction and background are favourable and how existing animal trails and human activities are likely to help or hinder your work. Such factors have to be weighed carefully if a lot of fruitless labour is to be avoided.

Many ingenious lures have been devised by people dependent on wild animals for their food, and the wildlife photographer on location in remote places should remember that the native peoples, with their special knowledge, may be able to help in enticing birds into camera range.

Baits in gardens and woodlands

Perhaps the most rewarding out-of-season work can be done in the garden. Characteristic studies of common birds like robins, starlings, sparrows (how few good pictures there are of these birds) and tits can be obtained quite easily. The simplest method is to set up a feeding table beside a permanent hide. If the latter is a reasonably strong affair made of wood, roofing felt or similar material, it will prove more serviceable than the ordinary canvas hide designed for portability and temporary situations. Or the bird table may be placed before a garden shed or an outhouse inside which you can be concealed.

Local birds soon become familiar with such permanent hides and the dummy lens, if food is regularly provided on the table. Given satisfactory lighting conditions, the main problem becomes one of getting the subject isolated from its fellows and in satisfactory surroundings. Keep well back if you are filming because garden birds are often alarmed by strange sounds. Photographs taken at the bird table, or of birds picking up food from the ground, are not very attractive; the food is too obvious and unnatural. It is far better to arrange a suitable perch above or

beside the feeding point on which your visitors may settle before dropping down for a meal. Such a perch can be changed when desired.

One way of baiting garden birds to a perching post is to drill small holes on one side near the top. These should be about half an inch in diameter and depth and filled with fats, bread soaked with honey, nuts and similar baits. The post is set up so that the holes are away from the camera and not shown on the print. Once the birds have discovered the food and that it can be reached without their leaving the top, good opportunities for pictures are obtained.

Similar ideas work well in woods where you can put out bait at suitable places near semi-permanent hides. Here you should be able to entice species within range that are not usually seen in the garden such as long-tailed tits, nuthatches and woodpeckers.

In the winter, poor light is often a problem. Apart from the long exposures needed on grey days, the resulting negatives, even if sharp, tend to be rather flat. The best conditions are provided by winter sunlight, the softness of which is very suitable. Flash can help to brighten stills and to shoot a highlight from the eye. Care should be taken when placing the hide to see that the background is unobtrusive and it may be necessary to rig up a backcloth to achieve this. The material should be light in colour, vaguely blotched with darker areas (preferably applied with a

Feeding tables are not always the most photogenic of settings. These cowbirds and Brewer's blackbirds would have made more attractive shots if taken on a perch just out of view of the table. 35mm SLR and 135mm lens (photo John Warham).

spray gun) and firmly fixed to a fence or other support so that the fabric cannot flap or sag. A backcloth should be put up well before photography is contemplated.

Baits in the open

For birds many kinds of bait can be used. Food is again the most useful, but naturally it has to be selected to suit the species it is hoped to lure to the camera. Robins seldom take notice of dead rabbits, or buzzards of mealworms. There are many natural and more specialized baits that work in appropriate circumstances.

For example, during bad winters many northern birds move south and become very dependent on hedgerow berries. Twigs laden with hips and haws, cotoneasters and suchlike, can be cut and set up in water before hides to induce the big thrushes like fieldfares or redwings and perhaps waxwings into camera range as they feed. The site has to be selected carefully, preferably in some place where such birds are normally seen—a sheltered spot in the corner of a field against a copse might do, somewhere in which the hide could be conveniently tucked out of sight. It is important to keep the food supply going, so that the birds make daily visits and become used to feeding there without being disturbed by man or by predators. This requirement applies generally to birds and baits: where many are gathered together the danger from predators increases and once casualties occur from hawks, cats or whatever, the other birds may become wary and difficult to film.

Thrushes and blackbirds also respond to fruit windfalls; most of these are collected and a continuous supply maintained in front of the hide. Many finches hang around stack yards in autumn and winter picking up the seeds they find there, and a hide set up in some out-of-the-way corner may prove an excellent means of showing these birds away from the nest. Weed seeds can also be obtained from farmers at threshing time and they form first-rate attractions for many kinds of small birds; grain makes good bait for parrots, finches and doves. The best place for laying bait for ground-feeding birds is where they will have a good all-round view and cannot be easily surprised. My wife and I have even used flour as a bait. We found that a covey of quail, on an island where we spent five months as sole human residents, liked the rice we gave them so much that after about three months they had gobbled up our entire supply. Then we discovered quite by accident that they also ate flour with evident enjoyment, mopping it up with their tongues.

Much feeding takes place early in the day, and you may find it better to enter the hide before dawn or your arrival may scare off every bird around and a long wait may be needed before any return. If you plan to work like this, then the site for the hide needs to be selected so that the light is in the right qarter. You do not want to find the slanting sun shining straight on to the lens when you are all set to shoot.

Insects are difficult baits to control, but they make obvious lures of insectivorous birds and European robins are very partial to mealworms. I admired Kenneth Bigwood's shots in his *Legend of Birds*[28] of a New Zealand flycatcher in which we first see the bird singing on a perch decoratively festooned with lichen and then, on the ground, gobbling up ant pupae from a nest which was presumably opened for the purpose by the photographer. Having seen for myself how tame these birds are, I can understand the feasibility of using insect lures.

A wide range of birds depend on nectar for a substantial proportion of their food supply. They visit flowers to probe the nectaries with brush-tipped tongues and, like insects, may be baited to a camera using a sugar-water mixture painted on to the flowers. I have known birds even to hop into a sugar basin and gobble the grains whole, and it is a well-established practice in Central America and the USA to attract humming birds with special feeders, simulating flowers. In Africa and Australia, honey-eating birds like white-eyes can be trained to feed regularly on bread soaked in sugar solution, and the strange honey-guides of Africa and Nepal can likewise be lured to pieces of honeycomb fastened to a branch. They eat the wax as well as the honey and digest it with the aid of symbiotic intestinal bacteria.

Currants, sultanas and suchlike are naturally palatable to fruit-eating birds. Bower-birds are fond of these, and I recall one housewife in northern Australia who complained bitterly of the way these enterprising creatures found their way into her kitchen, where they extracted the fruit from the cakes she left to cool after baking. This would have made an attractive shot in still or cine had they been performing at the time of our visit.

Egg thieving is a fairly widespread habit among birds, as it is with mammals and reptiles. Some kinds of magpies, starlings, bell-magpies, gulls and sheathbills can be lured to suitably placed eggs. In films shot in Antarctica you often see skuas robbing penguins of their eggs. However, the photographer should not deliberately lure the parent birds from the nest to set up such a shot. The cameraman may get his pictures, but the penguins involved do not raise any young that season, as they cannot replace lost clutches. On the other hand, quite normal predation of this sort can sometimes be captured on film. In C.K. Mylne's *A Waterbird's World*[29] he shows some excellent sequences of a European magpie making off with great crested grebes' eggs which the birds had been forced to abandon by natural flooding of their nest.

Precautions with carrion and fish

Carrion is attractive to many birds—for some it may be the mainstay of life. These include eagles, kites, ravens and other corvids, some petrels, albatrosses and skuas, and every reader will have seen films of vultures gorging on dead game animals. One of the things you have to guard against when filming at

A common buzzard just landed at a rabbit bait, taken from a hide at a site baited for weeks with scraps. Medium-format SLR, 250mm lens at 4 metres (photo Dennis Green).

carrion is that the bird might pick up the bait and fly off with it. So small animals like rabbits or hares need pegging to the ground. Also it is a good idea in warm climates to site the blind upwind of the carcass unless you have no sense of smell! Rabbits have often been used to lure magpies, buzzards and ravens. It is generally necessary to make a ventral incision to expose the viscera for such baits to be effective.

The birds that are attracted to carrion baits are usually very cautious. To outwit them, a suitable situation for placing a hide must first be found, preferably in a sheltered spot favourably positioned in respect to the winter sunlight and in an area frequented by the birds. The hide must be put up some weeks beforehand, and at a suitable distance from it a bait is put down, at more or less regular intervals—say every four days. A dummy lens is used in the usual manner (page 112).

The birds gradually associate the baiting place with food and become accustomed to the hide. A fresh bait is laid down when the time comes for the first session. A long wait is likely and two or more people should be available to walk away after the camera has been set up and focused, for these open-country birds can often count. Ensure that the peg to which the bait is fixed does not show on the screen, and bear in mind that hides do not keep out the cold wind—adequate clothing should be worn. Eric Hosking's idea is to use an old sleeping bag drawn up to the

waist—a hot-water bottle being put in the bottom if necessary.

Fish-eating birds can be baited with fish, gulls being readily lured in this way. It is also quite a common sight to see pelicans hanging around boats in estuaries when fish are being gutted.

Howard Cleaves's famous photographs of ospreys[30] fishing were taken (before World War I) by enticing the birds to attack a model goldfish anchored near the surface of a lake and in front of his blind.

Sixteen years ago I suggested how to photograph kingfishers in their burrows and also how to feed them from a sunken tank of clear plastic to form a baited pool. By using a polarising filter to eliminate surface reflections and slow motion to stretch out the time scale, the underwater movements of the birds can be recorded. This technique was adopted successfully by the Eastmans[31], but there are still plenty of birds whose activities underwater have still to be adequately recorded (page 232). The Eastmans' baits enabled them to attract the birds into a restricted area so that framing and focusing could be properly planned. This is the basic reason for baiting birds and it is worth the effort when films or stills can be obtained of activities that are otherwise impracticable to film.

Water as bait

Most land birds need fresh water and in dry country water-holes are visited regularly by birds seeking to quench their thirsts. The peak of activity is mostly towards dusk and in the morning. Whenever surface water is scarce, water baits may prove effective if you have water to spare for such purposes.

To attract small birds, I find an effective method is to make a

Crested pigeons drinking from a temporary pool made from polythene sheeting whose edges are hidden in the sand (photo John Warham).

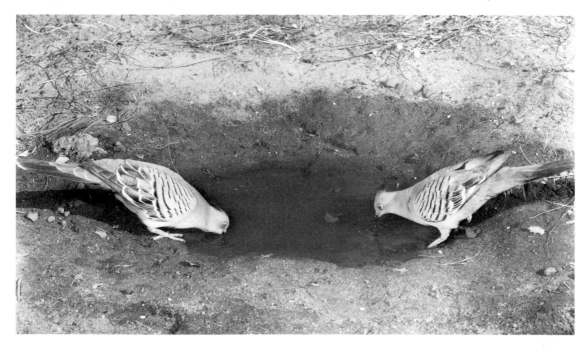

(1, 2) Alternative versions of can used to supply water to a water-drip bait over a long period. The can (a) can be fitted with an orthodox tap or rubber tube and clip (b) to supply the drip. A vent (c, d) must be fitted to admit air as the water drains out. (3) The can must be set fairly high above the ground, and preferably at some little distance so as not to discourage the birds. After turning on the drip, the photographer can conceal himself in his hide (e) to await the bird's arrival.

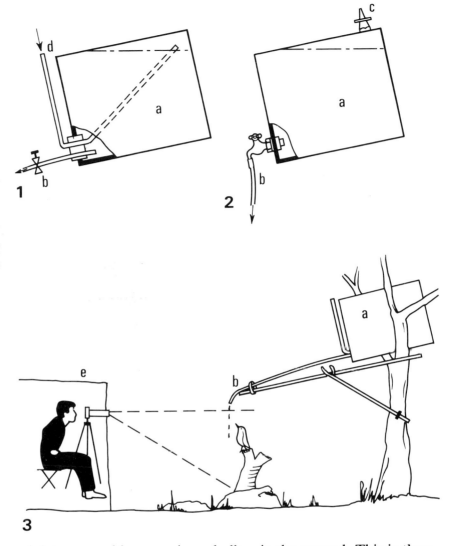

miniature pond by scooping a hollow in the ground. This is then lined with rather heavy polythene sheeting. The edges of the material are hidden by raking earth back on to them. You have then made a tiny reservoir which can be kept filled and made to blend with its surroundings. Another variation is to mix a cubic foot or so of cement and sand on a board and to shape the mixture into an irregular 'pond' by pushing a log or some similar object into the centre and allowing the whole concrete to set. The result is a small waterproof cement drinking-pool that can be recessed into the ground. If it is very hot and excessive evaporation proves a problem, adding a few drops of cetyl alcohol will help. By floating on the surface as a fine film, this substance reduces evaporation considerably, while being harmless to animals.

As with other baits, the local birds must be allowed time to find such lures. This may take longer than you expect even when

conditions seem ideal. Also birds tend to be shy of strange objects like your blind and they are doubly so when drinking, owing to the dangers to which they are then exposed from predators.

Birds discover water by sight, unlike mammals and reptiles, which seem to locate it mainly by smell. Birds are thus likely to react more quickly to moving water. To take advantage of this you need a water drip. My method is to set up a can in a sapling or on a branch near my artificial pool. The can must be securely fixed, particularly if it is plastic, so that when empty it cannot get blown to the ground. The can is fitted with a large cork carrying two holes, one to take a metal air-inlet pipe and the other a short piece of piping to which is fitted a length of good-quality rubber tubing and a screw clip to control the rate of flow (see page 91). The tubing can be quite long, providing that it ends below the level of the bottom of the can, and it is often possible and desirable to arrange that the latter is several yards from the pond. This is because a can is rather a conspicuous object stuck up in a tree and, if too near to the water supply, may deter some birds from drinking freely. The delivery tube may be let out along a suitable branch or a stick fixed in place for the purpose as shown. Four gallons of water will provide an intermittent drip lasting several days and nights. The moving water exerts a considerable attraction for birds, but it is obviously of little use in windy weather, as the drops get blown around and wasted.

At water baits you can shoot the activities of birds as they drink or bathe. These often make most attractive shots because there is usually an accompaniment of a good deal of wing flickering and display when several are trying to get into the act together. You can also arrange suitable perches to the rear of the pond, where the birds can settle while awaiting their turn.

Note that the pond is kept quite small. It should not be too small, however, because this may result in excessive fighting between the drinkers. A diameter of around 0.6m and a depth of perhaps 10cm is about right for most purposes, but would be too small for really large species like bustards or guinea fowl. Keeping the pool quite small facilitates photography, as the whole of the water source can be covered and it may be unnecessary to move the camera at all during shots.

Models to incite displays
Many birds become strongly territorial during the breeding season and display vigorously to intruding members of their own kind, apart from their mates. They may also react to dead specimens, to caged decoys or to suitable models, and to carry a mounted specimen into another's breeding territory is one of the easiest ways of luring males into range. The birds will often perform threat displays to the dummy or will attack it. Cleaves was probably the first photographer to use a stuffed owl as a lure, getting what were, in those days (about 1913), dramatic shots of a red-shouldered hawk attacking[30].

A blue-faced honey-eater about to drop down to drink at an artificial pool supplied by a water-drip. A synchro-sun shot. The perch was provided by the photographer (photo John Warham).

Proper bird skins are not always easily obtained, but a model carved from balsa wood may suffice if the characteristics peculiar to the species are stressed, like the orange breast of the robin. Models also stand up to rough handling, whereas skins do not—these are soon destroyed if live birds press home their attacks. Sometimes models can be dispensed with altogether, for birds will threaten their own images in a mirror just as they sometimes do in a window pane or in the chromium-plated 'mirrors' covering the wheel hubs of a car.

There are other ways in which models can be used. Wild-fowlers, for instance, often use rubber decoys when they are out after duck. I have used these myself to attract wild fowl into camera range by deluding them into thinking that the area in front of the blind was undisturbed and safe. Such models can be useful lures, but setting them out tends to be tricky; they are easily blown to one side by a breeze and are best anchored

An oystercatcher is attracted to its own image by a mirror set up in its territory. This kind of lure must be used with caution during the breeding season (photo Eric Hosking).

individually to the bottom. It is preferable to place them to one side of where you hope to shoot the wild birds, otherwise you may find the decoys and the real thing on the screen together and this will not look too good. These decoys can be painted with patterns appropriate to the species in which you are interested and are more effective if this is done.

Most readers will be familiar with the mobbing reaction of passerine birds to owls, hawks and cuckoos, a habit that occurs all over the world. The late Stuart Smith and Eric Hosking[32] described in a book their experiments on the reaction of birds when presented with a stuffed cuckoo. One notable finding was that most of the birds were far more concerned about the cuckoo than about the human handling it.

The mobbing reaction is a very strong one and the response to owls and hawks lasts throughout the year. A stuffed or model owl can be placed in some appropriate corner of a wood or large garden and, working from a hide, the behaviour of the local small birds can be photographed. In Britain species like chaffinches, jays, blackbirds and tits are readily attracted. The set-up does, however, need some care and organization. The owl has to be placed on a stump or a branch where it is clearly visible from the blind and positioned so that mobbing birds have handy perches to one side. This allows you not only to shoot CUs of their threats with the help of a long lens but also to switch to the standard lens

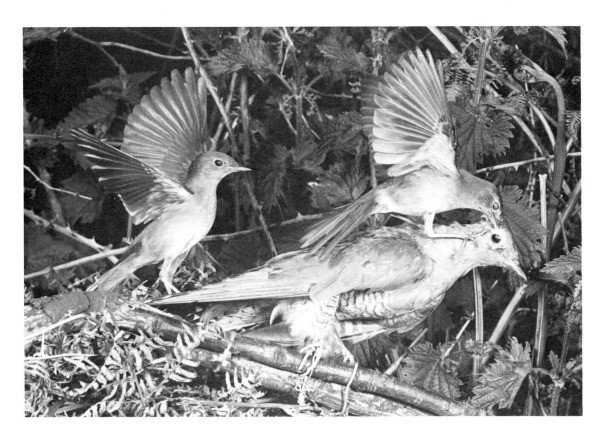

Many small birds' reactions to cuckoos are violent and may involve a temporary loss of fear of man. These nightingales responded vigorously to a stuffed specimen (photo Eric Hosking).

when they make attack flights. The effectiveness of the model will be enhanced if it can be made to move or swivel round. It could perhaps be pivoted on a disc and pulled by a string, or a small vane fitted to allow the wind to do this. Finally, for still greater verisimilitude, the owl's taped calls can be played back when the model is presented.

A word of warning about the effects of such experiments: birds' reactions to models can be very violent and may continue for some time after the stimulus has been removed. I discovered this when using a stuffed owl near a nesting blackbird many years ago. The male really became quite demented and attacked the dummy viciously. The trouble was that even when I took the owl away the blackbird was so wound up that several hours later he was still making occasional swoops at the stone on which the model had rested. So for a considerable period the regular feeding pattern for the chicks was disrupted and I could easily have caused the parents to desert altogether. From then on this male blackbird was extremely timid when I was around. The owl incident had evidently left a deep impression and clearly I was associated with this natural enemy. I have never again tried using such models near any nesting small bird and I would urge you not to use predator models during the breeding season. At other times, of course, they are unlikely to do harm.

Other lures and decoys

Other animals can sometimes serve as lures for birds. When duck decoys were used in Britain the birds were enticed to follow a reddish dog which led them in to their death. The dog seems to have represented one of their traditional enemies, the fox. George Yeates latched on to this weakness when he photographed wildfowl at a decoy and used a ferret on a string to bring the birds up to the camera.

The above are some of the more obvious ways of using lures, but all sorts of other tricks may be suitable on occasion. The wildlife photographer needs to be alert for possibilities, for they open up prospects for unusual shots. You may notice a nest-building bird searching for twigs of a particular size, and by providing a stock of these in the right place you may be lucky enough to photograph the actions involved in selecting them and subsequently to tie the sequences in with others showing the construction of the nest. Watching long-tailed tits one day, I saw that they sometimes removed white feathers from the nest lining and flew off with them. It was soon clear that they only did this when the chicks had no white faecal pellets to offer for removal. The adults' urge to remove droppings seemed to be so strong that they had come to use feathers in lieu of the real thing. When I placed a feather on a nearby perch, or indeed anywhere within a yard or so of the nest, the tits invariably removed these after feeding their chicks and so they offered excellent chances for shots showing this interesting facet of behaviour.

In certain circumstances and in some countries, live decoys may be used, for no model is as effective as a moving, living bird or mammal. Typically the decoy is caged and protected from attack and with care no harm comes to it. Such devices have been used to lure birds into camera range. Sometimes the effects are dramatic. In his study of the Australian magpie Dr Robert Carrick found that by carrying a decoy bird in a special cage surrounded by Potter traps, the whole of a territorial group of magpies could be caught for banding in one fell swoop in record time. These birds are so aggressive that any intruding magpie incites a concerted attack by the whole group and in their eagerness to get to grips with the intruder the birds unhesitatingly trap themselves.

Remote control

Some workers use remote control quite extensively. They set up their cameras covering a nest site or a bait, watch events from a distance and trip the shutter accordingly. This method has the advantage that the time-consuming job of getting the birds accustomed to the hide or blind can be dispensed with. If the operator needs a hide for concealment this can be placed 100m away where it is unlikely to cause any disturbance if sensibly used. The method offers real advantages with birds too timid to tolerate hides and for situations where hide making may be

This stuffed and long-dead tawny owl was quickly shredded by the sparrowhawks near to whose nest it was fastened. High-speed flash was essential to arrest the hawk's flight (photo John Warham).

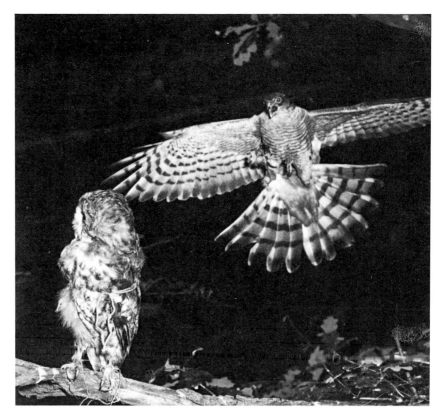

A white feather acted as a lure when placed near nesting long-tailed titmice; they responded as if it were a faecal pellet. The birds were tame and taken against a backcloth whose crease-lines spoil the result. Also the cloth should have been closer or paler so that the background was lighter (photo John Warham).

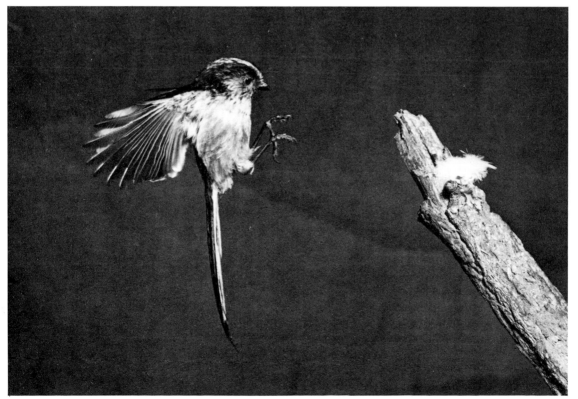

difficult—in tree tops and in bushes growing in swamps, for instance, or where a hide cannot be used without risking human interference. The camera can be clamped to a branch or a stake and the shutter tripped from a hide placed below the tree or on dry ground at the edge of the swamp and so sited that the nest or bait can be watched through binoculars.

With some shutters a simple system is to use a pneumatic release such as the 'Kagra'. This is a series of lengths of small bore plastic (*not* rubber) tubing which can be fitted via a small adaptor to the release socket. The shutter is fired by pressing smartly on a bulb. If both hands are in use holding binoculars, it is a simple matter to squeeze the bulb with one foot. Better still, for prolonged watching, the binoculars should be tripod mounted. For very long runs of tubing—30m or more—you may find that you need more pressure. This can be given with the help of an ordinary bicycle pump. This remote control system is straightforward but effective, the tubing can be laid through water, and the time lag between pressing and exposure is seldom serious enough to cause any difficulty. Care must, of course, be taken to see that the tubing cannot get constricted at any point.

Such a system has one obvious drawback—once the picture has been taken you must return to the camera to reset the shutter and wind on before further exposures can be made. This usually means disturbing the birds on each occasion and I hope that this is not the sort of behaviour that would commend itself to readers of this book.

However, with the improvements in reliability and compactness of motor-driven cameras, whether SLRs or cine, the scope for working by remote control is widened. With an automatic camera in which either shutter setting or iris alters, according to the light entering the lens, a whole roll of film may be exposed without returning to the camera position. Used in conjunction with a photo-electric trigger, bird photography becomes truly automatic. Flash can also be fired with each still exposure, and some cameras allow the flash to be coupled to the automatic aperture-control system.

The remote control unit can also be linked to a timer for taking shots at predetermined intervals. Most photographers, however, prefer to retain some measure of control and position themselves so that they can see the bait or the nest and hence can fire the shutter at the right moment. Control can be direct, via a pneumatic tube and bulb or an electric cable and press button, or indirect via an infra-red, acoustic or radio signal—the gadgetry needed is available for many of the better SLRs and cine cameras. Do not forget that you may need a licence to operate a radio link[78] and also that many motor drives are noisy, so need placing well back with the mirror locked in the 'up' position if possible. Shiny camera and lens fittings should be hidden. Perhaps the best arrangement is to mount the camera and motor attachment in a box whose sides and roof are hinged together so that after setting up, the sides and lid are

closed leaving an opening only at the front for the lens. The box has a green exterior and gives protection from the weather and conceals any bright or moving parts from the bird's view. Such a box can be fitted with a bracket by which it can be attached to a branch, stake or whatever with a strong 'clampod'. Or, if you are after birds at bait, you may find it more convenient to mount the whole apparatus on a tripod.

Some cameras and motor drives have an electromagnetic shutter, allowing remote control through a single wire and switch. With others, a solenoid can be connected to the cable release and a battery used for power supply. It is then possible to work hundreds of yards away from the camera.

Remote control with a motorised camera often enables advantage to be taken of transient opportunities. You may find a small water-hole where finches and doves are flocking to drink but, working to a tight schedule, you may have simply no time to try using a hide. A tripod-mounted remote-controlled camera, camouflaged by setting it in a bush perhaps, may enable you to get a few useful shots even in the brief time that is available.

On the whole, however, remote control seems to be primarily a method for special and difficult situations. In general it is far better to have full control of the camera and work from a hide where you can ensure that exposure is altered with fluctuations of light and the camera angle can be adjusted when necessary and so on. There is always a pretty large element of luck in remote control work but once the birds have accepted your hide, chance plays a less important part in the production of satisfactory results. For picture making with birds there is little doubt that the trouble to introduce a hide is well worthwhile. Likewise, if you are really interested in the bird and its behaviour, there is often no real substitute for close-up observation.

Play-back tape lures
Ornithologists have been playing back tape recordings of bird songs to birds ever since portable machines became available. Play back is used to evoke responses when trying to delineate territories, to establish the presence or absence of a shy or cryptic species, and is often used for luring birds into mist nets for ringing, measuring and release. The importance of song as a means of defending a territory from encroachment by rivals has been shown in a variety of ways as, for example, by the experiments done in the 1960s by Dr R. Carrick. Having removed male Australian magpies from their territories, he was able significantly to delay their reoccupation by rivals, merely by playing back the songs of the former owners. Without play back the territories would have been carved up among neighbours in a matter of hours.

With most passerines the maximum effect of play back is seen at the start of the breeding season, when territories and pair-bonds are being established. Quite poor recordings may be

effective then. Once the males have obtained their mates, responses often wane. There are many instances of play back being successfully used to photograph birds. A recording of woodpecker 'drumming' enabled Heinz Seilmann[33] to incite a black woodpecker to perform on its drumming branch so that the whole action could be filmed from a blind set up in anticipation. Acoustic clues, of course, are particularly important for nocturnal birds like owls and these are readily enticed by play back. Recordings have also been used to draw Leach's and other petrels within range during their night-time aerial flights.

Knowledge of the subject's behaviour is the key to success. Used at the right time and in the right setting, the birds may be lured to a cassette or other recorder. By placing the machine carefully, the resident birds may be enticed to alight on a convenient perch or stone onto which the lens has been trained. The camera can be hand held and hence is more mobile, and shots on a variety of perches can be obtained at a single session. Using a long lens concealment may be unnecessary; the birds may attack the recorder as the nightingales attacked Hosking's stuffed cuckoo (page 95). Be ready to take the photographs right from the start as the initial responses are often the most spontaneous and effective. Repeated playing will lead to adaptation and reduced reaction.

As with other lures, caution is needed in the use of play back tapes lest you disrupt the birds' behaviour patterns significantly. A few short attempts are better than one persistent and long one which may cause them to neglect other activities. Play back should not be used to lure birds that are feeding young. Under the terms of the British regulations this would probably be illegal with Schedule 1 species anyway (see Appendix B). It seems to be mainly a matter of using common sense, restraint, observing the effects of your activities and taking appropriate action.

For a useful practical account of this technique in luring British birds to the recorder, reference should be made to Blackburn[34].

Tape recordings are not always necessary. Some birds react not only to the sounds of enemies like owls or to rivals of their own species, but at certain times they can be 'called up' with the aid of squeaking sounds made by the lips. In the USA 'bird whistles' can be bought for this purpose. Such sounds can be most effective with small birds, particularly outside the breeding season, but the trouble is that it is difficult to anticipate when they will work and when they will not. If they do, then it may be quite easy, if you can avoid making sudden movements, to entice small birds like tits, flycatchers, warblers and even birds-of-paradise to within 3–4m, which is quite close enough for shooting if you have a hand-held or monopod-supported camera at the ready.

Birds at nests

Bird-at-the-nest photography is less important than formerly and in some quarters is actively discouraged, rightly so with scarce and endangered species. The role of nesting birds has lessened because the SLR has opened up so many other possibilities for photography. Nonetheless many bird photographs are still taken at or in the vicinity of nests and this chapter deals with how to go about the photography of the common birds of garden and wood (to which species the beginner is urged to confine his first attempts) which nest either on the ground or at not more than shoulder height in trees, bushes or undergrowth.

This kind of photography appeals for several reasons. Breeding behaviour is of great intrinsic interest and both sexes may attend the young. Also, the cameraman's basic problem of how to get near enough to his subject is solved by the bird's attraction to its nest, provided only that he can overcome the natural shyness of such a quarry. Few birds, however strongly attached to their eggs or young, will remain on the nest while you walk up to it, camera in hand; concealment is essential and should be provided by a hide or blind. This will be accepted by the birds as part of the landscape if it is properly presented to them, despite its obvious artificiality to the human eye.

Do not be deluded by the occasional photographs you may still see of apparently tame birds photographed without a hide, such as willow warblers perching on human fingers. Some birds may indeed pluck up sufficient courage to feed their chicks in full view of the unconcealed observer, but this imposes an unwarrantable strain on the parents who already have all their work cut out to rear their brood. Such methods are very liable to lead to the brood being dispersed, when most will die.

Choice of subjects
The beginner is recommended to choose as his or her first subjects those birds which are usually tolerant towards human beings and therefore not difficult to photograph. Robins, chaffinches, starlings, blue jays, and chickadees are often found in gardens and woods and are seldom camera shy. On pages 267–277 there is a list of common species with notes on their nesting sites, reactions to the camera, and the distances at which the latter should be placed in order to get images of satisfactory sizes. Note, however, that birds, like you or me, are of varying temperaments and two individuals of the same species may be

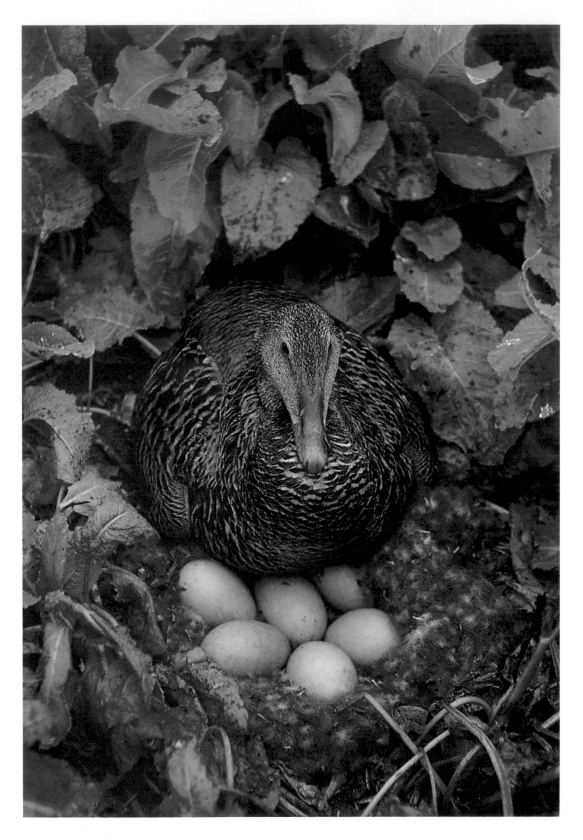

quite different in their reactions to the hide; one may be as timid as most members of its kind are confident.

In my opinion it is essential for the novice to avoid trying to do too much in one nesting season. He or she should be content to practice the skills which must be mastered before good work can be produced without harm to the birds. Many attractive opportunities for pictures may occur in the course of a spring and summer, but the beginner should limit his activities according to the time that is available and not hurry from one nest to another before the lessons of the first have been learnt.

Where to work

You must have somewhere to work. Public parks and gardens are quite unsuitable, for the bird-at-the-nest photographer must have privacy so that he may site his hides without attracting attention. Much can be done in large gardens where freedom from interference is assured, but the range of species in such environments is limited and access to some woodlands, fields and open moors is desirable. The more strictly the area is looked after the better, and provided the landowner has confidence in your integrity and care, particularly as regards game, you will usually find them all very helpful. Of course, a batch of prints at the end of the season is the least one can do in return.

Nest finding

First find your bird and its nest. Sometimes others will find them for you, but by and large the photographer must be his own field worker. He must be prepared to spend a good deal of time in the preliminaries before any photographs can be taken. Some books may help[35].

Nest hunting can be tiring, and in some types of country, exhausting. On the other hand, often it is easy. Much depends on the terrain, on your experience and what you are searching for.

There are two ways of locating nests—either by physical searching of likely places, or by watching the adult birds until their actions reveal their nests. The latter method is often effective when you can watch an area through binoculars, either without the birds being aware of your presence, or from such a distance that although they can see you, they are not too scared to visit the nest. This method is very useful with small birds feeding young still in the nest, since visits are frequent then and the parent birds seldom very timid. The point at which they disappear with food in their beaks should be noted (if necessary in relation to some adjacent prominent object) and you can then walk up, and by inspecting the bushes or foliage, can often find the nest without much further trouble. Many birds—fantails, wrens, lay-tailed tits—are also rather obvious when carrying nesting material. Their movements often reveal where they are building and the site can be noted or marked for later use.

In difficult situations the birds' movements may be watched

Eider ducks are one of the few British birds that are tame enough to photograph at their nests without a hide. This site was on the Farne Islands, the shot taken with a hand-held SLR and 135mm tele-lens (photo John Warham).

103

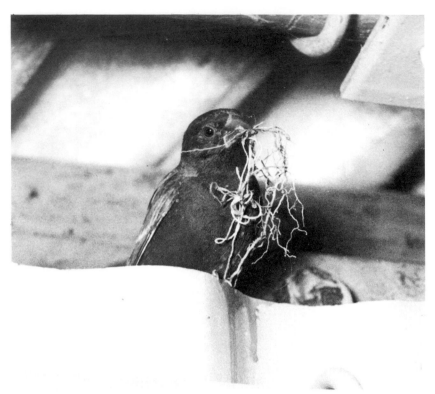

Nests are often found by watching where birds carry nesting material. This crimson finch was building in a shed on a farm in northern Australia, and a hide hidden in a corner enabled this result to be achieved. (photo John Warham).

Right: beneath a canopy of dog's mercury in an English wood this mallard cautiously approaches the nest she covered over when she left. On a first session such a bird should be allowed to settle down before any attempts at photograpy are made (photo John Warham).

from two different angles, thus revealing the precise location of the nest. The more you know about the birds' habits, about the size, placing and construction of the nest, the easier discovery will be. This 'wait and see' procedure is most effective with small birds like warblers, finches, tits and so on, since these readily perch on branches and stalks where they can be easily picked out as they move to and fro. It is not feasible with birds like duck, pipits, partridges and other kinds, which build in deep vegetation and approach beneath thick cover, since this conceals their movements. Nor is it of much help with birds of broad horizons, like lapwings, bustards and curlews, for these will seldom return to their eggs while being watched, even if from a distance, though they will often do so if you are sitting in a vehicle.

Lapwings are particularly cunning birds, and their behaviour is typical of that of most members of the plover family in whatever part of the world you may observe them. Nesting right out in the open on pasture or arable land they are able to spot the intruder from afar and walk off their eggs when you are still hundreds of yards away. They peck about nonchalantly as if feeding and at the same time edge further and further away from their nests. By the time you get near enough to cause them to fly up they are many yards from the eggs and you may search in vain.

Such guile is best countered by greater guile. It is easy to tell from the birds' attitudes, from their excited aerial flights and anxious calls, whether they have a nest in a particular field or

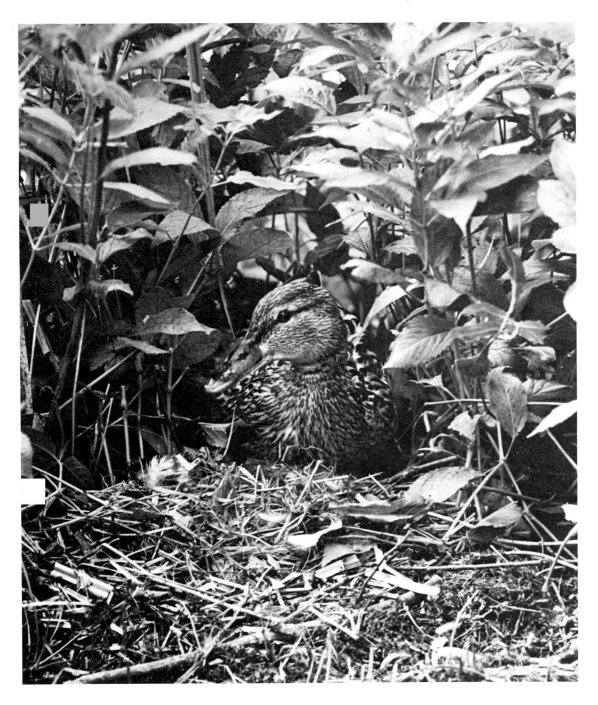

area. It is then necessary to examine the lie of the land to see if it is possible to get to the edge of the field without being seen by the birds. Perhaps there may be a ditch, a bank or a hedge running along one side by which an approach can be made. If such a concealed route docs exist, use it on a subsequent visit and when right at the edge of the field, still concealed and ready to note the point at which the bird arises, jump suddenly into view. The

nesting bird will either fly straight off the eggs or will run away from them. In either event, without looking to right or left, you walk forward to the point from which the bird arose. If the eggs are not immediately apparent, place something on the ground (the binoculars will do) and a little further searching nearby should reveal them. I have used this trick in many countries when seeking the nests of birds which lay in the open. The method may be appropriate to any situation where a concealed approach is possible along a belt of trees, a sunken road or fold in the ground, or through a wood adjoining the open nesting area and from the shelter of which a sudden emergence can be made. If two people employ the dodge simultaneously from different directions, their paths should intersect at the nest.

Many nests may be found by searching shrubberies or other likely cover. This is most effective in early spring before the bushes are clothed with leaves. When you know the area and the birds that have formerly bred there, it is surprising how favoured a certain spot will be year after year. When inspecting bushes and hedgerows it is best to bend down and peer upwards so that any nests are silhouetted against the sky.

On searching among rank and low herbage many species, such as warblers, duck and so on, may be flushed from their nests which they do not leave until the very last moment. A greater area may be covered by using a long twig which is drawn along the foliage as you work through it.

When a bird is suspected of breeding in a given area and other methods have failed to locate its precise whereabouts, systematic searching may be the answer, the whole area being carefully quartered to a definite plan. A nest discovered in deep vegetation, or other situations where there are no clear guides to its position, should be marked to enable the spot to be found readily on a later occasion. A stick placed in the ground a few yards away often serves the purpose. It should be perfectly clear to you but not sufficiently obvious to attract anyone else's attention.

Photographing nests and eggs
The nests and eggs of birds building within 1.5m of the ground are generally easily photographed. Others may be difficult to take because of their awkward placing. A magpie's nest in a tall thorn hedge would be a tough proposition, and for much the same reason we seldom see pictures of the contents of rooks' nests high in the trees, nor of the eggs of hole-nesting kinds like the stock dove.

From a hide the nest is viewed at a rather shallow angle, for the camera is placed to show the birds properly; when taking photographs of the eggs a much higher viewpoint is required. The usual procedure is to tilt the camera at about 75° to the horizontal so that all the eggs are visible, and to expose with the lens stopped fully down. A hand-held SLR may be adequate although nests in vegetation are often shaded and rather long exposures may be

called for. I prefer to use a tripod. A centre column type (page 46) is very suitable. If slow instantaneous exposures are used it pays, after focusing and picture composition, to lock up the mirror to avoid blunting the edge of the fine resolution due to 'mirror-flop', an effect that shows most at slow speeds.

In a picture of this kind everything should be in focus. A tilting top is essential to bring the camera to bear at the required angle. Focusing should not be done casually just because it is intended to close down to $f22$ or more; accuracy is still needed and attention should also be paid to the composition of the picture. Minor trimmings of the surroundings are generally needed.

With time exposures there is some risk of camera shake. An old dodge is to make the exposure by holding a card (which does not touch any part of the camera) or a notebook in front of the lens, to open the shutter and, after a moment's pause, to remove the card for the necessary number of seconds before re-covering the lens and closing the shutter. Any vibration taking place when the shutter is opened is nullified with this method. The idea will not work when there is a wind to move the vegetation or to vibrate the camera. It is then best to give a series of instantaneous exposures during moments when the foliage is at rest. For example, the meter may indicate an exposure of 1 sec at $f32$. This could be given in the form of five 1/5 sec exposures slipped in during momentary lulls.

A point to remember when working with colour film is that time exposures may require additional filters to maintain proper colour balance. Where this is necessary appropriate instructions are usually enclosed with the film.

Awkwardly placed nests may call for a variety of devices to bring the camera to bear at a convenient angle. In the case of a magpie's nest it might be necessary to set up a scaffold to overlook it or to use a pair of ladders lashed together to form a large pair of steps.

Tree-top nests can also be tricky. It *is* possible to lash a tripod to the branches and fasten the camera on in the usual way. If so, well and good, but as often as not the idea is impracticable. A hand-held SLR is often the easiest solution, but load with fast film so that you can use a small stop (for good depth of field) and short exposures (to counter camera shake due to your movement and that of the branches). You may find it safer to run a strap round your body to a trunk or limb to leave both hands free for camera handling. With nests well out along thin branches you may have to work well back and use a telephoto lens to get a satisfactory image. Such a subject can be tackled relatively easily, providing that you can get above the nest and hold your position with safety, while shooting at sufficiently high speed to make sure that you eliminate camera movement.

Young birds
Pictures of callow nestlings perched side by side on some flower-

decked branch still occasionally crop up in the springtime issues of illustrated magazines but fortunately it seems to be more widely appreciated that the attitudes depicted are unnatural and the photographs merely record the ignorance of the photographer and the editor.

The practice is deplorable for several reasons. When young birds are about to fledge, the slightest interference sends them scurrying prematurely from the nest in all directions. The family gets broken up and many of the chicks perish. The mortality, even if they are undisturbed, is high enough during these critical early days without their having to suffer additional losses at the hands of inconsiderate photographers. The experienced bird worker will have nothing to do with this sort of practice.

If pictures of nestlings are needed to complete a series they should be taken *in situ* during the youngsters' time in the nest. Just occasionally you may come across a well-feathered fledgeling bold enough to allow a close approach as it stands erect and natural on a branch. Then a hand-held camera may be very useful to take it before it decides to move. Electronic flash enables interesting pictures to be made of the nestlings' activities—their behaviour when preening, when exercising their wings and so on. The begging attitudes of young nidicolous species may make interesting and amusing photographs.

Selecting a nest for hide photography
Not each and every nest will be suitable for photography. With common birds there is no point in trying to work the first nest that is found. It is better to wait until several are available and then to select those most suitable, bearing in mind the points below:
1 Where the hide can be placed.
2 The position of the nest and hide in relation to the sun.
3 The amount of 'gardening' that will be required.
4 The possibility of human interference.
5 The background.
 Let us consider these factors one by one.
1 *Placing the hide.* At many nests you will have only a limited choice of positions in which the hide can be set up where the camera will be at the correct height and taking distance. For example, if the nest is in a large bramble bush, the hide has to be placed on the side of the bush where the nest is situated. Similarly, in woods and gardens the room for manoeuvre may be limited. In contrast, with nests in the open, like those of plovers, the hide may be pitched in any required position. Some ground nesting birds like larks and pipits conceal their homes in clumps of grass, and there is usually only one suitable position from which a good view is possible.
2 *The lighting* of the site is obviously important. The sun is due south at noon (GMT) in the northern hemisphere, which means that if the hide is placed south of the nest the sun will shine from the right in the morning and from the left in the afternoon. South

of the equator, of course, the reverse applies. Strong sunlight is often prejudicial to good bird photography because of the harsh contrasts it creates. The sun's position must, nevertheless, be considered, as well as the probable time of the day when you expect to be able to do the photography. A slightly veiled sun is ideal for bird work. Note that when the sun is shining it may throw the shadow of the blind across the nest and thereby complicate matters. In circumstances where it is impossible to site the hiding tent so that the sun will be to one flank or to the rear, you have to work either against the light (perhaps using flash) or only when the sun is clouded over. It may be better not to try working such a nest.

3 'Gardening' means the control of grasses, branches and other vegetation from the sides and front of the nest, to give the camera an unimpeded view. This opening up can only be done with care since it means directly interfering with the nest's immediate surroundings and your first consideration must be for the safety and well-being of the birds themselves. Leave untouched those nests which are placed in deep cover where extensive trimming would be required. It is better to wait until a more suitable site is discovered. Frequently an otherwise excellent nest must be turned down because some twig or branch supporting the nest obstructs the view.

It will be clear from all this that the amount and type of gardening needed before a nest can be photographed is an important factor which must be considered when weighing up its possibilities.

4 Human interference. It should be the rule that no attempt is made to photograph nests where the setting up of the hide is likely to attract the attention of other people. Despite camouflage, it is often impossible to conceal a hide sufficiently to deceive a human eye. Inquisitive people, children and youths, even if not intending to do any harm, may unwittingly destroy nests or cause the parent birds to desert. In woods and in private grounds the danger is far less and hides are fairly easy to conceal in such places. On open fields they are best sited where they are overlooked by some farm or cottage whose owners will keep a watchful eye for intruders.

In lush vegetation, tracks soon appear if the same route is used on successive visits to a nest; such revealing signs should be avoided by varying the route on each visit. Many otherwise excellent sites must be passed over because of the danger of human interference, but it is not only people that are inquisitive—beware of cattle. Hides set up in places to which cattle have access are doomed from the start. The herd is soon on the spot to investigate; they try to use the hide as a rubbing post. In no time at all both nest and hide are in ruins. A post and barbed-wire enclosure fencing in both nest and hide is the best way out, if special considerations warrant working in such places.

5 Background. In weighing up whether a nest is suitable for

photography, the nature of the background must be taken into consideration. Some sites are ruled out at once on this score as ugly obtrusive backgrounds can easily detract from the finest renderings of the bird and young. Fences, buildings, blobs of out-of-focus colour, distant tree trunks or branches which cut across the picture in such a manner as to distract the viewer—all these may have to be avoided. If this is impossible then the nest is unsuitable, unless special considerations are overriding.

Backgrounds are often very important in bird cinematography and have to be carefully considered when placing the hide, for here you cannot vary the angles of your shots but achieve variety by switching from long-shot to close-up and so on.

Getting the hide to the nest

Having found the right site, the next task is to get the hide into the correct position. This has to be done by accustoming the birds gradually to its presence. There are two ways to go about this— you can either build it full size some distance away and then move it nearer by stages, or a small hide can be made at the spot where it is required and over a period of days enlarged until ready for use. Each method has its snags and advantages; frequently either may be feasible.

Erecting the full-size hide and moving it gradually nearer entails more work than does the other method. Conversely, the birds get accustomed to the final shape and contour of the hide from the start, whereas with the second method the shape of the structure changes at each enlargement. Except when working in open places such as fields, heaths and moorlands, I prefer to build from small beginnings. In many situations, for instance on cliffs and in trees, this is the only practicable solution.

Once it has been decided from which side the nest is to be viewed, a start is made by driving a few branches or short stakes into the ground—three will suffice—around which a small piece of fabric is fastened. A sack serves excellently. The whole is pinned firmly together and held in place by short flexible twigs forced into the ground, so that if a wind arises the material cannot flap about. Few things upset wild birds more than the flapping of canvas. Branches and bushes nearby may be in violent agitation but the vibrations of the hide may cause the greatest alarm, even nest desertion.

The first construction will be perhaps 30–50cm high and about 30cm wide at the base. A few green sprays help to conceal it. Camouflaging of hides is seldom necessary for the bird's benefit. They will accept hides that contrast strongly with their surroundings, but it is always advisable in settled country to ensure that the structure blends into its environment to make it less noticeable to casual observers. Suitable material for this purpose is usually available on the spot, but care should be taken to see that bare branches are not left to call attention to your activities. Foliage should not be taken from close to the nest. On moorlands, prairie

The hide may be fully erected at a distance from the nest and then moved nearer day by day until it is in the required position. Another way is to erect it by degrees on the chosen site. First a few stakes or branches are draped with a sack (1). The next morning the erection is increased in size (2), and that evening or the next day it is replaced with the hide proper but only half covered (3). If all is well with the nest owners it may be completed after another 12–24 hours (4). It should be camouflaged against prying eyes, and a tell-tale path to it should be avoided. The nest is exposed as necessary for photography by 'gardening' (5, 6); some branches may have to be tied back at the beginning of each session in the hide and replaced at the end.

and similar open country situations, camouflage can be very effective unless the site is on a ridge and the hide silhouetted on the skyline.

People often ask how long they should take to get the hide into position. This will vary greatly with the situation, the weather, the length of time the watcher has to devote to his hobby, and not least, the temperament of the birds themselves. With small birds like robins, warblers, finches and thrushes, whose nestling periods last from 14 to 20 days, it should be possible to get the hide in position in four days and less if you can move it twice daily, say in the morning and the afternoon. A hide should not be moved too late in the evening lest the owner of the nest, upset by the change of scene, is prevented from returning before nightfall.

Ideally, with those species which rear their young in the nest, a start should be made when the eggs are on the point of hatching or have just done so. This will enable you to begin camera work before the young are more than a few years old, and when the hen spends a great deal of her time in either brooding or tending the chicks. The intervals between feeds are shorter too when the young are in their early stages of development, whilst at this time the parents are kept so busy that they often ignore slight sounds from the hide.

The ideal is often not possible, of course, and the part-time photographer may just not have the opportunity to begin according to the book. Instead he must do his hiding when he can, which may mean that his time for photography is limited, for young birds do not stay in their nests to suit our convenience. In any event it is undesirable to make any start until the eggs are believed to be about to hatch. This does not apply to wildfowl, gulls, plovers, waders generally, and terns, whose downy young run off the nest as soon as they are dry. These must necessarily be pictured on eggs if they are to be taken at the nest at all. With such species, hide building should not be started until incubation is reasonably well advanced.

A typical time-table for making a hide might be as follows:

The nest containing small young having been found over the weekend, on Monday evening the first beginnings of a hide are started, on Tuesday enlarged to about half full-size, and possibly on the evening of the same day increased yet again. At this juncture it is a good idea to fasten a dummy lens to the front of the hide so that the birds get accustomed to the eye-like glint of glass. This is quite important when you are using a zoom lens with a large front component. Such dummy lenses are easily made. The end of a round-bottomed bottle can be poked through the canvas and secured by a piece of string tied from the neck to the front crosswire. I use an old lens for the purpose. When the birds have accepted the third enlargement of the hide and the dummy lens, the structure may then, on Wednesday, be brought to full height and pegged down.

Where the subjects' reactions are doubtful it is a sound practice to watch the adults' behaviour with binoculars from a distance. Should the parents prove frightened and obviously most reluctant to return, the hide must be dismantled and either set up farther away (to be moved up later as already described) or another more cautious attempt made at erecting the hide on the spot where it will finally be needed. If the birds prove abnormally shy the hide should be removed and plans for photography abandoned.

The working distance of the hide from the nest is governed by the size of the bird, its shyness, the focal length of the lens to be used and the size of the image required. In Appendix A recommended distances are given at which some of the commoner birds may be photographed to obtain adequate images with different lenses—the bird being considered as broadside on

to the camera for the purpose of the calculations.

A hide placed too close to the nest means that the bird will appear too large on the negative or transparency. Ample surroundings should be included for several reasons. In the first place, although a close-up of the subject may make an attractive addition to a series, it is desirable to show something of the habitat in which the bird is nesting. Secondly, one can seldom be sure just where the bird will alight and what route it may take, and the greater the area covered the better the chance of obtaining pictures without lopping off the bird's tail. Many bird pictures are enlargements of only portions of the negatives.

Note that the completion of hide building precedes any adjustment to the surroundings of the nest. In most instances it is hoped that the beginner will choose the most open sites possible so that little gardening is needed. Robins, thrushes and many other common birds are often suitable, though of course all species will nest in deep cover and in unsuitable places.

'Gardening'

With the hide accepted by the birds, the delicate operation of opening up must be done if this is really necessary. The foliage must be so adjusted that the camera has an unimpeded view. Sometimes nests are situated so that the slight adaptations required may be done immediately before the first session—the branches or other obstruction being tied back with string or wire and released again when the day's photography is over. Where more alterations are called for they should be done by stages. It is usually possible to arrange things so that there is a certain amount of foliage at the front which can be adjusted by tying back at the last minute.

Nothing should be removed that can be fastened out of the way, and if branches *have* to be cut this must be done so that bare ends are not visible from the camera position; raw ends can sometimes be toned down by rubbing earth upon them. Apart from seeing that the birds do not suffer from the 'gardening' and that the stability of the nest is not endangered (some warblers site their basket-like homes very carelessly), the important thing is to make sure that trimming is not obvious. Broken stems with dying leaves go with bad workmanship and must be avoided. Considerable skill is sometimes needed in arranging the surroundings so that the final result is both pleasing and natural, perhaps even pictorial, like the shot on page 114. Tied back foliage is released at the end of each session so that the birds' privacy is restored. If necessary extra branches may be positioned to replace foliage that has been removed. In hot weather make sure that the branches do not die and draw attention to the nest.

The first session

If your memory is as poor as mine, it is a sound idea to keep inside the camera case a list of the items regularly needed on a

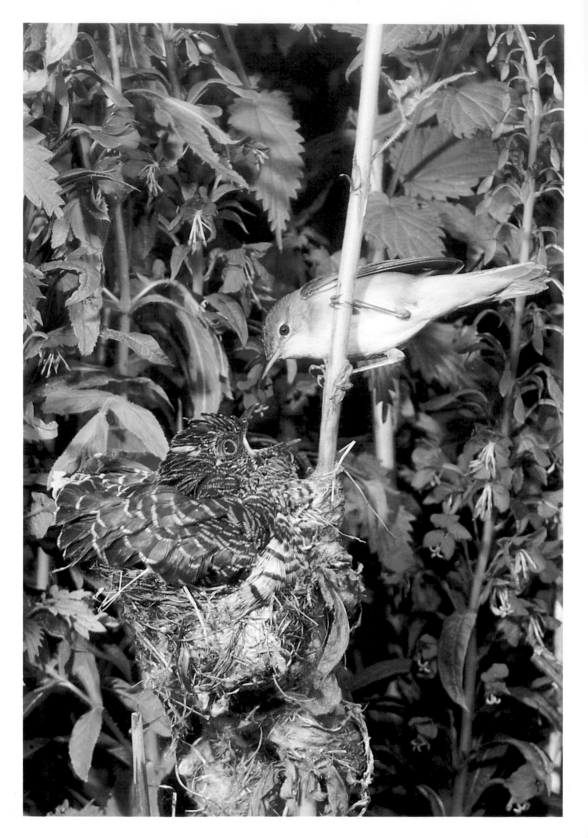

114

The photographer has handled this colourful situation well. The rather precariously-sited nest has not been disturbed and flash used discreetly to give quite a natural result; see page 168. Cuckoo-parasitised nests like this are always interesting, the foster-parents (reed warblers in this case) being stimulated to feed at high rates by the chick's persistent calls (photo Mike Wilkes).

'birding' outing. Before leaving home a check can be made against this to ensure that nothing has been overlooked. When you have come out prepared for a day's photography it is maddening to discover, when all set to begin work, that the cable release is missing. A checklist insures against such disappointments.

Setting up the camera for the first time at a nest generally takes longer than it does on subsequent occasions, and it is important to remember that while you are doing this the parent birds are being kept from their eggs or young. Thus the quicker you can get installed the less the danger for the birds and the sooner they settle down to their normal routine. To keep such disturbance to a minimum the bird photographer should work out a 'drill' for setting up, a definite sequence of steps to be carried out in a logical order. The kind of thing I have in mind is given on page 117 and this should be adapted to suit your own conditions and requirements.

This breakdown of events is not as formidable as it might appear at first sight and the following notes may be helpful:–

1 *Complete 'gardening'*. The rule is to 'under-garden' rather than to do too much, for presently a check will be made on the focusing screen to see if the opening up is adequate or whether further adjustments are needed. If the day is cold and the nestlings are small, cover them with a handkerchief or a cap so that they do not become chilled. They are even more endangered by direct sunlight, and it is wrong to attempt photography at nests where small young have to be exposed to strong sun. Such sites are unsuitable for photography, at least at the time of day during which sun beats down upon them, and in any event harsh lighting gives contrasty and unpleasant pictures. The gaping of adult birds as they shade their chicks from the heat is a distressing sight both in nature and in a print, though in tropical countries it is commonplace among birds whether they nest in the open or in the shade.

2 *Place something on which to focus*. It is a good plan to put something at the nest on which to focus and which corresponds to the expected position of the parents when they feed the chicks. It is important that this device, which may be a twig, a matchbox or anything else that is handy, should indicate the point at which the parents' heads are likely to be, as it is essential that whatever else may be out of focus, the head and eyes are quite sharp. When the place where the birds normally stand has been noted, it will be possible to place the focusing device with greater accuracy later.

3 *Erect tripod*. The tripod should be erected so that it is quite firm, the legs being pressed into the ground if necessary and high enough to bring the camera to bear on the nest—about 30 to 60cm above it. The legs should be arranged so that the tripod occupies the least possible space inside the hide. The best arrangement is to push one leg forward out of the hide through a slit in the canvas, about 20cm from the ground, and to splay the

other two sideways and backwards so that you can sit in between them.

4 *Fasten on tilting top*—if not permanently part of the tripod.

5 *Mount camera.* After attachment, the camera is turned so that the lens points forward roughly in the direction of the nest.

6 *Push lens hood through canvas.* Do not be afraid to cut into the material—the hide will be full of holes by the end of the season anyway and yet may still have years of hard wear before it. The hole should not, however, be too large. A vertical slit is perhaps best and the material should not be drawn taut against the hood or movements of the fabric may lead to camera shake.

7 *Arrange picture on focusing screen.* It will be found that the best position for the nest is for it to lie on the intersection of the lower-third of the negative and the central vertical line. If it is subsequently found that the parents habitually perch on the front rim of the nest, then the camera will have to be adjusted accordingly and so will the focus. Usually the birds tend to approach and feed the young from the sides of the nest or from the rear facing the camera.

8 *Check 'gardening' on focusing screen.* In step **1** it was emphasized that excessive opening up should be avoided. Now, having roughly focused, it can be seen on the screen which odd leaves may need adjusting. Watch for glaring grasses and twigs and for shiny leaves acting like small mirrors, and remove them if possible. The final result should look quite natural. Care should be taken to see that everything is firmly tied back so that if a breeze develops nothing can spring across the nest at a time when nothing can be done about it. The background should also be checked to see if the bird is going to be shown against any undesirable feature, and if so the offending object should be removed or the camera angle changed to avoid it. With some small birds a backcloth can sometimes be used behind the nest, but it is seldom very satisfactory. Out-of-focus blobs of light are often an irritation. In bushy situations, blobs may be eradicated by filling up the far side of the bush with brushwood.

9 *Focus.* This must be done with special care if disappointments are to be averted. Until there has been an opportunity of watching the birds from the hide you do not know just where they choose to stand when feeding, but as already pointed out, most of them prefer to perch at the rear of the nest and the camera should be focused on this assumption. Ideally the aim should be to get the foreground within the band of sharp focus and the background well out, so that the whole of the nest from the front almost to the rear is crisp and the bird itself stands out against the soft background. It is perhaps safest to focus (at full aperture) on a point slightly forward of the centre of the nest, since on stopping down, the depth of field will extend a greater distance to the rear of the point of sharpest definition than in front of it.

Focusing is simple with eye-level 35mm reflexes fitted with automatic lenses, for it is done at full aperture either by using the

116

Drill for setting up SLR camera in hide

Step	Points to Note
1 Complete 'gardening'.	With care. Cover young if cold.
2 Place something on which to focus.	The object to be in expected position of bird's head.
3 Erect tripod.	One leg forward, two to rear. Set it higher than nest so that camera points down.
4 Fasten on tilting top.	If separate from tripod.
5 Mount camera.	Adjust roughly in direction of nest.
6 Push lens hood through canvas.	Alter tripod position if necessary. Make sure there are no obstructions in front of lens.
7 Arrange picture on focusing screen.	Adjust camera as required. Nest should appear below centre of picture.
8 Check 'gardening' on focusing screen.	Framed area should look natural and background satisfactory.
9 Focus.	Focus accurately on object placed for purpose.
10 Make exposure reading.	Compare with TTL reading.
11 Set shutter speed.	Select appropriate setting taking account of normal rapidity of movement.
12 Check exposure, stop and depth of field.	Through TTL system and stop-down button.
13 Check all controls.	Make sure all settings visible directly or in viewfinder.
14 Check peepholes.	Adequate for good vision with comfortable posture.
15 Set out film, notebook, food, etc.	All immediately accessible.
16 Check hide from outside and attend to the wants of nature.	Hide must be completely opaque. Make sure camouflage well clear of lens.
17 Remove focusing object.	
18 Get settled in hide.	Make sure you are thoroughly comfortable.
19 Send off companion.	Make sure he/she knows time or signal to return.

ground-glass screen directly, or with the added refinement of the through-the-lens rangefinder. Providing that you adjust the camera position in relation to the front panel of the blind so that you can shift the focusing ring without your fingers being revealed or their movements disturbing the fabric, then the focus can be checked quickly before each shot. If, for instance, the bird comes to the back of the nest instead of to the front as expected, a quick turn of the focusing ring and you are ready to expose.

A system that I find useful in ensuring that my fingers do not inadvertently scare the bird when altering lens settings is to have a thin card about 12 × 10cm, with a round hole in the centre of such a size that the card slips tightly on to the lens barrel and can be held firmly there by the lens hood. The card can be waterproofed and stiffened by painting with varnish and it acts as a shield behind which you can reach forward and adjust the controls. This arrangement has the advantage over 'nurses sleeves' that the lens need not touch any part of the hide fabric, which means that movements of the fabric are not transmitted to the camera.

Reflex cameras with their continuous focusing facilities can be shifted easily to follow a bird moving from perch to perch or one that stands just outside the expected field covered by the lens, but to do this the camera has to be mounted on a smooth running pan and tilt head.

A hidesman's view. Through the peephole is an Antarctic tern incubating. The site was an isolated rock in the 'Furious Fifties', the hide a solid structure of hardboard capable of coping with 100-knot gales. 35mm SLR and 85mm tele-lens (photo John Warham).

After feeding their chicks, many passerine birds pause while looking for faecal sacs, and this is a good time to expose. The lyrebird here is just turning to fly away: her long curved tail poses a problem for the cameraman (photo John Warham).

10 *Make exposure reading.* Even using TTL metering, it is a good idea to check the light reading given by the camera meter from the hide position with that given by a separate meter held at the camera angle.

11 *Set shutter speed.* At this stage a decision must be made, based on your knowledge of the species and perhaps aided by the tables at the end of this book, as to how long the bird is likely to stand still and hence the slowest practicable shutter speed. With birds like robins, thrushes, eagles and owls, quite long exposures may be feasible but with many others, particularly small birds like tits, lorikeets and waders, short exposures are essential. With eye-level reflexes the ease of focusing means that you can expose even at full aperture in many instances. This allows you to use higher shutter speeds and also helps to throw the background out of focus and make the bird stand out. But, of course, the depth of field is reduced and focusing must be watched or you will find tails becoming blurred. Again, for 35mm users, long exposure times are not often very satisfactory because even when the bird has become conditioned to shutter sounds, it will probably start a little at the whirrs and clicks of a slow exposure and so exposures around 1/60 sec may well prove to be the slowest that can safely be given.

With an automatic camera, either shutter speed or iris stop will adjust according to the light received by the lens, but when

working from a hide you may prefer to switch to manual. Otherwise you may find the camera firing at 1/8 sec when the shortest sensible exposure would be 1/100 sec, to cope with the subject's movements.

12 *Check exposure and stop.* With TTL metering, the shutter speed selected, the stop and meter reading are all visible to one side of the screen.

13 *Check all controls.* See that all the controls you expect to use are readily reached. If you are not using a TTL camera, shutter and iris settings must be visible and accessible when you are seated. This is usually difficult from the normal position as you cannot lean forward to look at the scales from above or in front of the camera. A small dentist's mirror set at an angle on a short handle can help here.

14 *Check peepholes.* Now that the camera is set up, the stool should be positioned and a check made that there is a peephole giving an adequate view of the nest, its surroundings and preferably of the birds' expected lines of approach. Such peepholes need not be more than one or two inches across. The material should be cut along three sides of a rectangle and the resulting tongue of canvas pinned back. If at a later date this particular hole is not needed, the tongue can be pinned into its original position. One or two holes should also be made at the sides so that an all-round view is obtained. Such a wide field of vision is helpful in allowing the birds to be seen before they actually arrive at the nest; not all species advertise their whereabouts by song or by the rustle of their wings.

15 *Set out film, notebook, food etc.* You should be properly organised within the hide—everything in its place, and a place for everything. This ensures that when seconds count, the time taken in changing film, in refocusing, or whatever may be called for by the exigencies of the moment, is kept to a minimum. A caution here may be timely regarding sandwiches. They should never be packed in greaseproof paper for the rustle of paper or plastic is, of all sounds, the one birds seem to detest most. Sandwiches should be wrapped in a cloth.

16 *Check hide from outside.* This is done to see that none of the camouflage can blow across the lens and as a final check on the opacity of the material; if any doubt exists on the latter an extra piece of fabric can be pinned to the interior of the hide wherever it may be needed. While outside, attend to the wants of nature.

17 *Remove focusing object.* It is very embarassing to realise that it is still there when the bird reappears!

18 *Settle in hide.* Make certain you are comfortable and warm, the seat firm, the camera ready for use. If necessary apply mosquito repellent. Make sure that you can see clearly and are all set to shoot, then fasten up tightly from within.

19 *Send off companion.* It is often essential to have a helper who will fasten the hide up behind you, walk ostentatiously away when you are ready and return at the end of an agreed period.

This will generally deceive the adult birds, who have been watching all that has taken place, into believing the coast is clear. Crows, jays and magpies are not taken in so easily, and two or more people should walk away from the hide when you are tackling these wily creatures. If only a single companion is available, he or she may deceive the birds successfully by holding a coat or a piece of sacking at arm's length to simulate a second person.

Bird photographers often work in pairs; others prefer to work single-handed, getting farmers, country people or other interested persons to see them in or out of their hides. Often long-suffering spouses perform this valuable duty. You should arrange either for a definite time for relief (watches being synchronized) or for some signal to be made (such as showing a white handkerchief out of the corner of the hide) when you wish the helper to return. He or she may need binoculars to see the signal from a distance. In the event of the relief time coinciding with a long-awaited visit by the bird or the occurrence of a particularly interesting episode, your helper, seeing no signal, keeps well away and so permits the episode to be recorded or observed as desired.

Taking the photographs
A long or short wait may ensue before either bird returns. The waiting time depends to some extent on the care with which the hide was built and the opening up of the nest surroundings carried out. At first the birds will probably be hesitant, making several abortive attempts at alighting; even though they have taken a tantalisingly long time to come back, you should not make any exposure on their first visit. Let them feed the young and get settled down before beginning photography. If they feed frequently they should be permitted to make several visits; this will give you an opportunity to see where they perch and to make any last-minute adjustments to the focus or camera angle.

Only when the birds have overcome their nervousness, after the disturbance associated with your recent activities, should photography begin. If one of the adults settles down to brood, a picture will present no difficulty, and quite long exposures may be given. At the first click of the shutter the bird will very likely shoot up its head and peer at the hide. Make no attempt to wind on or rest the shutter until the tension has subsided and the bird is again relaxed. Gradually both of them will become used to the quiet sounds and they may even be 'broken in', so to speak, by quietly clicking the tongue, making the noise louder by degrees until this and the sound of the shutter is ignored.

Some birds become fantastically indifferent to noises. I remember a pair of bullfinches which were absolutely unperturbed by any sound from the hide, which was only 1.5m from the nest. Singing, shouting, whistling were all completely disregarded. Yet again, other birds may never become reconciled to the slight

sounds that must inevitably accompany photography. When really difficult sitters are encountered, it is generally wisest to leave them alone since the bird's welfare must be your first consideration.

Parents rearing young are best taken after the food has been disposed of and the chicks have subsided a little. Otherwise you may get a beautifully crisp study of the parent marred by a blurred mass of waving young in the foreground. After feeding, most small birds will pause intently to see if the chicks will eject any faecal sacs and this is the time to press the release. The droppings are picked up in the parent's bill and discarded when some distance from the nest.

Many species are still only for fractions of a second, and with such birds successful results depend largely on the cameraman's ability to anticipate these pauses and to press the release at the right moment. With more phlegmatic birds like thrushes and robins, on the other hand, a high percentage of the pictures should be free from movement. Your successes increase as you learn to anticipate the birds' intentions and to judge, almost by instinct, when to squeeze the release.

Pictures taken when the bird's head is turned directly towards the camera or completely away from it, so that neither eye is visible, are generally unsatisfying. So are those in which the bird appears strained and on edge—a sign of inadequate preparation

This Buller's molly-mawk stands out well from the cliff-face owing to a shallow depth of field given by the tele-photo lens, and the SLR release was pressed as the head was turned to one side (photo John Warham).

on your part. The eye should be obvious and the head more or less broadside on to the lens. With ground-nesting kinds the arrangement of the eggs often governs the angle at which the bird incubates. By observing how it sits, it is usually possible for the photographer to arrange the eggs so that the bird will settle down broadside on to the camera. This works well with plovers, stilts, terns and gulls and often with nightjars and stone curlews, most of which lay only two eggs.

It is desirable, though not always possible, to get a highlight in the eye, and in many cases where focusing has been accurate the image of the hide or some tree silhouetted on the skyline will be visible in the bird's eye. Use of a flash fill-in ensures such a highlight.

Some birds are continually on the jitter; they nod their heads or wag their tails. The secret of overcoming such movements lies in making the exposure just when the moving part of the bird's anatomy is about to change direction. Things get more complicated when both head and tail are in motion at the same time. It is then best to concentrate on eliminating head movement, trusting to luck that the wagging tail does not show. Possibly many exposures will have to be made before perfection is achieved; in any event the head and eye must be sharp.

Another tricky situation arises when both birds are together, since if one bird is still the other will probably be on the move. You have to take a chance here and either concentrate on the bird occupying most of the picture, or try to look at the scene as a whole and trip the shutter when, for a moment, all seems still. Clearly, the faster the shutter speed the greater the likelihood of a satisfactory result.

You will certainly meet with subjects which, like my bullfinches, become so accustomed to the sounds you make that they simply ignore the hide, and sometimes with birds that cannot be induced to remain motionless for a second. A sibilant noise from the lips, or a sharp click of the tongue, will make most birds pause just long enough for an instantaneous exposure. With very tame sitters, however, it may be necessary to put a finger out of the hide to attract attention and create the opportunity you need. A white feather twirled round slowly sometimes does the trick, but when I tried this dodge with one pair of long-tailed tits the birds simply flew at the hide, hovered before the peephole and tried, apparently out of sheer curiosity, to peer inside. Another small bird in Australia clung to the canvas, grabbed the feather and worked it into its nest lining!

Taking down the camera and packing up does not usually take long. Once again cover the chicks if the weather is cold, and it is most important before leaving to slacken off twigs and vegetation which have been tied out of the way. The nest must be adequately screened when the hide is unoccupied and additional foliage provided if necessary. The hide must be securely fastened up and the dummy lens replaced, while branches should be pressed into

Two bee-eaters on a perch provided near their nest. With two heads and tails in motion, care and skill are needed to catch them at the right moment for sharp and well-composed pictures (photo John Warham).

the sides if the situation is an exposed one and likely to be windy. See page 146 for combating wind.

Perches

After a few sessions it will soon be observed that each bird of a pair prefers to use a definite route when coming and going. By noting just where each perches, a series of pictures showing the birds away from the nest can be obtained. It will often be impossible to use existing perches without making some adjustments, and many kinds will readily take to a perch provided by the photographer. Nightingales, warblers, chats, tits, kingfishers and owls will all oblige, providing the perch is correctly placed. It should be set up to lie in the normal path of the bird as it comes to the nest. Any competing resting places should be removed or tied back if possible. Once it has become accustomed to using the perch the bird is likely to continue to do so on subsequent occasions.

It is important to select perches carefully. They must be appropriate to the species concerned and look entirely natural. Some time may have to be spent in finding just the right one for a given situation. When focusing remember that the bird's head will probably come slightly forward of the perch and this should be allowed for.

Sometimes, when a nest is unsuitable for direct photography through being too deeply hidden in foliage, badly illuminated or otherwise unsatisfactory, it is possible to take the birds as they pass to and fro. This is done by focusing on a favoured perching place where conditions are better than at the nest itself. This procedure can also be adopted to take advantage of a nest without subjecting it to much risk; opening up is not required and some very useful shots can be made if the situation is properly handled.

When you have finally done with a hide at a nest that is still occupied, prudence requires that you should not remove it abruptly unless the birds are very tame. Good housekeeping is important—remove all film cartons, lens tissues and the like and rake up trampled areas so as not to draw attention to your recent activities.

Special problems with 35mm SLRs

For bird-at-the nest work the SLR's main drawback is shutter noise and the noises involved in mirror movement and shutter resetting. To some extent the effects of such noise can be mitigated by working further back from the nest and using, say, a 200 or 250mm lens rather than an 85 or 135mm one. But I do not recommend working too far back because the hide itself gives some protection from view on the exposed side of a nest when it is opened up for photography. If the hide is set too far back this protection is lost and the chances are increased of exposure to predators.

The noise problem can be alleviated by locking the mirror in the 'up' position, but only at the expense of losing the TTL metering and viewing systems. The mirror can be dropped from time to time to check on exposure and framing, but this is only a partial answer. The best solution is to choose the quietest camera that is available from the start.

Most 35mm cameras have well designed shutter-release buttons. For working within hides, however, these are not very satisfactory because it is tiring to keep your finger resting on the camera waiting for the right moment to expose. Minutes may elapse before the chance is given. Hence the value of a good-quality cable release, about 50cm long which is kept smooth running by occasionally hanging it up on a line and allowing a little light oil to run down the inner core and so lubricate the plunger. With the SLR you should not rely solely on the view through the camera finder. You need the wider view given by peep-holes.

Using cameras with blade-type or sectional shutters
So far in this chapter we have been mainly concerned with SLR cameras equipped with focal plane shutters. Where cameras are used having lenses in sectional shutters, as with some 6 × 6 and 6 × 4.5cm models, or with monorails and press types, additional considerations arise.

The shutters are generally quieter than those on focal plane

SLRs but nevertheless make an audible click on release and usually another click as the shutter is reset. Providing you are cautious most birds become accustomed to the small sounds involved.

Many cameras in this category lack TTL metering so you must have some means for monitoring the light, either by using a spotmeter through a hole in the front of the hide, or perhaps checking light changes by making readings on the ground behind the hide where the birds cannot see your hand. You also need to be able to see all the lens settings from your sitting position. A small dental mirror may help here.

Working singlehanded
Much emphasis has been placed on the need to consider the birds' well-being when working at the nest. For this reason, if for no other, the assistance of a companion to see you in and out of hides has been advocated. But sometimes such a companion is just not available. When and how may a helper be dispensed with?

Most small birds nesting in bushy places where there is a good deal of cover are not unduly worried by hides which have been properly introduced by stages and many birds return readily to their nests when all movement has ceased in the vicinity. In these circumstances a companion *may* be unnecessary. Every bird is an individual, however; no two react exactly in the same way to a given situation. One robin may be confident, the next quite the reverse. So if you do try to work alone, the attempt should be abandoned if the birds prove undeceived by your disappearance.

Your exit is no less important than your manner of entering the hide; sudden emergencies should be avoided. Sometimes it is possible to slip out unobserved when the adult birds are away feeding. At other times when either parent is at the nest it may be sufficient to mutter softly and, by increasing the loudness of the voice, to cause the bird to move away and give you a chance to come out quietly. It may even be possible to creep out of the back of the hide while the bird is still at the nest. To do this successfully involves crawling on all fours. Every move must be planned in advance so that your departure is noiseless; and the hide must be kept between you and the bird. The success of such a method depends on the lie of the land, whether the off-duty bird is likely to be about, and on your subject's temperament. One of my early sitters was a tufted duck nesting on a sedge-covered ridge in an old gravel pit. Duck are difficult and shy creatures at the best of times and this bird was no exception, yet it was possible by opening the back of the hide to squirm away along the ridge without putting her off the eggs.

There are certain birds which regularly absent themselves from their nests for long periods. Where such nests are in woods or similar cover you can usually get installed during the owners' absence and, likewise, after a feed you can come out when there

is no sound of the birds in the vicinity. Doves and pigeons fall into this category, for they leave their squabs between feeds for up to four hours at a stretch. Other species, hawks and eagles, for instance, although allowing long periods to elapse between visits, have such keen eyes and wide horizons that the entering of a hide unattended merely invites failure.

Working single-handed is often necessary when you are working with owls after dark. Someone may be cajoled into seeing you in to the hide during the evening, but when it comes to arranging for a relief at one o'clock in the morning there is seldom a rush of volunteers. This snag can usually be overcome with the help of about 15m of rope. One end is left inside the hide and a bundle of sticks or a weighted sack tied to the other. This is placed on the ground well away from the hide so that it can drag freely through the undergrowth without getting entangled. The idea is that when you wish to pack up, by pulling steadily on the rope, the sack is drawn along the ground making a noise at some distance from the hide, a noise that gradually gets louder and closer. The owl will hop to the entrance hole, peer down towards the sound and depart to watch events from a perch near by. The sack is then drawn right up into the hide and to the accompaniment of a little singing perhaps, and flashing of torches, you dismantle the equipment and depart leaving the sack inside.

The same sort of dodge can be used at times from a ground hide as well as from a pylon and I have also employed it in a swamp. In that instance the rope was passed under a nail which acted as a pulley and then run underwater to a mass of floating branches or to a rubber dinghy. These were hauled in towards the hide when I had finished filming, flushing the sitting bird from her eggs and permitting me to emerge.

On taking a chance
Some of the most notable and unusual pictures of birds have been the reward of the cameraman's prompt and competent reaction to lucky opportunities. The bird photographer should be on the alert for the unusual and not afraid of taking a chance. The bird may be too near or too far away for correct focus, and a quick adjustment of the focus, followed by pressure on the release, are needed before the chance has gone for ever. Sometimes the subject may be perfectly posed but outside the field covered by the lens. Then the temptation to swing the camera on to the bird may be irresistible. Any such movement must be done with agonizing care and the traverse must be so gradual that the bird cannot detect it—or it must be made when its head is turned the other way. The odds are that the bird will walk away or fly off just as the picture is about to be taken, but sometimes such chances come off.

One of my favourite photographs—of a turtle dove in song— was made in a similar manner. Shy though these seldom-pictured birds are, it was possible to swing the camera on to the bird as it

A brown snake preying upon blue-wren chicks at a nest in South Australia. The camera had to be swung from the perch on which it was focused, trained and re-focused on the nest in order to catch this brief episode, a relatively simple task with a 35mm TTL SLR (photo John Warham).

stood quietly calling to itself, to focus accurately upon it and to make a series of exposures before the dove flew off to its nest.

Special problems with cine

For bird-at-the-nest filming, it is safer and more convenient to use a tele-zoom than to attempt to use a turret because it will usually be impossible to change lenses without risking frightening the birds. The to-and-fro movement of the zoom will usually pass unnoticed. It is important that light is metered via the taking lens and not through a separate light receptor cell, for it will be difficult to arrange that the latter has a clear view of the scene as well as the taking lens. If you are shooting, say, on 16mm with no TTL metering facility then you need some means of monitoring the light. The easiest method is to use a spotmeter that can be used to read the reflected light from the nest through a small peephole. If necessary the spotmeter can be clamped into

position on one of the uprights so that you can get a continuous reading.

You may well want to be able to swing the camera from side to side. You then need a horizontal slit in the hide with the flap pinned back to allow a free traverse. Ensure that such an arrangement does not let the bird see your movements. One simple method is to have a thin card that slips onto the lens barrel and shields your fingers from view.

Drill for setting up (TTL) cine camera in hide

Step		Points to Watch
1	Remove obstructions.	Tie back intervening twigs, etc.
2	Erect tripod and level up.	One leg forward, two to rear.
3	Mount loaded camera.	
4	Select lens to use.	Sight through range and select the most suitable.
5	Fit lens hood and position through front of hide.	Move tripod, level up and see nothing obstructs lens.
6	Focus and frame up.	
7	Check picture composition.	Adjust any intruding objects, background highlights, etc.
8	Check panning movement possible.	Pin back flaps in fabric that might interfere with traverse.
9	Set framing rate.	
10	Check adequate light available.	Through TTL system.
11	Check mechanisms.	Run film briefly; see zoom lever runs freely, etc.
12	Prepare camera.	Wind spring; check speed setting, footage and frame counters, variable shutter and battery leads, etc.
13	Check peepholes from within.	Ensure adequate for good vision and comfort, but not too big.
14	Set out all gear.	Notebooks, film, food, tape-recorder, etc, must all be immediately accessible.
15	Check hide from without.	Must be quite opaque, camouflage clear of all lenses and well tied back, peepholes properly pinned.
16	Attend to wants of nature.	Hide makes an unsatisfactory lavatory!
17	Get settled in hide.	Make sure you are comfortable and have all you need.
18	Send off assistant.	See that he/she knows time or signal for returning.

Taking a chance: the camera was swung right away from the nest to a turtle dove about 4 metres away, which paused long enough to allow refocusing (photo John Warham).

Stills and cine together

There may be occasions when you wish to shoot cine and take stills from the same hide and during the same session. This is not really a very satisfactory arrangement, though it can be done. Both cameras can be mounted on a single tripod via a board drilled to accept appropriate screws and each camera has its own independent tilt head (see page 46).

In practice it is difficult to divide your attentions between these two very different branches of photography and the experience is generally rather frustrating. You can easily miss getting some really exciting shots through trying to do both at the same time. It is also an awkward business arranging that the lenses on the two cameras are nicely placed to go through the front of the blind.

In my opinion the solution is to take the stills and the movies on separate occasions. This allows you to alter the working distance if necessary. The hide may have to be closer for the stills, particularly if you want to use flash, than for the movies. Trying to do both at once, though it might sound more efficient, is seldom satisfactory in practice, and you are more likely to waste a lot of film than to save any.

Bird series

No two bird photographers have exactly the same angle on their hobby. Some wish merely to obtain good portraits of their

subjects, others try to produce studies of a particular species covering as wide a range of activities as possible. There is much to be said in favour of a fine series of a single bird, whether common or rare. Such a series might cover some or all of the following facets of bird behaviour:

1 The building of the nest. 2 Close-up of the nest and eggs. 3 Nest and eggs shown in relation to the habitat. 4 Parent(s) incubating. 5 Change-over at the nest. 6 The hatch. 7 Newly-hatched young. 8 Well-feathered young. 9 Parent(s) brooding. 10 Parent(s) asleep on the nest. 11 Feeding of the brooding hen by the male. 12 Parents feeding the chicks. 13 The young doing their wing exercises. 14 The young preening. 15 Nest sanitation. 16 Family party after the young have flown. 17 Parent birds perched appropriately showing plumage or other sex differences. 18 Adult birds feeding in typical surroundings. 19 Flight studies at the nest. 20 Flight studies of the flocks. 21 Reaction to enemies. 22 Courtship displays. 23 Distraction and disablement displays. 24 Drinking, bathing, sunbathing. 25 Roosting. 26 Castings ejected. 27 The hides used, etc.

This is not an exhaustive list, though it may seem formidable enough; nor is it appropriate to all species. It will be realised that to assemble a series of pictures covering anything like the above range of habits would be quite a tall order, would involve working with several pairs and could only be covered over several years, even if the subject chosen were a familiar one like the robin, or a stout-hearted one like the long-tailed tit.

A bird series need not be limited to a collection of photographs or film sequences depicting the habits of one particular kind. An equally interesting and valuable series might show a single aspect of bird behaviour as revealed in a wide variety of species. A set of pictures of birds in their roosts might be made—or any other habit that took your fancy. There is plenty of scope for ingenuity and photographic skill.

Automated nest photography
With the advent of reliable motorised and automatic cameras and off-the-shelf photo-electric trip mechanisms, a new breed of 'gadgeteer' bird photographers has appeared. The more extreme of these seem less interested in the bird than in juggling with the circuitry. They can shoot a roll of film while resting at home or in the pub! Some excellent results can be achieved using automation but there are dangers, particularly for nesting birds, due to the temptation to leave the gear *in situ* without having first estabished that the birds will accept it. If they do not, nest-desertion and death of the young are probable. Thus, although the fully automated approach removes the need for a hide, it does not remove the need for direct observation of the birds' responses to the camera, flash and other associated equipment (page 265).

More difficult nest sites

Having succeeded in portraying some of the commoner species at their nests from the cover of a ground hide, you will probably want to do the same with other common birds like swallows and vireos whose nests are less conveniently placed. In this chapter some of the more important situations likely to be encountered are considered.

Pylon hides

The standard ground hide can only be used with nests not higher than about 1.5m, or at the most 2m, even if specially long uprights are used, extensions fastened to the tripod legs and a box used to stand on. For taller nests a pylon hide is usually the solution. Basically this consists of four uprights—probably taken from live timber (with the owner's permission)—which are sunk a little into the ground and braced together by smaller boughs fastened on by nails. The framework of such a hide is shown on page 134.

The bracing is done from the bottom upwards, and when a height is reached which will allow the camera to look down slightly into the nest, straight struts are fixed to carry a board. This is drilled with holes for standard screws, to secure the tilting head for the camera. A tripod is dispensed with in pylon hides. Providing plenty of holes are made in the board (which should be about 10cm wide by 1cm thick) a satisfactory camera position is readily found. A similar pair of bearers is nailed 0.6–1m lower and carry another board to form a seat. A few struts fastened diagonally, and guy ropes from the top, make the contraption stable. The upper portion is covered with canvas. Several pieces fastened in position with roofing felt tacks will be found more convenient than a standard covering. A foot-rest should be provided.

Such a hide cannot be built all at once. Apart from the risk of scaring the birds, the time needed would be so great that there would be a grave danger of the chicks or eggs coming to harm. Probably work spread over the evenings of a whole week will be required, the poles and spars being collected and carried to the site before beginning building. The canvas covering is introduced piece by piece, though this may be commenced before the framework is complete. At first the latter will seem flimsy and inadequate; as it becomes braced so it gains in strength. If needed, spars can be fastened from the uprights to adjacent

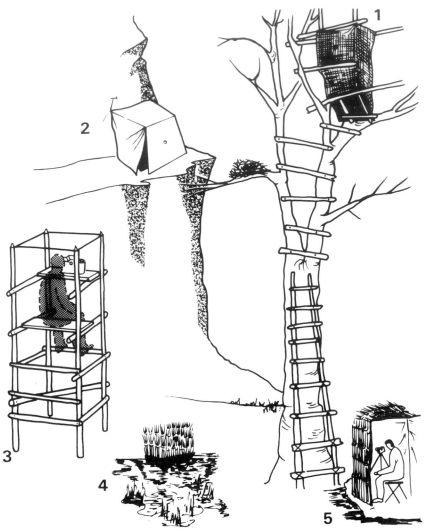

A hide to cover a tree-nesting bird is built of a framework of stout timber nailed or lashed to branches of the tree and covered with hessian or canvas (1). Birds nesting in holes in trunks, or in flimsy tree-tops incapable of supporting a hide, necessitate the use of a pylon hide (3); this is built of timber uprights and cross struts, braced by guy lines. A portable hide can often be used on a cliff ledge by wedging the uprights into crevices (2); note that it may be possible to photograph a nest in a cliff-side tree from higher ground. A floating hide of hurdles and reeds can be built on a flat-bottomed boat (4), and reeds make a good camouflage for the standard hide erected on the bank (5).

trunks to increase stability. The introduction of the dummy lens and the arrangement of the nest surroundings follow the usual pattern. Several nails should be provided for hanging coats and camera cases inside and a shelf is often useful.

Pylon hides are used at heights of up to about 12m. Above such heights the work involved becomes considerable and is not usually worth attempting unless you have a small labour force at your disposal. Occasionally it may be possible to use builders' portable scaffolding or slotted angle material and to fasten a hide on to this. By this means you can comfortably work at around 25m from ground level. The higher you have to go the more careful you must be to ensure that the top of the pylon is in the correct position for viewing the nest or whatever it is that you are to shoot. Once the pylon is erected its position cannot usually be altered. Nor can you move the camera closer to or further back from the nest. Any alteration in the field of view has to be done by changing lenses or by using a zoom.

Galahs at nest high in a tree: taken from a separate pylon hide at about 20 metres (photo John Warham).

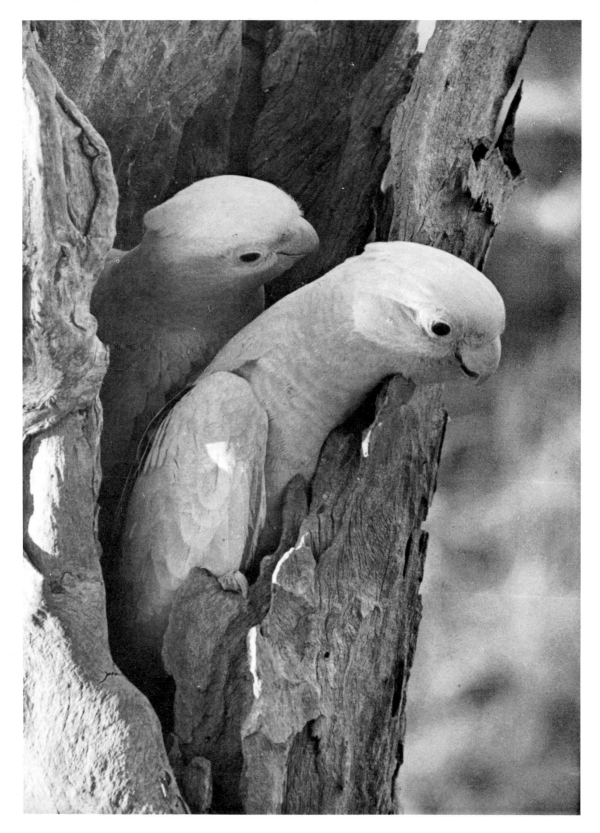

Tree-top nests

When attempting photography at nests in the tops of trees, the first task is to find a suitable site which can be overlooked from a position in the same or an adjacent tree. For example, in a rookery many of the nests will be at the very tops of the trees where hide building is impossible. With patience, however, a likely-looking nest may be discovered. The tree has to be climbed (climbing irons come in useful here) to size up the possibilities. If judged suitable some spars must be brought to the site, hauled aloft and then fixed by nails, ropes or wire among the branches where there are sufficient limbs to support a framework, and from which a satisfactory view of the nest is given. From these first spars the beginnings of a framework are made. This is gradually strengthened by the addition of further struts fixed to anything solid enough to hold them and when complete, canvas material is tacked into place. A ladder will be helpful, or a series of short and strong branches may be nailed at intervals of about 0.6m up the trunk, thus forming a ladder on the tree itself.

One of the big problems with tree-top hides is the wind. Not only does this flap the fabric and so scare the sitting birds, but on some days photography may be impossible on account of the swaying of the branches among which the hide is fashioned. Thin laths or branches nailed to the sides (not to the front or back) after the covering has been fitted will help to keep movement to a

These rooks were taken from a hide built in their tree. They were photographed early in the year before the tree came into leaf. The rather low viewpoint calls for small apertures lest the front of the nest become distractingly out of focus. Full exposure is essential with black birds (photo John Warham).

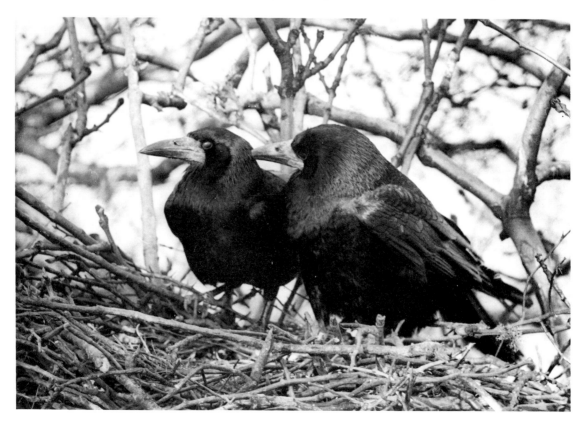

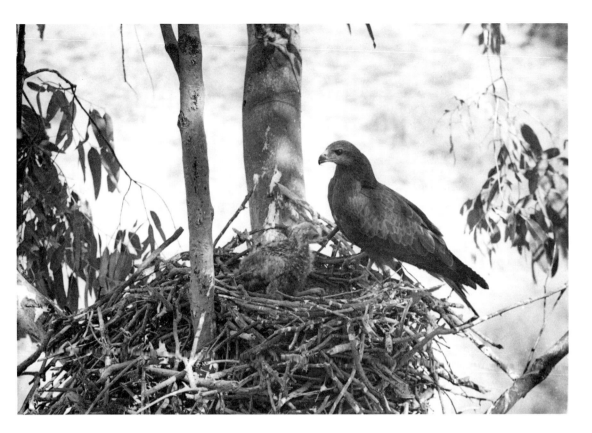

Black kite in a tree-top. Here the harsh tropical sunlight splotching the trunks and branches has been softened (but not eradicated) by a single flash, which also ensures an eyelight. Note that the background is fully exposed and no nocturnal effect is given (photo John Warham).

minimum, especially if the fabric is fastened to them with drawing pins or tacks. Another good idea is to fix a spar to connect the branch bearing the nest to the main supports of the hide, so linking the motions of the nest and the hide and preventing the former from swinging in and out of focus. This arrangement has the obvious disadvantage that any movement of the hide will be reflected at the nest so that a sudden slip by you could startle your quarry.

Hides in the tree-tops should be provided with a plank for a seat and a perforated board for mounting the cameras. A wooden floor is desirable, but if this cannot be fitted, sacking should be spread underneath to prevent birds which settle lower down from seeing you, and to act as a catching net in the event of any piece of equipment being accidentally dropped.

When working high up like this you need a rope to which camera cases and other gear can be tied for hauling from ground level direct to the hide. The rope may come in useful too to deceive the parent birds before settling down for a photographic session. If a sack is tied on and lowered down to your helper who promptly walks away with it, the parents will generally return quite confidently. This overcomes the difficulty of having companions who cannot climb the tree themselves. The sack can also be hauled up to simulate the return of an assistant at the end of a session.

Tree-top hides must be built slowly, giving the birds ample time to grow accustomed to each addition, particularly when it comes to fixing the covering. Any 'gardening' should be done before the hide is finished since it is often difficult to get to the nest once the structure is complete. With birds that use their tree-top homes year after year, such as rooks, egrets, herons, ibis and some eagles, it is quite possible to make the framework of the blind out of the breeding season when the birds are absent. When nesting has begun, all that is then necessary is to fit the covering to the framework by stages. This method ensures the minimum of disturbance for the breeding birds, and much of the hard work can be done at a slack time of the year.

Do not forget that you will usually have to remove any nails from trunks and branches when nesting is over. Dismantling of frameworks and pulling nails takes longer than you think and a good 'jemmy' is essential.

Tree-top nests on steep hillsides or in gullies can sometimes be viewed from ground higher up, and possibly even photographed from ground hides. Usually a telephoto lens of medium to long focal length will be needed, as the distance between camera and subject is likely to be considerable.

Nests on cliffs and crags

Hide photography on cliffs and mountain crags is an invigorating but arduous pursuit. The nesting sites of birds that breed in colonies are usually easy to find once you have got to their haunts, and the clamour of voices and the busy aerial traffic are obvious clues to follow. On the other hand, the nests of solitary species like ravens, buzzards and eagles may take a lot of searching out. Many sites are too dangerous to offer much hope of hide making. When a potentially suitable nest has been found, possible points from which it can be overlooked should be investigated. The use of a strong rope is often a big help in reaching such vantage points from which you can weigh up the possibilities. If a suitable spot is found—bearing in mind the lighting and similar considerations—then it may be thought desirable to remove a little rock in an effort to widen a platform to take the hide. A cold chisel and a hammer can sometimes work wonders where anything like a reasonable foothold already exists. On less steep slopes, with a covering of grass and thrift, uprights can often be forced into crevices and clefts. Then, by lavish bracing with guys, a hide of sorts may be built. If this has to be pitched on a steep slope, two uprights on the lower side will suffice, for crosspieces may be fixed to the tops of these and then forced into the ground on the higher side. It is surprising how, with a little ingenuity, quite unpromising places can be rendered comfortable and safe.

Note that this sort of work does not involve dangling precariously over cliffs on the end of ropes. Usually these are only needed to give the climber additional support over awkward

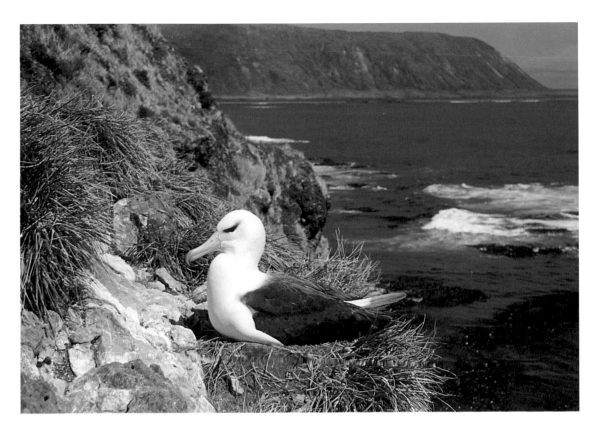

As with this black-browed albatross, cliff-nesting birds require ledges. The hide maker also depends on these ledges, tying the hide to the cliff with pitons and guy ropes. In this 35mm SLR shot the cliff face remains in focus nearer the camera, but sometimes this is impossible to achieve without a side-swing facility. The photograph would have been improved had the bird been facing the sea rather than the cliff (photo John Warham).

points or when carrying hides and heavy gear.

It is important to take precautions against anything rolling out of the hide. Camera cases should be tied to something firm, and sods can often be laid downhill to correct the slope. A board fixed between the lower uprights helps to increase stability.

Winds howl and eddy fiercely along exposed cliffs, and sods or rocks should be placed on the roof of the hide and all canvas pinned down securely. It is surprising how much a properly pegged-down hide can withstand. A canvas hide can take a lot of wind. My cliffside efforts have stayed firm in 80 mph winds due to strong material and good bracing.

Hole-nesting birds

A variety of birds nest inside holes of one sort or another, in trees, in masonry, pipes, stone walls and earthy banks. Species using such places include many of the tits, woodpeckers, barbets, storm petrels, owls and stockdoves. This method of breeding prevents pictures being taken at the nest itself and the camera usually has to be set up to cover the entrance hole. This may not be easy, for many birds fly straight into their holes and give few opportunities for pictures, except when they emerge and momentarily pause to look around before departing. Sometimes little can be done about this except to provide a convenient perch and to take the birds as they rest upon it. Tits, owls and redstarts are

often very obliging in this respect, but the perch must be carefully placed and alternative ones have to be removed.

With woodpeckers and tits and many others, greater opportunities exist when the young are well grown, for then they reach to the nest hole on their own account and the parents remain at the entrance while they give out the food. There is less movement after the feed when the parent pauses to collect the excreta, and this is usually the best moment at which to press the release.

At tree-trunk nests, due allowance must be made when focusing for the thickness of the bird, and some sort of focusing guide should be fastened by the nest hole to indicate the nearest point to the camera which must be sharp. A film packet serves the purpose and the print on this makes accurate focusing easy. If the wall or trunk in which the hole occurs is vertical and the camera is set square to it, there will be no danger of an out-of-focus foreground but with nests in tree trunks, parts of the tree may be nearer to the camera than others. Side swing of the camera back will then be found invaluable, if your camera has such a refinement.

When the hole is deep the nestlings may keep well back out of sight, so that you see nothing of them at feeding times and little of the parent except the end of the tail. This difficulty sometimes can be overcome by placing a stone or piece of wood at the back of the hole so that the young are brought forward into view. This can only be done safely, however, when the hole is larger than the birds require and where your alterations do not increase the risk of discovery by predators. Such additions must be removed when photography has finished.

The choice of position of the hide in relation to the nest may be controlled by the surroundings and by the lighting. The camera may have to be placed directly in front of the hole, but you will find that a position about half-way between a completely frontal viewpoint and a sideways one is best.

While some birds using tree-trunk cavities will fly out when the trunk is tapped—owls and stockdoves, for example—others sit tightly. When examining holes, note the condition of the entrances. If cobwebs are spun across them then clearly no birds have been inside recently. Sometimes claw-marks plainly indicate the visit of an owl, beak-marks the presence of a parrot. Woodpeckers usually sit tightly. If the hole is within reach, a small inclined mirror and a torch may enable you to look inside. Alternatively, it may be necessary to watch from a distance. Many woodpecker-type holes prove on inspection to be 'blind', and a useful check on the freshness of any excavations may be made by examining the ground below for tell-tale chippings. If the birds are suspected of boring, a cloth fastened firmly to the ground underneath will reveal any fresh chippings. By removing these from time to time you may discover when nest-making has been completed.

Placing a thin twig or bent across the entrance to a nest hole

may furnish a clue as to whether it is occupied. If the obstruction has been moved on a later inspection it shows that something has been inside—although not necessarily a bird nor one intent on nesting.

Birds by marsh and lake

Some of the most fascinating birds are those which frequent rivers, lakes and swamps. Some birds nest in the coarse vegetation by the water's edge; others, such as grebes, on the water itself or on the floating vegetation, like lily trotters, or among the lush grasses of marshy areas. Waterside nests may often be overlooked from a blind on the bank, but where the nest is too far out, the hide must be built in the shallows at the edge of the water. If the bottom is firm, as in most river beds, no special difficulties are encountered, but if, as often happens, there is much mud and silt, this may complicate matters. A large flat wooden board, say a yard square, may help to form a firm base resting on the mud, and long uprights can be driven into the bed of the lake around it. Planks may be needed to walk out to reach the hide without sinking in. The fabric cover may soak up water causing condensation on lenses. An anti-dim solution, as sold for spectacle users, may help to keep the protective haze-filter clear.

In some situations the only solution is a floating hide, built on a punt or on a raft of timber or oil drums. These must be firmly

Grebes make semi-floating nests along lake and reservoir shores, and can usually be taken from a reed blind on the bank. The low viewpoint chosen for this Great Crested Grebe makes full use of the water as a background (photo John Warham).

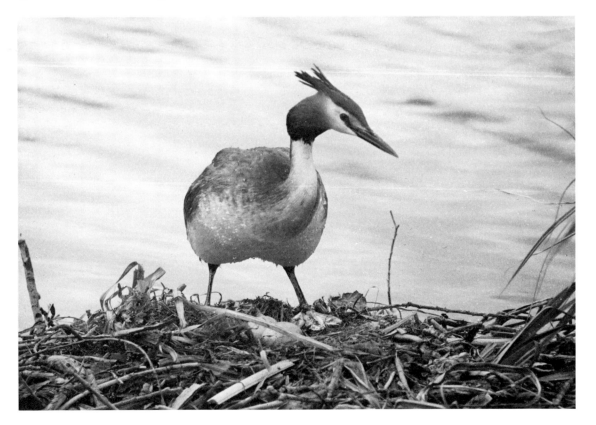

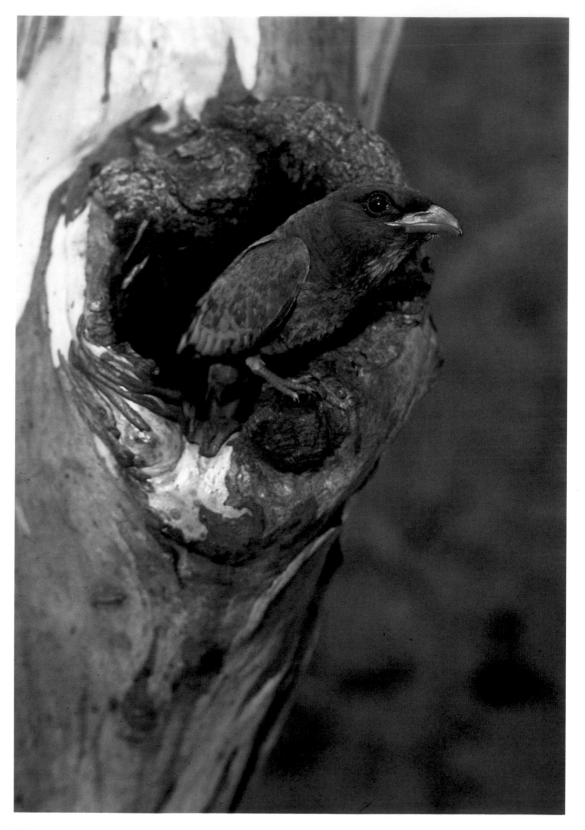

anchored to the bed by means of stakes driven well in; otherwise camera shake may mar your pictures.

Essentially aquatic birds such as grebes and loons, which seldom leave the water, may be photographed from behind a screen open at the back and with no roof. Such hides are conveniently made from lakeside reeds. Before photography the reeds are tied back over several days from the blind to the nest, not the reverse, which might expose the nest to enemies.

When coming to hides at nests of herons, bitterns, ducks and others that use thick cover and often sit tightly, try and flush them before you get close by making plenty of noise as you approach. This probably makes your visit less alarming, the bird less likely to displace eggs or chicks in a startled departure and more ready to return quickly. When attempting to show birds floating on water ruffled by the breeze, it is a good idea to make the exposures when the bird rises on the crest of a wavelet, since in this way pictures free from movement are more likely to be obtained.

Bird photography in marshy places where snipe, plover, wagtails and the like are probable sitters, offers little difficulty unless cattle have access to the area. If so the hide must be surrounded with an adequate barrier of posts and wire.

Nests on moors and beaches
When working on moors, beaches, prairie and similar exposed places the wind may be a major problem and it is usual to keep hides as low as possible and to stack stones and turf around them to anchor the canvas securely. Hides may be made solely of stones or peat. When working on a slope it is worthwhile taking the trouble to dig into the slope and level off the floor of the hide. Otherwise it will be difficult to use the stool, and a kneeling position in such a restricted space leads to agony and cramp. Comfort is most desirable in any hide, for it enables you to concentrate on picture-making without being distracted by aches and irritations.

Searching for nests on moors and grasslands must be largely a matter of observation from a distance, coupled with your knowledge of the terrain. Moorland birds are very thin on the ground, and it is generally easier to discover nests along the sides of gullies bordering the streams than on the open tops.

Dollar bird—a hole-nester taken from a tall pylon hide. These and other hole-nesters like woodpeckers have to be caught as they enter or leave, and best results are often obtained when the chicks are large and crowd to the entrance to be fed, allowing ample time for adjustments to focus etc. (photo John Warham).

On sea beaches, too, nests may be hard to find, especially those of solitary birds like oyster catchers and the many plovers which lay highly camouflaged eggs on pebbly foreshores. The presence and behaviour of the birds will give a clue as to where they are breeding, and the suspected area may be watched from behind a groyne or the grass of the dunes. Once all is quiet the birds usually return to their nests fairly readily. Those kinds which nest in colonies—terns for instance—are not so difficult to locate and once the breeding area has been found eggs are frequently so plentiful that they cannot be overlooked.

Beach hides are likely to be subjected to the vicissitudes of the wind, and they should be well guyed, with stones laid around the bottom and on the roof (see next section).

With ground-nesting birds the tendency to use too high a viewpoint should be guarded against. The higher the camera position the greater the depth of field, but a bird portrayed so that too much of its back is shown looks neither natural nor attractive

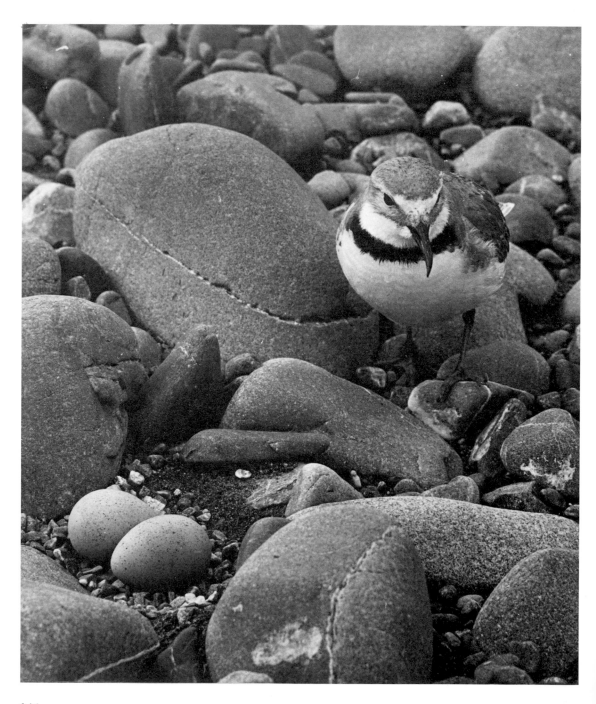

in a photograph. For such birds a short tripod is desirable, the camera being placed probably no more than 0.6m from the ground.

In addition to picturing the bird as it incubates and stands by its nest you may wish to make some shots as it stands several metres away from the eggs. First ascertain the normal lines of approach (ground-nesting birds, like other kinds, usually have well-worn routes to their nests) and then decide where the oncoming bird is to be photographed. A small stone is then placed at the spot as a guide. When the bird returns the release is pressed as it comes up to the mark. If necessary a click of the tongue may be given to make the bird pause long enough for the picture to be made. When attempting shots of this sort it may help to use two cameras mounted on one tripod, one camera being trained on the eggs and the other on the bird's line of approach.

Combating winds

High winds are a major problem for bird photographers. Birds are often very nervous of a flapping blind, and there is a danger of camera shake as the material pushes against the tripod and the lens panel. Winds are often strongest on open beaches, in seabird colonies around the cliffs, and on exposed islands. There are several ways to tackle the problem. Extra guys may be fitted. Ropes can be tied tightly round the sides and front (but not the back) both inside and out, thus restricting the movement of the canvas which may be pinned to the ropes. A very good answer is to use wire netting (page 146). A single piece, as long as the combined lengths of the sides and the front of the hide and nearly as wide as its height is needed. The cover is removed, the netting folded to fit snugly against the uprights (leaving the back open, of course) and the cover and guy ropes replaced. The canvas can then be fixed to the netting with pins in as many places as may be necessary. On windy days there are usually momentary lulls, and it is during these that the pictures should, if possible, be taken.

Some unorthodox hides

From time to time the keenness of individual photographers spurs them to undertake very difficult tasks and leads to the making of ingenious hides.

The most interesting studies of ground-nesters like waders, larks and gamebirds are often those taken as they approach their nests. Regular routes are usual, and careful focusing on these routes can give results like this example— a wrybill. Adequate depth of field to ensure sharp foregrounds and eggs is essential (photo M. F. Soper).

Pylons are necessary for high sites when there is no adjacent tree or other natural feature from which the nest can be overlooked. But very high sites require something more than the usual wooden affair made from local materials. Several workers have called upon the resources of builders and have had tubular scaffolds set up on which the hide has been placed. Harold Auger of Lincoln designed and constructed from 1in tubing a portable pylon hide having a maximum height of 20m. The whole can be carried by two people, and this worker's exquisite pictures of herons and rooks leave no room to doubt the effectiveness of the device.

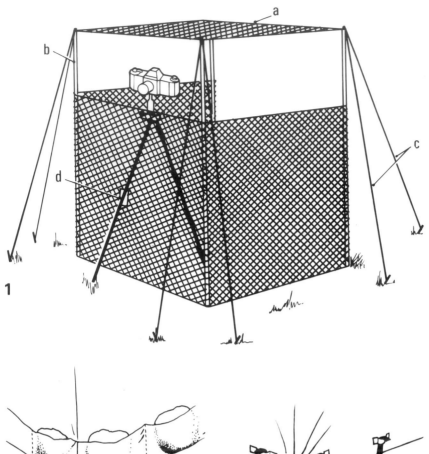

1

2

3

(1) A simple method of strengthening a ground hide against wind pressure. Wire netting is wrapped around the uprights (b) of the hide to strengthen the sides, and more netting is fixed to the roof (a). A hole has to be cut in the wire (d) to allow the front leg of the tripod to protrude. Guy ropes (c) are used lavishly to keep the hide firmly pegged to the ground. To prevent flapping and undue draught, the sides of the hide may have pockets at the bottom (2) which can be filled with heavy stones. Or strong loops may be sewn on (3) and subsequently pegged down with metal stakes.

A difficult problem faced Harold Platt and Arthur Brook when they set out to portray choughs at their nest inside a disused lead mine. The ledge on which the nest rested was in a vertical shaft where water dripped continuously, and in order to position the camera it was necessary to fasten it, together with the flash gear, on to the top of a telescopic tube. In this way the camera could be raised to the correct level, focusing having been carried out by prior estimation. The shutter and the flash were worked by remote control from below. Despite the fact that the whole apparatus had to be dismantled after each exposure, some excellent pictures were made—a just reward for hard work and enterprise.

The late A.W.P. Robertson's 'mobile' hide consists of a baseboard, 1m square and hinged in the middle as shown on page 60. At the corners of the square are fixed four upright pegs on which the corner poles fit snugly, and there are also holes in the baseboard to allow it to be pegged securely on the ground. On this baseboard the uprights, crosswires and canvas covering are erected and the whole can be moved bodily from place to place. If

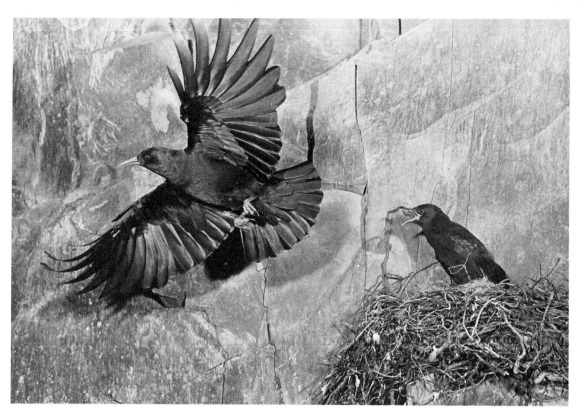

These choughs were taken at a nest in a mineshaft in Wales. Note how the pale walls of the shaft have helped to make the black birds stand out. Two high-speed flash tubes were used (photo Harold Platt).

it is found just before the first session at the nest that the hide is too close or too far away, it is an easy matter to make the necessary alteration to the siting of it. Once it is correctly placed pegs can be put in and the guying done in the usual way. Such a hide seems to offer distinct possibilities when working in gull colonies; at sites where it is to be moved into position by stages; in sheltered areas where guying is not needed; and particularly with wary birds, when the minimum of noise and disturbance is desirable during the introduction of the hide to the nest.

More solid materials than fabric can be used for hides, of course. Hardboard screwed on to a wooden frame has often been used and such hides are a good deal more stable in windy situations. P.O. Swanberg's mobile hide (see page 148) is prefabricated and can be assembled on the spot and shuffled around if necessary by the cameraman while he is still inside. This kind of hide is particularly good in very exposed places—with terns nesting on open beaches, for example, and very useful when shooting shore birds. The photographer can then keep adjusting his position according to the light and other factors. Substantially built hides like these are more practicable in cold climates or cold weather, as they afford some protection to the observer. They can also be sited in extremely exposed spots. One of my own hardboard hides, never intended to be permanent, withstood a succession of storms during which gusts up to 100 mph were recorded at a meteorological station 200m away.

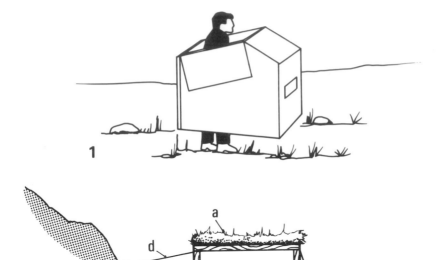

1

2

(1) A mobile hide devised by Dr Swanberg. It is made from hardboard or plywood screwed to a frame. (2) A hide for use on steep hillsides or islands. (a) Turfs on roof, (b) turfs etc. packed in to level up floor, (c) board to shore up turfed floor, (d) guy ropes.

Vehicles as hides

Quite a lot of bird photography can be done from the driving-seat of a car or truck, for, as you will have noticed, many animals show little fear of a vehicle. The best examples, perhaps, come from the African game reserves, where a wide range of species can be shot in comfort from a safari van. Much can be done elsewhere too, in this way. In Britain, for instance, it is relatively easy to photograph hedgerow birds on quiet country lanes using a 300–500mm lens.

If you use the vehicle as a mobile hide and film through the windscreen with doors and windows closed, you have in effect a blimped camera, for little sound should penetrate to the outside. It is naturally necessary to avoid sudden movements and if the vehicle is used often for this sort of work it would be worthwhile fixing curtains to side and rear windows which can be pulled across before photography. In this way any movements you make are much less likely to be noticed by your quarry.

Photography can either be done forward through the windscreen or, by suitable manipulation of the vehicle, through an opened side window. When filming through glass this must, of course, be clean and the lens needs to be close to the glass or reflections will interfere. If it cannot be placed close up, then you

will probably have to use a polarising screen correctly set to eliminate the reflections.

I find that it is an awkward business using a tripod inside the family-size British car, but special stands are now made that fasten on to the windscreen with supports to the floor, and these enable a camera to be mounted over the front seat and at a convenient level for shooting and simple clamps are made to mount a camera on a half-opened side window (page 46).

When travelling through good wildlife country, the camera can be kept at the ready and on some sort of support like that above. A polythene bag will protect the camera and can be whipped off when a chance offers—an eagle on a wayside telegraph pole, a yellow hammer or a field gull, a quail in a rickyard. If you have a companion who can work the camera while you manoeuvre the vehicle, so much the better. This manoeuvring calls for a good deal of care. You have to get down to low gear and quietly edge forward until near enough, and all this calls for a nice judgement. You will find, too, that while many birds ignore a car that passes on the road quite near to them, they are less indifferent to one that is moving slowly and still less so to one that stops. The engine should be switched off while the film is running, but not until you are really close enough for shooting. Even if the animal shows no sign of unease and you want to get closer for a second take, starting up the engine will usually cause its rapid departure. With stills, providing that you use a high enough shutter speed, you *may* be able to expose without switching off the engine.

As they cannot usually be left in place, vehicles are seldom suitable as hides at nests unless the birds are tame, readily accept the vehicle's introduction and, equally important, its removal.

Permanent hides

These are familiar to visitors at wildlife sanctuaries, such hides often being built up in trees or on stilts at vantage-points. Hardboard nailed or screwed to a wooden frame serves quite well for less permanent installations as, for instance, a season's observation post on a seabird colony. They may have sliding openings that can be closed down and clamped tight from within when the hide is unoccupied. In such a hide a tripod is normally dispensed with. Instead, a shelf drilled with holes is positioned at the front of the blind on which the cameras can be mounted. Such an arrangement is very convenient unless the weather is blustery. Then, despite strong guys, a hardboard-covered blind tends to vibrate, and this may be obvious on films taken from a shelf fastened to the framework. Under such circumstances you may get better results from a canvas hide, for in this case the tripod can usually be so arranged that movements of the fabric do not affect camera steadiness.

Birds underground

A wide variety of birds burrow when nesting and quite a number

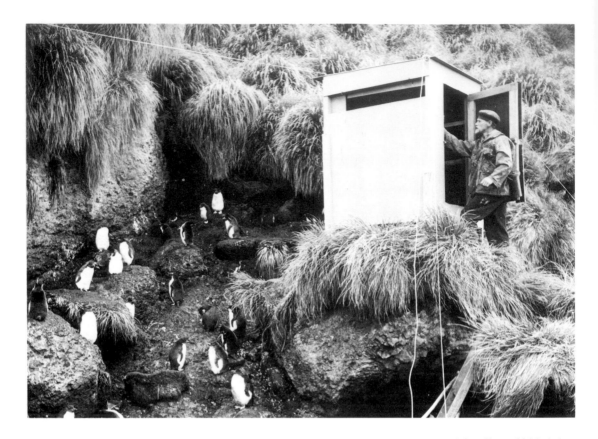

roost underground as well. These include familiar sorts such as kingfishers and bee-eaters (many species worldwide) and, less familiar to most people, species of parrots, motmots, todies, auks, pigeons, swallows, shelduck, petrels, penguins, barbets, puff birds and honey-guides, to name but a few. Such underground retreats not only afford protection for the animal concerned against predators but also against the extremes of weather and climate. The 'micro-climate' inside a burrow is usually very different from that in the open air outside, being cooler in hot climates, and warmer in cold ones.

So it is hardly surprising that some birds rear their young underground. The adults themselves are well adapted to survival in the outside world, but their newborn young are not. In the more equable conditions underground the chicks can grow until their own temperature-regulating mechanisms mature and become effective.

Birds with such fossorial habits certainly pose very difficult problems for the wildlife photographer, because he naturally wishes to show the whole of the life patterns of his subjects and not just those which are simple and easy to take. And here we may conveniently extend the discussion to cover the photography of those which use holes in trees as retreats or breeding sites—doves, parrots, owls, nuthatches, pardalotes, woodpeckers and many others. From a photographer's point of view the problems

A hardboard hide is best for semi-permanent use in very exposed conditions where gales, rain or snow are frequent, as in this hide for photographing rockhopper penguins. Note the adjustable slots. Cameras are set on shelves, and strong guy wires are essential (photo John Warham).

150

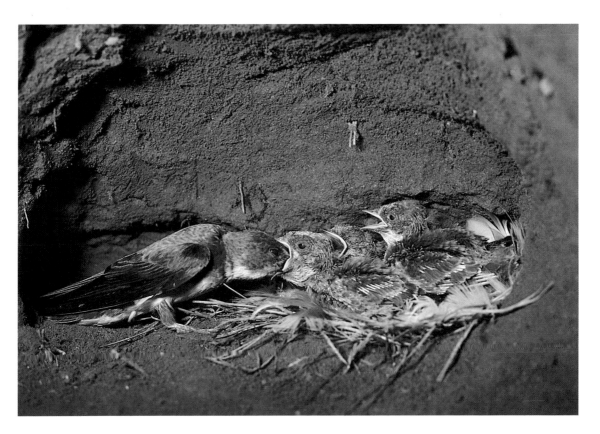

Sand martins in their nest chamber, which has been excavated from the side. Some of the problems with this technique are discussed on page 157 (photo Mike Wilkes).

of taking birds in such places are much the same as those underground.

Preparing the burrow

How do you train a camera on to a burrowing bird? This is certainly difficult and has only been achieved with a few species so far. Clearly you cannot sight down the burrow through the entrance hole, because most tunnels are crooked anyway and generally far too long. All that can be done is to dig down to the nesting or breeding chamber and make an artificial window through which it may be possible to eavesdrop on the occupants.

Some idea as to how this may be attempted and of the snags likely to have to be overcome may be apparent from a consideration of methods that I have developed over the years in studying nocturnally active petrels at night in their burrows.

Petrels are seabirds, most of which are active on land only after dark. They have one photographically convenient habit—they cease brooding their chicks when they are only two or three days old. Thereafter, for the 40–120 days that elapse before the young fly, they are visited only at night. So it is quite possible during the daytime to remove the chick from the burrow and excavate the nesting chamber while the parents are both at sea and therefore unaware of what is going on.

First of all, if possible, I select burrows that are in reasonably

level ground and where the nesting chamber is within arm's reach. At two to four days old, i.e. as soon as brooding has stopped, the chick is removed and placed in a box or other container where it keeps warm whilst the structural alterations are made (*see* opposite). Then I push a cloth into the nesting chamber and, with the aid of a stick, spread this out to cover the whole of the cavity so that dirt falling from the roof during digging does not mess up the floor of the nest.

The position of the chamber is then carefully gauged and a rectangle of earth above the chamber is very carefully removed with a sharp-edged spade. The edges of the excavation are sloped away so that the walls do not crumble into the cavity. What rubbish does fall into the nest on to the cloth is carefully removed and the nest cleaned up. Then a previously prepared roof of wood is fitted in place at about the same height as the original earth roof now removed. If the ground is suitable this lid may be placed on a small shelf dug into the hole. Hardboard is suitable for roofing only with small birds like storm-petrels and prions. It sags too easily when damp to be feasible for larger species. When the excavation has been arranged so that the lid fits properly, the chick is replaced in the nest, the lid brought down and the turfs are replaced so that the original insulation is restored. Two or more thicknesses of turfs can be used if necessary, extra ones being dug from elsewhere as required.

In all this it is important to see that the entrance hole and the access tunnel are not disturbed. To the returning bird the burrow must look and smell untouched. The importance of keeping the surroundings intact arises because once they have alighted it is probably by quite small features in the local terrain and by smell that the petrels are guided to their burrows and by which they distinguish them from thousands of similar burrows on every side.

Building a dark hide

If the excavation has been done carefully the alterations will be unnoticed by the parents when they come back in the night to feed their chick. It is then possible to proceed to the next stage, which is to build a hide straddling the chamber so that, by lifting the false roof, events in the burrow can be seen and recorded after dark. This hide has to be light-tight—it is a 'dark' hide—and is best made from hardboard screwed on to a wooden carcass and fitted with a door at the rear which can be securely fastened both from inside and from without. The general shape will be clear from the diagram opposite. The whole affair needs to be securely pegged down by guy ropes from the top four corners, because petrel colonies are generally in very windswept regions. The hide is so placed that once again the entrance to the tunnel is in no way obstructed.

The dark hide has generally to be erected at one go, but the birds can be conditioned to this if a box or boxes are put on top of the chamber some nights beforehand and this pile increased in

Preparing a dark hide over a petrel's nesting chamber. (a) Nesting chamber, (b) entrance, (c) boxes to simulate hide, (d) box containing chick removed from nesting chamber, (e) false roof, (f) cloth to catch digging debris, (g) turfs replaced, (h) dark hide, (i) infra-red lamp or flash tubes.

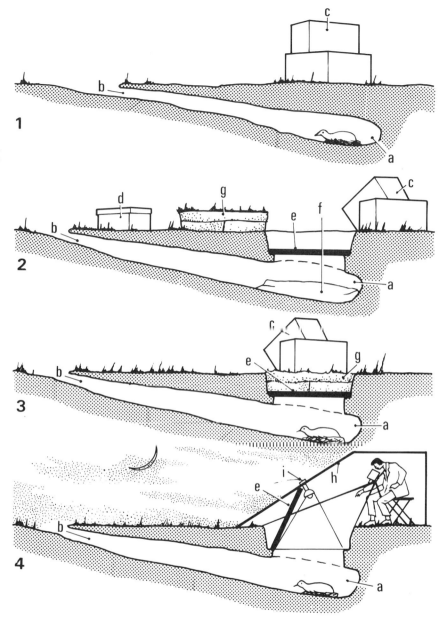

size from one night to the next. This conditioning process can conveniently be started before any attempt is made to open up the burrow, because the longer that photography is delayed after the hatch the higher the percentage of blank nights on which no parent appears. With medium-sized petrels like Manx shearwaters or gadfly petrels, the chick only gets fed about once every three to seven nights once it is past its first week of life.

Lighting the burrow

With the false roof lifted, the interior of the hide and the nest cavity are connected; the birds are literally at your feet. It is

Moulting little penguins photographed from a 'dark hide' in their nesting chamber underground (photo John Warham).

therefore extremely important that there are no chinks to allow moonlight or starlight to enter, and the observer has to be very quiet. For still photography flash is used and the nest itself is illuminated by a faint and deep red light which must be powered by an accumulator so that there is no tendency for flickering to occur. Most petrels seem very timid of white lights, and because of their sensitivity to noise it is doubtful if any but a few efficiently blimped cameras could be used at such close quarters with the lid lifted.

Therefore to film the interesting mutual behaviour between adult and chick it would seem essential to rely on infra-red illumination, or, better still, to use a photo-multiplier system or 'nightscope' (page 228).

Furthermore, to help in cutting down the sounds perceived by the birds the false roof would probably need to be underlaid by a sheet of heavy plate glass carefully cleaned so that shots could be taken through it. Infra-red, of course, brings other problems in its train—discussed in Gibson's authoritative book[36]—and the glass would not help the definition either.

Despite these difficulties, I believe that it would be possible to film burrowing petrels. This would certainly be a project worth tackling for its scientific interest alone, because very few ornithologists have ever seen how burrowing petrels feed their young and behave inside their nesting chambers.

Although I have stills of many kinds of burrowing petrel using the dark-hide technique, I have never tried to film them in their burrows and this would be quite a difficult project to pull off. It is most likely to succeed with the smaller species like the prions and the storm-petrels of various genera. What is quite useless is to start excavating while the adults are still in attendance by day, i.e. during incubation. The parents can be returned to the burrow after the roof has been fitted, but they will nearly always leave that night and the egg will be subsequently deserted.

Alternative types of hide

A modification of the above method and one that can be adapted for photography is to build not a hide but an observation box over the opened chamber (see page 156). This is quite small, is lightproof and contains a battery-operated red light or flash-tube inside. A simple viewing tube, normally closed by a cork at the top, doubles as the access point for the camera lens. There are no

Blue tits in a nest box, a modern example of a technique pioneered by Oliver G. Pike; see page 156. The low-speed flash used has not quite frozen the movements of the wing tips (photo Mike Wilkes).

turfs on top of the roof, which is hinged to the inside of the box and can be drawn up from outside by means of a string when it is required to make observations through the viewing tube.

This basic system of the dark hide, while difficult to apply to cinematography of the petrels for which it was developed, seems likely to be of more use with some of the other burrowing birds listed at the beginning of this section.

Long ago, Oliver Pike[16] shot great tits in a nest box, the back of which could be removed and replaced by a sheet of glass. He found that the parents soon became conditioned to accept the daylight flooding into the nest box and was able to shoot them in close-up using a 12in lens on his 35mm camera. Sielmann's work on woodpeckers is more recent and better known[33]. He sawed open the nest from the rear and built dark hides right up to the trunk, then conditioned the birds, without a great deal of trouble, to accept spotlights. In essence, opening up a chamber in a tree and in the ground are similar operations and as woodpeckers, bee

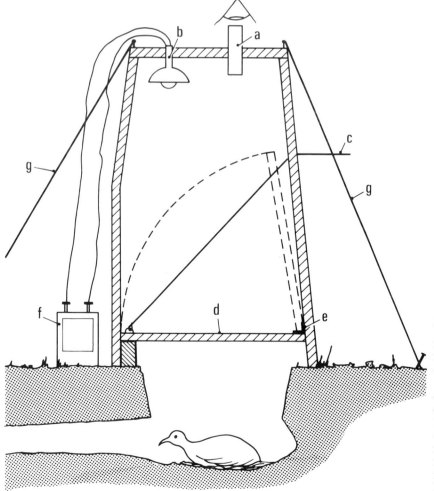

An observation box can be used instead of a hide for photography of birds in underground nesting chambers.

(a) Observation and camera tube, normally closed with a cork. (b) Infra-red lamp or flash. (c) Draw-string to raise false roof. (d, e) False roof hinged to facilitate raising. (f) Battery for lamp. (g) Guy ropes.

eaters and kingfishers are fairly close relatives, it is not surprising that some success has been achieved in photographing some of them underground. The best known is the Eastmans' enterprising work with the European kingfisher[31].

In gaining access for photography to tree trunks and to burrows, excavation from the side is often more practicable than from above. It may be necessary to fit a sheet of glass on the side of the chamber to face the camera, so that the chamber is intact but exposed to view. Glass barriers between the camera and the subject quickly get dirty. Burrowing shearwaters and penguins, for example, react to white lights or bright red ones by starting to burrow in an attempt to extend the nesting chamber so that they obtain the darkness they require. In doing so they toss back the earth into the nest, so that any glass roof soon becomes partly obscured and useless for filming through. Sielmann had trouble with his woodpeckers in wet weather—their breath misted up the glass—while when it was dry the glass soon became greasy through contact with the chick's feathers. Provision has to be made, therefore, for the removal of the glass from time to time (when the adult birds are away of course) for cleaning.

Another problem with glass concerns the lighting. Unless the lights can be inserted into the burrow from above, i.e. behind, the glass, perhaps with the help of fibre-optics (page 229), the lights have to be on the camera side of the glass. This means that reflections are likely to pose serious problems. Polarising screens on the lens and in front of the lights may be needed to alleviate this. For technical details see Blaker[21].

It will be obvious that burrow or tree trunk excavation is not to be undertaken lightly. It involves a lot of disturbance for the birds, and is often quite impracticable. The best conditions obtain when a hole or burrow is used during successive breeding seasons, or as a roost or shelter at particular times in the year. The chambers can then be opened up and modified when not in use. For burrowers like blue penguins, shearwaters, prions and other petrels I have turned the nesting chambers into nest boxes, accessible from above in the owner's absence. Having left the approach tunnels unchanged I have found the birds back in residence during subsequent seasons allowing photography without further excavation.

Flash and artificial light

The ever-increasing speed of photographic materials and of optical systems means that 'available light' photography is becoming increasingly possible. Despite this, there are still plenty of occasions when the ambient daylight is insufficient or unsatisfactory for bird photography and artificial light is needed. This can either be the sole source of illumination, as when making still or motion pictures at night, or can be used to supplement or to control the existing ambient light. On days with clear skies in summer and in the tropics the light may just be too strong and a fill-in light is required to control contrast and give properly balanced transparencies or negatives.

Artificial light for still photography is usually some sort of flash, typically electronic flash. Most 35mm cameras have shutters internally synchronised for flash. For cine work in the field, artificial light means battery-powered spots that can be erected on stands or attached directly to the camera.

For work with the many birds that are nocturnally active (not only owls but many petrels, nightjars, frogmouths, oilbirds and some parrots) flash is essential for their photography when breeding or feeding. Flash is also needed for stills of wild birds in their night-time roosts. In addition, many species are active both by day and by night and flash is necessary to show them after dark. Shorebirds, for example, have a daily feeding cycle that is controlled by the tides and many feed at low water by day or by night. The same is true for many kinds of wildfowl, herons and even for some terns.

Seeing what goes on

If you wish to learn something of the birds' behaviour in addition to photographing it, it is obviously necessary to see what is happening. On moonlight nights and in the early evening this is easy enough, but when dark it may be quite impossible to see anything but the vague shapes of the trees around you. Peering out into the gloom like this is very tiring; bushes and limbs appear to move and it is very annoying after firing flash to realize that you have been deceived by a knobbly branch. Furthermore you may fall asleep and miss a visit altogether. This is easily done when owls are the quarry, as these birds' feathers are designed to make no sound as they stroke the air with their wings. If the birds do not call before coming in and the young do not advertise their

Barn owl taken with single bulb by 'open-flash' technique. Reflector was above and to right of lens, but there were no problems with shadows in this 'back-groundless' situation. Owls perch readily, and the fence post was set up near an active nest site (photo John Warham).

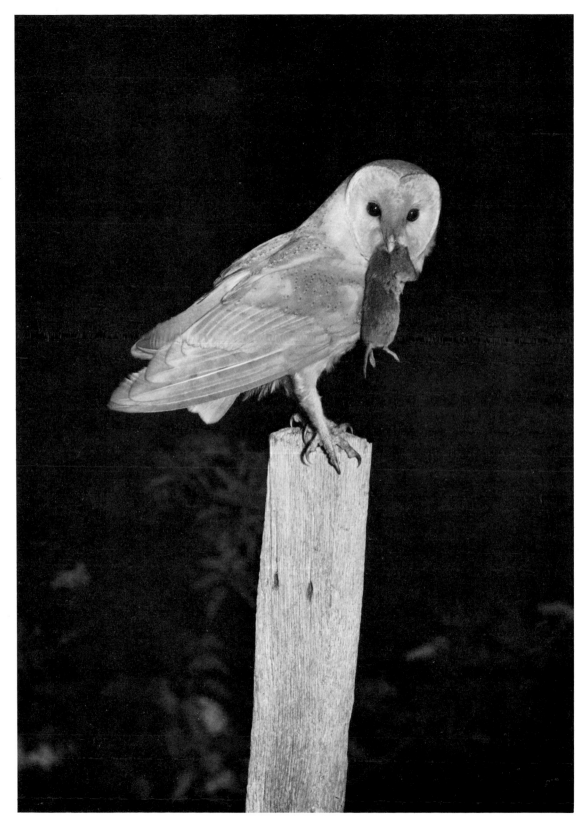

nearness by giving the hunger call, the only indication of the adults' arrival may be the rasp of talons on a branch.

Fortunately, although effective under conditions when our own are naturally useless, the eyes of many nocturnal birds, owls included, are not sensitive to the red end of the spectrum and in my experience will ignore dull red lights. With their aid the site can be illuminated and the birds' behaviour observed. The red light must not flicker or move (a battery of adequate capacity is necessary) and the switch should be silent. If desired, another red light can be used inside the hide for note-taking. One pair of barn owls allowed me to use a white light at their nest, and later I even made a cine film of their activities with the aid of two 500W floods without causing any alarm[46]. Nightjars would probably accept a red illuminant, and shearwaters and other nocturnal petrels show little fear of red lights providing these are neither bright nor flickering.

The open-flash method

At dusk and after dark the ambient light may be so low that no fogging of film will occur if the shutter is open for several seconds, and pictures may be made using the open-flash technique, the shutter being opened, the flash fired, and the shutter closed. When it is really dark the shutter can be set in the open position with little danger of anything being recorded unless the skyline is included or the moon comes out.

Owls in particular perch readily and often sit quite motionless, making the 'open-flash' method quite feasible. If the bird holds a rodent in its beak the flash should not be fired until the animal's tail has ceased to swing, otherwise your picture may be marred by the blur of the prey.

Owls soon become accustomed to sudden flashes. At first they may fly off, but usually they hold their ground and probably turn to glare at the hide. If you have two reflectors you may be able to get a second shot as the bird stares straight at the lens, providing you can wind on the film quickly enough. When visits are infrequent this arrangement, which enables two pictures to be made in quick succession, is a great help, and another advantage given by two flash units or bulbs operated separately is that you can choose which to fire according to whether the bird faces to the left or right. The point here is that the light should be so arranged that the shadow of the head is thrown behind the body. Otherwise the bird's profile tends to be lost among the shadow. If the bird is looking to your left the lefthand unit or bulb should be fired and vice versa; if full face, then either will do.

When working at nests a companion is needed to see you into the hide in the usual way and a relief is most desirable since nothing is more likely to upset the birds than your sudden emergence at the end of a session. It is often impossible to tell whether or not the birds are in the neighbourhood. However, with owls it will generally be found that there is little activity after

midnight so that you can generally pack up before it gets too late.

The frequency of an owl's visits to a nest depends to some extent on the age of the owlets. When these are small the hen will spend a lot of time with them, brooding, tearing up the prey brought in by the cock, and so on. Later both bring food to the nest. Sometimes long intervals occur between feeds and on nights which are dark, windy, or wet, there may be little activity, for under these conditions hunting is difficult and often abortive; so is owl photography.

Be careful when working with owls. Some kinds, notably the tawny owl of Europe and some of the horned owls of Europe and North America, may attack those who approach their nests after dark. A hat should always be worn when working near the nest, or a coat thrown over the head; perhaps even a crash helmet if your particular birds are known to be an aggressive couple, since owls generally strike at the head with their strong talons.

Electronic flash

The majority of flash work with birds involves the use of some kind of electronic flash. This is now a commonplace tool for amateur and professional workers in many photographic fields. Cheap lightweight units are plentiful. The light emitted by the flashtube is brilliant, of short duration, similar to daylight in colour temperature and of soft contrast. This gives flash one advantage over daylight, for the colour temperature of daylight often varies during the course of a session and so do the colour casts in the photographs. If flash is the main light, however, the results will be compatible for colour with one another. The flash lasts only a short time and the amount of light thrown out is constant as long as the user does not fire the flash prematurely. Finally, the tubes are not expendable but can give many thousands of flashes before they are worn out. All these properties are of great value to the bird photographer.

There are two main types of electronic flash, true high-speed flash operating at high voltages and giving exposure times of 1/5000 sec or less, and the popular low-speed outfits operating at low voltages and which are much lighter but give comparatively long flash durations.

Firing of all electronic flash units is done via the X-setting of the synchronised shutter. The flash duration is short so that, with sectional shutters like the Compur, any speed setting can be used—the flash goes off in the middle of the opening. Cameras fitted only with focal plane shutters are less suitable, for these do not permit the full potential of a true high-speed flash unit to be realised. If the shutter is operated at less than full slit width, only a part of the film is exposed. In practice, with most focal plane shutters, settings shorter than about 1/60 sec cannot be used but there are a few makes with which shutter settings as brief as 1/125 sec are possible. The real snag with focal plane shutters becomes evident when you wish to use the high speed of the flash

to freeze subject movement and have to work under high ambient light conditions, as on coral reefs or deserts. It may then be quite impossible to prevent the formation of a duplicate, partly overlapping, daylight image. The resulting 'ghosting' is usually ugly, unnatural and confusing.

For wildlife photography, an electronic unit must obviously be capable of battery operation. Often a battery charger that can be plugged into the mains supply to bring the batteries back to their fully charged state after use is built into the set. Two flashheads will be needed so that some control of modelling can be achieved and each head should have about 2m of cable running back to the unit or to the synchro-flash lead. This ensures that the flash heads can be moved around as required. The reflectors themselves should not be too shallow, for in most bird situations you do not want a wide spread of light but rather a comparatively narrow cone of illumination. At about 2m, for instance, it is seldom necessary to light up an area more than about 1.5m wide. But watch for hot spots: you need good, but not patchy, lighting. With some of the more expensive models the width of the flash beam is adjustable to match the lens in use (see page 171).

Some sets can also be operated on half power and this is a useful facility because there are times when it is necessary to reduce the amount of light thrown on to the subject—when switching to flash fill-in perhaps—and it is inconvenient to shift the lamps further back for this purpose.

Electronic flash units do not make much noise when they fire— just a sort of 'pop'—but beware of sets where the control switches click loudly when they are depressed. All equipment intended to be used within hides needs to be as quiet in operation as possible.

Using flashbulbs

Flashbulbs have a number of disadvantages for bird work. If much flash photography has to be done they add considerably to the cost per exposure. Then there is the very real difficulty of changing bulbs without scaring your normally nervous sitters. And finally flashbulbs are seldom sufficiently fast burning to give sharp pictures if the bird is moving. For these reasons bulbs have nowadays little application except where a great deal of light is needed to cover a wide field of view—taking a herd of ostriches at night perhaps.

Low-speed electronic flash

Every photographer taking close-ups of birds needs one of these lightweight and inexpensive outfits. Most are well designed and some of those in soft plastic containers seem to be able to stand a good deal of rough treatment. They are powered by dry batteries or lightweight accumulators, while some have flash heads that can be tilted and focused. These low-voltage units seem to be more efficient in their use of energy than the high-speed ones, are much safer when used under moist conditions than high-speed flash,

and some makes have sealed heads which appear to be reasonably showerproof. For general use you really need a set that throws enough light to give a guide number of around 50 to 60 (feet) on 25 ASA colour film. This sort of number should refer to conditions of use when firing into foliage, not in the light interiors for which one suspects many of the optimistic guide numbers are calculated. The greater the light output, the slower the flash.

Low voltage sets generally have short recycling times—the unit is ready to fire again by the time that you have wound on the film. Some recycle so quickly that they can be coupled to the motor drive to shoot at 5 fps, although, due to the noise produced, such a facility has limited application when photographing wild birds.

Many so-called 'computerised' flash units measure automatically the light reflected from the subject, and cut off the flash at a predetermined level. If the camera lens is set to the correct aperture for the film in use, correct exposure of the main subject is automatic. More advanced units can be set to work with a range of apertures for each film, but naturally the smaller the aperture the more restricted the maximum range. Of course, automatic flash systems suffer from the same problems as any other auto-exposure system.

Some flash units have a detachable metering cell. Thus the automatic exposure system works even with the flash remote from the camera, or with the flash tube tilted to bounce the light from a reflector. Virtually all 'computer' flash units can be set for full output to give normal manual operation.

The closer the subject, the wider the lens aperture and the faster the film, the shorter the flash. In extreme close-ups, normal 'computer' flash units can give flashes of 1/50000sec and shorter, but the usual range is 1/500 to 1/5000sec.

The most sophisticated automatic flash systems are those built into some modern SLRs. The meter measures the light reflected from the film, and cuts the flash off when enough has reached it (depending on the speed set on the camera's own film-speed dial). The most versatile can control more than one flash at a time: if one flash is mounted on the camera, the system sets the shutter speed and displays a 'flash ready' signal in the viewfinder.

Electronic flash in the field

The organisation of the camera and electronic flash gear within a hide involves few changes from normal procedure. Naturally the birds must be accustomed to reflectors by means of suitable dummies gradually introduced in advance. Inside the hide, the power unit and its switches must be conveniently placed by the left hand so that the other is free to operate the cable release— that is, assuming that you are righthanded. The flash heads can be placed somewhat forward of the hide. They are best mounted on studio-type metal stands of the portable folding kind, but spare tripods or even clip-on holders fixed to nearby branches can be used if necessary. Ball-and-socket heads provide an easy method

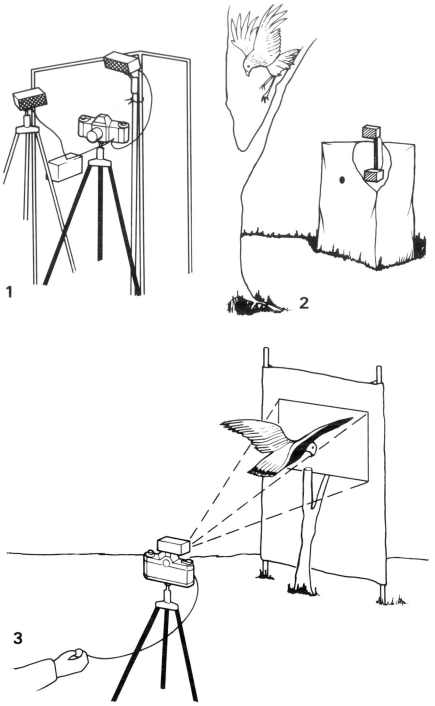

A convenient way to set up electronic flash is to mount it on a tripod with a ball-and-socket head, or on a camera fixed to a stake or the hide framework (1). The set-up shows an outfit and extension set coupled to fire together. Flashbulbs can be used, particularly for nocturnal birds (2); but bulb changing is a disadvantage, and if the subject is a tawny owl the photographer should at least wear eye protection lest he is attacked. Electronic flash is valuable for birds in flight; a simple set-up is to arrange a baited perch against a background cloth and shoot on the hit-or-miss principle as the birds come and go (3).

for adjusting the reflectors to throw light in just the right direction. The ball-and-sockets should be rather large, however, and fitted with a locking device.

Once all is ready and you are expecting the bird, the flash unit must be kept charged so that flash is available instantly when

required. If you have plenty of notice of the birds' approach it is not necessary for the lamps to be readied continually but usually no such warning is given. Most units include a small neon pilot light which glows when the minimum voltage has been built up and this is a big help at night.

Units that include a vibrator in their circuits emit a humming sound when switched on; birds generally show no fear at this for it is a steady sound and is seldom loud. With ground-nesting species I prefer to raise the power unit and its contained vibrator off the floor of the blind, hanging it by a nail from one of the hide supports or standing it on a wad of foam material so that vibrations and noise do not get carried through the ground to the bird. This also prevents dampness coming in contact with the apparatus.

With low-speed flash most normal movements of the subject, except flight, are eliminated; the action being arrested as the bird is momentarily illuminated. Thus there is no excuse for lack of crispness because, providing that the camera has been correctly positioned and the bird is in focus, it will be rendered with detail as fine as that possible with the optical gear used. Nevertheless, the release should not be pressed blindly. It is still important to judge the correct moment for taking the photograph. Now, however, you are not seeking to slip in an exposure when the bird is still, but simply trying to ensure that it will be recorded in a pleasing and natural posture or to catch an interesting episode.

Again, as with ordinary daylight photography, rear views and full-face shots are seldom very satisfactory and it is most important to try and catch the bird when an eye can be seen. A good highlight in this is an asset and almost certain to be obtained when using flash. Two lamps can be readily used and their synchronisation assured, either by the leads from each being plugged to a single lead which plugs into the X-socket, or the second and third tubes can be fired photo-electrically by a sensing device by which the main light triggers off the 'slave' lamps.

A variety of these remote-control sensors are available. They are small and inexpensive but for use in daylight must be firmly fixed to point at the main flash head so that they respond only to the light emitted from that. Furthermore, although their use may eliminate the need for leads from the camera to each head, connections are still required from the sensor to the slave lamp it serves. Thus it is customary to mount the remote control unit close to the auxiliary light which must, of course, contain its own power pack. Another system is to have both lights plugged into the one power unit so that the total output is shared between the two. For instance a unit that will give 100 joules when one flash head is plugged in, gives two 50 joule pulses with two lamps and so on. Again, both are fired simultaneously by one connector to the X-socket on the shutter. In general the greater the number of lamps fired from one unit the longer the effective flash duration.

Electronic flash at night

Nocturnal birds seldom respond adversely to electronic flash—it is over and done with before they have time to react and many owls, nightjars, frogmouths and suchlike seem to behave just as though the flash was a natural event, like lightning. If they are looking straight at the reflectors, however, the flash may temporarily blind them and if they are flying they are liable to collide with obstructions during their brief blackout. The good photographer avoids this. Owls are perhaps the most attractive of nocturnal species to photograph especially when the young are old enough to come to the entrance of their nest at feeding times, or in situations where the camera can view the inside of the nest—as may be possible with barn owls in pigeon cotes or with tawny and long-eared owls in the old nests of other birds.

Electronic flash in daylight

One of the snags encountered when using flash, particularly electronic flash, by daylight is its lack of penetration into the background. While the main subject may be well lit, the background is often underexposed and appears dark in the print or transparency. Thus a bird perched on a post in the sun and taken with electronic flash using a shutter setting of 1/250 sec will be almost solely illuminated by the flash if the stop is *f*16 or smaller with slow film. Little or no daylight will register and the

Fantail warbler: strong sunlight and very contrasty surroundings controlled with flash heads above and on either side of lens (photo John Warham).

Tawny frogmouth taken at night on feeding perch with one flash close to lens. Trunk in foreground is overexposed, but little control is possible with reversal film (photo John Warham).

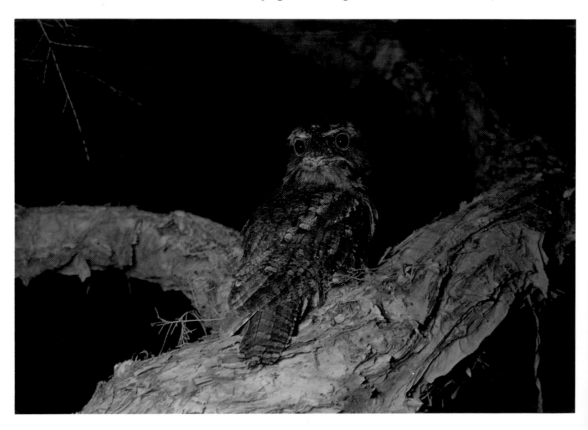

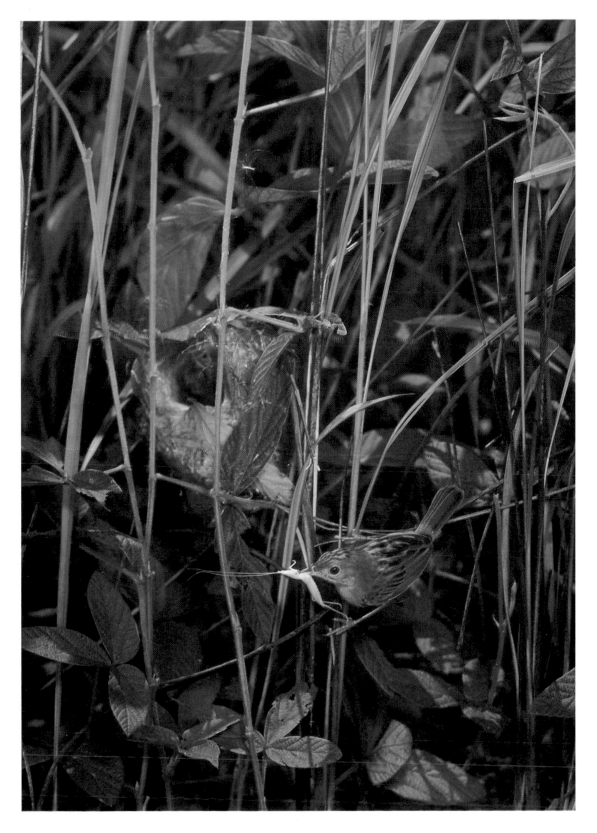

bird will be shown against a very dark or completely black background. If the species is a diurnal one then the result will be clearly quite unnatural; at night it would not be perched but asleep.

What can be done to avoid such false interpretations? In the first place the situations in which the photographs are to be taken have to be carefully selected. The nest sites most suitable for daytime flash photography are those with fairly close backgrounds—sites within crevices in tree trunks, in ivy against walls, in banks or termitaria, and so on. The background should not be too close, however, for it is better if it is slightly out of focus, otherwise the bird may be lost against it. Great depth of field is often a disadvantage when photographing birds.

There are times when birds at an otherwise unsuitable site may be photographed against a backcloth, but this is a procedure only possible with the tamest of species, with tits and garden birds for instance. A backcloth if used must be light in colour to be effective—pale green is as good a shade as any—and if possible it should be fixed little more than 0.6m behind the nest or perch. It is important to see that the material is quite tight and does not sag on its supports as folds will be very obvious in a print. A painted sheet of hardboard is ideal. Needless to say any backcloth introduced to a nesting site has to be set up in stages if the birds are not to be alarmed.

A synchro-sun shot of a brown honeyeater. One light illuminated the bird and flower, daylight only the background, which was underexposed a little to tone down distracting highlights from pale twigs (photo John Warham).

Blue tits: a high-speed shot taken in garden with two lamps against a carefully placed backcloth. The bird was caught as it flew from a perch (out of sight) to its nest along a prefocused flight path. Exposure about 1/3000 sec (photo John Warham).

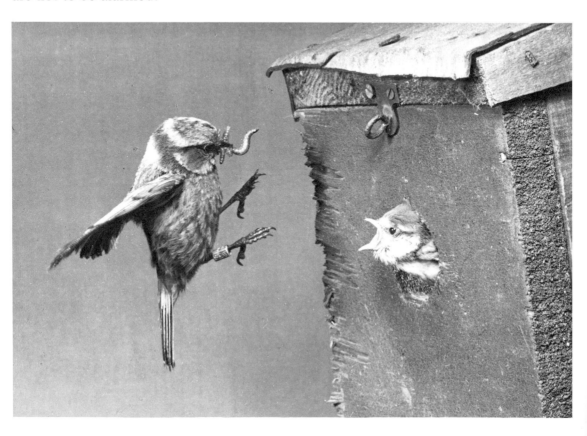

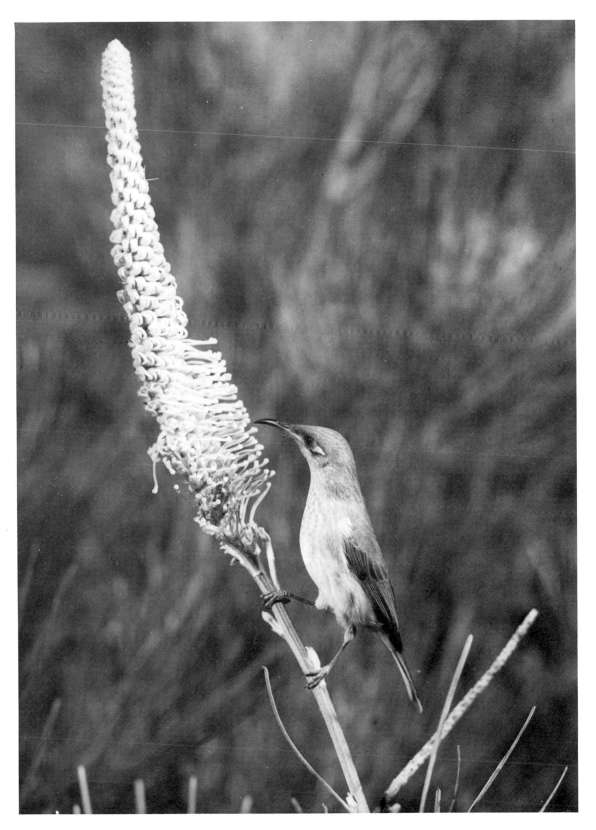

Another way in which black backgrounds may be avoided is to use comparatively slow shutter speeds so that both daylight and flash are recorded. A guide here is to set the shutter speed for the background and the iris for the flash. For example, suppose the flash requires an aperture of $f16$, an exposure reading of the background is taken and the shutter speed noted for an aperture of $f16$. If this is, say, 1/125 sec then a camera setting of 1/125 sec and $f16$ will provide a correctly exposed background, and the flash will fully illuminate the subject. If the natural lighting on the subject is as bright as that on the background, this might result in overexposure of the subject. The best course is then to reckon the aperture required by the flash as one stop smaller than it would normally require—in this case $f22$. The camera would then be set at 1/60 sec and $f22$; this gives the same exposure to the background as 1/100 sec and $f16$, but the smaller stop reduces the effect of the flash on the subject. If this is still too bright in the picture the process can be continued to 1/30 sec and $f32$, and so on.

The obvious snag with such a method is that an important advantage of electronic flash—its speed and consequent elimination of failures due to subject movement—is relinquished. If the bird moves during the period that the shutter is open, the daylight image will show movement and the picture will be a jumble with one image imperfectly superimposed on the other—'ghosting'. All the same, when you are not concerned with taking action pictures the method has much to commend it. A few experiments with various kinds of subject will establish the best relationship between stop and shutter speed when using daylight and flash together.

The tendency to light the background inadequately is aggravated if the reflector is placed too low. Ideally, to ensure that the foreground and the background of a nest are equally illuminated, the flash head should be vertically above it throwing the light straight down. Such an arrangement is obviously undesirable and impracticable so a compromise has to be made, the lamp or lamps being fixed well above the level of the camera and probably some distance forward of it. One solution which is sometimes possible is to fix a third lamp high up and well forward to illuminate the background. Generally, however, the foreground will get a greater amount of light than the rest of the picture. How to deal with this when printing is discussed later in this chapter.

Another reason for keeping flash heads high is that this helps verisimilitude in daytime shots. For these, the effect of the flash should be imperceptible; a low light looks false since natural lighting comes from above, not from below.

Projected or telephoto flash

Most commercial electronic flash units and flash bulb systems spread the light over a wide arc, as they are intended for use with standard lenses. If a telephoto is used, much of the light is wasted

and the iris must be opened up to allow for the rapid fall-off in intensity according to the inverse square law. With projected flash, however, the light is concentrated into a narrow beam so that, ideally, the field illuminated coincides with that covered by the telephoto or mirror lens.

Most flash makers provide adjustable lamp heads so that the light can be spread through wide and narrow angles according to the camera lens being used[37]. With this system, the bulb-to-lens distance is almost constant so that the range of concentration of the beam is limited and ineffective with telephotos of more than about 200mm focal length. With long telephotos and mirror lenses it is necessary to build your own system[38] or have one made to order. For this you need a Fresnel lens or screen.

Fresnel lenses are lightweight plastic screens cut into concentric prismatic ridges. They are of varying focal lengths and concentrate the light in the same way as do the big prism lens systems used for projecting lighthouse beams. By placing a suitable Fresnel screen the correct distance in front of the flash tube or bulb, the resulting beam is narrowed (see below).

The distance between the flash bulb or tube and the Fresnel screen is critical for controlling the beam angle. Ideally, the focal length of the screen needs to be adjusted according to the focal length of the taking lens. It has been found, however, that a Fresnel lens of 175–300mm focal length, set correctly in front of the flash head produces a very narrow beam and projects the flash a long way. For the best results, the distance between the face of the flash unit and the Fresnel lens has to be a little greater than the focal length of the taking lens. The precise setting has to be found by trial and error, by firing the flash through the screen at carefully measured flash-to-screen distances at a flat wall and examining the area illuminated by the flash in relation to that covered by the taking lens. The Fresnel screen can have either the flat or the ridged side towards the tube. With the latter, the ridges are protected from dirt, but the separation needed will be different from that with the ridged side outwards. Having determined the correct separation, a series of test exposures is made of the wall to establish the guide number for the film used. The separation between the flash head and the Fresnel lens is critical and must be fixed positively for consistent results. A simple housing made from a lightweight box or tube is con-

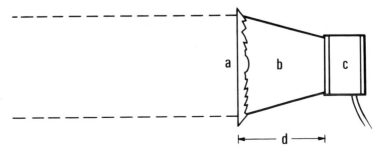

Projected flash using a Fresnel lens. The distance (d) needs to be slightly more than the focal length of the camera's telephoto lens. (a) Fresnel lens, (b) tube fitting tightly on flash head (c).

structed for this purpose, to fit tightly over the flash head and carry the screen at the correct distance for the taking lens.

Having concentrated the beam, it is also essential to see that the field covered by the projected flash coincides with the field covered by the taking lens. This means that the flash unit, with its attached Fresnel screen housing or reflector, must be firmly fixed in correct alignment with the lens. Usually the unit can be fastened via the camera shoe, but it may prove necessary to make some slight adjustments to ensure that the alignment is quite precise. With long telephoto and mirror lenses it may help to support the front of the telephoto-flash on the barrel of the taking lens so that any whip of the housing is eliminated.

This system becomes rather cumbersome with long lenses—say in the 1000mm range—because the Fresnel screen must also be about that distance from the flash. Miss C. Miles has pointed out to me that the screen-to-flash distance could be reduced if, instead of using a simple positive Fresnel screen, a Galilean telescope system was put together using a combination of a positive (enlarging) Fresnel lens set in front of a negative (reducing) one. With screens of the correct power correctly separated, this 'telephoto Fresnel' lens would be much more compact and manageable, but as far as I know such a device has not been tried although the screens are available[39].

The concentration of light possible with projected flash is great and very high guide numbers are attainable using fast film. Well-exposed photographs are feasible at $f8$ to $f16$ using 500 and 1000mm mirror lenses over distances as great as 70m or more.

How useful is projected flash to the bird photographer? Well, for work at nests and similar controlled sites using medium-range telephotos (85–200mm) there is little need to have a concentrated light source and anyway two or perhaps three heads are usually required, none on the camera itself. When stalking birds at dusk or after dark, however, a concentrated beam fired from the camera has clear advantages. It allows you to tackle birds in inaccessible situations such as those roosting high in branches or nesting in difficult sites where a near approach is impracticable. Daylight applications include stalking birds in forests or in other shady places and, in more open areas, as a fill-in light when using mirror lenses. The system can also be used with high-speed flash for flight studies of birds flying to and from nests or food sources where a close approach is either physically impossible or is undesirable for fear of alarming the subject, as with rare and endangered species.

High-speed electronic flash

High-speed flash is only essential when you want to capture really fast movement, particularly of small birds in flight. With creatures like humming and sun birds, tits, silvereyes, and wrens, all of which have high wing-stroke frequencies, even exposures as short as 1/5000 sec will not completely arrest movement, while

low-speed equipment would be quite inadequate. Thus if you really aim to tackle high-speed bird photography you need a high-speed flash outfit. You need at least two flash heads, each taking a flash tube. It is desirable that these both produce a total output of around 200 joules. This is adequate for most work, both in black-and-white and colour, using reasonably fast film.

Unfortunately high-speed battery-operated (and hence portable) flash outfits are no longer made commercially; lightweight low-voltage models dominate the market. There are plenty of mains-operated stroboscopes able to deliver very short flashes at high repetition rates but these are useless in field conditions and in any event produce too little light for our purposes. Hence high-speed units for field conditions have to be specially made.

This is not beyond the competence of a good electronics engineer. The man who designed the first of the modern electronic equipments, Professor Harold Edgerton, has published several practical circuits for outfits able to deliver short-pulse flashes lasting only 60 micro-sec or less (1/17000 sec) at intensities quite adequate for our needs[40,41]. Others have also published circuits for similar units[42,43]. Edgerton used xenon-filled fused quartz tubes such as the FX-113C-1[44] with special electrolytic capacitors. His designs can power three lamps. Any source of electrical energy producing 500V can be used, including dry batteries, although for some purposes a voltage regulator may be needed. Electronics is a rapidly changing field and published circuits are soon out of date, so it pays to consult an electronics expert before building your own unit to ensure you use the best, lightest and probably the cheapest components.

It is still impossible to combine short flash duration, adequate light output and really light weight in one package. Edgerton's three-lamp outfits, in a carrying case, weight about 9kg. This is certainly an improvement in weight on the two-lamp outfits of the late 1940s and 1950s, but is still sufficiently heavy to deter many potential users who work in rugged outback locations far from access by road. However, it should be realised that these new circuits do ensure that all movement is frozen, which was more than the commercial portable high-speed units achieved.

A unit such as Edgerton's is also quite compact, quiet and holds its charge in between shots with little drain on the battery. The recycling time (i.e. the time between flashes with a fresh battery) takes 5–10 sec, a reasonably short period, though longer than that is possible with many low voltage units.

Electronic flash and bird flight
Large birds like herons, eagles and geese are relatively easy to photograph on the wing, using natural lighting and a shutter speeded to 1/500 or 1/1000 sec. Small birds are much more difficult to portray well and, even at 1/1000 sec, most shots show an excessive amount of movement. High-speed flash is the answer, of course, but do not be misled by the specifications for

computerised lightweight units. In most of these the flash duration varies according to the flash to subject distance. The flashes may be truly high-speed at very short distances (about 1/50000 sec). Unfortunately, at the usual distances of about 1.5m or more at which bird photographers work, the flash speeds are quite slow. If you 'cheat' the control unit by arranging that some of the light bounces back to the sensor from a card set close to and to one side of the flash beam, and so get a short flash, the amount of light is reduced. For practical purposes it would be of little use with birds unless ultra-high speed film was used or the processing was forced.

The techniques for making flight studies of small and medium sized birds at close quarters are basically the same whether low-speed or high-speed flash is used. Low-speed units may give acceptable results in some circumstances, particularly with larger and slower moving species, but of course they will be pretty useless if you wish to 'freeze' rapid movers like tits, silvereyes or humming birds. For such work it is almost essential to take the bird on a known and predetermined line of flight. My pictures in this category are almost all taken as the bird flies from a perch to a given point—usually the nest or food—or as it leaves such places or alights there. The catbird picture below is a good example.

In setting up the camera for such shots a piece of string

Spotted catbird leaves its nest. A single flash caught the bird as it slid from nest in thick jungle habitat. The pylon hide used was sited for nest pictures, and a shorter focal length lens would have ensured that all the bird was in the frame instead of having a wing tip amputated (photo John Warham).

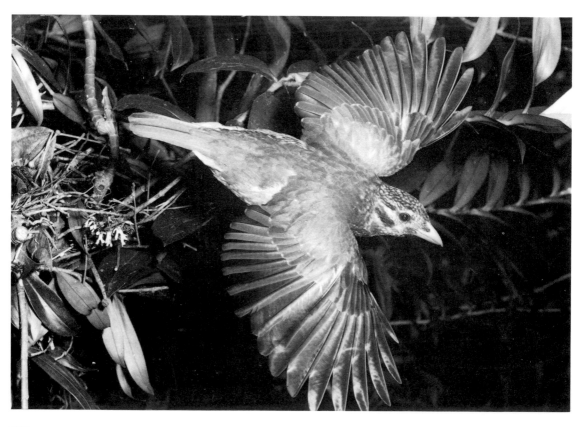

fastened from the perch to the nest, or a thin stick laid across these two, helps to indicate the expected path of flight and acts as your focusing guide. The bird's customary flight line will have been ascertained by prior observation. In this way you can train the camera to cover a definite section of the flight path. The guide should not be placed to coincide with the path of the bird's body, but should be placed a little forward of that, to come about $2/3$ along the nearer wing when this is at the centre of the down stroke. On stopping down, the band of sharp focus will then include the wing nearer the camera, the bird's body and possibly most of the far wing as well. If this line of flight is not exactly parallel with the plane of the film then, with a monorail camera, the side swing can be used to make the focal plane coincide with the flight path image.

A kingfisher diving from its nest. Without a photo-electric trip the cameraman needs to have a very fast response or the bird will have passed out of the picture area by the time the shutter fires. To reduce the risk of this the camera and hide should be set well back, thus increasing the flight path covered (photo Alan Shears).

Often the distance between perch and alighting point will not exceed 1½m, but the lens may well cover only a part of this path, unless the hide is well back. When taking the photographs you have to try and ensure that the bird is in the correct section of the flight path at the moment of flashing; frequently objects in the background can be used to help in gauging this. Obviously the bigger the field covered the more likely you are to get a good result. For these shots a 6 × 9cm camera seems to be a better proposition than 35mm, for it is much easier to blow up a small section of the large negative to give a good, sharp and grain-free

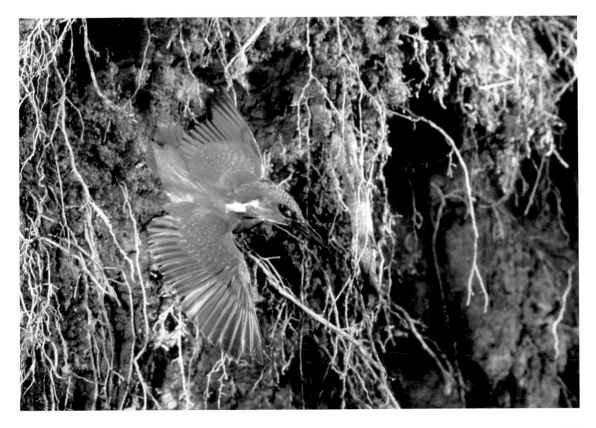

print, than to use a small portion of a 35mm negative. A 5 × 4in monorail camera would improve performance still further. For projection, only part of the transparency need be used.

As soon as the bird leaves the perch your fingers must be ready to press the release. Judgement of the correct instant is not easy and may follow as fast as possible on the bird's flight from the perch. The usual fault is that you press too late but skill does come with practice, though you are bound to have disappointments with beautifully sharp tails disappearing over the edge of the negative.

For flying shots by day a shutter speed must be chosen which is fast enough to prevent the registration of any daylight image, at least in that part of the picture where the bird lies. In the absence of an adequate background close enough to reflect the flash light back to the camera, the resulting photographs will look as though they have been taken at night. Careful selection of site and camera angle are again important if this is to be avoided. If no background is available you have to be particularly careful to see that any brightly lit areas, such as blobs of sky filtering through foliage, do not intrude. Otherwise you may find a patch of sky registering through the bird's wing. In the time that elapses between the shutter's opening and the flash, the sky may record on the emulsion, after which the bird's motion carries it forward until a wing comes into line with the light patch and in this position is illuminated by the flash. For such situations a focal plane shutter is not suitable; at least 1/200 sec is needed and this in effect means relying on a blade-type shutter.

A flying bird presents a much larger object than it does when at rest. A lens-to-subject distance suitable for a stationary bird will be too small for convenience when tackling flight studies. Clearly the further back you are the better your chance of catching the bird's image on the negative. So if you have been making bird-at-the-nest studies and want to take some flight shots, you have either to move the hide further back or switch to a lens of shorter focal length. The latter is generally more convenient and I find that after using a 135mm lens for 'static' shots, I can readily change to an 80mm one for the occasional flight photograph that may be needed to complete a series.

Relying on your quickness of response in pressing the release to catch the bird in mid-flight is good fun. Inevitably, however, there are many failures and you need to make a series of exposures in order to get a few that are sharp and show the bird in an interesting attitude. This can be expensive both in time and money. Some people just cannot acquire the knack of anticipating the bird's moves and of acting in time. So automation of the taking process has its attractions, particularly for those with a penchant for gadgets. Adaptations of laboratory techniques long used in ballistic and wind-tunnel studies, in which the bird itself triggers shutter and flash, can be used with wild subjects in the field.

Grey petrels in flight at night. One flash head was on the camera, the lens being set at a predetermined distance and the flash and shutter fired when the bird was judged to be at the correct distance. For such studies a 6 × 9cm camera with sports finder (page 31) is more effective than a 35mm SLR, as fast-moving targets at night cannot be followed in a normal viewfinder (photo John Warham).

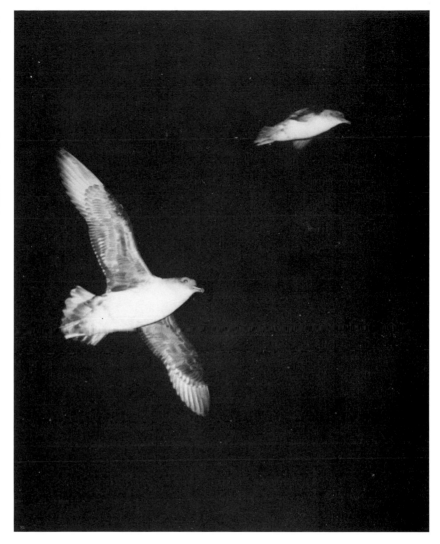

This system basically depends on having the camera shutter released by the interruption of a light beam, i.e. firing shutter (and flash) photo-electrically. The beam is carefully arranged so that the birds have to cross it when coming to their nest or perch. Interruption of the beam generates an impulse in the circuitry which in turn activates a solenoid which triggers the camera shutter and hence fires the flash tubes. The narrow beam is produced from a lamp directed accurately onto a photo-electrical cell. A red or an infra-red beam can be used, or the photo-cell can be arranged to receive daylight and its decrease, due to the passing of the bird, can be used to generate the pulse that in turn releases the shutter.

A number of circuits have been published from which the electronics gadgeteer can put together his own unit. This usually includes a small remote control box for switching the device on or off from a distance. The Heiland release[45] is often used for the

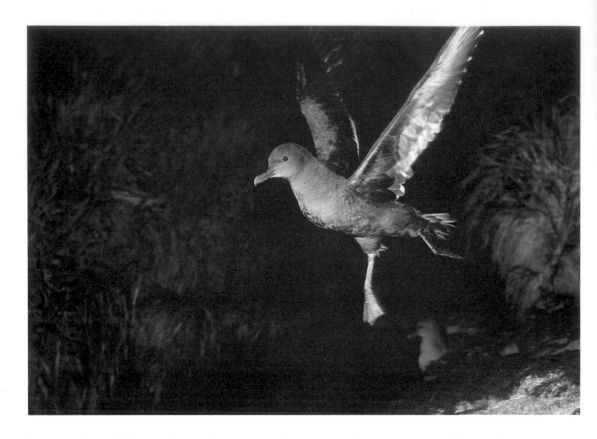

shutter solenoid but other makes are available. Published circuits for photo-electric releases should be used as guides only. A good electronics man will have ideas for simplifying the circuitry using the most up-to-date components and the result should be a better, lighter and probably cheaper job, quiet in operation.

A note concerning solenoid releases. These can exert a considerable pressure and it is important that they are adjusted to move the plunger through the correct stroke distance to fire the shutter and no more, or the shutter may be damaged.

There are a few general points to be mentioned about photo-trip devices. In the first place setting-up time is quite prolonged, for the components must be correctly aligned to function properly. This may mean subjecting the birds to more than normal disturbance. The extra time is taken up by the need to align the light beam on the photo-electric sensor precisely and to ensure that neither can move thereafter, for any movement will interrupt the beam and fire the shutter prematurely. Again, the actual positioning of the beam is very important if the bird is to cut it at precisely the point on which the camera is focused. It helps if the beam can be orientated to cover a substantial part of the flight path covered by the lens. The value of a large format camera is again evident. It is also possible to arrange for two beams to intersect and to have two photo-receptors linked to a circuit that will activate the shutter solenoid only when both

Sooty shearwater steps off: one low-speed flash attached to camera, which was prefocused for departure from rock. Foot shows movement, but not enough to be distracting (photo John Warham).

beams are broken. This means that the camera can be focused at the point of intersection of the beams and great precision in placing the bird in the picture space obtained. But clearly this system involves even more setting-up time and will fail if anything occurs to disturb the alignment of any part of the twin-beam arrangement. As with single-beam schemes the shutter will fire whatever breaks the circuit. Only too often this is not the bird, but a passing bug or beetle!

Photo-electric trip devices work best with blade-type shutters as, with these, the time lag between the initiation of the electric stimulus by the beam-cutting bird and the firing of the shutter and flash is so short that the bird has not passed beyond the point of a sharp focus. Here $6 \times 6\text{cm}$ cameras like the Hasselblad, or Linhof and such types with blade shutters, come into their own. According to T. Davidson, the author of one 'how-to-do-it' article on photo-electric trips, the delay in his circuit was

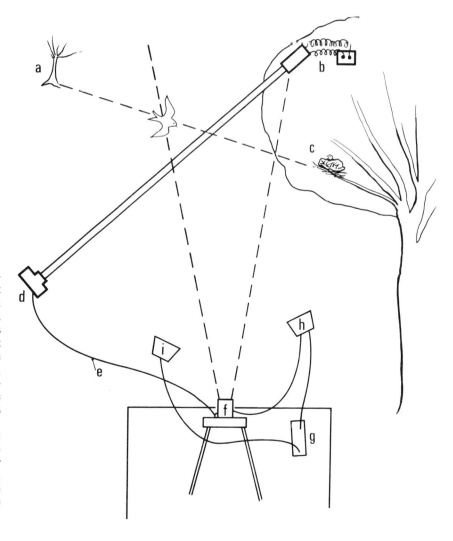

Arrangement of photo-cell control for flight photography. The beam is aligned across known flight path. Bird triggers circuitry when it has not quite reached the centre of the field of the lens, to allow for time lag between breaking the beam and the shutter's opening. (a) Perch, (b) lamp and battery, (c) nest, (d) photo-cell, (e) lead to solenoid or motor-drive, (f) camera, (g) power pack, (h) main flash head, (i) second flash head.

1/116sec[43]. The mirror locked in the 'up' position also helps shorten the delay.

Electronic flash in the rain

In a country with a climate as erratic as Britain, bird photography is by no means solely a fine weather pursuit and one advantage of flash is that you can use it instead of natural lighting. The weather may be fine enough when you enter a hide but during the course of the session storm clouds may roll up and with the bird now at its nest, perhaps only just back after a long absence, you may be unable to dismantle the flash gear without driving the bird off. You may, of course, have instructed your relief to get you out if the weather deteriorates, but quite often a fixed relief time has to be agreed which assumes fine weather. Your sudden emergence before your relief arrives is inadvisable and may prove disastrous to any chicks in the nest being shielded by a parent.

Thus the flash heads may have to be left exposed to the weather. With low voltage apparatus this is not much of a problem and some flash heads are sealed and may even be waterproof. If this is not the case, a simple answer is to slip clear plastic bags over each head at the start of the session and keep them in place with elastic bands. You can then carry on in the rain providing that the camera inside the hide can be kept dry.

The situation is more difficult when using high-speed flash, for any water leakage may cause violent short-circuiting and perhaps a serious electrical breakdown. The voltages set up in the power unit are high enough to be dangerous to the user and special care is taken in their design to ensure proper insulation. It is foolish to try to operate such gear in wet weather or other moist conditions without taking special precautions.

This sort of apparatus can, however, be showerproofed. The flash heads, being outside the blind, have to be tackled first. The bases of the tubes must be sealed so that water cannot trickle down to the contacts and this can be done with generous use of a suitable plastic insulating compound. Alternatively, you can try pulling a sleeve of thin rubber (such as part of a child's balloon) over the base of the tube and on to the top of the holder. In any event a polythene bag (deflated) should be pulled over each flash head and reflector. The power unit, being inside the hide, is less of a problem. It must be kept off the ground so that water cannot get in from below and can be completely covered with a big polythene bag. Usually it is possible to work the control switches and so on without removing the bag at all. See that water cannot run down the lamp leads to the plug outputs on the power units. Another point to insulate properly is the connection between the synchroniser lead and the flash heads. This may need sealing with a thin elastic rubber sleeve. These precautions will suffice to enable shooting to carry on during showers, but in the event of heavy and persistent rain the sensible course is to disconnect the gear and to see that it is thoroughly dried out before reuse.

When the humidity is high, even when rain is not falling, there is frequently a diminution of light output with high-speed units— power leaks away unused under these conditions. Another snag is that reflectors often become misted over in damp situations like marshes with evening mists and then they cease to reflect properly. This trouble can be countered by spreading a little glycerine over the reflecting surfaces.

Exposure, development and enlarging
The stop needed when working with electronic flash is readily determined once the guide number of the unit has been ascertained. This guide number or flash factor is a multiple of the lamp-to-subject distance and the *f* number needed to give properly exposed negatives or transparencies. When the guide number is known, the *f* number is obtained by dividing the guide number by the distance of the flash tube from the subject being photographed. The guide number increases with increasing speed of the emulsion used. Manufacturers furnish the guide numbers for their products but these are best used with discretion and are often rather optimistic. You need to make your own trials under characteristic field conditions. My practice is to keep a card in the camera case listing the meter settings for all the films that I use, together with the data for tungsten lighting and their correct guide numbers for my particular electronic flash gear.

Using a 100-joule high-speed outfit and one tube, you can expect to have a guide number of at least 100 (feet) with high-speed film. This means that correctly exposed negatives will be obtained at *f*20 when the lamp-subject distance is 5ft ($100 \div 5 = 20$), or *f*10 at 10ft and so on. The guide number known, it is only necessary to measure the distance from the subject, e.g. a nest, to the flash reflector and to divide that distance into the guide number to get the stop required. Be sure that the guide number given by the maker of the flash apparatus is based on feet and not on metres! Where two 100-joule tubes are used, both at the same distance from the subject the guide number will be around 145. If one lamp is nearer than the other, base the *f* number on the one that is the closer. The other is usually best ignored as it will be contributing little to the overall level of lighting. Many quite small low-speed units will provide enough light to give guide numbers of around 55 (feet) with medium-fast colour film, and such levels are really quite adequate for much bird-at-the-nest work, particularly if a second lamp can be added that doubles the total light output (the guide number is not doubled though, just increased by $\sqrt{2}$, i.e. 1.4 times).

High-speed flash gives images that are rather soft in contrast, though full of detail. It is usually best to extend development times to give greater contrast and increases of up to 50% of what would be given for daylight exposures are quite usual. Low-speed units need little if any increase. Once a satisfactory development technique has been arrived at to give the sort of negatives that

you prefer, changes should not be made until you have good evidence that worthwhile improvements are possible.

When enlarging from electronic flash negatives, some control is almost always needed to correct overlit foregrounds. The projected image is progressively shaded from the top downwards so that the foreground gets a longer exposure. In addition it is often found necessary to hold back parts of the background and to print out things like tree trunks and the fronts of nests which have caught the flash, to achieve an improved and balanced picture. When you have used colour reversal film, of course, nothing can be done about this sort of blemish—you have no control after exposing, so great care needs to be taken to see that the lights are placed so as not to overexpose objects in the foreground. This generally means keeping the lamps quite high, well above the camera level. If you use colour negative film, some control is possible during printing and this is definitely feasible when printing on papers like Cibachrome directly from positive transparencies.

Filming with artificial light

It is comparatively easy to take stills of animals in the dark by using flash, but it is a different matter trying to film after dark, because nocturnal animals are clearly unlikely to be keen to face floodlights. Even if they would accept them, there is no means of powering lights in the vast majority of wildlife situations.

So it is not surprising that until recently very few wildlife films had been made at night. My first attempt was in 1949, when I took some black-and-white film of a pair of barn owls feeding chicks in their church tower eyrie[46]. The church was wired for electricity, so that I was able to get plenty of light with two 500W floods at about 2m. The intriguing discovery was that the birds took absolutely no notice of the lights, but shuttled to and from the nest without even looking at them. They must at least have felt the heat generated.

V.W. Smith and R. Killick-Kendrick filmed a marsh owl in Nigeria. The light came from a portable electric generator via 100m of cable, a variable resistance and a 500W lamp. The light was turned up from a dull orange glow to full intensity after the bird had returned to the nest. These photographers made the interesting observation that 'after its initial nervousness the bird accepted the full intensity of the light quite unperturbed, though half the swamp was bathed with a dazzling light'. It seems from additional information given to me by Dr Killick-Kendrick that even this initial nervousness could have been induced by the sound of the generator only 100m off, rather than by the noise of the camera itself.

Since then many people have shot film of birds using artificial lighting. Sometimes the light is needed to take diurnally active species in dark situations. For instance, swallows nesting in barns, outbuildings and under dark eaves usually require extra lighting,

and this is often easy enough to arrange by plugging in to the mains. C.K. Mylne's RSPB film *Swallows at the Mill* is one of several in which the swallow nesting shots were obtained with the help of photofloods powered from the mains supply. The birds took little if any notice of the lights. Maurice Tibbles's excellent BBC film on the domestic pigeon provides another example[48]. Here, artificial lighting was used discreetly for the shots of nests inside buildings. Swifts too inhabit dark nesting sites beneath eaves. Charles Palmar tells me that his swifts showed some unease when subjected to photofloods, but thinks that had he used a dimming switch they would have been quite relaxed. Their uneasiness could have been as much the result of camera noise as of the lights.

Lights (or mirrors to deflect the sun's rays) are usually necessary when filming in caves, and cave-dwellers include not only bats but also a surprising variety of birds—swiftlets, sun birds and others. Most of these occupy dark niches in the cave walls and cannot be shot without supplementary lighting. Much the same applies to the darker parts of the rain-forests. For such conditions the ideal solution would be to use a portable lighting plant from which conventional floods could be fed through a dimming switch, but the ideal is often unattainable in wildlife work and there are plenty of situations where the going is too tough to use portable equipment of this type without a team of helpers. Nevertheless, small and relatively portable generators, quiet in operation and able to power 100–200W AC lights, are readily available and in conjunction with fast film extend the possibilities of filming with lights powered directly from the generator.

Television cameramen often use battery-powered lights or 'sun-guns' for shooting short news interviews and similar camera lights can be effective when filming birds after dark or under poor lighting conditions.

Suitable equipment can be bought off the shelf, but all have the disadvantage that a battery pack light enough to be carried around in field use will not produce a beam strong enough for shooting at 24 fps and maintaining a steady colour temperature for more than 3–5 min continuous filming. Attempts have been made to rectify this. One firm makes a power pack of batteries in the form of a belt that is strapped onto the cameraman[49]. More usually, powerpacks are carried slung over one shoulder.

In selecting one of these outfits it should be remembered that all need some AC supply mains (or portable generator) to recharge the batteries after use. Then again, for wildlife work, the lamps have to be used in the open, perhaps in humid conditions, and it is essential to see that they can be used in such conditions without damage. As high voltages are not involved, there is no danger to the operator, but a fair amount of heat is liberated and proper ventilation is needed. Ideally, too, you need two lights so that some modelling can be attempted and the heads

should be capable of being set up on stands. Finally, for this special application, instead of the usual on-off switch, a dimming switch is most desirable so that the lamps can be turned up gradually to full strength. This is probably unimportant where the lamps are used in daylight—most animals will hardly notice them at this time anyway.

Spotlight filming

Now that really fast cine films are available, spotlight cinematography is a possibility. Indeed, this was done by Mortimer Batten years ago[50], when he fitted powerful headlamps in his car and directed the whole thing on to his quarry. Spotlighting depends on the fact that many nocturnal animals are dazzled by a strong light beam. They can be held in the beam and approached quite easily. Flying birds can sometimes be pinpointed so that they gradually slide round down the light and can be literally picked out of the air. You must not make a noise or allow any part of your body to get in front of the light.

For photography, spotlight and camera are mounted rigidly together on a bar and the light is then accurately centred so that at a distance of from, say 10m to infinity, the beam falls on the middle of the field covered by the lens. For shooting at night, no viewfinder is used. As long as the bird is held in the centre of the light its image will be in the centre of the picture area. The spotlight needs to be powerful and the bulb is set in the reflector so that at the taking distances envisaged, the beam is neither too concentrated nor too diffuse, but gives a reasonably even illumination over most of the area covered by the lens. The beam needs to be rather narrow in order to concentrate the light and in any event need not be wider than the quite small area covered by the telephoto lens. The battery must be fully charged and filters may be needed to ensure an acceptable colour balance. As soon as the battery starts to fade, colour balance may be drastically shifted towards the red.

A spotlight can be made quite easily and cheaply. I fitted a 100W quartz-iodine bulb to a reflector taken from a 'sealed beam' car headlight. By squeezing the circular reflector in a vice it was distorted so as to throw a horizontal ovoid of light. After careful experiments to establish the correct position of the bulb in the reflector, I can light up an area a little larger than that covered by a 75mm telephoto lens. Having had a simple camera shoe fitted to the Bolex, the spotlight is attached directly to the camera so that the centre of field of the light coincides with that of the lens. Concentrated like this, the light at night is startlingly bright and with average backgrounds and 160 ASA colour film I can shoot at $f5.6$–$f8$ at 24 fps. Indeed the light is sufficient to shoot even on slow film at around $f3.5$.

The unit is powered by a conventional lead-acid 12V motor cycle battery. Fully charged this allows about 3 min filming before the light starts to tail off and to redden, but with judicious

nursing, allowing the battery to recover after each shot, a single fully-charged battery gives quite a workable shooting time. In 5 min you can shoot 180ft of film at 24 fps and it would be possible to carry a second battery-pack to double the available shooting time.

This arrangement can be operated by one person, an asset since night-time work can be quite tricky and we are not very well adapted to operating after dark in the woods and fields ourselves. Hence the fewer the number of people trampling around the less danger of disturbing the quarry.

My spotlight's main function has been for filming petrels at night on their breeding colonies. Here thousands of birds are

A 16mm cine camera fitted with standard camera shoe to take a bracket holding spotlight head. 100-watt quartz-iodine bulb was powered by 12-volt accumulator. Spot is adjusted so that centre of beam coincides with centre of picture area. (photo T. R. Williams).

sitting on the surface or at the mouths of their burrows and although they are reasonably tame they are also easily scared. If you tread on one in the darkness it flails off into the night and most of its neighbours scatter in alarm. Hence when filming them I find it much better to work alone and to move quietly and cautiously through the colonies.

The light thrown by the spot is intense and if turned suddenly onto a petrel it jumps as if hit by something solid. Really engrossed birds will continue their courtship and other activities in the full glare of the light if it is switched onto the ground or vegetation nearby and then cautiously shifted directly onto them. If the spotlight has been correctly centred and the stop and taking distance set beforehand, then filming can begin as soon as the birds are in the centre of the light. The added lamp and its bracket increases the camera weight but I find that the support of a monopod helps to give steady pictures without reducing flexibility and portability significantly. The battery is carried by means of a case and a shoulder strap.

The Peace River Films team[51] used a quartz light focused by a parabolic reflector which was tripod-mounted rigidly with the camera for filming animals after dark during the production of their film on a pond eco-system *Still Waters*. As others have found, most of the nocturnal species encountered were not afraid of the light.

Colour balance seems rather less critical when filming at night. At any rate I have mixed spotlight sequences taken on three kinds of Ektachrome in the same film without changes in colour quality being apparent or raising comment.

Quartz-iodine or similar halogen lights operating in the open are not dangerous, for the voltages are low and the bulbs do not shatter if splattered by rain, but they should not be handled with the bare fingers, even when cold.

Another way to build a spotlight for filming would be to concentrate the light from a halogen lamp with a Fresnel lens in the same way as described for projected flash (page 171). Separate assemblies would be needed to match different lenses, as a beam concentrator designed to fill the frame for a 75mm lens would give too much spread for a 150mm one.

Bird photography on expeditions

This chapter concerns the role of the bird photographer on expeditions which have mainly scientific objectives. An African safari, for example, is a quite different enterprise and, while it may be an excellent way of getting to know the larger birds and mammals of a particular area, it is not appropriate for the serious bird photographer whose subjects' activities seldom fit in to the strict timetables and itineraries of packaged tours. Furthermore, you are often prohibited from leaving your vehicle!

On most expeditions the photographer's main concern is with cinematography. Stills tend to be supplementary to film-making, with individual expedition members responsible for their own records of their work.

The kind of cinematography done by zoological expeditions varies from the collection of film which may be used commercially and may contribute towards the costs of mounting the expedition, to film of purely scientific value. Often the duties of photographer are delegated to a member with some knowledge of the subject who also has his own research progamme to pursue. In practice, the research naturally tends to get priority. This is not a satisfactory arrangement for achieving high-quality photographic coverage. If it seems probable that a good film will have worthwhile commercial possibilities—not forgetting the income likely to be derived from sales of stills for articles and picture stories—then a member whose full-time job is photography will be needed or a good deal of money and film is likely to be wasted. Judging by some of the results it often is! On the other hand, if filming is to be just a means of making scientific records, then the ornithologist concerned will usually have to do the shooting himself.

An expedition photographer needs to know beforehand his terms of reference and unambiguous arrangements should be made as to the ownership of copyrights in exposed material. The matter has been discussed by Holdgate at a conference on photography on expeditions[52]. (See also books on photography on expeditions[53].) The photographer also needs to have a reasonably clear idea of the sort of situations in which he or she will be expected to operate and the sort of subjects to be filmed, in order that the right equipment can be assembled. It is necessary to know, for instance, whether hides will be required, whether he should budget for shooting any high-speed film, how much film will be needed and how much can be afforded (the

minimum is probably three times the footage of the intended film), whether macro close-ups are to be shot and so forth.

There is a lot the expedition photographer must do before the party leaves. Hunting for the right equipment for the job may involve testing secondhand items. Cameras should be checked over and lubricated by the makers and the cameraman must make some trials with these and inspect the results carefully long before departure. Indeed, by then he should be completely familiar with all the equipment and its idiosyncrasies.

It is usual to take colour stock all of the same batch number to ensure that the colour balance is uniform. If this is done, a roll should be test-exposed and processed before departure, just to confirm that the batch is faultless. Arrangements may also have to be made for the exposed 'rushes' to be cleared through customs, processed and viewed by someone responsible who can, if possible, advise the expedition on the quality of the results. For dealing with these matters a shipping agent may be needed. He cannot only clear exposed film but advise on deposits and documents needed to get equipment and film stock through foreign customs and import controls.

Firm arrangements must be made, too, for the storage of processed film until the expedition returns. In many countries the film makers and wholesalers have their cool rooms and, if approached beforehand, will take care of film while the party is away. Needless to say, all concerned should know the aims of the expedition and every effort should be made to interest the film manufacturer and the suppliers of equipment in the work of the party, as their help may be needed if anything goes wrong.

When the film is intended to be a major source of income, then clearly a spare camera will be essential, otherwise an accident halfway through shooting will mean not only the end of the film project but also a waste of time and money and a lot of unusable film. Similar reasoning cautions against too much reliance on a zoom lens as a maid-of-all-work. This can easily get a bad knock in the expedition's first days in the field and thereafter be useless. If it has been carried instead of a battery of separate lenses, such a loss might deal a fatal blow to the photographic programme.

Duties of the expedition photographer

The spare camera need not be the latest model, but it must be reliable and its efficiency must be checked. This camera should not be regarded as something that all and sundry can play about with. It is there as an insurance and as a second camera, and your safest stance as photographer is not to accept the proficiency of your fellow members as cameramen at their own valuation. You may have to be quite tough on this point until there is practical evidence of their competence and reliability.

The expedition photographer's job is often difficult, not only because he may have to film under trying conditions but also because, if he is to get good sequences of members in action, his

work is likely to conflict with theirs. Unless care is taken, he may become rather unpopular. At times he may have to interrupt their work and hold up progress while some incident is filmed, even re-enact episodes in the field. Thus the whole party must realise from the outset what is involved, understand the photographer's role and agree to co-operate in making the film a success. How this is done will depend largely on the personality and good sense of the photographer himself and of his sense of proportion. He should try to indicate to members, while the expedition's programme is being planned, the sort of things that he thinks should be taken. Later, the specialists themselves may suggest appropriate occasions when a cine record should be made.

The more the cameraman knows about the birds and their habits in the region where he is going to work, the more useful he will be to the expedition as a whole and the better able to anticipate the demands to be made upon him. He should obviously read up all that he can about the country beforehand. Knowledge of local conditions may be very important, whether certain subjects are taboo, whether photography at night is allowed, and so on. Also, as there are very few places nowadays which people have not previously visited, other films may have been shot in the region planned for the expedition. Some effort should be made to look out such films and to view them, by contacting appropriate organisations like the National Film Library and the Scientific Film Association in Britain. Such films, even though quite old, may provide valuable leads on shots that should be taken and on what aspects of biology have already been covered.

Even if your shooting location is outside the tropics it may be necessary to pass through them to reach the expedition's locale. Raw stock sent by air should not suffer much in transit, though planes sometimes stand in very hot places at intermediate staging-points. More care is needed if it is being shipped by boat. Here film must be carefully stored; the holds of ships are often far from cool. If accompanying members of the party are travelling by sea, it is perhaps best to have the film packed in several sealed boxes and marked 'wanted on voyage'. It should then be possible to keep an eye on the temperatures and if necessary arrange with the purser for the boxes to be loaded into a cool store or refrigerator along with the meat. Make sure that the boxes do not get buried when new supplies are taken on board!

In the field at last, there are many points to watch. For one thing it is important to get the first exposed reels back to a processing laboratory for a report, while reliable lines of communications to civilisation remain. These lines should be kept open as long as possible. Once satisfactory reports have been received filming can proceed with greater confidence, but regular checks should continue to be made via the agents in the country where processing is being done. This will not necessarily be in the

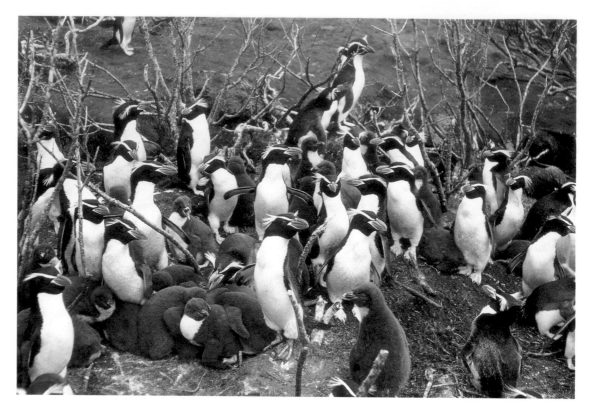

home country. The nearest reliable laboratory may be much more convenient than this. When despatching the exposed takes the possibility of loss *en route* should always be borne in mind and all the photographic eggs should not be entrusted to one basket if this can be avoided. Vital shots should always be duplicated when practicable, preferably on the spare camera, so that key takes are on different rolls and can be despatched at different times. Whatever method is employed the exposed film, whether cine or still, should be sent by the quickest and most reliable means to the processing laboratory or the photographic wholesaler's cool room. Prompt despatch is particularly important when you are working in hot and humid conditions.

Developing the story line

While shooting, the cameraman should be turning over in his mind the possible ways in which the shot will fit into the film. In so doing he will come to realise when and where subsidiary shots are needed and will take these there and then if possible.

The story line may be dictated by the objects of the expedition or it may evolve only slowly during the course of the shooting. The easy way out is simply to build up the film around the expedition and the birds studied, i.e. it just becomes a documentary in which the scenes follow more or less naturally in chronological order. Many expedition films follow this pattern, which tends to be monotonous. We see the same old scenes time

Penguins live far from processing laboratories, and exposed film may have to be stored for months before development. But although most penguins do not inhabit Antarctica (as popularly thought) they do live in cool temperate climates where film can be stored in sealed containers with desiccator, underground or in cool caves; see page 207 (photo John Warham).

and again—people digging out Land-Rovers, jacking Weasels from crevasses, inching cautiously round precipices and this sort of thing. The cynic often suspects that the predicaments depicted would never have arisen had the expedition members been more experienced.

A more enterprising approach uses a story-line threaded through a basic idea around which the whole of the expedition's work can be seen to revolve, about the fauna of the region viewed from some selected angle perhaps. The expedition's doings may feature only to a limited extent required for the maintenance of adequate human interest. It may be impossible to envisage this type of treatment beforehand. The possibilities may only become apparent when shooting is well advanced, perhaps through discussion among fellow members who may have quite original angles to suggest. But the sooner the treatment is roughed out the better for the photographer's peace of mind, so that he can make certain that appropriate linking sequences are taken to ensure continuity.

It hardly needs stressing that the cameraman must make notes of all the shots he takes. Film processing laboratories supply camera report sheets for this purpose and on these full details are kept of every take. If a sound track is also made, a separate magnetic sound report will be needed. The more detailed these reports are the better. This information will be vital later if the

King penguins and chick: the picture tells a story, but not quite the one that might appear. The hungry chick is probably going to get no food, as the adults are bystanders, not the parents, and they appeared merely puzzled by the chick's supplications. For a penguin group this is quite well composed, devoid of fussy background, but catchlights in the eyes would have helped. A tele shot on 35mm SLR (photo John Warham).

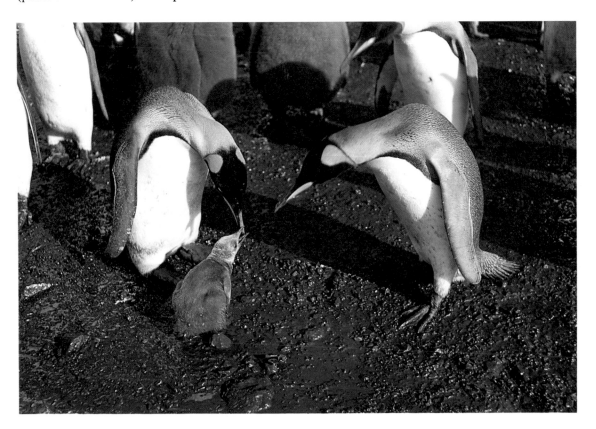

191

film has to be edited perhaps thousands of miles from the scene of the shooting. A register of exposed material in which each roll is allocated a number must be kept. This number can be scratched on the end of every roll, so that eventually each can be tied back to the report sheet. In cables or correspondence the various rolls are referred to by this number which is beneficial to precision and economy of words.

In addition to shots of the birds and of the members of the expedition at work, the photographer needs adequate material showing the other animals and their habitats. When based on a restricted area like an island or working from one location, it is an excellent idea to take the scenic material soon after arriving, because the whole area is then new to you and first impressions are most vivid. If left until later, familiarity may blur perception and you may even forget to make the shots at all.

These scenics may be the first to get back to the laboratory for a report. Once again look out for visual variety, vary the angles of the shots and take advantage of interesting light or cloud conditions and suchlike. Many of these shots will be discarded in editing, but there can be little variety in a film if a conscious effort is not made to get varied material on location. If your notes are reviewed regularly, it will be apparent which shots are still missing and action can be taken to make good these deficiencies. Once back home it is very unlikely that the money will be available to return for retakes, at least in wildlife work!

Care of film and equipment
When on the move the cameras have to be kept ready for use. They can be held in sealed plastic bags that can be quickly removed while getting into position for shooting. A monopod proves handy on these occasions if there is no time to use a tripod. The cameraman needs to have a nose for interesting happenings and must anticipate openings for unusual and significant shots and must plan accordingly.

If it proves impossible to get exposed material back and to receive regular reports on this, even more care must be taken to check the cameras regularly, clean the mechanism and gate and so on. Processing colour in the field is out of the question, but a few 50ft rolls of monochrome can be taken and processed with the aid of one of the various daylight-loading tanks, which usually handle 100ft of 16mm film. Inspection of the results with a pocket magnifier enables mechanical faults, dirty gates etc., to be identified and rectified. Such a system of insurance against losses through unperceived errors or faulty gear should be seriously considered if normal checks seem out of the question.

Exposed film must be treated with great care. If it cannot be flown out, then it should be sealed up in its original can with tape and the correct report sheet attached to the can with any special instructions, such as for forced processing and so on. If the original can is not available all misleading labels must be

removed. The cans should then be loaded into another container. Biscuit tins are good because the lids can be soldered on and the whole made watertight. A bag of dried silica gel can be put inside before sealing. But do not forget to label them clearly or to paint their contents on each one—and keep them out of the sun! These tins in turn can be placed in wooden or cardboard boxes for additional protection before despatch.

There will be times when the camera has to be loaded on to the photographer's back and carried, perhaps for long distances. Take a minimum of equipment—the zoom may be useful here. Remove the camera from its case and carry it in the rucksack inside polythene and cotton bags fastened by a draw string. Rely on a monopod for support.

In the heat

The tropical regions of the world are well known for their wealth of animal life and for the colourful and even bizarre kinds of birds to be found there. Endless opportunities exist for bird photography and, although much fine work has been done in the warmer parts of the world and in the southern hemisphere, many species have yet to be photographed and many more have only been pictured quite inadequately.

The conditions under which bird photography is undertaken in tropical areas may by very different from those prevailing in North America or Britain. Heat, humidity, and dust raise problems, as does the frequent shortage of water suitable for processing stills. Bad communications are often a bugbear. An advantage is that the weather is often predictable with cloudless skies day after day, while the rains may fall at more or less regular seasons, during which movement of vehicles may be impossible. Breeding seasons generally follow the rains, though many sea-birds nest all the year round. The general methods of using hides and blinds as described in previous pages still apply. It is surprising how timid many kinds of birds prove to be in remote areas where human beings are seldom seen.

Nesting birds in colonies

The tropics are noted for the large colonies of seabirds—sometimes numbering a million or more individuals—which resort to isolated islands for nesting. Such places offer wonderful opportunities for photography. The birds may be very tame. I have walked through colonies of noddy terns where the nests were so thick on the ground that I had to step over the sitting birds, which refused to leave their eggs, merely raising their beaks and wings in aggressive display. It is unnecessary to use hides with such fearless individuals, but I always prefer to work concealed when time allows. This ensures that your subjects act naturally, carry on with their domestic duties—feeding the chicks, courting their mates, bickering with their neighbours—without being distracted and angered by your movements.

The enormous numbers of birds in such colonies raises special problems. One of these is how to isolate individual pairs for photography. Although you may wish to show something of the colony as a whole and to include many nests on one negative or film sequence, for close-up work it is better to concentrate on a single nest. It may be difficult to find one where the heads or tails of neighbours do not intrude distractingly into the picture area. The thing to do is to search around the edges of the colony where isolated pairs are more frequent. If the hide can be sited to overlook several nests some feet apart, then it is possible by swinging the camera to get shots of each (perhaps at different stages of the breeding cycle) during a single session. With tame birds of this kind it is sufficient to fix up the hide without any preliminaries, but it is generally best to leave it in position for a day or so beforehand. Even with isolated nests it will be found that off-duty birds frequently walk into the foreground to sleep or preen just where they are out of focus and unwanted, but that is only to be expected in such crowded communities.

The huge clouds of birds hovering over their breeding grounds are well worth recording, but your efforts to do this may be foiled time and again by a knot of inquisitive or aggressive individuals which hang calling in the air above. Some of these generally succeed in getting into the picture and, being far too close to the camera, spoil shot after shot. Where such numbers are encoun-

Brown booby and chick taken with available light on a coral cay. Note how the bounce light from the sand fills the shadows below the bird and reduces the overall contrast. 35mm SLR and 135mm lens (photo John Warham).

tered, camera and cameraman inevitably get spattered with droppings.

A tremendous amount of light is reflected from the sand and coral beaches typical of many tropical seabird colonies and small stops and short exposures are possible. Situations tend to be contrasty, but reasonably good negatives can usually be produced without the need for a flash fill-in, if you slightly overexpose and curtail development a little. When filming great care is needed in exposure—see below.

Baiting in the tropics

Two forms of bait are particularly effective in hot climates— carrion and water.

Carrion in the form of carcasses, entrails, waste food and so on, forms a powerful attraction for birds like kites, vultures, many kinds of eagles and sea eagles. The hide, for obvious reasons, should be pitched up-wind and well away from the bait and should be set up days or weeks before photography begins. If a perch can be provided on to which incoming birds can alight before dropping down to feed, so much the better. Or the bait can be placed near some existing perch.

Water exerts a powerful attraction to birds of many kinds, the more so during dry seasons and periods of drought. Advantage can be taken of drying up water holes, in the beds of rivers and elsewhere, to site a hide and record the various visitors that come

These pelicans and their creched chicks are shown on their hot, arid nesting islet. The birds are timid, and this long shot was made with a good tele-lens well stopped down. Despite the high ambient light levels with glare from sky and coral sand, the contrast range was not excessive and overexposure is all too easy under these conditions (photo John Warham).

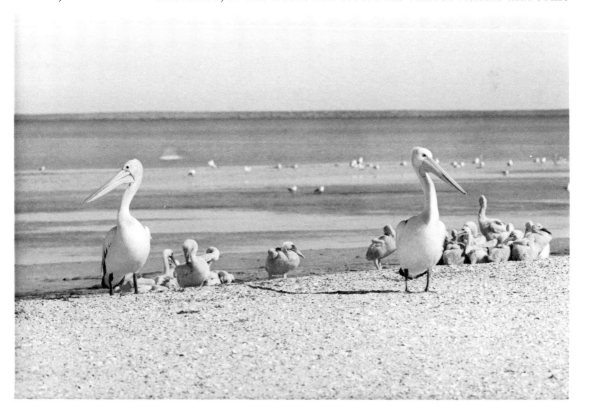

to drink. The photographer can also provide a water-bait in the shape of an artificial pool, and the best method is to arrange for the water to drip down from a can set up in a nearby bush (page 91).

Swamps, deserts and forests

Bird life is often prolific around tropical swamps and lakes and methods of finding a nest follow the same patterns as in more temperate regions. Mosquitoes are usually bad and so are the snakes. An inflatable rubber dinghy is very handy from which to search the edges of the water. If the lake is shallow enough for wading, the dinghy can be used for towing gear to and from hides placed in trees, or on islands rising from the water.

In semi-desert areas, thorny scrub is widespread and even this arid country may carry many breeding birds following the rains. The bushes may grow up to 9m or so, but generally without a straight branch in them and are unsuitable for hide making. Yet at times nests may be everywhere among the scrub—eagles and hawks in the bigger bushes and other birds lower down. Long hide poles have to be included in the equipment if it is intended to tackle the higher nests in such terrain.

On sand plains and deserts, it is a sensible precaution to fit an optical flat into the filter holder in front of the lens to protect it from the scouring action of wind-blown sand. The same device will prevent salt spray getting to the lens surfaces when the camera is used by the sea. When sand blows it is difficult to keep cameras and equipment clean, but this must be done somehow or much damage may result and films may be ruined through abrasion marks and 'tram-lines'.

In forests and timbered country, the common problem is the excessive contrasts encountered owing to the patches of light that filter down through the trees. Even among scrub, nests and their surroundings are inclined to be very contrasty and much tropical bird photography suffers from excessive 'soot and whitewash'. With stills the problem is easily solved by the consistent use of flash fill-in and the rule given earlier, 'aperture for the flash, shutter speed for the background', again applies. Since the sun is generally high in the sky, reflectors will be placed at camera level.

I find a satisfactory arrangement is to have two lamps, only one of which is used at a time. With the hide placed north of the nest (in the southern hemisphere) the righthand flash is used in the morning when the sun is coming up from the east, and the lefthand one fills in the shadows as the sun moves towards the western horizon in the evening. Electronic flash is ideal. Even when using a fill-in flash, attention should be paid to the background, for bright branches and leaves may be very distracting and should be removed or controlled.

The background problem becomes acute when working in the tree-tops since the glaring branches behind the nest form a definite distraction. Some amelioration can be effected by

restrained use of flash fill-in, taking care that the shutter speed selected underexposes the background a little, but not enough to create a night-time effect (page 166). Sometimes little can be done. It is impossible to clamber out to the offending limbs and no use waiting for dull days—they may take months to materialise. Some improvement may be possible by printing-in the denser portions of the negative during enlargement, by overexposure and underdevelopment, or by overexposing and aftertreating the negatives with a reducer of the ammonium persulphate type which reduces contrast without eliminating shadow detail.

The conception of rain forests as habitats teeming with life, with exotic birds dancing in the tree-tops, and with bugs, snakes and leeches to torment the traveller, is somewhat overdrawn. Some rain forests may be rich in wildlife, others, for no obvious reason, are poor. In some you are pestered by insects, in others conditions are quite tolerable. What the photographer finds most troublesome is the lack of light and the high humidities.

At times I have found the light so low that even at noon there has been no appreciable deflection on my meter. Flash solves the problem with stills but without auxiliary lights filming is impossible. If you have to include the forest floor in the picture area, care should always be taken to avoid underexposure. The dark, moist earth of these forests is extraordinarily light absorbent and underexposure is all too easy.

The light problem is best solved by working at the edge of, rather than inside, the jungle. In most places likely to be reached by the wildlife cameraman, trails exist. There are the access tracks cut by timber workers and tribesmen, clearings made by foresters and miners and so forth. These places offer opportunities of seeing and photographing the rain forest birds without having to machete your way yard by yard through vines and lianas and, more important, the lighting is better here. A freshly cleared section soon becomes clothed with secondary growth, but for several years such places provide areas of light in the darker climax forest. Furthermore, the birds are more varied in such places than they are beneath the closed canopy.

When filming under the canopy, high-speed stock will be needed. Along tracks and clearings slower film may suffice, but the contrast range has to be watched and a fill-in light will often be of great value if of daylight quality. Backgrounds, too, tend to be troublesome, particularly small things like the shiny leaves commonly possessed by tropical plants. These can sometimes be removed or the viewpoint for the shot may be altered to avoid them.

Some birds of course, keep to the dense vegetation and can only be photographed there. Others are canopy dwellers and never descend to the floor of the forest. If you have to film them, then you have to get into the canopy too. Clearly this calls for detailed knowledge and plenty of local labour to build blinds in

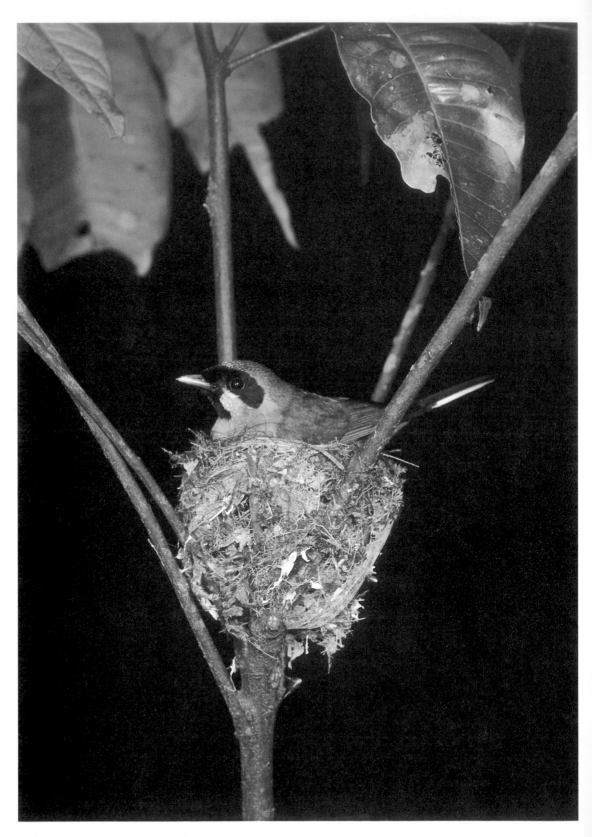

the tree-tops, etc. Times when the effort is most likely to prove worthwhile are when isolated trees, in bloom or in berry, are flooded with birds attracted by the harvest of fruit and nectar.

The rain forest is not the best place in which to sit still for hours at a stretch, but the nature photographer often has to do just that. You have to cope with conventional pests like mosquitoes and less familiar ones like leeches or disease-carrying ticks and mites. In Queensland I used to spray the inside and outside of my hide and the vegetation immediately nearby with an insecticide before starting work. I find this essential, because mosquitoes find hides most attractive as daytime refuges, yet they don't stop biting then. I also daub a repellent like dimethyl- or dibutylphthalate (DMP and DBP) on boots, socks, wrists and neck to prevent mites from wandering on to my body. The same repellents are used to keep mosquitoes away.

These chemicals are greasy and not particularly pleasant to use, and in hot weather their effect lasts only an hour or so, but the inconvenience is far preferable to unpleasant irritations like 'scrub itch' and the more serious scrub typhus, which was until recently a killer.

Combating heat

Hides can become abominably hot, even in the sun of a comparatively mild northern summer; in the heat of the tropics they can be unbearable. The photographer cannot change the weather and the local birds are accustomed to the heat; breeding, sleeping and feeding despite it. Those who wish to photograph them must learn to cope with the heat, and one way to do this is to work in the early morning before the sun has climbed too high in the sky. At this time of the day the birds are most active. By midday and throughout the afternoon, many rest in whatever shade they can find; bird photographers do the same. With very tame birds it may be possible to sling a fly sheet between trees to shade the hide and the nest as well.

Bags made from flax are used in hot climates for holding water. Gradual seepage and evaporation cools the contents if there is a good circulation of air, such as when the bag is fastened to the front of a moving vehicle. The same principle is used in the design of the 'cool safe' used by travellers to keep meat and fats in some sort of condition. These 'coolers' consist essentially of a metal box covered with hessian on to which a trickle of water falls to keep the whole thing moist. Evaporation from all sides keeps the inside temperature well below that of the surroundings. On very hot days I have sometimes fixed a water-bag on the crosswires at the back of the hide to provide cool drinks when they were needed.

In the hot season direct sunlight can quickly destroy eggs and chicks. These must be shaded while the camera is being set up or removed and special care taken to ensure that the birds are not kept from their nests under these conditions.

Spectacled flycatcher. This shot was made with flash alone, but the dark background is authentic as under the rainforest canopy the light was very poor. Note the twin eyelights due to the use of two flash heads (photo John Warham).

Heat saps one's energy and flies are perhaps just as exhausting. Fortunately, in dry areas at least, when it is really hot (shade temperatures of 105°F and over) the flies are usually dead or dormant. Flies inside hides can be maddening; spraying with insecticide before each session is again essential. A fly net to droop from your hat over the face wards off many insects that would otherwise crawl into your ears, eyes and nostrils. These nets are a boon also when working in the open or tramping through the bush in search of nests.

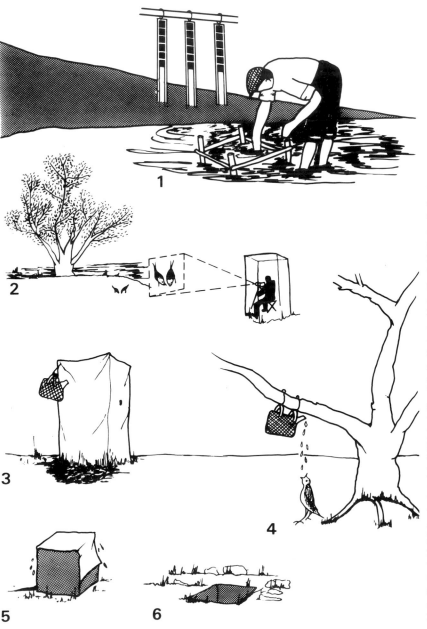

In the tropics black-and-white films may be washed in a river or tidal estuary by driving in stakes and making a frame on which to loop them (1). In the dry season water is a great attraction to birds, as it is to other creatures, and a water hole makes a good site for 'wait and see' pictures (2); or a dripping water bag or can may be hung in a bush or tree (4). A supply of cool drinking water for the photographer is ensured by hanging a flax water bag on the hide; evaporation lowers the temperature (3). A cool safe for materials may consist of a tin draped with a wet cloth (5); and in waterless desert regions a hole in the ground uncovered to the cold night air, and covered again before sunrise, remains cool during the heat of the following day (6).

Care of materials and equipment

Heat and humidity can create havoc with photographic gear and materials. Of the two, humidity is the worst. Films may be stored in plastic bags in sealed tins inside a cool safe, of the kind already described. This is quite effective provided that there is an adequate supply of water (not necessarily fit for drinking purposes, and when humidity is not high enough to prevent evaporation). In inland continental regions of the tropics, where days are hot and nights surprisingly cold, a pit dug in the ground makes an excellent place for keeping sensitive material (page 200). After dark the hole is uncovered to allow the night air to cool the contents. In the morning, before the sun has risen, the pit is recovered with blankets, hides or some other suitable material so that the cool air is retained and the same procedure is followed each evening. If a vehicle can be parked over the hole during the day shading it from the direct rays of the sun so much the better. A polystyrene picnic bin may prove more convenient for daytime storage than a pit. Occasionally caves can be put to use, for these are often cool even on the hottest day.

In hot climates you have to be constantly on the alert to see that cameras and other sensitive equipment, like exposure meters, are not left in the sun. Metal cameras may become too hot to hold after only a few minutes of such treatment and permanent damage may result to shutter, lens and film. Needless to say all sensitive materials should be tropically packed and their seals should not be broken until shortly before use. Both fresh and exposed film should be stored in airtight boxes if possible and I recommend that these should be painted externally with aluminium paint. This reflects light and heat and is preferable to using aluminium boxes as the metal soon gets tarnished and oxidised and loses its reflectance. The boxes can be repainted between trips.

In very humid conditions, like those encountered in rain forests and mangrove swamps, it is important to be alert to the danger from moisture condensation. This is most likely to occur towards evening when the temperature is falling or when you are shooting among very lush vegetation. With a reflex, the impaired definition should at once alert you to what is happening and it can often be countered by applying a fine film of glycerine to the protective filter over the lens. If carefully rubbed on, this should not critically impair definition and may enable shots to be taken that would otherwise have to be abandoned. Condensation also readily occurs on polished reflectors and these can be treated in the same way.

The bloomed coatings of lenses seem very susceptible to damage by humidity and so, too, is electrical gear, but a good deal of protection can be effected by the intelligent use of polythene bags to cover equipment. At times even the cameras may need to be stored in a dry box overnight and when not in use.

Another point to note is to avoid leaving equipment or camera

cases directly on the ground. It is better to raise them a little in some way—on boxes perhaps, or even on tins of food—and once again plastic sheeting helps to prevent moisture from seeping up. Hides should be given waterpoof roofs of heavy polythene sheeting—fitted *under* the canvas.

Mildew will readily attack leather parts, and these and the lenses must be kept clean. If necessary, fungicides can be used cautiously on cameras and other gear. Under humid conditions cooling devices based on water evaporation are useless, but unexposed film in sealed packings will keep quite well if kept out of the sun. It should be kept as cool as possible, preferably near the forest floor, where the temperature is seldom very high owing to the perpetual dampness there. Greater care is needed, as always, with the exposed shots, for the film will now have taken up a good deal of moisture and if cooled below the dew-point this moisture may condense on to the film and ruin it.

The answer is a dry box. The film spools, not in their cans, but with just an elastic band to prevent unwinding, and film cassettes, are placed in a large metal box that can be completely sealed. This box either has a false bottom perforated with holes and containing silica gel, or perforated tins of this substance are placed in the box along with the films. The best type of silica gel is the 'tell-tale' variety, which is bright blue when dry and capable of absorbing, but pink when saturated with moisture and therefore exhausted. The silica gel is regenerated by heating—a dry frying-pan over the camp fire or Primus is excellent for this. After at least five days of desiccation, so that the moisture can be drawn out from the tightly coiled film, the rolls are quickly replaced in their containers, which are carefully sealed, and these rolls should now be dry enough to withstand cooling below the dew-point. Make sure that the film is left inside long enough and that the silica gel is not allowed to remain once it is exhausted. The box must be absolutely airtight when closed and must be neither opened unnecessarily nor left open for more than a few seconds. Uncooked rice, thoroughly dried at about 200°C (390°F) is also said to be a useful makeshift desiccator.

Colour in the tropics

Colour is a 'must' for the stills wildlife photographer in the tropics with so many brightly hued birds available. Some of the brightest of these are quite deliberate in their movements—parrots and macaws, for instance, and give plenty of chances for shots with little risk of loss through subject movement even if flash is not being used. Contrasty situations are usual, particularly among vegetation. Under such circumstances electronic flash fill-in is almost essential to bring the contrast range within tolerable limits. A few trial exposures may be needed to establish the correct stop and shutter speed ratios. Once more, to avoid over-flashing, the shutter speed should be sufficient to give a true rendering of the background and the stop correct for the flash.

Processing in the field

Nature photographers in the tropics may be away from their 'base' for months at a stretch. It is inadvisable to keep exposed film in hot, humid conditions for long before development. Latent images may fade and fogging occur. Colour films that cannot be field-processed must simply be carefully stored as described earlier and sent for processing as soon as possible. Black-and-white film can often be processed under field conditions and it is desirable, on long expeditions, to develop a roll or two at intervals as a check on exposures and equipment. A defect not discovered until you are back home usually means that retakes are impossible.

It is often feasible to rig up some sort of night-time dark room, inside a vehicle for instance. Alternatively, a changing bag can be used to load a tank and the film processed in one of those one-solution 'develop and fix' formulae, designed for just these difficult conditions. The larger sizes of film are advantageous if field processing has to be done because it is very probable that the water supply is not the best, so some specks of dirt or debris are liable to remain on the film after drying. You can usually get away with these on 6 × 9cm but not on 35mm, where the results may be completely ruined.

It is tricky too when the water supply gets above 27°C (80°F), as often happens in tropical climates. Development is done after dark, and if the temperature falls appreciably during the night, developers and other solutions are made up during the day and put outside so that they cool down in the night air. Several buckets of water for washing are also cooled, since it is important that all processing solutions and the water for the first few washes should be at about the same temperature.

Development is followed by a chrome-alum hardener bath, fixer and final washing. If water is scarce it may be sufficient to give just a few washes, or a hypo-eliminator may be used. Films are then dried, rolled up in black photographic paper and put back in their metal containers. They are rewashed when more favourable conditions are encountered.

When the temperature of the developer cannot be reduced below 32–35°C (90–95°F), films must be prehardened. This is followed by an MQ developer loaded with sodium sulphate, according to the manufacturer's recommendations.

Films can sometimes be washed satisfactorily in streams, rivers, and even in sea water. I usually construct a frame from branches within which the developed films are stretched horizontally between film clips. The frame can be covered with the fine gauge copper gauze used for fly-proofing windows. This prevents any large particles of leaves or debris touching the emulsion. Sea water is effective but it is not often possible to put the films in the sea on account of the waves and the danger of sand abrasion. The water must be bucketed out and the films washed by hand.

Cine in the heat

The cinematographer's problems in the heat are much the same as those of the still photographer—problems of overheating of equipment and of damage to photo-sensors left pointing to the sun and so forth. Careful judgement of exposures is often necessary, preferably with a narrow-angle meter, because under harsh lighting conditions colour film will not cope with the high contrasts. The exposure must be right for the bird, even though highlight and shadow areas have to take their chances. Sometimes a sun gun can help to reduce the contrast range. Tree-top sites are again difficult but a focusable fill-in light may solve contrast problems here too.

When filming in hot, dry conditions dust is often a major hazard. Lenses must be covered with haze filters or optical flats to prevent any danger of sand-blasting or minor scratching. The cameras should be carried in dustproof plastic bags. Great care may be needed in changing films so that dust does not penetrate the camera.

I have seen the use of changing-bags recommended when in the desert. These may be practicable when temperatures are not excessive, but they often are. Then changing-bags are quite useless because the perspiration runs off your fingers and it becomes quite impossible to load inside any sealed bag without the film and the mechanism getting moist, and this almost certainly means that jamming results.

The situation will be even worse if you are incarcerated in a hide where the temperature may be up to 60°C (140°F). Where dust is a real hazard the best answer is to change films inside a vehicle, if possible, where the danger from dust will be reduced and the light can be subdued. Alternatively, reload under a loose black cloth to shut out most of the light and obviate the danger of fogged edges. It may be necessary to wrap an absorbent cloth round your forehead and wrists to absorb perspiration while handling film. Quite often you simply have to take a chance that dust has not seeped in and then to clean the camera at the first opportunity. Speed in unloading and reloading is essential. In such difficult conditions the user of a professional camera is at an advantage because he can use large magazines and make sure that plenty of film is loaded each night for shooting the next day. Loading time is also reduced with magazine-loaded cameras. Should you find yourself with a half-exposed magazine of fast film so that overexposure is probable even when the lenses are fully closed down, then the variable shutter can be closed up or a neutral-density filter placed in the light path. The Bolex shutter, for instance, closes down to give an effective exposure of 1/600 sec, adequate to cope with almost any outdoor situation even with 200ASA film.

When in the sun, the camera must be protected from direct sunlight whenever possible. Otherwise metal parts become too hot to touch and it is easy to imagine what is happening to the film

cooking inside. You cannot then blame the manufacturer if the film jams. In hot places you have constantly to be on the watch that the camera and other delicate gear is not left out in the blazing sun. Cover it up when not in use; the habit soon becomes automatic.

Heat haze often prevents long-shots with telephotos because of the loss of resolution but, of course, a shimmering backcloth to close- and mid-shots may be very effective in conveying the 'feel' of the country and conditions.

In the cold
In extreme conditions like those encountered in the polar regions or on the tops of high mountains, cameras are pretty severely tested. Mechanisms tend to become sluggish and normal lubricants cannot be used on equipment like tripod heads which may have to be run dry or oiled with kerosene. The makers should be asked whether they can provide any 'winterisation' for their cameras and if necessary the equipment should be returned for treatment. Because of the problem of battery failure, hand-wound still and cine cameras tend to give better service than more elaborate models.

Films become brittle when very cold, and static discharges during wind-on and running may give trouble. There is little that can be done about that except to try and ensure that the film and camera are not at different temperatures. Brittle film is very sharp so needs careful handling lest the edges cut your fingers. Also the edges of movie film tend to rub off onto the gate and other parts of the film transport mechanism, leaving a powdery white deposit, or particles of film. If these are not removed promptly, abrasion marks may ruin subsequent takes. Synchro-cables and leads also become brittle and readily break, a defect that may not be apparent.

Frost forms on lenses and metal parts when a camera is carried outdoors from a warm interior and when a cold camera is brought inside it is soon covered with condensed water vapour. Condensation may take place not only on external surfaces but, if the film was loaded in warm or humid conditions, on internal ones as well and this may cause jams and ruin the film. Thus it is better not to keep frequently-used cameras and other equipment in heated quarters but in weatherproof boxes or cupboards outside, or in places like food stores, which are unheated and where the temperature is not too different from that outside. When indoor shots have to be made, the camera should be brought inside by stages and the process reversed when you have to take a camera from inside outdoors. It is a good idea in either event to keep the camera in a plastic bag so that any condensation tends to form on the outside of this rather than on the camera.

Storage of unexposed and properly sealed film poses few difficulties but care is needed with exposed material. Films that were loaded into the camera in the open and were then cold can

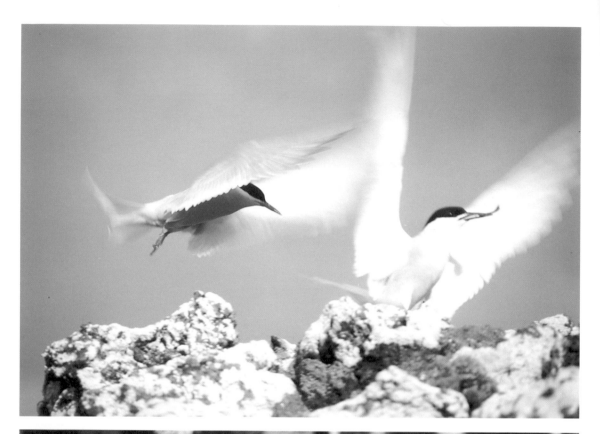

206

Sometimes action is more easily conveyed by blurred wings than by ones frozen by flash, but composition then becomes mainly a matter of chance, as in this shot of Antarctic terns in aerial display (photo John Warham).

Interesting heads make interesting pictures. This light-mantled sooty albatross head filled the frame at about 2 metres with an 85mm tele-lens (photo John Warham).

Southern skuas in snow. Under such conditions most polar species are reluctant to leave their nests and good shots may be possible without concealment. Hand-held SLR 135mm tele-lens and 1/125 sec exposure (photo John Warham).

be taken out and stored cold with some confidence. Those loaded indoors, however, or in warmer conditions, cannot be stored below freezing point without the risk that contained moisture may turn to ice and ruin the film. Such film has either to be stored in cool but not cold conditions or the moisture must first be extracted by placing the rolls inside a desiccator filled with fresh silica gel or calcium chloride for several days. The films are then quickly wrapped in foil and reboxed and sealed for storage in cold, but not deep-freeze, conditions.

Black-and-white still film is best processed at the earliest opportunity. This is done at base in a properly heated and equipped darkroom and calls for no special comments. Colour film and cine film may be a more difficult problem but Kodachrome and Ektachrome seem to keep without apparent deterioration for nine months after exposure, providing that the above precautions are followed. Film to be used indoors must be brought inside and allowed to reach ambient temperature before the seal is broken. As this will take several hours it is best to keep the material indoors overnight and to load the camera, also acclimatised to indoor use, the next morning.

A spacious changing bag comes in useful when you have to reload in the open. It prevents snow getting into the camera when drift is flying and helps to avoid frostbite, as it is rather difficult to load a camera while wearing gloves. Cold is also harmful to

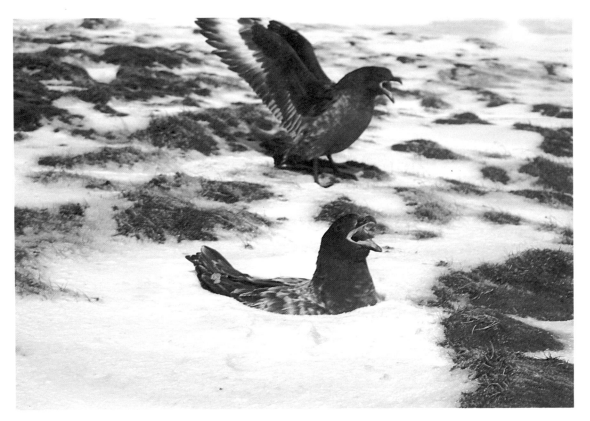

batteries. If using battery-powered cameras or flash outdoors, the normal procedure is to keep the power unit under your clothing so that the battery is not chilled appreciably. Likewise you should remind expedition members to bring a good stock of the small batteries needed for still camera operation—they may not last so long in the cold as at normal temperatures. It is sometimes feasible to keep a set of batteries in a pocket near your body and slip these into the camera before a photography session.

When working in snow or rain showers a plastic bag can sometimes be kept on the camera until the shot has to be taken when it is whipped off, the exposure made, and the cover immediately replaced. But in heavy drift or moderate snowfalls photography is hopeless as all detail goes and it may be quite impossible to keep the lenses clean. Particularly when accompanied by wind, low temperatures are very unpleasant for a cameraman. Metal parts may be dangerous to touch with bare hands. Herbert Ponting inadvertently let his tongue touch the brass bindings of one of his cameras and had to drag it clear, leaving a part of it behind. Cameras are simply not designed for operation under these conditions, nor are the controls easily manipulated when wearing gloves. Thin gloves that permit some freedom of movement do not give much protection against frostbite. However, a cable release can be operated when wearing gloves.

Penguins in snow or surf need full exposure or details of head and eyes are lost. In the surf fast shutter speeds are needed to freeze movement, and small apertures to get good depths of field; this generally means using fast film. 1/500 sec on 6 × 9cm Graphic camera (photo John Warham).

208

When you have to work for any length of time at a particular place, at penguin colonies for instance, a hide is necessary to give some protection from the weather. The hide can be a mobile or collapsible affair but in the polar regions it is best made from solid stuff such as hardboard.

Do not be misled by the apparent tameness of polar birds, particularly Antarctic penguins. These may be readily photographed without concealment but, if you want to work close in, it is far better to use a hide so that you can move freely and change films and so forth without the birds noticing. If they do they will inevitably be distracted from their normal behaviour.

One minor point: remember that huskies love eating leather—they will chew up your nice leather cases and stray straps if they get the chance so keep these out of harm's way!

Photography for field ornithologists

Much of the basic data needed by the field ornithologist involves direct observation of birds to record behaviour, to count their numbers, and to note their foods and feeding habits. Photography can be an important tool for collecting such data.

Clearly the value of photography varies with the problem and the approach taken for its elucidation. In a few instances the photographic record provides the main data base—the primary record—as in the case of the behavourial work on the kittiwake done by Dr J.C. Coulson, in which colour-banded pairs were photographed automatically over a breeding season. More often photographs comprise a secondary record, supplementing information registered by other means. In either situation, the photographically-recorded data may never be reproduced as photographs, although the camera does have an important role for providing illustrations. Well-taken, well-chosen and well-reproduced photographs can provide a very efficient and concise way of conveying a lot of information economically.

Selection of illustrations is important. Half-tones are expensive to reproduce, so your editor is more likely to acquiesce to their use if each has a high 'informational content'—showing several significant features in each picture. Photographs that do not complement and add to the information in the text are unlikely to be acceptable. Of secondary importance are the aesthetic qualities of the photograph, although there is no reason why one should not aim at producing scientifically valuable photographs that are also good pictures.

The mode chosen by the ornithologist depends greatly on the subject, on the cost and value of the photographic record to the case being studied and on the aspect of biology involved. The mode may be still or cine or both, colour or monochrome or both, in two dimensions or three (i.e. stereo) or both.

For ease of discussion however, I am treating the roles of stills and cine separately, an artificial separation of course for their functions often overlap and complement one another.

Cine for the ornithologist

Advantages of cine. For a general introduction to the work of the scientific film maker Strasser's book[54] is recommended. For the scientific ornithologist cine offers some important advantages over stills photography:

1 It gives a permanent record of events which can be viewed

Southern skuas: a still with a big informational content (nesting habitat; adult sexes alike; display; clutch size and egg pattern etc.). In colour even more information would be recorded (photo John Warham).

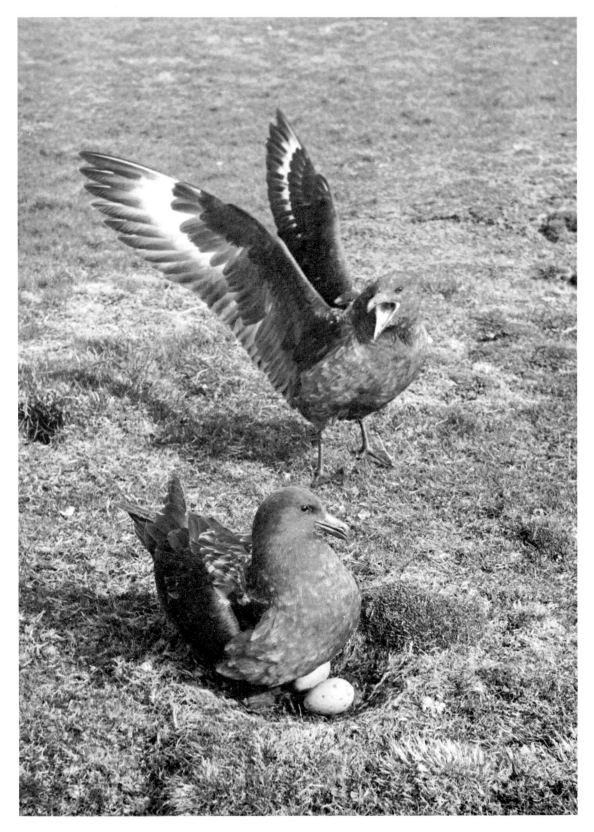

repeatedly at leisure and if necessary many miles from where the shots were taken.

2 This record can be made into loops for continuous projection or it can be speeded up and slowed down as required during screening. Furthermore, it can be viewed and discussed with and by research associates or experts who have either not the time or opportunity to witness events at first hand. Suitably edited it may be used as a teaching aid.

3 The events being recorded can be of a wide variety of size and can be either simple or complex in detail. Photography can record the surges of a great flock of feeding shearwaters or the pirouettings of a lone goldfinch on a thistle.

4 Events can often be recorded by the cine camera far more completely and rapidly than by any other method.

5 Events too rapid for the human eye to appreciate can be captured on film and so can extend the range of human vision. Fast events can be slowed down and slow ones speeded up.

6 As the pictures are taken at a known and predetermined rate, a built-in time scale is included which can be used quantitatively.

7 Many field experiments are complex and time-consuming to set up. A complete cine record enables the utmost value to be gained from the results and reduces the need for tedious and time-consuming repetition.

8 Usually the whole scene is recorded and this may include features that while appearing of no importance at the time, subsequently prove of considerable significance.

9 Filming may be done at a distance and records made of otherwise unapproachable species.

10 Selected frames may be used as the basis of sketches.

Some drawbacks. No technique is without its imperfections and there are certain snags associated with the use of cine film in field research of which intending users should be aware. These include:

1 While the highest quality is often unnecessary, as many of the shots will not be intended for general screening, nevertheless a good deal of skill is required to get scientifically satisfactory results.

2 Filming tends to be time-consuming and expensive.

3 It is difficult to avoid the record acquiring a subjective character. For instance, the camera angle often has to be fixed, the pictures are normally only two-dimensional and so on. Since direct prints from cine films are pretty useless as illustrations, the simplified sketches themselves introduce another falsification of the facts.

4 The inevitable delay between shooting and viewing can limit the value of the method where the film is being relied on as the prime record of an experiment or behaviour pattern.

5 For some kinds of research, still photographs are both adequate and cheaper.

Possibly the most important role for cine is in recording bird behaviour. This is often complex, composed of very rapid movements and quite impossible to describe adequately by means of a tape recorder or stills camera. Costs of filming can often be reduced by shooting in black-and-white. The cine record comes into its own particularly when the field work is done far from the place where the data are analysed and written up for publication. It is extremely comforting, when after many months in the field in some remote region, you finally leave for home sure in the knowledge that your bulging notebooks are supported by a good coverage of the key events on cine film. As you run this film time and again through your viewer or editor it is surprising how often significant details of behaviour become apparent that were overlooked in the field.

Equipment required

The type of gear needed for research filming depends largely on the use to which the film will be put later. If it is intended for public showing or for viewing by critical scientific audiences, then it calls for a 16mm camera meeting the requirements discussed earlier. If the film is intended merely to supplement direct observations written down on the spot, or dictated into a tape recorder and copies are not needed, then the advantages of Super 8 should be seriously considered.

What are these advantages? Perhaps the most important is the lightness of the 8mm camera compared with its 16mm counterpart. The smaller camera often weighs only one third that of the larger one and possesses equivalent facilities. This factor becomes very important when working in remote areas away from roads. Everything then has to be carried either on your back or on pack animals and with food, traps, sampling gear and so on to carry, lightness is essential. Another advantage of the smaller camera is that it is very versatile and can usually be hand-held, even when shooting through telephotos or zooms, with little risk of intrusive camera movement. It offers other distinct advantages too, in reduced initial costs for the camera and its associated gear, while even more pronounced savings in running costs are possible because of the comparative cheapness of Super 8 film.

The best 8mm cameras are so highly engineered (in some ways more advanced than professional ones) with 'electric eye' exposure control and first-class lenses that, in conjunction with modern high-resolution films, they offer a practical means of recording animal behaviour where copies are not required for critical audiences. It is important, however, that the animal should appear large in the 8mm frame to ensure that, despite the small picture size, its movements can be clearly seen. Notwithstanding the excellence of 8mm equipment and the constantly improving quality of film available in this gauge, it is pointless expecting such a small format to do too much especially on a large screen. If you anticipate using your films for viewing by critical

audiences, the shooting on 16mm will generally be more satisfactory.

Shooting technique

It goes without saying that for success in making research films detailed knowledge of the subject is essential and normally it is the zoologist who does the shooting. If not, then it might be a technician or a field assistant who is entrusted with the task. Whoever it is, he must be completely *au fait* with the problem and the reason for the film.

Shooting can generally be done to a definite plan geared to the cycle of events in the birds' lives. A plan is essential, or important sequences may be completely overlooked. When the film is intended as evidence for a particular thesis, or as an introduction to a piece of research, much footage may be shot after the main work has been completed. In this event there is no reason why a complete script and treatment should not be drawn up before shooting begins. Otherwise, when film provides the primary record, then clearly, shooting cannot be so precisely planned: it proceeds as the need arises.

With research films, even more than with expedition and general wildlife photography, accurate records of each shot made at the time of shooting are essential. These will not only list photographic data where relevant, but time, location, sexes and identifying marks of the birds concerned against the start and end footage for each shot. The notes should always give too much rather than too little detail. It is amazing how frequently you look back at field notes and discover that apparently unwanted trivia are found important later. Furthermore, while in general natural history work the aim is to avoid overshooting, many retakes may be needed in research filming, so that variations in patterns can be assessed and to ensure that the record is truly representative of the specific behaviour being studied.

The research record must be as objective as possible, therefore the scientist needs to be acutely aware of the danger that his actions while filming may modify the behaviour of his subjects. To guard against this danger, which may not be at all obvious, there is a great deal to be said for using hides even with apparently tame birds. Tame as some may appear to be, the movements involved in turning over the pages of a notebook, in retensioning a camera spring or in setting a stop, do have some effect and may completely alter the sequences of the behaviour patterns that would otherwise have taken place. Thus concealment, although restricting the camera angles available and the observer's mobility, is really quite important. When the ground is fairly level there is no reason why the hide itself should not be capable of being moved (see page 148). In static situations where the camera can cover the bird, or birds, under investigation from a fixed position, then the camera can be operated by remote control. It is loaded, focused and if necessary camouflaged and

controlled from a distance, via an electric or pneumatic release attached to the camera's cable release or perhaps by some more complex electronic, sonic or radio signal.

Importance of time scale

To make the most of the cine camera as a recording device, the time scale incorporated in the constant frame rate should be used. With this time base it is quite easy to work out the intervals between the different portions of a movement. For example, a simple way of determining wing stroke frequencies is to film the bird in flight and then work out the number of frames covering one complete stroke. Knowing the rate, it is then simple to work out the wing stroke frequency under the conditions at the time of filming.

When timing it is very important that the accuracy of the framing should not be taken for granted and these should be checked by filming a stop watch. Spring-driven cameras tend to slow down slightly as the spring unwinds. Therefore, when the maximum accuracy of the time base is desired, a full calibration curve of footage shot against time has to be drawn up. It means, too, that when working with a spring-driven camera every shot should be started with the spring fully tensioned.

Once this calibration has been done the shots can be subsequently marked up on the editing bench by aligning them with a strip of blank film on which the time intervals have been scratched to form a time scale. Calibration may also be needed when electric-motor drive is used. Here, although the rates of framing should be constant, it is unlikely that they will be exactly as indicated on the speed dial of the camera and for very precise work the rates should be determined beforehand.

An alternative method, unfortunately seldom possible in the field, is to follow the practice in motion-study films and incorporate a chronometer in the field of view. This is generally arranged so that the clock comes into one bottom corner of the picture. Under this very convenient system, each frame has its own built-in time reading. A simple battery-driven digital clock with large figures is ideal.

Clearly, such a method has practical limitations. While it might be quite useful when working in static situations like seabird colonies, it will not be much use when the field of view needs to be altered frequently, as when working with more mobile species.

Records of behaviour

Cinematographic records are exceptionally valuable when studying animal behaviour. A frame-by-frame analysis of the film can reveal the actual movements, and even very complex patterns can be unravelled. Where the movements are rapid, the necessary increase in clarity can be obtained merely by decreasing exposure times. This is one advantage of the variable-speed shutter. With such a device it may be unnecessary to resort to the more

expensive and less convenient option of filming at higher frame rates. Usually, even if some movement shows in a bird's limb, the direction and position of this will be quite clearly seen in the editor and interpretation will be easy enough. For much the same reason, the result may not be ruined by the bird moving slightly out of focus, providing that it is quite clear what is happening.

Dr Bryan Nelson has pointed out that a short film of typical behaviour patterns for a species or bird group can be very useful for circulation among colleagues working on allied topics. Occasionally films are made available as supplements to books or research papers, adding a new dimension to the information.

It should perhaps be pointed out that videotape is becoming the preferred medium in the role of primary recording system for bird and animal behaviourists. The cameras are portable, use tape that can be erased and reused and can have a small viewing screen built in, enabling the scientist to play back immediately what has been taped. Hence much uncertainty associated with photography is eliminated as the investigator can quickly see whether the shots show the points required. Such a system seems likely to be cheaper and more practicable under open air conditions than 'instant print' cine film such as Polavision, in which, about 90 sec after shooting, a cassette of film is ready for showing if its special projector is available.

Criteria for research films
If the cine record is to be built up into a proper research film, then rather rigid criteria must be applied during editing. As evidence for the researcher's theories, or to present his discoveries, the material must be presented carefully, impartially and factually. The shots, therefore, must not be strung together in a manner that loads the evidence to support a particular theory. The camera can lie easily enough and conscious care is needed in shooting to ensure that it does not. Editing, too, must be objective.

This means that some of the normal conventions used in cinematography may be quite inappropriate. Cut-aways to condense time, for instance, are an obvious falsification of the facts and may give quite an erroneous impression. Clearly, it may be quite impracticable to show the whole of a cycle of behaviour patterns that might extend over several hours, but the time scale of these events and the manner of their compression can be made clear in the commentary or by subtitles. It is often inappropriate to alter the sequence of the shots, for these may have to be screened in the same order as they occurred in the life of the bird. Again, it may be necessary to screen a number of shots of the same behaviour pattern, so that the audience can pick out the finer details in the repeats or to emphasize the constancy of some movement. Such repetition would often be quite unacceptable to a non-scientific audience.

Research films are generally handled rather like papers. The

problem is stated, the methods used to tackle it are shown, then come the shots showing the facts, their significance is debated and the conclusions summarised. Key references can be inserted at the end, and if so they must be screened long enough for the viewers to note them down if they so desire, or listed in a handout for the audience.

Dr A.R. Michaelis[55] suggested that where a research film is constructed in this way the type of editing should be made clear in the titling, for example, 'Objective editing: minimum use of cinematographic conventions'; whereas, in a film where the shots have been deliberately rearranged to support some hypothesis, this, too, should be clearly stated in an appropriate manner. It is quite clear, however, that cine film is a medium in which it is often quite impracticable to work completely objectively. All that can be done is to aim at objectivity and consciously to organize the editing to avoid any unfair emphasis. Another useful brief discussion on factuality in scientific films by Dr G. Wolf appeared in *The Photographic Journal*[56] some years ago.

Time-lapse techniques

This well-known device involves shooting at greatly reduced rates. On subsequent projection at normal speed, the slow-moving events filmed are speeded up. The method seems to have first been used in 1900, when Dr W. Pfeffer at Leipzig University filmed the growth of various plants at 3 frames per minute. Since then the technique has been applied to many botanical and zoological processes and especially to events like cell division. It has been little used in field ornithology where the need is generally to slow down fast motions in order to understand them. Time-lapse, however, was used successfully to film radar displays of bird migration[57]. The results speeded up on projection indicate dramatically the directions of the migrating flocks, and it has also been employed in studies of nesting peregrine falcons[58].

Cine cameras can be used to take single frames at predetermined intervals, e.g. to keep an automatic watch on a nest or on a colony. Whether this would enable speeded-up projection to be made and a time-lapse created would depend on the time intervals chosen and the amount of movement occurring between shots, but in many instances no such facility would be needed. Instead, each picture would be used as a separate still and, by viewing the series, gross changes in events and movements among the animals concerned would be clear.

For some work of this kind, still cameras that enable a wide field to be covered at high resolution are more suitable. But when a long series of shots is needed, perhaps covering several days' activity, then a cine camera may be a more practicable tool because of the great number of pictures that can be made on one length of film. After all, 100ft of 16mm film accommodates about 4,000 frames. Many of the better Super 8 and nearly all 16mm cameras can be operated on single shots and can be coupled to

units that allow the intervals between shots to be adjusted according to the needs of the investigator and the situation. For field use the camera and its 'intervalometer' has to be battery-powered, and if running time is to extend over several days a heavy battery pack is almost mandatory.

If the results are to be speeded up during projection, i.e. to be true time-lapse, then comparatively high rates per second might be needed. For recording gross changes and general activity patterns, however, much lower frequencies often suffice, perhaps in the region of 1 frame every 5 min. At such a rate 100ft of film will record events for 66 hours without any attention.

Provision has to be made to protect the gear from inclement weather, for coping with light changes and for stopping the film transport at night and restarting it in the morning. An electronics man could probably devise quite a simple circuit linked to a light-meter for switching off the current when the ambient light falls below a particular value and reactivates the system when the light increases in the morning. In all these battery-powered automatic systems it is important that as little power is wasted as possible. If records have to be continued after dark then flash or some artificial light system or a 'nightscope' (page 228) will have to be used.

Automatic bird photography for scientific purposes has been rather little used, although in some circumstances it could be much more effective than collecting the data by direct observation. It can save much time and energy involved in going to and from the study area, converts intermittent checks into continuous records and has a built-in time scale to boot. Also, since only a camera and its associated gear is involved, this can easily be housed in a box and concealed without any hide being required.

Graphs and diagrams

In scientific films, graphs and diagrams are almost obligatory. These have to be carefully executed and good use can be made of colour and animation to emphasize particular points.

A film which made excellent use of graphs and diagrams was made of the Australian mallee fowl[59] by H.J. Frith. This is a dry-country bird which builds a mound of earth mixed with leaves and twigs into a natural incubator for the 20 or more eggs deposited by the female during a long breeding season. The short film shows something of this annual cycle and particularly how the male adjusts his behaviour over the months to cope with changing conditions within the mound. His main task is to keep the eggs at the correct temperature for their development. We see him, in the spring, when active fermentation is liberating large quantities of heat, digging out the mound each morning to cool the eggs and prevent them from being cooked to death. Then, later in the year, when fermentation has ceased and the mound is 'dead', the film shows how he opens it out at midday so that the eggs still remaining can be warmed directly by the sun's rays.

218

These shots are nicely linked together with very clear animated graphs which trace the temperature changes within the mound as the season advances. This is a good example of a film that succeeds in presenting a fascinating piece of research in a way that anyone can comprehend.

Stills for the ornithologist

Where continuous records of fast movement are not necessary, stills are often adequate. The 35mm SLR has been a real boon, releasing the scientist from the need to be an expert camera handler as well as expert in his or her research field. Typically stills are made on colour reversal film. The transparencies can then be used directly, either for preparing drawings and/or for detailed examination. A low-powered binocular microscope is a very convenient way of inspecting the detail on a slide. When monochrome prints are needed these can be obtained, via internegatives, of a quality adequate for much scientific illustration, if the originals are pin-sharp and not of excessive contrast.

Photographs unaccompanied by precise data have usually little or no scientific value; careful documentation of every shot is essential, if often tedious. A few 35mm cameras and some larger format ones have 'data backs' allowing a little information to be recorded on the edge of each frame. This is a valuable facility for scientific work as a number or some other reference on each

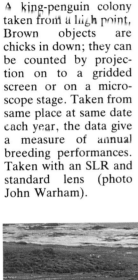

A king-penguin colony taken from a high point, Brown objects are chicks in down; they can be counted by projection on to a gridded screen or on a microscope stage. Taken from same place at same date each year, the data give a measure of annual breeding performances. Taken with an SLR and standard lens (photo John Warham).

picture provides a much clearer link with the field notes than the frame counter and edge numbers on the film.

Recording habitats and techniques

On the basis that a picture is worth a thousand words, a few well chosen stills can set the scene of a particular study very effectively. This is very true in ecological work where habitats may be of prime importance. Techniques too are often more clearly explained with the help of photographs, although a film sequence is sometimes even better and shots showing techniques employed are often essential in research films.

Bird census work

Counting colonial species is often most conveniently done from still photographs. Large seabird assemblages can be recorded on single negatives or on a series of overlapping ones taken from the same point. The number of birds can subsequently be counted on enlargements.

The effectiveness of the method depends on finding a viewpoint from which the whole of the colony is visible and on achieving adequate resolution, so that each bird can be picked out on the prints. Such photographs may be retaken at appropriate intervals or on the same date annually from the same spot, to check on population changes and other trends. Such comparative counts are particularly applicable with birds like gannets, petrels and penguins, whose breeding timetables vary little with weather conditions so that the various stages fall on the same dates each year and repeat counts are thus comparable (see page 219).

Groups of as many as 100,000 birds can sometimes be covered on a single shot. If necessary several shots, from slightly different viewpoints, may be made and the counts averaged out to allow for any birds concealed by their fellows, vegetation or in small pockets of dead ground. Notes taken on the ground are often essential for accurate evaluation of the photographic data.

A number of successful censuses have been made from aerial photographs. Wildfowl counts are regularly made in Russia and the USA from aircraft and the RAF used aerial photography to count flocks of moulting shelduck off the German coast in 1955. Drs Fleming and Wodzicki also relied heavily on counts made from aerial pictures in their census of the gannets in New Zealand, where many breed on inaccessible stacks. Conventional light aircraft seem to make the best platforms for this kind of photography. Helicopters, despite their manoeuvrability, vibrate so violently that, in my experience, the resulting definition even at 1/500 sec is inadequate for this kind of work. However, better results may perhaps be possible with different types of helicopter.

Aerial surveys from photographs are used by scientists of the Antarctic Treaty nations in regular counts of several kinds of penguins to be used as biological indicators of the effects of harvesting of 'krill' (*Euphausia superba*) in the Southern Ocean.

The species chosen all feed primarily on these crustaceans so that changes in the penguin populations should reflect changes in their food supply and a sustained decline of the penguins could indicate overfishing of the krill.

Some workers have correlated the results of aerial and ground surveys. In the Ribble Estuary of north-east England, Dr W.G. Hale photographed wader flocks using a 35mm camera from a light aircraft at about 170m and found an excellent agreement between his counts and those made simultaneously by colleagues from the river bank. On colour transparencies he could separate dunlin, knot, godwit and oystercatchers, particularly when the shots were taken against the light.

Photography can also be used for counting flying birds in discrete flocks. With skill, small groups of a few hundred can often be counted quite accurately by eye but it is often easier to use a camera if the whole flock can be caught on one negative. As the birds are usually clearly defined against the sky, their images need not be pin sharp. Providing that each bird can be clearly distinguished, they can be counted directly from the negative or transparency during projection. Professor Dunnet of the University of Aberdeen censused rooks photographically by taking flocks as they flew in to their roosts. He used a Polaroid back and could check on the spot that each shot had the information he needed.

Rockhopper penguins. With colonial species, matt prints on to which nest-site letter and band data are written directly can be used during routine checks. Rocks and other irregularities serve as guides for observer to pinpoint each nest circled on the print. Annotated data give flipper band letters identifying each member of each pair.

R = VN ♂ & U/B ♀
T = VI ♂ & OW ♀
U = OV ♂ & PV ♀

V = WE ♂ & VB ♀
W = VJ ♂ & U/B ♀
X = WN ♂ & U/B ♀

Y = VS ♂ & OT ♀
Z = Both U/B
U/B = Unbanded.

Checking study colonies

Many colonial birds use the same nest sites during successive seasons and remain faithful to their mates year after year, so that photographs of bird colonies can be used to identify particular nest locations by observers previously unfamiliar with the terrain. This method of data collection was used by Robert Carrick of Australia's National Antarctic Research Expeditions. Biologists making brief visits during annual changeovers of scientific parties used prints of small sections of the study colonies, orientated on that particular part, and then recorded precisely where each pair was nesting by pricking the print at the exact spot where the bird was standing or sitting. The identifying data (band numbers, etc.) were then added on the reverse of the photograph against the puncture. The accumulated data over many years from quite different recorders were used in analyses of population turnover, productivity and the like.

Page 221 shows part of a composite photograph covering a small rockhopper colony I studied. The ringed letters designate nest sites and the marginal data the band letters and sexes of the normal occupants. Using such photographs subsequent observers, unfamiliar with the colony and not in fact ornithologists at all, were able to record facts regarding matings, divorces and other changes during later years when I was on the other side of the world.

Black-footed albatrosses taken with a 135mm lens. The 35mm SLR is ideal for series-action shots, but with birds like these, which tend to wander widely during display, it is best to work well back to facilitate the repeated adjustments to focus and framing (photo John Warham).

If colour photography is relied upon to record colours, a colour scale must be incorporated in the picture and the scale filed with the transparency. This shot shows Snares crested penguin band AEL, and records facial and underflipper patterns, bill and eye colours (photo John Warham).

Recording the unusual

Photographs are useful to show as evidence of abnormal, disputed or previously unrecorded events. Thus, while some readers might well be doubtful of the authenticity of a report of a rook's nest on the ground in a hayfield or of a cardinal feeding a goldfish (both examples from recent journals supported by photographs), a clear picture of the event often resolves such doubts. Two different USA parties on the Antarctic ice came across penguin tracks 186 and 250 miles from the nearest sea. Since these flightless birds breed only along the coastline, they must have walked at least those distances across the ice after finding some, as yet unknown, route on to the Antarctic plateau. Doubtless the birds subsequently perished, but who would have accepted such a story from parties lacking ornithologists without the supporting photographs?

Bird identification

Many ornithologists enjoy hunting for rarities, which leads to problems of identification. At bird observatories all rare birds captured are usually photographed in the hand so that diagnostic features can be shown. Such photographs may be useful in training other observers in what to look for. Photographs are, of course, of value for supplementing written descriptions and are sometimes sufficient in themselves for specific determination. A few years ago J.L. Bull reproduced a black-and-white picture of an albatross off Long Island, New York. The print was made from a high speed Ektachrome 35mm transparency taken with a Contaflex fitted with a 7×35 monocular lens. Even without the accompanying description it is quite clear that this was a yellow-nosed albatross, a rare straggler from the South Atlantic, rather than one of several other albatrosses that could have found their way to New York.

Systematics

Photography has been little used by taxonomists except for the preparation of illustrations in their reports and papers, but with the increasing need to rely on data from living birds rather than on specimens (in many parts extensive collecting is no longer permissible), systematic photography of plumages and anatomical details are likely to be used increasingly in the future. The colours of the 'soft parts'—irides, bills, feet and so on—which often change rapidly after death, can also be recorded quickly with a 35mm camera. For critical work a standard colour strip should be included in each shot as a check on the accuracy of the rendition and on possible subsequent fading of the transparency. A Kodak 'Colour Patch'—a colour chart exposed briefly at the head of a roll of cine film as a guide to the printer—makes a convenient colour reference. It also helps if good quality duplicates of transparencies are needed.

I used an SLR to record the beak and eye colours of each

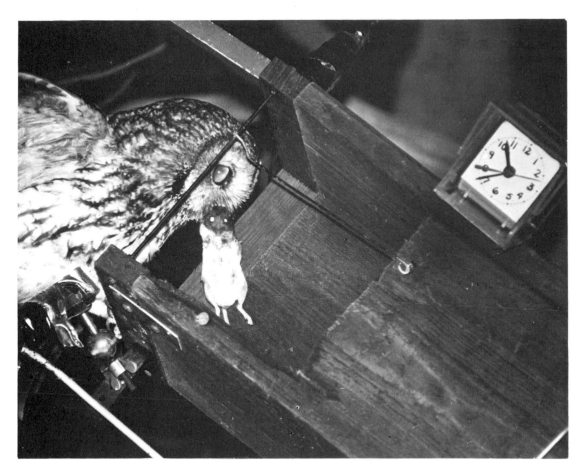

Tawny owl arriving at the nest-box with a woodmouse; Wytham Wood, Oxford. The picture was taken with the automatic apparatus shown in the sketch (photo G. Hirons).

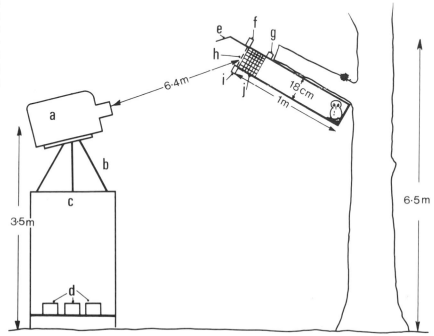

(a) Plastic cover housing camera, motordrive, flash and relays. (b) Tripod. (c) Platform. (d) 6-volt batteries. (e) Mirror, to observe nest-box. (f) Light-operated switch. (g) Clock. (h) Infra-red beam. (i) Lamp. (j) Wire netting.

member of 14 pairs of giant petrels during a two year study of their biology. In none of these birds were the eye and beak patterns identical and the transparencies were of great value during subsequent work 13,000 miles from the study site. The photographs formed part of the data used by a colleague and myself in deducing that I had actually studied two distinct 'sibling' species of giant petrel, rather than the one previously recognised. This discovery was amply confirmed by subsequent researchers.

Food analysis

Bird foods are investigated mostly by direct observation of feeding birds, by the examination of pellets disgorged through the mouth which contain indigestible fragments, or by the examination of stomach contents. Food can also be identified from photographs. Electronic flash is essential here as pin-sharp results are needed to enable insects and small seeds or fruits to be identified. At Oxford, where studies of tits have been conducted for many years, Dr T. Royama used an automatic flash camera fired by the alighting of the tit at its nesting box. This gave a record of each beakful of food that was brought in (page 227).

The photographic method has certain advantages over older methods in that soft foods, which leave few traces after digestion, are recorded. Also, the birds are not harmed and the chicks are not deprived of food as happens when a 'dummy' chick (which begs automatically when the alighting parent depresses a lever) is inserted in the nest as a means of getting food samples. The photographic method is only applicable when the food is clearly visible. All the same, it has been used with birds as different as puffins and owls, as well as with passerines like Royama's tits. As with other techniques there are pitfalls. Short-circuits in wet weather can be troublesome but more difficulties arise when young birds sit outside a nest and run down the batteries, either because they use the switched perch or squat in the beam of the infra-red trip. Usually nothing can be done to stop this but even so, the method can be very successful for recording activity at earlier stages of the breeding cycle when the chicks are restricted to the nest. I know of no one who has succeeded in adapting the technique to open cup-nest situations, the difficulty here being that the adults can approach from any direction and hence miss any prepared perch or trigger.

Behaviour

Although cine sequences are often essential when detailed analysis is required, stills can play a part for recording typical postures and behaviour patterns, for illustrating articles and books, and so on. Often it is difficult to expose at the right moment to catch the bird at the extreme of a particular posture and here a Polaroid or similar back can help, allowing you to see just what you have got and so lessening the need for multiple exposures. Relevant data can be written on the back of the print

Cosmia trapezina

Tit entering nest-box. On alighting on perch at entrance, switch is depressed that fires flash and shutter. Flash ensures pin-sharp pictures and food item can be identified as it is held in the beak (photo T. Royama).

Tipulid fly

at the time, so reducing the risk of error. However, such backs are not available for most 35mm SLRs, so that a 6 × 6cm or 6 × 9cm or larger apparatus may have to be used. Another approach is to use a motor drive to take a series of shots throughout the action and so get the one that you really need. Not having to wind on manually also means that you are less likely to scare the bird if you are unconcealed as there are no visible hand movements involved. You also know the time intervals between shots—this can be useful in some kinds of investigation.

For field workers wishing to keep their photographic techniques as simple as possible, it may be best to ignore daylight completely and take all close shots by flash using a fast shutter speed. All that has then to be remembered is the flash factor appropriate to the film in use and to adjust the stop according to the distance from camera to subject. With fully automatic units even these calculations may be unnecessary.

Extending the range of human vision
Photography can often be used to reveal what the eye cannot see. High-speed flash photography and slow-motion cinematography

provide the most obvious examples. New techniques can also be involved. For example, Despin and his fellow workers published[60] photographs showing the distribution of heat on the surface of Humboldt penguins as revealed by a 'thermograph' coupled to a cathode tube display. The machine detected the infra-red radiation and the tube presented the information in seven colours corresponding to seven steps in the surface temperatures. The display was then photographed for study and reproduction. Such work has been done mainly under controlled conditions with captive birds but these heat detectors are becoming more portable and may prove useful in some kinds of field investigation. They allow surface temperatures to be monitored from a distance while the birds are undisturbed and unrestrained.

There is also some scope in bird photography for the use of photo-multiplier systems such as 'nightscopes'. These amplify the available light and give clear images on a screen under starlit skies. On a dark night, or in a forest, the weak beam of a pentorch clipped to the scope is adequate. There are several designs, most costing several thousands of pounds, and they are small,

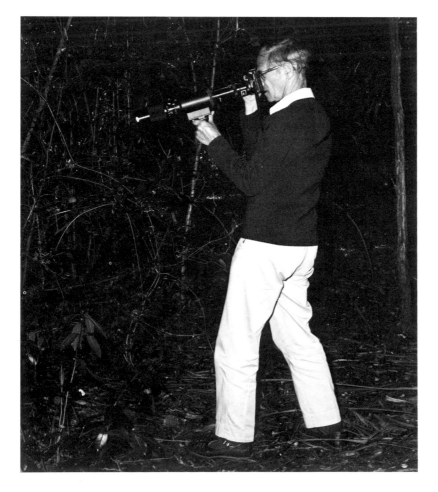

'Nightscopes' are quite small and readily portable, in this case attached to a 35mm SLR and with a 135mm telelens fitted. With fast film useful negatives or cine can be obtained even by starlight (photo T. R. Williams).

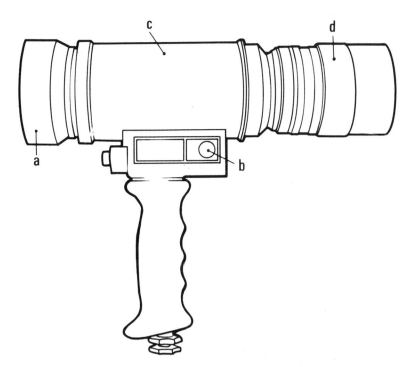

(a) Nightscope eyepiece and coupling tube for cine or still cameras. (b) Gain control. (c) Electron lens and photomultipliers. (d) Objective.

silent, portable and easily adapted to fit 35mm SLRs. Such night-viewing devices use ordinary lenses—standard, telephoto, or zoom. The image is of the greenish, cathode-ray tube type and with high-speed film quite reasonable monochrome negatives can be made. Such systems are useful when conventional flash would disrupt the bird's behaviour. They are better than infra-red, for example, for taking burrowing petrels. Movie cameras can also be attached to nightscopes. The equipment is usually too expensive for most ornithologists' resources but could conceivably be hired for a specific project.

Another technical development with some potentialities in the field of bird photography is endoscopic photography. First developed for examining and later filming the interiors of people's stomachs, the device could have applications when photographing birds in tree-trunk nest or perhaps underground. The modern endoscope is based on fibre optics in which a bundle of flexible fine glass fibres is used to pipe light down to the cavity, while a second bundle with a lens at the end, allows the investigator to see inside. A camera—cine or still—can photograph the view. A similar device is used in some viewing systems for cine cameras and Polaroid sell an endoscopic attachment for medical use linked to their 'instant movie' system. Fibre optics could conceivably be used to take hole-nesting parrots and the like *in situ* without having to excavate the trunk, but they are not the answer for most ground-burrowing birds as it is very difficult to insert the light and the lens system down the entrance tunnel without both becoming clogged with earth.

Another piece of gadgetry of some interest is the stroboscope

or 'strobe'. This is a pulsed light source which can be adjusted to fire at predetermined rates. Typically, a special electronic flash tube is used and the images recorded with special cameras. Alternatively, the firing rate can be adjusted to synchronise with a movie-camera shutter so that the flash fires each time the film stops at the gate. If high speed tubes are used then each frame should be pin-sharp providing focusing etc has been done correctly. So stroboscopes can also extend the range of human vision. Unfortunately the system has rather limited field applicability at the moment because, due to the problem of disseminating the heat generated in the tube when firing at, say 24 fps, the actual light output is rather low. Also the equipment is designed for mains operation. Strobe sequences such as those of humming birds hovering before flowers, appear to have been made in gardens where mains power can be tapped and are of birds that are very tame and will permit the tubes to be placed very close to them. Some brilliant examples of birds flying in captivity taken by a strobe have been shown by Dr Hans Oehme and his colleagues in East Germany[61].

Rather different is the recording of a series of stills images in rapid succession, like those of a bird in flight. This technique has been developed in laboratory situations by researchers into ballistics and natural flight. Marey, for example, was using flash duration of 1/25,000 sec in the 1890s and in his bird flight studies he did not separate the images but allowed them to stay

Little Owl flying to nest, a modern chronophotograph. For such studies a dark, featureless background is essential to prevent 'ghosting'; night provides this (photo Stephen Dalton).

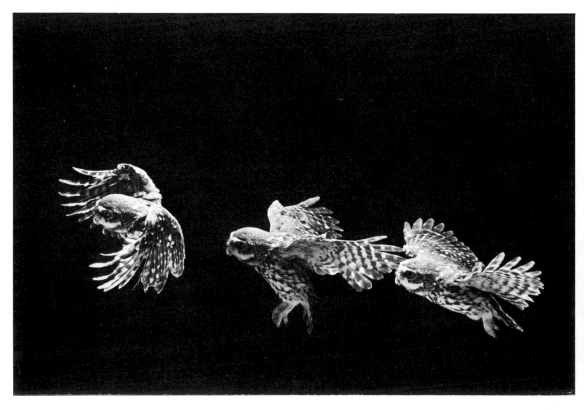

This Emperor penguin is not flying above the clouds but diving beneath the Antarctic ice in search of food. Rolleimarin IV, *f*3.5, 1/125 sec and flashbulb on Ektachrome 160 (photo G. L. Kooyman).

superimposed to create a general impression of the movement—see the 'chronophotograph' on page 13. Such multiple imaging has been rarely used in field situations. For much scientific work it probably has little to offer over high speed movies and it is hardly possible to record several images of a moving bird on one piece of sensitive material, except at night, because the background will be successively exposed and lead to multiple ghost images. To take such a series the camera can be set up on a flight line as described on page 175. Instead of a single flash, however, a battery of flashes is used, each powered separately, which are fired in sequence via some sort of electronic switch. Thus when the shutter is released or the trip beam broken, the switch fires the flashes one after the other and, with care, a series of images is captured on the same piece of film. Stephen Dalton[62] is the only person I know of to have done this with wild birds. He found that a major problem was how to reduce the time lag between the bird's breaking the trip and the actual firing of the flashes. It was all too easy to find that while the flashes had all fired, the bird had actually passed through the field of view of the lens. Dalton tackled part of the problem by using a special shutter that took only 1/400 sec to open and which he fitted in front of the taking lens, setting the focal plane shutter in the 'open' position. Using computer technology the time lag in the circuitry is negligible, and the firing can be set finely enough to respond when the front

or rear of the beam is broken. The lag with the mechanical linkage at the shutter, however, is still a problem. Obviously it helps to have a long flight path between the perch and the alighting place so that the trip, whether this is just your finger on the release or a photo-electric one, is sufficiently far back from the field covered by the lens to compensate for the delay.

Another means of extending the range of normal vision is to take the camera underwater. In good light and clear water it is possible to take quite reasonable pictures of submerged birds by shooting from above. Real underwater work, however, in which you are immersed with the birds, is a specialised field in which I have no experience. Some of the earliest essays in this medium must have been the photographs of gentoo penguins taken by Dr P. Grua. More recently Dr G.L. Kooyman[63], in the course of research on the physiology of diving in emperor penguins, has photographed them underwater off the Antarctic ice-shelf. One of the best films of underwater subjects comes from Werner and Helga Urban's *Vogel unter Wasser*[64], which shows some familiar pond birds in very unfamiliar situations. Whether the film was shot from some sort of submerged hide or using a wet suit and an underwater camera housing I do not know, but the birds shown seem quite oblivious of the photographer. The film includes remarkable sequences of crested grebes stalking their prey, of a dabchick swimming along with a school of dace, of coot thrashing fiercely with lobed feet to drive their heads down to the weeds on which they are browsing, and so on.

Diagrams from photographs

Although photographs are often used directly to illustrate scientific articles, line drawings are much cheaper to reproduce and ornithologists can persuade editors to use more drawings and diagrams than photographs. Another advantage is that confusing and irrelevant details in background or foreground can be eliminated, allowing the viewer to concentrate on essentials. Finally, for such sketches one normally uses only the main outlines of the bird so that even fuzzy shots may be useful. The important thing is that the photographs show accurately the attitudes or events in question, allowing the draughtsman to prepare drawings of equal accuracy.

Sketches can be based on stills, transparencies, negatives or cine frames. Tracings can be made from stills either directly from a print or by placing the negative or transparency in the enlarger and outlining the birds from the projected images on the baseboard. Some scientists have used black-and-white prints from 16mm cine frame as illustrations for their papers. These are not really satisfactory because the definition is usually poor and the results seldom justify the expense. Their only advantage to my mind is that they are more objective than sketches—but on every other count good sketches seem more suitable.

I find that one simple way to make such sketches is to select the

Still photos, particularly if not quite sharp or with muddled backgrounds, as here, can be used as basis of simple sketches for illustrating research papers, as with these displaying Snares crested penguins (photo John Warham).

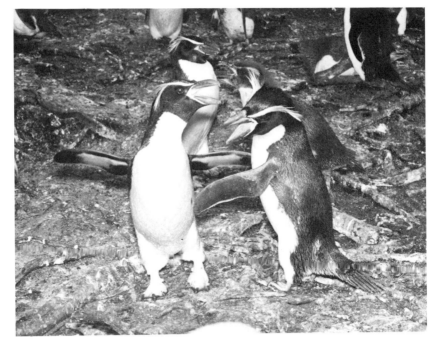

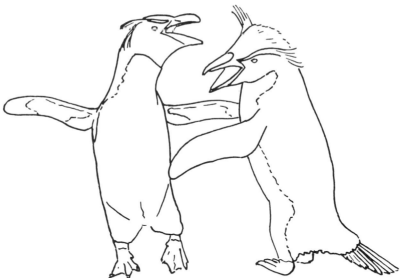

most suitable frames at the editing bench, mark the appropriate portion of the reel by inserting paper slips, and then to blow up these frames in an enlarger to the size required in the drawing. A piece of drawing-paper or card is then inserted into the enlarging easel and the outline of the bird sketched in directly, while the image is being projected. Several separate outlines are made at the same time in case the first attempt at inking-in is unsatisfactory. Care needs to be taken that the enlarging lamp is not kept burning so long that the film is overheated.

Selection of the most suitable frame is important. The bird should be sufficiently well defined to reveal the action to be

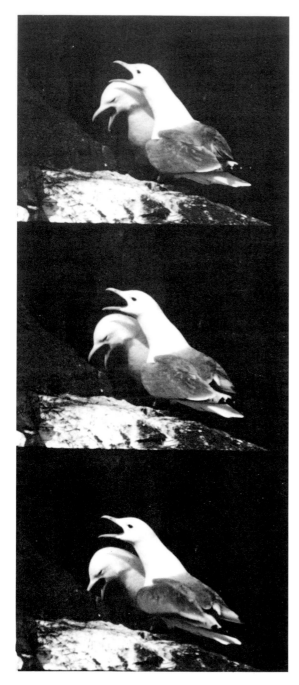

Prints from small-gauge cine film: it can readily be seen that their quality is not good enough to illustrate scientific papers. An alternative is to project selected frames in an enlarger and make sketches directly on the easel. Unwanted detail can be eliminated as in the sketch here, made from 16mm film of kittiwakes in mutual display (16mm cine and sketch by John Warham).

sketched. The frames on either side of the good one are often blurred.

This selection of a sharp-imaged picture is vital if 8mm film has been used, otherwise it may prove impossible to get good sketches by this method. Hence the importance of shooting in this format with a camera having a variable-speed shutter. In both gauges the subject should be large in the frame, although on 16mm quite small images will serve.

Another method of making excellent sketches from still negatives and cine frames has been described by Drs Barnett and Donald of Glasgow University, whose paper should be consulted by those interested[65].

The figure opposite was derived by projection from cine images. There are many other examples in bird literature. A particularly good case from movie film illustrates the methods used by black cockatoos to extract the larvae of *Xyleutes* (a kind of outsize goat moth) from the trunks of eucalyptus trees in New South Wales[66].

Stereo

Stereo photographs using stereo cameras can be made in the same way as normal photographs but provision has to be made for two lenses when working from hides. The results can be reproduced for three dimensional viewing, with or without a stereo viewer, if the pairs are printed at the correct distance apart. Bird stereos, particularly in colour, can be startingly attractive, as visitors to the Royal Photographic Society's exhibitions over the years well know. I know of no instance, however, where stereo-pairs have been used in scientific bird articles, except by palaeontologists to display bird bones. One example of stereo used in a field study was that of Dill and Major[67]. Here stereo photography in conjunction with photogrammetry helped elucidate the structures of flying flocks of starlings and dunlins. It was found that each species formed groups with a characteristic pattern of cohesion. The special high speed manoeuvres used by the flocks when menaced by a predator like a peregrine or a 'threatening' aircraft were also analysed with the help of the photo-records. For a general introduction to stereo photography, with particular application to natural history work, reference should be made to Pat Whitehouse's article[68].

Automatic stills

The possibility of using cine cameras on single frame to monitor field events photographically has already been mentioned. Cine has the advantage that on single shot the cameras are quieter than most automatically operated SLRs and on cine you can usually get more pictures at a loading. Yet if bigger pictures are needed, one of several kinds of 35mm still cameras can be set up to cover the nest, feeding place or whatever is being studied, and if linked to an intervalometer, can make exposures at predetermined intervals. Most such cameras can be fitted with 250 or 750 exposure magazines—at a price. A few companies also make cameras specifically for automatic interval photography for scientific and surveillance work, e.g. for use in banks. Some of the Robot models would be excellent for automatic surveillance of birds and bird colonies. The range includes models that can take 200ft magazines (giving 2400 frames 24×24mm or 1600 frames 24×36mm). They can be spring- or battery-driven,

coupled to a time control unit and to electronic flash up to 1/500 sec. Used with an instrument panel, a clock dial, a counter and written data can be recorded on the corner of each negative or transparency—an ideal arrangement for scientific work.

Planning, shooting and editing the film

Some bird films just grow, perhaps from quite casual shooting around a particular species, idea or place. A party may go somewhere which is seldom visited and the person in charge of photography may have no very precise idea as to what he will find. He has to build up his film as he goes along and pick up a story line where he can. Too often the result is a sort of ornithological travelogue. At other times a wildlife film is the result of deliberate planning around a particular theme. Generally speaking, this planned approach produces by far the best results.

Most documentary films start as ideas in the originator's mind from which a provisional treatment is worked out. This explains the idea and the film's underlying 'story line', its mood and the sort of audience to which it will be slanted. Later, and often only after quite a lot of research, a script is prepared. This lists all the 'visuals', shot by shot, and details how these will be made. In addition a breakdown script is usually prepared in which each shot is listed in finer detail for the use of director and cameraman. The costs of such preliminary work may amount to 5–10% of the direct costs involved in making the film, costs that are incurred before a single frame is shot.

With wildlife films no talking script is needed except for these scenes involving human action. Such scenes may well call for detailed thought and scripting. For popular films, the human angle is often regarded as important in the eyes of potential purchasers, so that care must be taken to see that such shots are not spoiled by inadequate acting and staging. While birds are not human, they can still misbehave in front of the camera, showing nervousness and so on. It is the wildlife cameraman's job to see that his subjects are, and look, relaxed.

Bird films, then, are often hard to script, but the shooting should be done to some sort of plan and must have an underlying theme. At one end of the scale there is the wholly scientific film, probably interspersed with graphs and diagrams, which aims to explain a particular piece of research to a specialist audience. At the other end are many films of wide general interest slanted at the layman, the sort of thing that reaches our television screens. Furthermore, it is sometimes possible to construct a film in such a way that it appeals visually to both scientific and lay audiences, only the commentary being adapted accordingly. Alternatively, using the same basic shots, two quite different films may be

constructed, slanted at quite different audiences or markets. It is perhaps worth pointing out here that, in general, the public will accept an increasingly scientific content in wildlife films. Perhaps this is one of the reasons why many bird films made 20 or 30 years ago seem hopelessly naïve when screened today.

Know your birds

Once you have hit upon an idea for a film, it is necessary to think around it and to investigate the ways in which the subject can be treated. The director and/or cameraman must know the basic facts about the lives of the birds to be filmed and of any associated animals that may be involved and about the environment in which they live and to which they are adapted. He or she must know, for example, the breeding timetables and food habits, climatic details such as the duration of wet and dry seasons, and at what stage in the annual cycles the various animals are most likely to be approachable. If such facts are not known, then they must be searched out. For animals, from amoebae to primates, the key sources to published research are the *Zoological Record*, published annually by the Zoological Society of London[69] (the section *Aves* covers bird literature) and *Biological Abstracts*, published in parts in Philadelphia[70]. Both are to be found in university libraries and in the larger public libraries. Local avifaunas, of course, are covered by many specific handbooks and such works can again be found in libraries.

In many wildlife films the whole treatment and development hinges on only a handful of essential sequences. These key shots are the core on which the rest of the film is supported. Such shots are frequently difficult to take for various reasons. They may involve behaviour that occurs only at certain times of the year or that takes place in difficult situations photographically, and so forth. To know and recognise what these shots are again brings us back to the need to known intimately how the bird lives—as in the example of Oliver Pike's cuckoos (page 20).

Plan the key shots

Key shots in popular films are often the sequences which you hope will make the audience sit up and take notice and say to themselves 'that's good'. In scientific films they are perhaps more likely to be the sequences showing the actual discoveries that have been made.

Thus the first concrete step to take when planning a wildlife film, once the general basis of the treatment has been decided, is to work out what the key shots are likely to be and to find out when and where they could be taken and what special help or equipment may be needed to do this.

It may not be the photographer's responsibility to record the sounds as well as the visuals, and the sound side of bird filming is no concern of this book. Nevertheless the key sounds must obviously be thought about concurrently with the key shots. They

will often have to be taped at the same time as the shooting is done, but not necessarily in synchronisation. Indeed, for various reasons, with nature subjects, most of the sounds will be recorded 'wild' and synced up to the film later.

Although some sort of plan is needed, however humble the film, in order to avoid wasted effort and resources, the plan should not be too rigid. It will often have to be altered, for in the course of shooting it may become apparent that the whole concept and slant as originally envisaged is unsatisfactory. Also, it frequently happens that the most attractive and stimulating shots are those that you never imagined during the planning stage.

Once the key shots have been roughed out, all efforts must be concentrated on them. Without these you may not have a film at all. I once decided to make a film about the barn owl. This would have involved showing the animals' behaviour in the nest and many of the key shots had to be shot at night. I had found the right place to do this, with an AC mains supply to feed the floods. I had planned to take the key shots in the late spring or early summer. Unfortunately, however, there was an abnormally cold winter and I was completely foiled by the behaviour of the owls. Instead of nesting at their usual time, they must have laid when the snow was still on the ground, and by the time I was free to start filming the chicks were flying. This was a failure in my knowledge. I had not realized that a hard winter did not necessarily spell disaster for barn owls as it did for many birds. Perhaps the reverse was true, for the owls probably nested early because there was an abundance of food available in the form of dying and weakened birds and mice, so that they could breed earlier than was normally feasible or safe. Clearly, without the key shots in the bag, it was quite pointless to shoot the ancillary sequences that I would have needed to round out the film—things like swifts climbing skywards in the dusk, a pipistrelle on the wing, woodcock roding and so forth. In bird photography you can never count your chickens before they're hatched.

A practical example: the European robin
To illustrate some of the points mentioned above, let us take a hypothetical bird film, centring around a single species and see how this might be planned. Although I have chosen a familiar European bird, a rather similar scenario might serve for the quite different but equally familiar American robin—and many related passerine species. For each, however, rather different key shots would be appropriate.

First of all the treatment must be decided. The film is needed for a non-specialist audience but is also to be suitable for screening as a semi-educational film for schools. Well, with such a common bird, plentiful both in gardens and deciduous wood-lands, there are no problems as to availability. It is soon discovered, too, that a good deal is known of its biology and life

cycle, thanks to the work of David Lack of Oxford[71]. His study was done as a part-time occupation, generally between dawn and breakfast-time, while he was a schoolmaster. A good many shots of the life of this bird could well be made during similar hours. Using the late Dr Lack's outline of the robin's world, it is found that, in general, these are solitary birds with strongly territorial tendencies, but without any very dramatic actions apart from the display of the red breast when threatening rivals. It is decided to emphasise the bird's solitary nature and to show typical incidents in its annual cycle. A preliminary diagnosis of the possibilities suggests that the whole action can be hung on less than a dozen key shots:

1 The solitary robin in winter—perched among snow—baited to a garden perch.

2 Robin uses man, pheasant, mole as beater to loosen earth and uncover food—baiting mealworms needed; assistant.

3 Winter song—catch bird on cold morning when breath comes out like steam—150 or 250mm telephoto.

4 Territory holding. (*a*) Fighting and threat—drive to boundary and film encounter between adjacent territory-holders—Aug/Sept or Feb/April; help needed. (*b*) If (*a*) does not work, use mounted specimen or mirror to invoke threat: Feb/April.

5 Nest building—hide and 150mm lens; April.

6 Courtship feeding—before incubation—150mm. After incubation, 75mm and hide.

7 Feeding fledged young—monopod and 100mm.

8 Robins parasitised by cuckoo—get original clutch, clutch plus cuckoo egg, small chick alone in nest and large chick being fed by fosterers.

At the same time that the possible key shots are worked out, the sort of actions that would provide useful supporting material, cut-aways, etc. can be thought out:

Robins at nest (hides—several varied sites); chicks and how they match their surroundings in the nest, zoom in; robin's enemies—sparrowhawk flying, cat stalking and with robin in mouth, little or tawny owl, weasel, hedgehog; robin's neighbours—pheasant incubating, nightingale, garden warbler singing, willow warbler at ground nest, etc.; robin's perch-and-dart feeding technique (bait ground mealworms in winter); young song thrushes for comparison breast patterns with young robins; dead robin on ground against snow; typical habitats perhaps shot from same position in winter, spring, summer and autumn to show alteration in ground cover (allow adequate footage for mixing and mark exact spot for shooting); robin's food—BCU of winter moth caterpillars, plant bugs, and so on feeding (extension tubes), some in BCU in robin's bill (nest shot); food pellets (extension tubes).

Some key sounds must be thought of too:

Male robin's spring song; autumn song for comparison; dawn chorus with robin prominent; violent song during territorial

skirmish (use dummy or tape?); alarm; caterpillars chewing.

It will be quite obvious to any reader with a passing knowledge of robins that some of the key shots are going to be difficult to obtain, for though these birds are pretty tame around our gardens they can be very secretive and shy in the breeding season. To film nests being built, for instance, you might have to find several nests in the course of construction before you would find one that was suitably lit and whose owners will tolerate your blind. If you pitch this too close they will probably shift somewhere else, so nest building is likely to require the use of a pretty powerful telephoto. With a 150mm lens and a bird as small as a robin, the camera will have to be about 10m away if the bird is to appear at a reasonable size in the frame—see page 268.

Key shot **2** is another difficult one. It refers to the fact that European robins, like quite a lot of small birds in other parts of the world, follow other animals about in winter because, in turning over the leaf litter (or digging gardens), these animals uncover food which the robin darts down and retrieves. You cannot go out into the woods in the winter, however, and expect to see this sort of thing. Probably to show this action you will have to bait the leaf litter with mealworms and get a particular bird to associate you or some assistant with this food.

Key shot **4** refers to the well-known use of the orange breast in threat, and this is undoubtedly a 'must' for a film of this bird, as it is one of the few dramatic actions it makes. If it cannot be filmed by driving one male into the territory of another, then it is comparatively easily evoked by a stuffed robin, a model or even by a mirror. If the experiment is conducted in the vicinity of a nest, this should not be too near or the disturbance may result in nest desertion. The mirror takes the place of a stuffed bird or a rival; the robin, seeing its reflection, threatens with loud song and posturing and may even try to fight. Such experiments need careful planning, and you have to make sure that the bird will come into the right position to see himself in the mirror and so provide your shots.

Note that the ancillary shots listed are not essential to the success of the film and few of these are likely to prove hard to take. The nesting sequences, for instance, merely involve the correct techniques using a hide or blind, but they do require that nests are found in photogenic or reasonably well-lit places. The shots also involve quite a number of animals apart from robins. This is intentional, for most audiences get visual indigestion if they see nothing but a single species for 20–30 min. Thus the scenes of the main performer are rounded out by showing its surroundings and some of the birds which share its habitat, the creatures that prey upon it and those upon which it preys in turn.

No human interest shots are listed, but some will have to be provided—perhaps banding operations at an observatory after an influx of continental robins and so forth. Excessive human interest is as bad as too little in a wildlife film. Some of those

produced by expeditions devote so much footage to showing the intrepid members that the animals they went to study hardly get a fair showing.

At the risk of labouring the point, it will be clear that an intimate knowledge of the robin's life, and of the country where you intend to shoot the film, is going to make a great difference to the quality of the result and the variety of the shots which you obtain. If you know nothing about robins when you begin such a project, you are going to know plenty before it is finished! Clearly, too, a single person tackling a subject like this could not hope to take all the shots in a single season—this would certainly have to be done over several years.

Shooting

Many birds make up for the fact that they have smaller brains than ours by their more highly developed senses of hearing and sight. Thus they are well equipped to avoid human beings and it is this sensitivity that is the chief challenge to the wildlife photographer. Most of the larger birds simply disappear at our approach. This timidity can be overcome by filming from concealment, but even then there are still problems of noise to be faced.

Reducing camera noise

The reduction of noise can be tackled in several ways. Obviously a camera should be selected that is inherently quiet and without switches which click when used. Professional cameras wired for sound are blimped so that the noise of the mechanism is eliminated and does not record on the tape. The new tendency to make self-blimped and portable cameras is a step in the right direction as far as the wildlife photographer is concerned, though it should be remembered that it is often perfectly feasible to film when sound recording is hopeless due to wind, rain, or traffic.

Home-made blimps have been produced and it is comparatively easy to build a blimp of sorts for a camera like the Bolex, by constructing a box with hinged sides and plastic-foam padding. This can be closed up round the camera during shooting, but this inevitably affects ease of handling and a motor drive is needed. Even so, the quality of the muffling achieved would most likely be much inferior to that given by a commercially designed blimp. Usually, in the absence of a really silent camera, it pays to keep well back from the bird by using a suitable telephoto-lens. Camera sound is then sufficiently muffled by the time that it reaches the bird to pass unnoticed or at least to be accepted. Many 16mm cameras can be fitted with a sort of flexible blimp or 'sound barney' made of foam-padded material. This clips on to the camera and helps protect and soundproof it.

With timid species you may be able to shoot while some other noise obliterates that made by the camera, such as waves breaking on a pebbly beach, motor traffic and so forth. Many years ago I tried shooting rooks from a tree-top hide at a small

colony by the London—Edinburgh railway line. The pair whose nest I overlooked proved pretty sensitive. Taking stills was no trouble, but as soon as I started the cine camera the birds shot off like rockets and naturally they were not in any hurry to get back after such a scare.

Trains, however, were very frequent on the nearby railway line. I soon found that I could film quite comfortably as long as there was a train passing at the time, but if my finger stayed on the button after the guard's van had passed, then the birds were again away like a flash!

There were two snags. In the first place every shot has an out-of-focus train tearing across the background, which is rather distracting to say the least. Secondly, each shot ends with an unconventional and unwanted fade-out as the smoke from the engines, steam in those days, drifts thickly through the trees and across the lens!

One disadvantage of modern cine cameras is that they are designed to reach full speed almost instantaneously. In consequence, when you press the starting-button there is a sudden burst of sound and it is this rather than the regular purr of the running mechanism that usually causes the most trouble. Also the din and the general noise level is greater at high than at low filming speeds. At 8 fps, many cameras are relatively quiet and this can be put to use sometimes with tricky subjects. Many will accept the noise the camera makes at 8 fps, but are uneasy at that made at 24 fps. If you start filming at the slowest speed and then gradually increase the speed setting to 24 fps you can sometimes take shots that would otherwise be impossible without blimping, or a long training programme to accustom the bird to the noise. This method does not harm the mechanisms of some cameras (the Bolex, for instance), as the filming rate can be increased while the film is rolling, but it would be advisable to check with the manufacturers before doing this with other makes.

One of the obvious snags of the last method is that you are wasting film by starting at a slow speed; everything shot below 24 fps has to be discarded. One answer is to try to get the animals used to the mechanism by running the camera without any film. This has often been done, but it is rather inconvenient and can result in good chances being missed. It is a reasonable system perhaps when you are going to spend a considerable time with the bird in question. There is the danger, however, that the bird proves less timid than anticipated, so that by the time you have loaded up and are ready to shoot your chance has gone.

Personally, I always prefer to have a loaded camera all the time; you never know what may happen. If your camera has a variable shutter, you can close this, run the loaded camera to get the animal conditioned and then backwind before opening the shutter and starting to shoot. Some people use a device like an egg-whisk to accustom their subjects to a noise similar to that made by the camera and this can be quite successful. To be

absolutely effective, however, what is really needed is a second camera running empty, so that when the subject becomes used to this, the loaded camera can be started and the other stopped. Clearly this is not very practicable, but a portable tape-recorder makes it an easier proposition. Make a tape of the camera motor running at 24 fps and play this back from your blind or filming position, to condition the bird to the noise. You now have the advantage that the tape can be started with the volume turned down and then gradually increased. When the subject is relaxed while the volume is as high or higher than that required to imitate the running camera, the latter is then started and the recorder volume simultaneously turned down. With a jittery subject this method of slipping the camera on while there is a lot of other noise to distract the animal's attention can be used repeatedly.

Know your equipment

Birds do not always behave predictably. If they did, few of us would be interested in photographing them. It is all the more important, therefore, that you are so familiar with your equipment that you can get into action with the minimum of delay if this need arises. Things like rewinding after a shot, checking the footage meter, noting the sun's direction and therefore the best shooting angle; all these come automatically to the trained person.

Automatic, too, should be the photographer's concern for the pictorial quality of his shots. The best bird films are works of art in their way, but the artistry lies not only in the quality of movement and grace in the animals depicted but also in the cameraman's eye for composing a scene, for picking the angle where the lighting is right and for his knack at shooting at just the right time. If the basic pictorial quality is not there on the film, no amount of skilful editing and cutting can create this later. Thus the experienced photographer almost instinctively tries to place his subject properly in the frame, does not shoot with excessive foregrounds or blank skies and avoids jerky panning. His horizons are consistently level even when conditions are difficult, so that you have no desire when viewing the finished product to turn your head on to one side to correct the verticals!

Pictorially, one rather restricting characteristic of small-gauge cinematography is the great depth of field given by lenses of medium or short focal lengths. This is not necessarily a good thing when you are trying to compose a shot, because in wildlife work you often want to make the subject stand out from its surroundings. If the camera is stopped down to *f*16 or less, however, this may be difficult. Here is one situation where a variable shutter can help. By doubling the shutter speed you have to open up by one stop and by quadrupling the speed you need to open up by two stops and the wider apertures mean less depth of field. This may not be a satisfactory arrangement if the animal is moving about and the taking distance is varying a lot, but if its

movements are restricted, then with accurate focusing the wider aperture may be no disadvantage. A point to watch here is the background. Bright colour patches behind the subject can be very distracting when they go out of focus: the cure can be worse than the complaint.

Composing the picture

The ability to compose the picture as the films run through the camera is only acquired by practice. It comes of having a seeing eye, of noting some trick of the lighting which can be turned to advantage, of not worrying too much about sticking to set rules. Whether or not editing is to be the cameraman's responsibility, you have also to bear in mind the way in which the shots being made are likely to fit into the finished film, to look forward in your mind's eye to that end product all the time, to its tone, tempo and story line. So, while you should not overshoot, you have to make certain that enough of each shot is taken to give adequate room for cutting. In panning, for instance, it is customary to start the shot with the camera still, to shoot the pan and then to end with the camera still again, so that the editor has a good 45cm or so at start and finish to make his cut. Another point to remember is to collect the subsidiary shots which may be needed to give continuity to the key shots. Such cut-aways often cannot be scripted for and they may just be incidents which happen concurrently with the main action, incidents which the skilled cameraman takes advantage of when he has the chance.

The dope sheet

In normal documentary production the camera operator keeps a 'dope' or camera report sheet. On this he notes down the technical data relative to each shot, what each is supposed to show, the location of the shooting and so on. Such data are invaluable later when piecing the takes together to construct a film. One copy goes to the processing laboratory for guidance.

Even if yours is a one-man effort, you must have a dope sheet of sorts and must make a note of each shot *at the time of taking* for future reference. This includes the unplanned shots taken for possible use as cut-aways, links between sequences or establishing shots.

Exactly analogous considerations apply to sound recordings. Otherwise, when editing the reels later—maybe months or years afterwards—the details will have been forgotten. This may result in errors creeping into the film, into the commentary, for example. Such errors are certain to be detected sooner or later by some members of an audience, most likely sooner than later, and these people will quite reasonably suspect that there are other inaccuracies of which they are unaware and rate your film accordingly. The only way to keep such slips to a minimum is to make accurate records of the shots on location immediately after shooting each scene.

Collecting ancillary shots

The ancillary takes will usually include shots of the bird's habitat, and such shots should not be skimped or passed off as straightforward and simple. Nor should they be left to the last moment before they are made. Such scenic material may be rather difficult to take, because these shots are often used to establish the setting for the various sections of the film and to do this they must convey the feel of the place, capture something of its atmosphere. This is not done just by taking a few casual pans and hoping for the best, but may involve quite a bit of thought and reconnaissance.

Shooting habitat shots may call for some ingenuity as straightforward wide-angle views may be inadequate. John Borden has described[48] how his team producing a film about life in a pond rigged up a cable 'dolly' 100m long which could be fixed between any two trees. The camera was suspended from the cable by two skateboard wheels and could be drawn to and fro smoothly with a nylon line over a pulley. The footage shot by this device gives a close view of the pond and its surroundings from an unusual angle and one far more effective than that gained from a helicopter or fixed wing airplane, as well as being less noisy and disturbing to the inhabitants.

As filming continues and the shots are steadily being collected it is necessary to review from time to time what has so far been achieved and whether you are getting adequate visual variety. To ensure this it is often worth taking a good shot from more than one angle if possible and a generous mixture of long, medium and close shots is needed. High and low viewpoints should not be overlooked if the subject warrants these. For television, with its small screen and imperfect resolution, plenty of close-ups and big close-ups are essential. Visual variety is also obtained from shots of animals other than birds about which the film is primarily concerned.

Checking the exposure

If your camera lacks automatic or semi-automatic exposure control, a careful check has to be made on exposures during changeable weather. You may have to keep watching the run of the clouds, so that shots can be started knowing that the sun is not going to be obscured until the take is complete or vice versa.

Shooting in colour calls for extra care in calculating exposure, particularly where contrasts are high. When the light reading on the highlights is more than four times that on the shadows, then the film may not record all colours accurately. You have then to decide whether you can allow some inaccuracy in colour rendering at one end of the scale or the other. Usually the only thing to do is to see that the bird itself is adequately exposed and hope that the rest of the picture will not be too bad.

Quite frequently it is obviously useless shooting at all. One of the commonest situations encountered in nature photography where this applies is when filming among grassy vegetation or

bushes in the sun. With a still camera you simply use a flash to fill in the shadows, but when working with a movie camera fill-in light is often out of the question. Occasionally, perhaps, reflector screens might be used to throw light into the shadows, but most birds are not prepared to face such objects and they are easily blown over in the slightest wind. Battery-operated lights can be used for short periods (see page 182), but for providing fill-in their colour temperature must approximate to that of daylight. The contrast problem is naturally not quite so critical when filming in black and white, since it is the accuracy of the colour rendering that gives trouble. There are times, however, when shooting even on monochrome is pretty hopeless.

Subject behaviour

In good wildlife films the subject behaves naturally. It is important that your activities do not cause abnormal behaviour in the bird being filmed. It should look relaxed because it *is* relaxed, going about life in its usual way. This does not mean that your shots need be dull; it is normal and natural for blackbirds, when establishing their territories in late winter, to end their interminable zig-zag threat parades with quite fierce battles during which the protagonists may well end up at your feet as a mass of feathers with claws interlocked and beaks gaping before they separate, the loser to flee, the winner to preen and perhaps relax. Such shots look and are dramatic. What is not normal or natural is for a herd of zebra to tear across the landscape away from a low-flying plane or for a bird to dive hundreds of times at a camera set up near its nest because of its fear of this incongruous object.

All the time filming is going on, the needs of the subject should be considered. It is wrong to keep birds who are desperate for water away from it just for the photography; to prevent birds from getting back to their chicks or indeed to subject wild animals to any sort of unnatural hazard or stress, particularly as these can be avoided by skill and understanding. People who cause distress and death are often ignorant rather than callous and much of the trouble arises because they are too lazy to take the time to use well-tried techniques.

Human interest

The television companies and many other potential purchasers of bird films prefer plenty of human interest in the material they buy. This may be provided in many ways, maybe by showing aspects of the lives of local people or tribesmen as they in turn affect the lives of the animals filmed or how these in turn affect human communities. Sometimes the films are built up around the film-maker's own work so that he or she becomes part of the story line, or it may be that a research team is involved and the film includes sequences showing how they work in counting the birds, marking and trapping them, shifting threatened species to safer areas and so forth.

Perhaps the most important point to watch when taking these shots is that the humans, whoever they are, act naturally. Those involved should know what the film is about and why the shots of their activities are needed and above all that they do not stare at the camera. Human interest material must, of course, be strictly relevant to the story or theme of the wildlife film. Be cautious about including yourself in the film: this is sometimes overdone and bores audiences. They do not mind a few shots of you in action, perhaps lining up the camera on some animal featured in the film, but too many shots of this sort becoming irritating.

Where people are involved there is generally no reason why the sequences should not be scripted beforehand so that the man behind the camera knows just what is required and when to stop shooting. He will, in any event, be alive to the need to get sequences of human interest relevant to the film's theme, and when the chance comes he will take these whether or not they have been thought of in the planning stage. Such unplanned shots are often the best, as they tend to have a spontaneity entirely suited to a film mainly devoted to wild animals.

Should it prove difficult to get a group of people to behave naturally when the camera is turned on them, one way out of the difficulty may be to focus and frame up on the group and then to film this while standing with your back to them. You actually pretend to be adjusting the mechanism, whereas you are in reality pressing the cable release and hoping that those behind you are relaxed and behaving as required. If the pan head has a scale inscribed on it, you can even make a pan shot if you have first established the limits within which the camera can be moved. Clearly such methods and others involving deception have to be used discreetly and with common sense.

Editing and presentation
The shooting side of cinematography is rapidly becoming automated and almost anyone can expect to produce correctly exposed shots at their first attempt nowadays. Parallel with this, equipment and film stock improvements permit shooting under what were formerly marginal or even impossible conditions. Some people think that because of these improvements the need for skill is disappearing too. I do not think that this is true. After all, it is only the mechanics of photography that are affected by these developments; the cameraman's skill and especially his imagination are still individual attributes. There are still plenty of challenges remaining for the wildlife cine photographer, even in a tight little island like Britain where you might think the possibilities for filming birds were exhausted.

The coming of automation at the shooting end of film-making should mean less wastage and ought to enable the cameraman more opportunity to concentrate on the creative aspects of his work—on finding new angles and relational shots and in visualising their context in the finished print. This in turn should give

editors better material with which to work to produce really effective presentations. Thus there will be even less need than there is now for retaining in the finished work shots that are technically faulty just because they were so difficult to take.

Editing is a specialised subject and there are many much better qualified to write about this than I am. In many types of work, for example in educational films, expert knowledge is needed. All that I should like to do here is to discuss a few general points that seem particularly relevant in wildlife work. For general guidance on techniques the reader is referred to the introductory exposition by Baddeley[72] and to more detailed works like that by Reisz[73].

Common defects
Looking at ornithological films, it is rather remarkable how the same defects, most of them quite elementary, crop up again and again. This applies not only to amateur productions, but to a surprising number of professional ones as well. Filmgoers are accustomed to very high standards of presentation in entertainment films, and it is not unreasonable for them to expect similar quality in nature films too, despite the very different budgets under which they are made. Some of the commonest photographic defects in wildlife films are these:
1 Fogged edges.
2 Jerky pans and other examples of camera instability.
3 Unnecessary repetition of shots showing identical or very similar behaviour.
4 Out-of-focus shots retained, e.g. animal moves too close during a take.
5 Too much foreground or too much sky.
6 Tilting horizons.
7 Bad composition generally.
8 Colour quality changes between adjacent shots.
9 Subject is obviously nervous, perhaps even scared stiff.

The reasons for all these faults will be quite obvious and little comment is called for except to urge that all such sequences are ruthlessly chopped out on the editing bench. Over-repetition is rather common with amateur films, presumably because the cinematographer just cannot bear to abandon some of his shots. They are mostly very good, but just will not stand much reiteration in the context in which they are used.

Lack of precision in cutting is another common error. We see a bird, for instance, fly from a post and then, instead of a prompt cut to the next shot, we are left looking at the empty post for a couple of seconds before the scene changes.

Variation of colour quality can be due to many factors, to shooting at different times of the day, or to the use of different film stocks, or to variations in processing. If such varied material has to be incorporated in the same film, then the shots should obviously be separated by appropriate cut-aways or fades, so that

the audience's attention is not directed to the variations, as it must be when they are run side by side.

Such faults are missing from good wildlife films. Here the material is built up skilfully round its theme. The editor's cutting controls the pace of the production and the whole film has unity. Furthermore, the cameraman's skilful and imaginative shooting conveys to the viewer the feeling that he or she is seeing life almost at first hand and is privileged to witness something not often revealed to the layman.

By appropriate means the setting and the atmosphere of the habitat is established as in the riverside scenic shots of the Eastmans' kingfisher film[52].

A good film also leaves the intelligent viewer with the feeling that it was made honestly and that the animals seen were no worse off after their encounter with the photographer than they were before. There will be no gimmicks, no faked contests and no captive animals mocked up as wild.

Suitable soundtrack

One of the most irritating affectations is the excessive use of background music. Some of the sounds dubbed on to nature films seem not only far too loud but quite inappropriate, and you cannot help speculating what sort of moronic audience the makers were aiming for. Adults can surely look at a colourful landscape for a few brief seconds while the scene is established without the need to have their ears blasted with sound lest they fall asleep.

If music has to be used—and there are some excellent nature films with none at all—it should surely be used discreetly. It seems most appropriate at the start, during the titles, when it may help to establish the mood of the film, and again at the end. Musical extravagances like fitting martial rhythms to territorial combats or slimy strings when a snake slithers across the screen seem pretty naïve even in films for children. By and large, in a well-constructed wildlife film with plenty of interspersed 'show-stoppers', there seems to be little need for musical effects. Not that the sound track will be empty, of course; in between, or overlaying, the sounds of the birds it is reasonably simple to run sounds typical of the habitat where the takes were made. Appropriately handled, the normal noises of an English wood or of the coconut groves on a Pacific island can be quite effective with films made in these places but sound levels should be carefully controlled so as not to interfere with the clarity of the commentary.

Stills and black-and-white shots

Sometimes it is impossible to film a key shot but good stills are available. At a pinch you can get away with an occasional still interspersed with the movies—a BCU of a bird's head, for example. Providing the picture is held only for two or three

seconds and its colour quality matches the rest of the film, most of your audience will never realize that you have inserted a couple of feet from a still transparency. There is at least one gadget that fits a 16mm camera and permits a single frame to be copied for projection[74]. Or you can be quite blatant and do as in the Eastmans' kingfisher film and shoot some of the colour plates from a book to put the European kingfisher in a world setting.

Again, in an emergency, it is possible to use black-and-white shots in a predominantly colour production. Such shots will be of very special events where colour film could not be used, e.g. infra-red or night-scope studies. Mixing monochrome and colour is not otherwise advisable, but may be quite acceptable in scientific work, in which the content is usually far more important than niceties of presentation.

Many wildlife films deal with birds from regions remote from the viewer's experience. In such films it would seem self-evident that good maps should be included, but they rarely are. It is as though, having edited the shots, the producer was too exhausted to finish the job off properly by preparing them. No doubt the type of country can be well shown in the establishing shots, but nevertheless many people do like to get their bearings, and for this there is no substitute for good clear maps. They can be inserted at the start of the film or, if the location changes, at the appropriate places as the story unfolds. Such maps have to be specially drawn, usually in a simplified style.

Commentary and continuity
The commentary has to be thought out before or parallel with the editing, and if the shots have been well taken and properly laid together—e.g. dragonfly lays eggs among reed stems/cut to red-winged blackbird hunts among stems and removes eggs one by one/cut to blackbird feeds chicks—then the commentary can be brief and restricted to what is necessary for comprehension of the picture.

In natural history films, as in others, you have to watch that continuity is maintained—that the shadows do not change between successive shots supposedly showing consecutive events, etc. David Attenborough[75] gave some examples of blunders made at the editing bench. He quoted one case where a man is seen trapped in a tree by a buffalo, followed by fine shots of the animal from a high viewpoint. The commentary emphasises the danger to anyone on the ground at that time, but then gives the game away by cutting to a CU of the animal's head that could only have been shot from ground level. Well, of course, no wildlife film can be the truth, the whole truth and nothing but the truth, but such *faux pas* naturally throw doubt on the integrity of the film as a whole. This may be unfortunate, to say the least, because usually most of the other shots will have been made under perfectly natural conditions, perhaps at some risk to the photographer.

Films having a high scientific content cannot reasonably be

judged by the same criteria as entertainment films, but faults like those listed at the start of this chapter will need excising. The commentary here may have to be more involved than in simpler productions and, in order to get over a point that cannot be carried by the visuals, fairly extended explanations may be needed. Then it may be helpful to have shots running rather longer than normal which either contain relatively little action or action that calls for little audience participation and so allows them to concentrate on the commentary. Thus, although it is good sense not to overshoot, there are occasions when extended shots are required, and if the cameraman knows this he can see that these are made. In any event, long shots can always be cut down. The reverse is hardly feasible, though sometimes short shots without much action have been salvaged by duping twice and then splicing the two up as a single shot.

Finally there are basic methods and concepts relating to film making, whatever the subject, and these are not covered here. Of many excellent guides to film techniques those by Beal[76], Callaghan[77] and Strasser[54] should prove adequate for most purposes.

Birds as pictures

The bird photographic community is composed of individuals, with individual approaches to their hobby or work. Some aim primarily at showing birds in action, recording how they live, and may be more ornithologist than photographer. With many, photography is the prime interest, the bird and its natural history secondary, its role seen more as a subject for picture making. It is to this latter group that this chapter is addressed. I do not overlook that many photographers mainly interested in bird behaviour still try (and often succeed) to make their results truly pictorial when the occasion permits this. Some thoughts on the characteristics of a good bird movie have already been given (page 250).

If you want to turn out photographs that are aesthetically pleasing—the sort that you would hang in your living room—there are many advantages in being able to control the setting of the photograph. Hence some of the most noteworthy examples show birds in situations where the photographer has been able to exert some control over the composition of the picture and plan this in advance—i.e. at bait, on a perch or at or near a nest. Luck, of course, does play a part, for an unanticipated trick of the lighting may transform a run-of-the-mill shot into a winner, but luck will not produce consistently good pictures.

When working with colour you have less control than with black and white once the exposure has been made, and planning beforehand becomes even more critical. With reversal film, nothing can be done to correct distracting highlights after the button is pressed—such faults must be corrected by proper choice of shooting angle and so forth before the exposures are made. Again, with such film, it is not easy to correct for the bird's faulty positioning in the picture frame, particularly on 35mm for, unless resolution is very high, enlarging only a part of the frame may be impossible without serious loss of overall definition. Using colour negative material, some local control can be effected during printing, but again this calls for more skill than with monochrome and mistakes are far more expensive.

Many fine bird pictures are made with 35mm SLRs but because the lens is fixed in relation to the film plane, control of out-of-focus parts of the picture may be impossible. Where such control is needed a larger view or monorail camera with its rising front and swing back may be necessary. Recognising this need some 35mm camera makers market lenses that can be shifted asymmet-

rically in their mounts to simulate the traditional effects of side-swing and rise and fall front. These lenses are very expensive, however, and they are mostly of short focal length and of little interest to the bird photographer.

What are the aesthetic qualities that differentiate the few bird pictures from the many bird photographs? I suggest that some or all of the following will be found in most of these:

1 While the bird and the foreground is sharp the background is either out of focus or is unobtrusive so that the main subject stands out, clearly defined.

2 The composition is well balanced so that the observer's eye is stimulated but rested and does not wander about aimlessly seeking some feature to hold the attention.

3 The photograph conveys something of the atmosphere of the bird's environment, perhaps sparking off personal memories in the viewer. Usually, though not always, this requires that adequate surroundings are included in the picture area.

4 The bird is shown in an attitude that captures the essence of the bird's character. You feel impelled to say 'Yes, that's just right, just how you see it'.

5 Whether static or in action the result is self-explanatory; the picture tells the story.

6 The bird's eye is clearly defined and contains a 'catchlight'.

7 The colour balance is good; there are no discordant, distracting, and inappropriate colour masses in the background.

8 The event depicted is genuine, a true record of a natural occurrence.

Among the illustrations in this book a number seem to me to meet these criteria. I find highly satisfying Harold Lowes's dipper (opposite) and Mike Soper's tui (page 256) which are more than good bird portraits, for they convey a feeling of the time and place where they were taken and, even in reproduction, of the immaculate print quality of the originals.

Such results seldom arise by accident, by the cameraman's affinity with the fish that lays a million eggs in order that one may survive, as George Bernard Shaw once put it, but they are a consequence of deliberate planning and selection. The end-product is visualised at, and often long before, the moment of exposure. Even when the scene is unplanned and shooting off the cuff, the composition is controlled and the camera angle varied, if possible, for the best pictorial effect.

Whether, with such volatile subjects, the results as hoped, is quite another matter: all that the photographer can do is to try and take advantage of opportunities for successful pictures as opposed to accurate records.

How the head lies in the picture frame and the way in which the bill is turned often proves important. In static or action shots where the head is side on to the camera you usually need appreciably more space in front of the bill than behind the tail, for the centre of attraction is the eye and this, rather than the

This dipper in midstream is just how one sees him: the composition is excellent. The diffused background helps focus attention on the bird and its stony perch (photo Harold Lowes).

centre of the bird's body, needs to be somewhere near the centre of the picture. A catchlight in the eye, readily provided by flash near the camera, is valuable with dark-eyed birds. It is essential with species like crows, king and emperor penguins whose dark eyes lie in patches of black feathers: without catchlights in their eyes such birds make disappointing and rather dull subjects.

Where two or more birds form the central features of a photograph the disposition of their bills and the way their heads are turned can be decisive. With the terns on page 259 for instance, notice how the composition is helped by the way in which both bills point in the same direction. Notice too how cramped this pair is in their frame, a little more room on the right hand side would have been an improvement. Not that it is always necessary to have a lot of room around the subject, but if the surroundings do not appear on the negative or transparency you cannot do anything about this later. If you have too much, however, you can at least crop the surplus during enlarging. This problem is particularly acute when the need for adequate surroundings conflicts with the need to fill the frame to ensure adequate quality in large prints.

The bird pictorialist aims at accuracy combined with artistry. He abhors trickery. There are no false moons printed into his owl studies and none of those pin-sharp flight shots taken against plain, aseptic backgrounds. These are seldom taken in the wild and you may find that the photographers are singularly reluctant to reveal their methods. If so, be suspicious; many examples are of wild birds which have been trapped and confined in a plain-walled room, empty but for a single perch to which the wretched victim is forced to fly through a photo-electric trip. Sometimes the photographer unwittingly gives the show away by inappropriate backgrounds, like the colourful, pin-sharp studio shot of an exotic parrot perched on a branch of a bush native to a land far away.

This tui, a honeyeater, has been sucking nectar from the kowhai blossoms. The curve of its body and the bird's pleasing placement on the branch combine to make a memorable bird portrait. The softly diffused background and the eye-light help to convey the bird's alertness (photo M. F. Soper).

For pictorial work the setting must be chosen carefully. Colonial species like flamingoes, terns and penguins can pose problems due to the intrusion of out-of-focus birds in front or rear. A search for pairs on the edge of a group may help but remember that peripheral pairs often suffer higher mortality of eggs and young than do central ones. Special care may be needed, therefore, to see that your actions do not contribute to such losses. The pictorial photographer also takes time over the selection of perches (page 125) which are really appropriate and attractive and, at nest sites, avoids features that may be discordant, particularly obtrusive backgrounds. Flash can often help here for by underexposure, the background can be made less obtrusive. This can be arranged by using higher shutter speeds and lighting the bird by flash. The honeyeater on page 169 is a good example. Taken in brilliant sunshine, this would have been a hopeless shot without the aid of flash. The background of a mass of spikey leaves caught the sunshine in a way that would have been extremely distracting but, by appropriate underexpo-

Lesser noddies nest colonially, but this pair at the edge of a colony were isolated from the rest by choice of view point. That the beaks point in the same direction helps the composition (photo John Warham).

The trefoil window and heraldic wing position of this barn owl flying up to its nest inside a church tower help to make this an attractive picture. One electronic flash tube above and to the left of the camera (photo John Warham).

sure plus a little burning in of light patches during enlargement, the background was adequately controlled.

This photograph, in fact, provides a number of lessons in photoplanning. I had noticed that in a small patch of virgin scrub the grevilleas were blooming and had attracted many honey-eaters. So I picked some of the blooms and kept a fresh collection of these in water-filled beer bottles before a blind fitted with the usual dummy reflectors. This went on for several days, the flowers being replaced as they faded.

I had one session in that hide, had one chance for a photograph and took it, with the result you can see here. Only one bloom was covered by my lens. The spike was fixed so that it was fairly rigid but I tested how much swing would occur if a bird alighted by moulding a lump of plasticine around the stem. Owing to the length of the flower stalk, there was not much spare space on the 6×9cm negative but I knew that if a bird did come in it would

alight at the base of the spike where the opened florets would be within reach. I also cleared a few very prominent twigs from the background. I was really very fortunate that this planning paid off so well with just a single shot. Nowadays with a quiet, motor-driven 35mm, I would probably have managed at least three shots during the episode.

Background control is also aided by the use of long focus and telephoto-lenses whose shallow depths of field diffuse distant objects and so help to make the subject stand out. I like to get everything in front of the picture, up to and including the bird, sharp and everything beyond it well-diffused. Meticulous focusing is, therefore, often essential and a careful consideration of the depth of field when the lens is stopped down may be needed to avoid distractions in the background which are not apparent when focusing at full aperture but which become only too obvious when stopped down. In colour, where an impression of depth is not solely controlled by the recession of the planes, such an arrangement of sharp and diffused zones may be less important, but it is still often highly desirable.

I find that some bird pictures which achieve publication are inappropriate in our field. Those especially which seem to make an affectation of excessive grain and contrast, blurred definition and deliberate distortions of colour balance. Many of us have discarded similar shots as not worth keeping without even drying

Red-necked avocet, a graceful and delicate bird caught preening: ample surroundings help to convey the spaciousness of the habitat. Note how the foreground is in focus but the background well diffused. (photo John Warham).

the processed film. Occasionally flight studies with blurred wings do give a better impression of movement than high-speed shots where every barbule is frozen sharp, but such effects need to be used very sparingly (as, for example, on page 206).

For many people striving to produce bird pictures, their final objective is a print rather than a transparency. A print will never have the sparkle of a well-lit transparency but makes a more convenient mode of displaying the result. Only a very few black and white bird studies are made as straight prints, most negatives give improved results with a little judicious 'dodging' and 'printing in'. To produce sparkling prints with a wide tonal range I find that it is most important to use just the right grade of paper. It pays to stock the products of several manufacturers as their papers are generally ¼ to ½ a grade apart. Underdevelopment seems fatal to print quality and I always develop fully, generally for about 1¾ min at 24°C (75°F).

When you are printing in colour, control is much more tricky, but some improvement is often possible during enlargement.

Ethics

It is not possible to photograph or even to watch birds at close quarters without having some effect on their behaviour or habitat, however cryptic these effects may be. No quantitative data are available to measure such effects, particularly increases in nest desertion, predation, and reduction of breeding success, partly because all occur naturally in the complete absence of photographers. Total loss of eggs or chicks to predators is very common among small birds of tropical zones: most start renesting within a few days of the loss. In all cases extra losses due to photography should be few if proper methods are adopted and such extra losses as do occur are usually negligible in comparison with natural mortality and with those due to other human activities—bulldozers and development, fires, forestry practices and the spraying of herbicides and pesticides. With rare species however, even slight risks may be unacceptable.

Carelessness by some bird-at-the-nest photographers has been criticised by other naturalists and it is fortunate that the development of the 35mm SLR has helped increase the popularity of away-from-the-nest photography. Even so, excessive zeal by those attempting to take birds wild and free can bring its own hazards. In many countries where bird watching is popular, the appearance of a rarity has to be kept secret lest hordes of ornithological rubber-necks drive the visitor off or hasten its death by persistently shifting it from its feeding place. A notorious example was the bustard that visited the county of Kent in Britain in early 1978. It was seen without incident by 200 local people on the day after its discovery, and for two months all went well until the national 'grapevine' latched onto the news. A new influx of watchers and photographers ensued. Many were well behaved, but almost daily someone insisted on flushing the bird from its feeding place to see it fly. This not only upset the bustard but also the landowners and the local bird watchers and photographers who, as elsewhere in most western countries, depend so much on the cooperation of farmers, foresters and others on the land.

The ethical aspects of bird photography have been clarified in Britain by the legal provisions of the Protection of Birds Act 1954-67. This, among other things, prohibits 'wilful disturbance' at or near the nest of the rarer species listed in Schedule 1 of the Act and photography at or near the nest constitutes such disturbance. Experienced bird photographers who wish to photo-

graph these rarer kinds in Britain at or near the nest must get a licence from The Nature Conservancy—details in Appendix B. Other countries also impose restrictions, e.g. it has been illegal since 1954 to photograph some Iceland rarities at the nest without a licence.

The 60 or so birds on the schedule still leave about 130 species commonly nesting in Britain that can be photographed without any formal permission. Supplementing legal restraints *The Nature Photographer's Code of Practice* was produced by the Association of Natural History Photographic Societies and is available from the RSPB, The Lodge, Sandy, Beds, SG19 2DL, England. The parts directly applicable to the bird photographer are:

Introduction
There is one hard-and-fast rule, whose spirit must be observed at all times—'The welfare of the subject is more important than the photograph'.

This is not to say that photography should not be undertaken because of slight risk to a common species. But the amount of risk acceptable decreases with the scarceness of the species, and the photographer should always do his utmost to minimise it. Risk, in this context, means risk of physical damage, suffering, consequential predation, or lessened reproductive success.

The law as it affects nature photography must be observed. In Britain the chief legislation is the Protection of Birds Acts, 1954–67, and the Conservation of Wild Creatures and Wild Plants Act 1975, though by-laws may also govern activities in some circumstances. In other countries, you should find out what restrictions apply.

General
The photographer should be familiar with the natural history of his subject; the more complex the life-form and the rarer the species, the greater his knowledge ought to be. He should also be sufficiently familiar with other natural history specialities to be able to avoid damaging their interests accidentally. Photography of scarce animals and plants by people who know nothing of the risks involved is to be deplored.

For many subjects, 'gardening' (i.e. interference with surrounding vegetation) is necessary. This should be to the minimum extent, not exposing the subject to predators, people, or adverse weather conditions. It should be carried out by tying-back rather than cutting-off, and it should be restored to as natural a condition as possible after each photographic session.

If the photograph of a rarity is to be published or exhibited, care should be taken that the site location is not accidentally

given away. Sites of rare birds should never deliberately be disclosed.

It is important for the good name of nature photography that its practitioners observe normal social courtesies. Permission should be obtained before operations on land to which there is not customary free access, and other naturalists should not be incommoded. Work at sites and colonies which are the subjects of special study should be coordinated with the people concerned.

Photographs of dead, stuffed, home-bred, captive, cultivated, or otherwise controlled specimens may be of genuine value, but should never be 'passed off' as wild and free. Users of such photographs (for exhibition or publication) should always be informed, however unlikely it may seem that they care.

Birds at the nest
It is particularly important that photography of birds at the nest should only be undertaken by people with a good knowledge of birds' *breeding* behaviour. There are many otherwise competent photographers (and bird-watchers) who lack this qualification.

It is highly desirable that a scarce species should be photographed only where it is relatively frequent. Many British rarities should, for preference, be photographed in countries overseas where they are commoner.

Photographers working abroad should, of course, act with the same care they would use at home.

A hide should always be used when there is reasonable doubt that the birds would continue normal breeding behaviour otherwise. No part of the occupant (e.g. hands adjusting lens-settings, or a silhouette through inadequate material) should be visible from outside.

Hides should not be positioned on regularly used approach-lines to the nest, and (unless erected gradually *in situ*) should be moved up on a roughly constant bearing. They should not be allowed to flap in the wind.

A hide should not be erected at a nest where the attention of the public or any predator is likely to be attracted. If there is a slight risk of this, an assistant should be in the vicinity to shepherd away potential intruders. No hide should be left unattended in daylight in a public place.

Tracks to and from any nest should be devious and inconspicuous. As far as possible they (like the gardening) should be restored to naturalness between sessions.

Though nest failures attributable to photography are few, a high proportion of them are the result of undue haste. The

maximum possible time should elapse between the constructive stages of hide movement (or erection), introduction of lens and flash-gear, gardening and occupation. There are many species that need at least a week's preparation.

Each stage should be fully accepted by the bird (or both birds, where feeding or incubation is shared) before the next is initiated. If a stage is refused by the birds (which should be evident from their behaviour, to any properly-qualified photographer), the procedure should be reversed by at least one stage; if refusal is repeated, the attempt at photography should be abandoned.

In difficult country, acceptance can be checked indirectly by disturbed marker-twigs, moved eggs, etc., provided the disturbance in inspecting the markers is minimal.

The period of disturbance caused by each stage should be kept to the minimum. It is undesirable to initiate a stage in late evening, when birds' activities are becoming less frequent.

Remote-control work where acceptance cannot be checked is rarely satisfactory. Where it involves resetting a shutter, or moving film on manually between exposures, it is even less likely to be acceptable because of the frequency of disturbance.

While the best photographs are often obtained at about the time of the hatch, this is no time to start erecting a hide—nor when eggs are fresh. It is better to wait till parents' reactions to the situation are firmly established.

There are few species for which a 'putter-in' (and 'getter-out') is not necessary. Two may be needed for some wary species.

The birds' first visits to the nest after the hide is occupied are best used for checking routes and behaviour rather than for exposures. The quieter the shutter, the less the chance of the birds objecting to it. The longer the focal length of lens used, the more distant the hide can be and the less the risk of the birds not accepting it.

Changes of photographer in the hide (or any other disturbance) should be kept to the minimum, and should not take place during bad weather (rain or exceptionally hot sun).

Nestlings should never be removed from a nest for posed photography; when they are photographed *in situ* care should be taken not to cause an 'explosion'. It is never permissible to prevent artificially the free movement of young. The trapping of breeding birds for studio-type photography is totally unacceptable in any circumstances.

The use of play-back tape (to stimulate territorial reactions) and the use of stuffed predators (to stimulate alarm reactions)

should be considered with caution in the breeding season, and should not be undertaken near a nest.

Birds away from the nest
It is not always true that, if technique is at fault, the subject will either not appear or it will move elsewhere and no harm will be done.

Predators should not be baited from a hide where hides may later be used for photography of birds at the nest.

Wait-and-see photography should not be undertaken where a hide may show irresponsible shooters and trappers that targets exist; this is particularly important overseas.

The capture of even non-breeding birds just for photography under controlled conditions is not an acceptable practice. Incidental photography of birds taken for some valid scientific purpose is acceptable, provided it causes minimal delay in the bird's release, but in the UK this must be within the terms of the licence issued by the Nature Conservancy Council.

The reasons behind most of the points in the code will be self-explanatory to readers, and although the code is based on conditions in Britain, its general tenets are mostly applicable anywhere in the world.

Appendix A: a guide to photographing British birds at their nests

The following tables are intended to provide a guide for the beginner in bird photography. In particular the camera distances are suggested ones and not intended to be strictly adhered to although they are based on experience and should be found useful in estimating the possibilities for photography at any particular nest site.

Working days
These are the approximate number of days that elapse between the time the hide may be erected and the time the young depart—that is, the number of working days available for photography. With chicks that stay in the nest for a while and then wander off—as happens with nightjars and some gulls—this has been allowed for. Where the young leave the nest as soon as they are dry, like ducks and waders, it is assumed that hide building will not be attempted until the eggs are half incubated. Thus the figures in this column represent half of the normal incubation periods for those birds.

150mm lens
This is assumed to be used on 6 × 6cm or 6 × 9cm film, and the distances ensure a 30mm long image of the bird taken sideways on to the camera.

90, 135 and 250mm lenses
This range includes those lenses most useful for 35mm studies. The distances given provide images of the birds 15–16mm long.

Maximum exposure
The exposure times given are the longest that may be tried with the bird standing at its nest. If it is sitting, much longer ones may be practicable. It is assumed that a reasonably quiet shutter is used. If you have a very quiet shutter, longer exposures should be possible without too many failures due to subject movement.

The birds
These are divided into groups, which it is thought may best assist the photographer—the first group a selection for the beginner, the remainder arranged according to habitat.

Species	Work days	Camera distance (ft)				Max exp (sec)
		6 × 6cm 150mm	90mm	35mm 135mm	250mm	
Chaffinch. Neat mossy cup with pale reddish marked eggs in hedges and bushes 4–7ft up. Careful 'gardening' often needed.	14	3½	3½	6	11	1/30
Common Whitethroat. Basket nest with grey-brown eggs in vegetation by streams, in bracken, in bushes and hedges. Tame. Careful trimming needed as nest flimsy. Perches readily.	12	3½	3½	6	11	1/30
Great Tit. White, red-spotted eggs in holes in trees and elsewhere, beneath roofs and in nest boxes. Tame. Rapid movements. Perches readily.	19	3½	3½	6	11	1/125
Greenfinch. Greenish spotted eggs in cup nest in hedges and bushes 5–10ft up. Not difficult. Fairly long waits between feeds when young big.	14	3½	3½	6	11	1/30
Lapwing. Four pointed olive-brown mottled eggs on sparse lining of straws on ground in meadows or arable land. Must be worked on eggs. Choose nest overlooked by farm, etc, for safety.	14	6½	6	10	18	1/8
Robin. Buff mottled eggs in nest on ground, in holes in banks, walls, etc. Confiding, stands motionless and perches readily.	14	3½	3½	6	11	1/8
Song Thrush. Blue, black-spotted eggs in mud-lined nest in hedges and bushes 4–7ft up. May be wary but stands still.	14	5	5	9	15	1/8
Starling. Blue eggs in nest beneath eaves, in holes in buildings, trees etc. Small pylon hide may be needed. Restless – skill needed to stop movement.	20	5	5	9	15	1/60
Swallow. White, red-spotted eggs in mud nest supported on beams in outbuildings. Confiding but restless. Flash generally needed. Second brood often reared in same nest.	14	4	4	7	12	1/125

Birds of hedgerow and woodland

Species	Work days	Camera distance (ft)				Max exp (sec)
		6 × 6cm	35mm			
		150mm	90mm	135mm	250mm	
Blackbird. Greenish, brown-mottled eggs in firm cup nest in bush, hedge or fork 4–7ft up. Often timid; deliberate in movements. Full exposure for feather detail.	14	5½	5½	9	16	1/8
Blackcap. Buff, brown-blotched eggs in basket nest of bents fixed in bush or bramble 3–5ft up. Usually fairly tame. Care with trimming as nest often poorly supported.	12	3½	3½	6	11	1/30
Blue Tit. White, red-spotted eggs in nest in hole in tree or wall. Tame but very restless. Perches.	16	3½	3½	5	11	1/125
Bullfinch. Blue, spotted eggs in fine nest of roots in bush or bramble 4–7ft up. Often tame.	14	3½	3½	6	11	1/30
Garden Warbler. Buff, grey-blotched eggs in basket nest in bush, bracken, etc, 3–5ft up. Usually fairly tame. Care with trimming as nest often poorly supported.	10	3½	3½	6	11	1/30
Hedge Sparrow. Bright blue eggs in cup nest low down in hedge, bush or bramble. Difficult to show well on account of jerky movements.	13	3½	3½	6	11	1/125
Linnet. White, red-spotted eggs in cup nest fixed in bush or hedge 4–6ft up.	12	3½	3½	6	11	1/60
Long-tailed Tit. White, red-spotted eggs in domed moss and lichen nest hung in honeysuckle or bushes 2–6ft up. Very tame but rapid in movement. Perches readily.	15	3½	3½	6	11	1/125
Mistle Thrush. Buff mottled eggs in firm cup nest in fork of tree 6–15ft up. Pylon hide usually required.	14	5½	5½	9	16	1/8
Nightingale. Olive eggs in nest of leaves close to ground in thorn bush or bramble. Stands quite still. Prefers dense cover where light poor.	12	4	4	6	12	1/8

Species	Work days	6 × 6cm 150mm	90mm	35mm 135mm	250mm	Max exp (sec)
Turtle Dove. White eggs on flimsy twig platform in bush about 5–12ft up. Very timid, no hide till eggs hatched. Often deserts if disturbed from eggs.	18	6½	6½	10	18	1/8
Willow Warbler. White, red-spotted eggs in domed nest on ground beneath clump of grass. Tame.	14	3½	3½	6	11	1/60
Wren. White, red-spotted eggs in domed nest fixed in dry bracken, ivy, holes in walls, etc. Tame.	16	3½	3½	5	11	1/60
Yellow-hammer. Pale, brown-scribbled eggs in nest of bents in bush, hedge or on ground or bank.	12	4	4	6	12	1/30

Species	Work days	Camera distance (ft)				Max exp (sec)
		6 × 6cm 150mm	90mm	35mm 135mm	250mm	
Coot. Buff, black-spotted eggs in shallow nest of rushes, etc. at water level. Common but reluctant to face occupied hide. Best results when eggs starting to chip.	12	7½	7½	12	21	1/30
Dabchick. Yellowish, stained eggs on floating nest of damp weeds at edge of lake; not in running water. Must be worked on eggs.	10	6½	6½	10	19	1/30
Kingfisher. White eggs in chamber bored in river bank. Takes readily to properly placed perch.	25	3½	3½	6	11	1/8
Mallard. Large white eggs in loose nest of down and grass on ground beneath brush or coarse vegetation. Often well away from water. Timid, must be worked on eggs.	15	7½	7½	13	21	1/30
Pied Wagtail. Grey, speckled eggs in loose cup nest under cover in woodpiles, outbuildings, ledges and holes. Moving tail chief problem.	14	4	4	6	12	1/125
Redshank. Buff, brown-marked eggs in shallow nest of sedge, etc, on ground in damp meadows and bogs. Must be worked on eggs.	12	5	5	8	15	1/60
Reed Bunting. Pale brown, black-scrawled eggs in cup nest in coarse grass and low bushes 1–14ft up. Usually tame. Nest sites very contrasty.	12	3½	3½	6	11	1/30
Sedge Warbler. Freckled buff eggs in rough cup nest low down in waterside weeds. Tame.	14	3½	3½	6	11	1/60
Snipe. Light brown eggs, mottled with darker-brown, in shallow nest of sedge, etc, on ground in damp meadows and bogs. Must be worked on eggs.	10	5	5½	8	15	1/60
Skylark. Speckled drab-grey eggs in cup nest	10	4	4	6	12	1/30

Species	Work days	Camera distance (ft)				Max exp (sec)
		6 × 6cm		35mm		
		150mm	90mm	135mm	250mm	
hidden in grass on meadow land.						
Tufted Duck. Large white eggs in nest of dark down and grass, etc, on ground in waterside cover. Timid. Must be worked on eggs.	12	7½	7½	12	20	1/30
Waterhen. Buff, black-spotted eggs in loose cup of sedge under cover of water-side vegetation, usually a little above the water level. Common, but very reluctant to face occupied hide. Best results when eggs starting to chip.	11	6½	6½	11	19	1/30
Yellow Wagtail. Olive eggs in small cup nest on ground beneath grass clump. Moving tail chief problem.	13	4	4	6	12	1/60

Moorland birds

Species	Work days	6 × 6cm 150mm	35mm 90mm	135mm	250mm	Max exp (sec)
		Camera distance (ft)				
Black-headed Gull. Greenish-brown, dark-blotched eggs in shallow nest on sandhills, seashore bogs, sewage farms. Frequents boggy ground. Colonies often very large.	18	6½	6½	10	19	1/8
Curlew. Large, olive brown-blotched eggs on ground in heather or rough pasture. Usually rather timid; must be worked at eggs.	15	8½	8½	15	27	1/8
Dipper. White eggs in large mossy domed nest under banks and waterfalls. Always near mountain stream. Usually tame.	20	4	4	6	12	1/125
Grey Wagtail. Pale eggs in cup nest under stone by fast flowing rocky streams. Usually tame: wagging tail a problem.	12	4	4	6	12	1/125
Meadow Pipit. Greyish eggs in cup nest on ground beneath grass clump, etc.	14	3½	3½	6	11	1/60
Merlin. Round, red-speckled eggs on ground beneath heather. Nests neither abundant nor easily discovered. Low hide best.	21	6½	6½	10	19	1/30
Red Grouse. Buff, black-marked eggs on ground amongst heather or bracken. Low hide, well concealed. Worked at eggs.	11	6½	6½	10	19	1/8
Ring Ouzel. Greenish, brown-marked eggs in cup of grasses on ground beneath bracken, heather or stones. Full exposure needed for feather detail.	14	5½	5½	9	16	1/8
Wheatear. Blue eggs in hole in ground or stone wall. Wagging tail chief problem.	15	3½	3½	6	11	1/60

Species	Work days	Camera distance (ft)				Max exp (sec)
		6 × 6cm *150mm*	*90mm*	*35mm* *135mm*	*250mm*	
Carrion Crow. Greenish, grey-marked eggs in large nest. Solitary. A wary bird.	30	8	8	15	24	1/8
Greater Spotted Woodpecker. White eggs in cavity bored in tree trunk. Entrance 7ft and more in height. Clings motionless to trunk. Allow for thickness of bird when focusing.	20	5½	5½	9	16	1/8
Green Woodpecker. White eggs in cavity bored in tree trunk. Entrance 7ft and more in height. Clings motionless to trunk. Allow for thickness of bird when focusing.	20	6½	6½	10	19	1/8
Kestrel. Round, brick-red eggs in hollow tree, hole in ruin, old crows' nest, etc. Pylon needed. May be worked on hard-set eggs.	34	7½	7½	13	21	1/30
Rook. Olive, brown-blotched eggs in huge stick nest in tops of trees. Colonial. Difficulty in finding position overlooking nest. Hide framework may be built in winter as nests used each year.	30	8	8	15	24	1/30
Sparrow-Hawk. Pale red-blotched eggs in self-built nest in trees from 15ft upwards. Pylon needed. May be worked on hard-set eggs.	31	7½	7½	13	21	1/30
Tree Creeper. Red-spotted white eggs in shallow nest fitted behind loose bark against tree trunk. Tame but very active.	14	3½	3½	6	11	1/125
Woodpigeon. White eggs on shallow twig platform in bushes and trees from 6ft up. Choose a low nest. Must not be flushed till eggs hatched or desertion probable. About 4 hours between feeds. Very wary.	28	7½	7½	13	21	1/8

Species	Work days	Camera distance (ft)				Max exp (sec)
		6 × 6cm 150mm	90mm	35mm 135mm	250mm	
Buzzard. Large, rounded, reddish-marked eggs in large nest on cliffs, or inland on crags and trees. Stands still except when feeding young.	40	9	9	15	27	1/8
Common Tern. Buffish, black-blotched eggs on ground on beaches or islets. Colonial. Must be worked on eggs.	16	6½	6½	10	19	1/8
Cormorant. Large whitish eggs in large flat twig and seaweed nest on rocks overlooking sea. Can often be stalked when near nest. Full exposure needed.	30	12	12	20	35	1/8
Great Black-backed Gull. Large brown, dark-spotted eggs in shallow nest on ground on cliffs. Seldom many together. Hide required.	35	9	9	15	27	1/8
Guillemot. Blue, buff, green or other coloured egg, marked black, grey, etc, and laid on narrow ledges overlooking sea. Many birds side by side. Allows close approach when with young. Nest often inaccessible to camera. Bird's constant movement of head makes exposure difficult.	14	7	7	12	20	1/30
Herring Gull. Brown, chocolate-marked eggs, in flat nest of weeds on rocks adjoining the sea. Hide needed but birds usually easy.	32	8½	8½	15	25	1/8
Kittiwake. Buff, grey and brown-marked eggs in seaweed nest on cliff ledges. many together. Tame. Often difficult to find good viewpoint.	30	7	7	12	20	1/8
Oyster-catcher. Brown, black-blotched eggs on ground amidst pebbles or vegetation. Often rather timid; worked at eggs.	15	7	7	12	20	1/8

Species	Work days	6 × 6cm 150mm	90mm	35mm 135mm	250mm	Max exp (sec)
Puffin. White egg down burrow below ground. Colonial. Prefers turfy sidings above the sea. Will usually allow a close approach without hide.	40	6	6	9	16	1/8
Razorbill. Buff, black-marked egg on ground among rocky debris on cliffs. Nests in colonies. Will usually allow a close approach without hide.	14	7	7	12	20	1/8
Ringed Plover. Buff, black-spotted eggs laid on ground, lined with tiny stones, on sandy or pebbly beaches. Must be worked on eggs. Generally quite tame.	12	4	4	7	12	1/30

Birds of the night

Species	Work days	Camera distance (ft)				Max exp (sec)
		6 × 6cm 150mm	90mm	35mm 135mm	250mm	
Barn Owl. White eggs laid in hollow trees, lofts in barns and church towers.	60	7	7	12	20	1/8
Little Owl. White eggs laid in hole in tree or masonry. Usually tame: stands still for several seconds. Perches readily.	25	5	5	9	16	1/8
Long-eared Owl. Eggs laid in old nest of crow, magpie or hawk. Least common of woodland owls. Prefers conifers.	22	7½	7½	13	21	1/8
Nightjar. Rounded, white, brown-mottled eggs on ground: no nest. Prefers bracken covered patches in woods and commons. Site difficult to find. May be photographed by day when incubating.	14	6	6	9	18	1/8
Tawny Owl. White eggs laid in hole in tree or building, or in nest of crow or hawk.	30	8	8	13	21	1/8

Appendix B: birds on Schedule I of the Protection of Birds Acts 1954–1967

Under this Act a group of British birds is given special protection in addition to the general protection afforded all birds in the United Kingdom. The species listed may not be wilfully disturbed at or near the nest and may be photographed only with permission of The Nature Conservancy, 12 Hope Terrace, Edinburgh, EH9 2AS.

Avocet
Bee-eater, all species
Bittern, all species
Bluethroat
Brambling
Bunting, snow
Buzzard, honey
Chough
Corncrake
Crake, spotted
Crossbill, parrot
Diver, all species
Dotterel
Eagle, all species
Fieldfare
Firecrest
Garganey
Godwit, black-tailed
Goldeneye
Goshawk
Grebe, black-necked

Grebe, Slavonian
Greenshank
Harrier, all species
Hobby
Hoopoe
Kingfisher
Kite
Long-tailed duck
Oriole, golden
Osprey
Owl, barn
Owl, snowy
Peregrine
Phalarope, red-necked
Plover, Kentish
Plover, little ringed
Quail, European
Redstart, black
Redwing
Ruff and Reeve
Sandpiper, wood
Scaup

Scoter, common
Scoter, velvet
Serin
Shrike, red-backed
Sparrowhawk
Spoonbill
Stilt, black-winged
Stint, Temminck's
Swan, whooper
Tern, black
Tern, little
Tern, roseate
Tit, bearded
Tit, crested
Warbler, Dartford
Warbler, marsh
Warbler, Savi's
Whimbrel
Woodlark
Wryneck

Appendix C

Shooting distances (ft) with different lenses on 16mm

Length of bird	Focal length of lens					
	25mm	50mm	75mm	100mm	150mm	300mm
ft in						
2	—	2	3	4	6	12
3	1.5	3	4.5	6	9	18
4	2	4	6	8	12	24
5	2.5	5	7.5	10	15	30
6	3	6	9	12	18	36
9	4.5	9	14	18	27	54
1 0	6	12	18	24	36	72
1 6	9	18	27	36	54	108
2 0	12	24	36	48	72	144
2 6	15	30	48	60	90	180
3 0	18	36	54	72	108	216
4 0	24	48	72	96	144	288
5 0	30	60	90	120	180	360
7 6	45	90	135	180	270	540
10 0	60	120	180	240	360	720

The figures within the heavy lines are the approximate distances *in feet* between camera and bird to produce an image occupying half the frame width, i.e. for average mid-shots. Thus, to get a picture of a vulture about 2ft from nose to tail, half filling the frame, you would need to shoot from about 36ft using a 75mm lens, or 24ft with a 50mm lens.

References

1 GUGGISBERG, C.A.W. *Early Wildlife Photographers*. 1977. David and Charles, Newton Abbott.

2 MAREY, E.J. *Le Mouvement*. 1894. Masson, Paris.

3 CAMPBELL, A.J. *Nests and Eggs of Australian Birds*. 1900. Privately printed, Sheffield.

4 MAREY, E.J. *Le Vol des Oiseaux*. 1890. Masson, Paris.

5 DUGMORE, R. *Nature Pictures*. 1901. Ann. Rep. Smithsonian Inst. for 1900: 507–515.

6 DUGMORE, R. *Nature and Camera. How to Photograph live Birds and their Nests*. 1902.

7 HARRIS, H. *Essays and Photographs: some Birds of the Canary Islands and South Africa*. 1901.

8 van SOMEREN, V.G.L. and R.A.L. *Studies of Bird Life in Uganda*. 1911.

9 HAVILAND, M.D. Notes on the breeding habits of the Asiatic Golden Plover. 1915. *British Birds* 9: 82–89.

10 TURNER, E.L. *On "wait and see" photography*. 1915–16. *Brit. Birds* 9: 102–108; 258–264; 282–289; 306–313.

11 SHIRAS, G. Photographing wild game with flashlight and camera. 1906. *National Geographic Magazine* 17: 367–423.

12 NESBIT, W. *How to hunt with a camera. A complete guide to all forms of outdoor photography*. 1926.

13 EDGERTON, H.E. Humming Birds in action. *National Geographic Mazagine*. 1947.

14 ALLEN, A.A. *Stalking birds with a color camera*. 1954.

15 BERG, B. *Mit den Zugvogeln nach Africa*. 1925.

16 PIKE, O.G. *Nature and my Cine Camera*. nd. Focal Press.

17 SEITZ, A. *Ethology of the Grey Goose*. Film (b & w). IWF No. C560.

18 DEMOLL, R. *Die Flugbewegung der grossen und kleinen Vogel*. 1930. *Zeitsch.f.Biol.* 90: 199–230.

19 STOLPE, M. and ZIMMER, K. [*The whirring flight of Humming Birds in slow motion films*]. 1939. *J.f. Ornithol.* 87: 136–155.

20 ZIMMER, K. [*The flight of Sunbirds*]. 1943. *J.f. Ornithol.* 91: 371–387.

21 BLAKER, A.A. *Field Photography*. 1976. Freeman, San Francisco.

22 Kennett Benbo Tripod & Manfrotto 3D Tripod Head—R.P. Beard Ltd, 10 Taylor Avenue, Old Kent Rd, London SE15 6NR.

23 Kaiser Rifle Grip—Bush & Meissner Ltd, 275 West End Lane, London, NW6 1QS.

24 BOND, T. *Colour—here today, gone tomorrow.* 1979. *RPS Nature Group Newsletter* 13: 15–17.

25 Fensman Portable Hide—Jamie Wood Ltd, Cross St, Polegate, Sussex.

26 PETERSON, R.T. *Wild America.* Film (colour).

27 POLLOCK, H.J. *Wild Life Wonderland.* Film (colour). 1960. In UK from Australia House, Strand, London WC2.

28 BIGWOOD, K. *Legend of Birds.* Film (colour). In UK from New Zealand House, Haymarket, London SW1.

29 MYLNE, C.K. *A Waterbird's World.* Film (colour). 1963. From RSPB, The Lodge, Sandy, Beds, SG19 2DL.

30 CLEAVES, H.H. *Hunting with the Lens.* 1914. National Geographic Magazine 26: 1–35.

31 EASTMAN, R. and EASTMAN, R. *The Private Life of the Kingfisher.* Film (colour). 1968. BBC.

32 SMITH, S. and HOSKING, E. *Birds Fighting.* 1955. Faber & Faber, London.

33 SEILMANN, H. *My Year with the Woodpeckers.* 1959. Barrie and Rockliff, London.

34 BLACKBURN, F. *The uses of play-back tape.* pp 137–154 in D.M. Turner–Ettlinger (Ed.) *Natural History Photography.* 1974. Academic Press, London

35 CAMPBELL, B. and FERGUSON-LEES, J. *A Field Guide to Bird's Nests.* 1972. Constable, London.

36 GIBSON, H.L. *Photography by infra-red: its principles and applications.* 1978. 3rd ed. Wiley, New York.

37 RIVELLI, W. Norman 200B Electronic Flash (field tests). July 1977. *Photomethods Magazine.*

38 SCULLY, E. *Tele Flash? You Bet! It's simple.* 1972. *Modern Photography.*

39 Optical Sciences Group, 24 Tiburon Street, San Rafael, Cal 94901, USA.

40 EDGERTON, H.E. *Electronic Flash Strobe.* 1970. McGraw Hill, New York.

41 EDGERTON, H.E. MACROBERTS, V.E. and KHANNA, M. *Improvements in electronics for nature photography.* July 1969. *IEEE Spectrum* 89–94.

42 COOKE, D.A.P. *Flight photography with electronic flash.* pp 179–192 in D.M. Turner–Ettlinger (Ed.) *Natural History Photography.* 1974. Academic Press, London.

43 DAVIDSON, T. *Photoelectric Nature Photography.* 1958. *Phot. Soc. Amer. J.* 24: 31–36.

44 E.G. & G. Inc, 160 Brookline Avenue, Boston, Massachusetts, USA.

45 Honeywell Photo Products, P.O. Box 5227, Denver, Colorado, USA.

46 WARHAM, J. *The Technique of Wildlife Cinematography.* 1966. Focal Press, London.

47 SMITH, V.W. and KILLICK-KENDRICK, R. *Notes on the breeding of the Marsh Owl (Asio capensis) in Northern Nigeria.* 1964. *Ibis* 106: 119–123.

48 TIBBLES, M. *The Life of the Street Pigeon.* Film (colour). BBC.

49 Cine 60 Inc, Film Center Building, 630 North Avenue, New York, 10036, USA.

50 BATTEN, H.M. *Electricity and the Camera.* 1939. Moray Press, London.

51 BORDEN, J. *The Making of "Still Waters".* 1978. *Film-makers Newsletter* 11: 25–30.

52 HOLDGATE, M.W. *The Purposes of Photography on Scientific Expeditions.* 1961. *Photo.J.* 102: 345–353.

53 JOHN, D.H.O. *Photography on Expeditions.* 1965. Focal Press, London.

54 STRASSER, A. *The Work of the Science Film Maker.* 1972. Focal Press, London.

55 MICHAELIS, A.R. *Research Films in Biology, Anthropology and Medicine.* 1955. Academic Press, New York.

56 WOLF, G. *Factuality in Scientific Films.* June 1968. *Photo. J.* 173–177.

57 EASTWOOD, E. *Radar Ornithology.* 1968. Methuen, London.

58 ENDERSON, J.H., TEMPLE, S.A. and SWARTZ, L.G. *Time lapse photographic records of nesting Peregrine Falcons.* 1972. *Living Bird* 11:113–128.

59 FRITH, H.J. *The Mallee Fowl.* CSIRO film (colour). 1957. In UK from Australia House, Strand, London.

60 DESPIN, B., LE MAHO, Y. and SCHMITT, M. *Mesures de températures périphériques par thermographie infra-rouge chez Le Manchot de Humboldt (Spheniscus humboldti).* 1978. *Oiseaux et RFO.* 48: 151–158.

61 OEHME, H. *Die Flugbewegungen ruttelnder Vogel.* Film (b & w). 1978. From Akad. der Wissenschaften Der DDR, 1136 Berlin (East), DDR.

62 DALTON, S. *The Miracle of Flight.* 1977. Sampson Low, London.

63 KOOYMAN, G.L. DRABEK, C.M. ELSNER, R. and CAMPBELL, W.B. *Diving Behaviour of the Emperor Penguin.* 1971. *Auk* 88: 775–795.

64 URBAN, W. *Vogel unter Wasser.* Film (colour). 1978. From 8504 Stein, Nurnberg, Guttkneckstrasse 20, West Germany.

65 BARNETT, S.A. and DONALD, G. *Medical and Biological Illustration* 1961. 11: 214–218.

66 McINNES, R.S. and CARNE, P.B. *Predation of cossid moth larvae by Yellow-tailed Black Cockatoos causing losses in plantations of* Eucalyptus grandis *in North Coastal New South Wales.* 1978. *Austr. Wildl. Res.* 5: 101–121.

67 DILL, L.M. and MAJOR, P.F. *Special structure of bird flocks. Natl. Res. Council Canadian Field Note.* 1977. 76: pp. 49.

68 WHITEHOUSE, M.P. *Stereophotography.* pp. 317–341 in D.M. Turner–Ettlinger (Ed.) *Natural History Photography.* 1974. Academic Press, London.

69 *Zoological Record.* Annual publication of the Zoological Society of London, Regents Park, London NW1 4RY.

70 *Biological Abstracts.* Biosciences Information Service, 2100 Arch Street, Philadelphia, Pennsylvania 19103, USA.

71 LACK, D. *The Life of the Robin.* 1953. Penguin Books, London.

72 BADDELEY, W.H. *How to Edit.* 1958. Focal Press, London.

73 REISZ, K. *The Technique of Film Editing.* 1968. 2nd ed. Focal Press, London.

74 Duplikin IV 'Freeze-Frames' device—Century Precision Cine/Optics, 10661 Burbank Boulevard, North Hollywood, California 91601, USA.

75 ATTENBOROUGH, D. *Honesty and Dishonesty in Documentary Film Making.* 1961. *Photo. J.* 101: 97–103.

76 BEAL, J.D. *Cine Craft.* 1974. Focal Press, London.

77 CALLAGHAN, B. *Manual of film-making.* 1973. Thames and Hudson, London.

78 In the UK, licences to use radio-controlled cameras are issued from: R2 Division, Home Office, Waterloo Bridge Road, London SE1 8All

Index